the complete

Cats in the Sun

the complete

Cats in the Sun

HANS SILVESTER

CHRONICLE BOOKS

SAN FRANCISCO

Copyright © 1993, 1995, 1997, 2000 by Editions de la Martiniere
Translation copyright © 1994, 1996, 1997, 2000 by Chronicle Books

All rights reserved. No part of this book may be reproduced in any form
without written permission from the publisher.

LIBRARY OF CONGRESS CATALOGING-IN-PUBLICATION DATA AVAILABLE.

ISBN 0-8118-2909-X

JACKET DESIGN: Julia Flagg

Printed in Italy

Distributed in Canada by Raincoast Books
9050 Shaughnessy Street
Vancouver, British Columbia V6P 6E5

2 4 6 8 10 9 7 5 3 1

CHRONICLE BOOKS LLC
85 Second Street
San Francisco, California 94105

www.chroniclebooks.com

introduction

the book you hold in your hands is like a family album for me. In some way, I am like a father to all these cats. I knew them all. Many of them became real friends.

These images stir up countless memories. I devoted eight years of my life to the cats of the Cyclades. I love them for what they are—half-wild, unpredictable, mysterious, ferocious, self-assured, arrogant, and extremely sensitive to signs of sympathy or love. I understand them perfectly, and our rapport is truly a marvel. They hold an important place in my life.

This book is the reflection of a long succession of happy moments, the product of long waiting, but also of accident and chance. From a purely technical point of view, these images were realized in an instant, the shutter-speed varying between $1/250$ and $1/1000$ of a second. The magic of photography!

Neither wild nor domestic, these island cats are very different from those we keep in our homes. They belong to the village; they are fed by its inhabitants and by the fisherman who toss them fish at the docks. The cats add to this all sorts of prey: mice and rats, lizards, snakes, birds, small crabs, and various insects. While they live at liberty, these cats are not spoiled: they are forbidden access to homes; they have no master, belonging instead to one and all. Their life is hard. Without human control of their numbers, they reproduce very quickly and catastrophe becomes inevitable. They must survive

hardships: during the cold, wet winter, food becomes scarce. The hungry cats easily fall victim to disease, and in the whole group of islands, there are but two or three veterinarians.

The images in this book evoke the idea of a rare happiness. It must be understood that I invented this dream island, capturing these photos on twenty-two different islands. On each voyage, the magic of Mykonos, Milos, Santorini, Tinos, Syros, Amorgos, Folegandros, Sifnos, Paros, Naxos, and Ios, never stopped working. I eliminated from my scenes the cars, the tourists, and many other elements. I created this "Cat Paradise," which exists nowhere else but in this book.

Just like the sun and the wind, these cats are an integral part of these islands. They are there as they have always been there. Aboard the boats, they protect cargo against mice and rats. Enclosed in ships' holds, they have made tours of the world, making their escape at the first opportunity. They keep watch over the crops and storehouses for the islands' population. Domestic cats have always been useful animals to humankind, controlling the population of the rodents that cause epidemics of plague and cholera.

The Greeks' attachment to animals is that of the people of the South. They don't like cats so much as they tolerate them. In difficult circumstances, seized by pity, they are ready to help them.

During the past eight years among these cats, I've witnessed radical changes in their life on the islands. The international scourge of mass tourism has battered these places, eradicating their traditions. Very quickly, tourism has become the soul "growth industry." A flood of money has been poured onto the islands. Everywhere, thin-walled cement hotels have been constructed. In summer, a charter air service links these microcosms to the metropolises of Europe. On certain islands, the cats are photographed like celebrities. Lying in the sun, they become the principal attraction for the tourists. In July and August, the cats seek refuge on the roofs, taking back the streets only at night. It is no longer their home. For all that, this "invasion" of Northern people can be a stroke of good fortune for the cats. Many of them are adopted by animal

lovers. But for those that remain, the winter is even harder than in the past—many inhabitants of the islands now leave for Athens or elsewhere.

A great part of the cats' lives is secret, unraveling in the darkness of night or in places inaccessible to humans. Roofs, caves, ruins, and woods become the theater of their adventures. By day, they sleep or rest. One day they are here, the next they have disappeared without a trace. Even if one has observed the cats for a long time and thinks he knows them well, one is always surprised. Their curiosity may lead them to an isolated beach or a church roof. In any place where the rodents haven't taken cover, a cat is sure to be lurking nearby.

In the countryside, it is said that a house without a cat is a sad house. And it is true. In our house in Provence, our two cats lead a happy life; they share our home and have a place in the family. We assure them of food and well-being, and they are free to come and go as they please, or at least it seems so. They hunt a lot, and often proudly present us with still-living mice. They are part of our life, even as they guard their independence. Their presence means a great deal to us. It guarantees us an exceptional quality of life. We have had cats more than forty years, and they are for us an unceasing source of joy.

In the industrialized countries, we have surrounded ourselves with an unbelievable number of machines of all sorts, supposed to make our lives easier and give us more free time. Man and machine have become inseparable in daily life. In the modern world, the presence of cats and dogs takes on a capital importance. It reestablishes a necessary equilibrium, which is more and more threatened in a world ruled by machines; in a word, these animals bring life. For city children, bonding with another living thing is essential. They learn to know it, talk to it, play with it, share their secrets; they raise it and care for it. In this way, they learn respect for another, and friendship.

Humans have created different breeds of cats, with specific characteristics. Of all domestic animals, cats are without a doubt the best adapted to modern times. Wherever they are, they are capable of being happy—so long as they have someone who loves them.

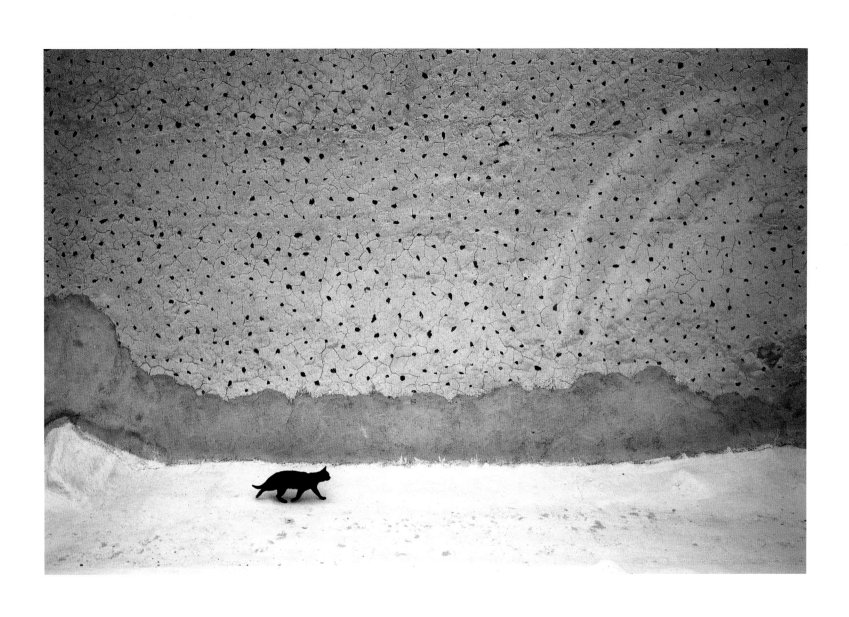

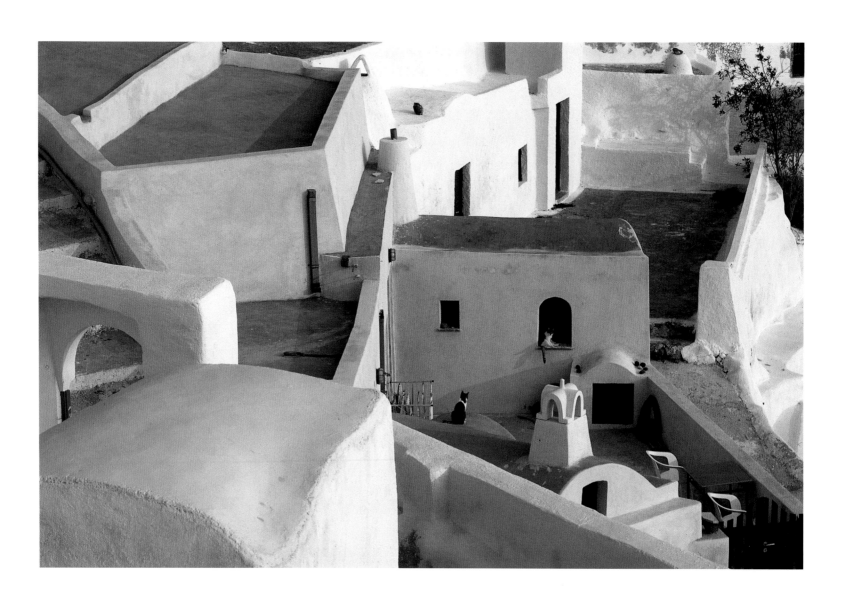

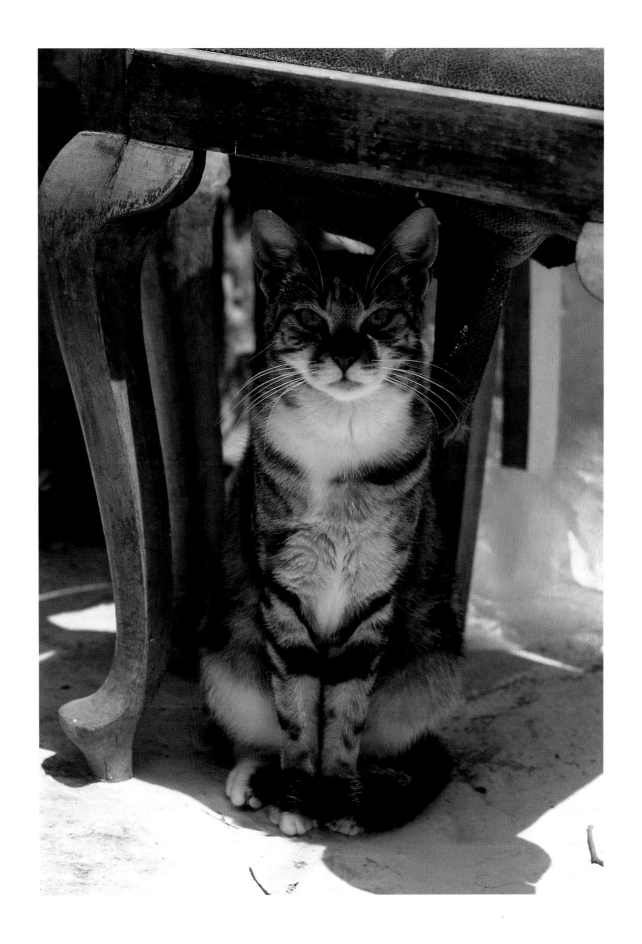

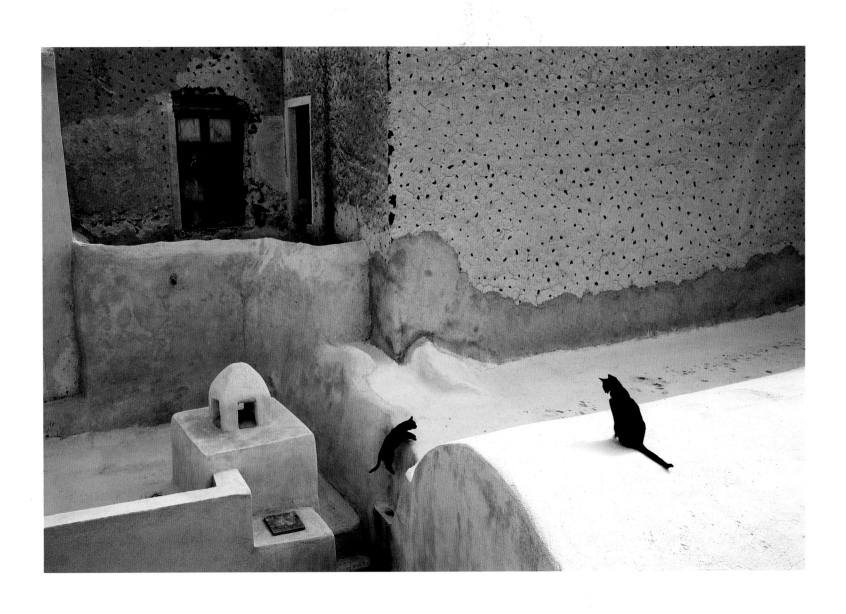

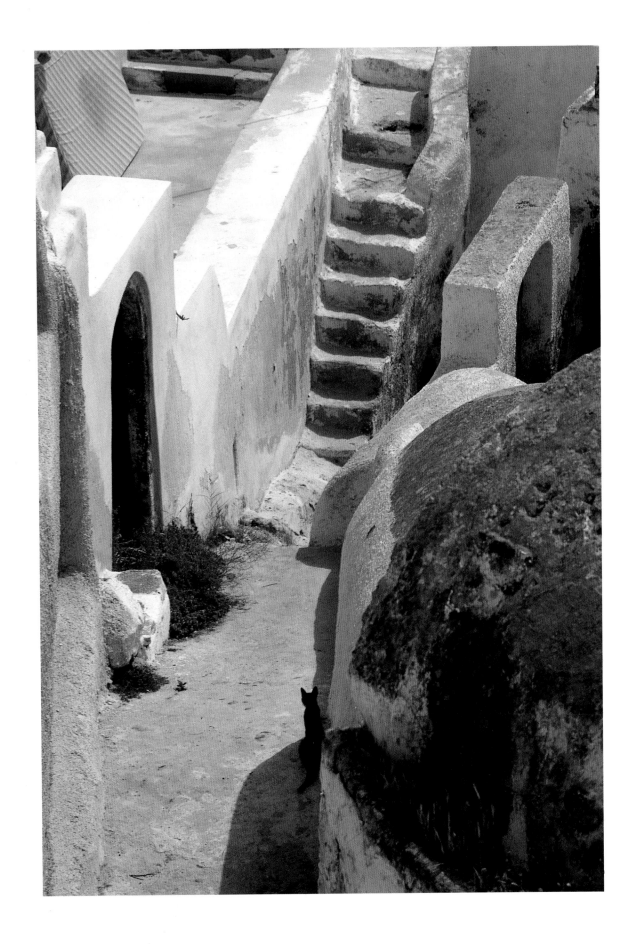

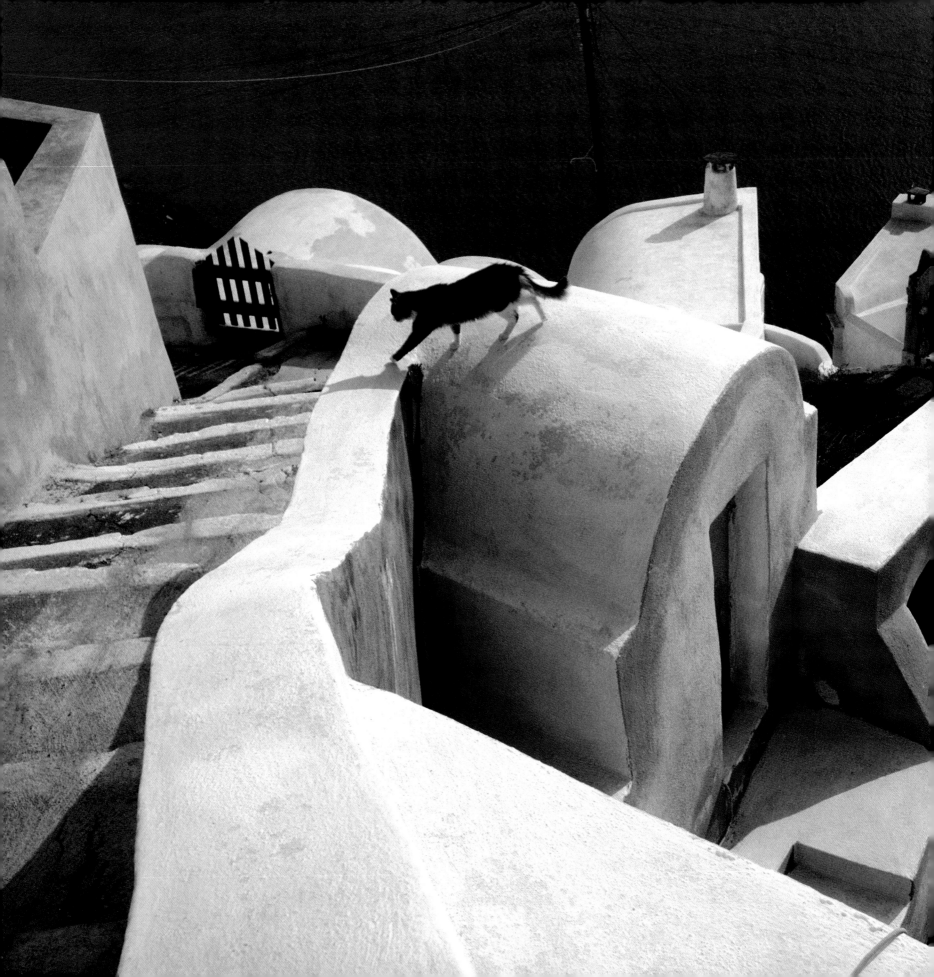

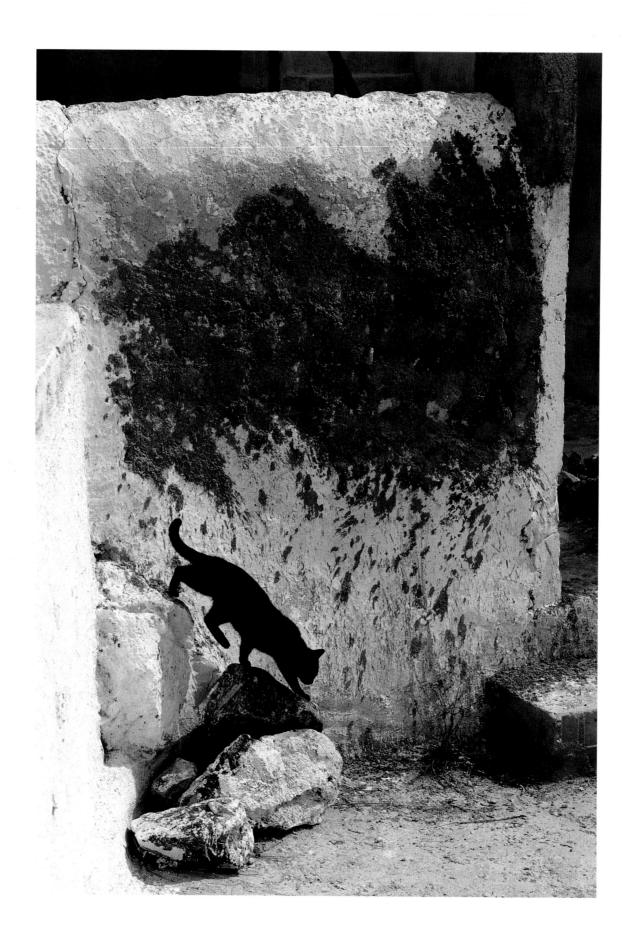

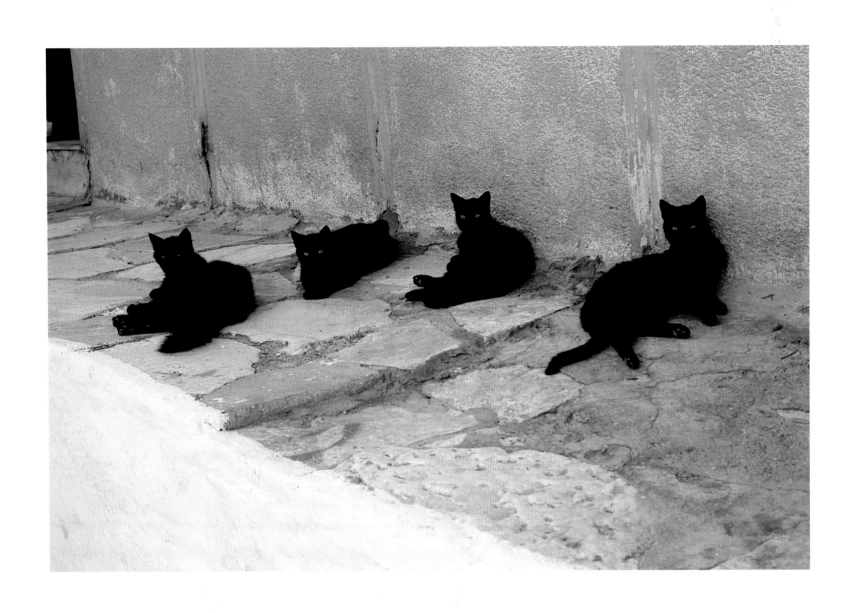

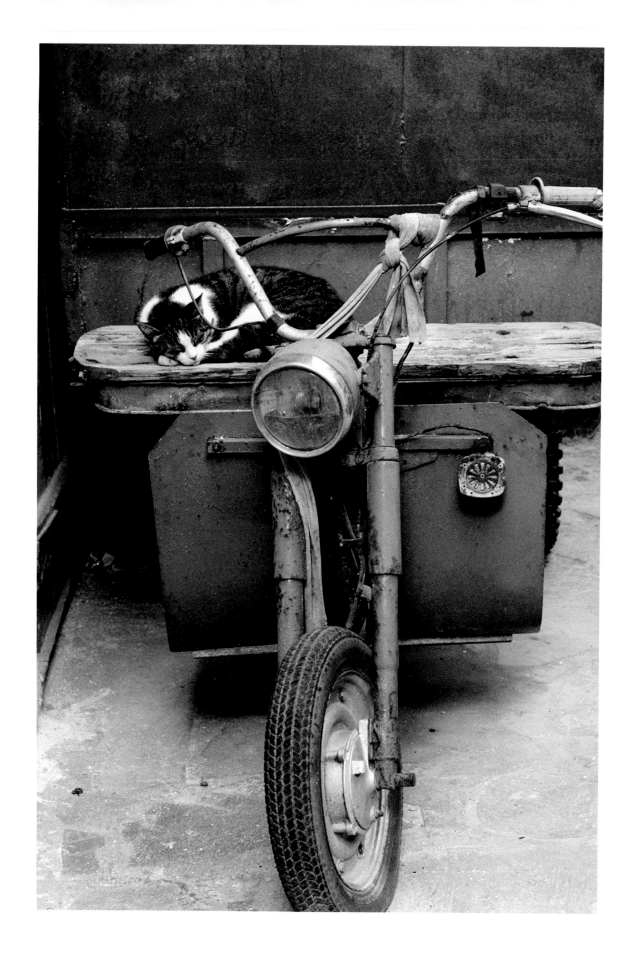

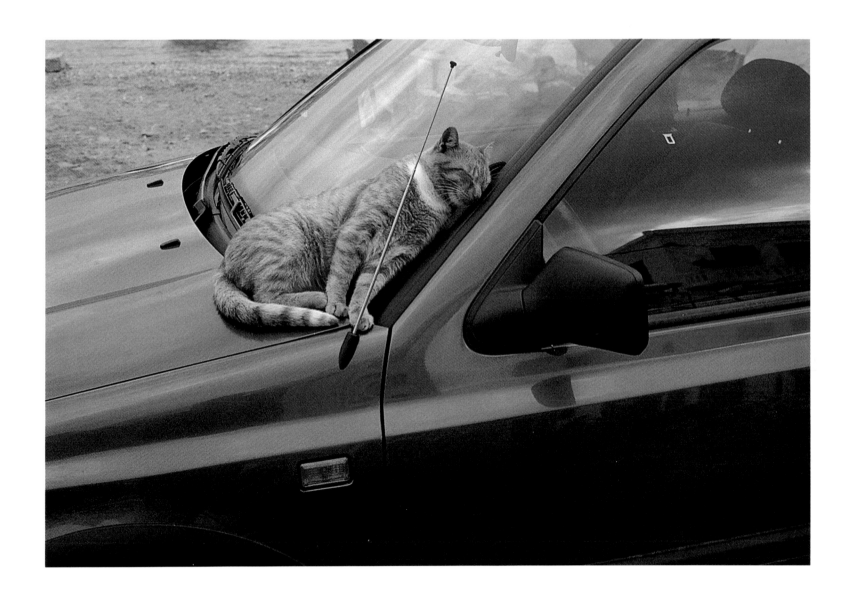

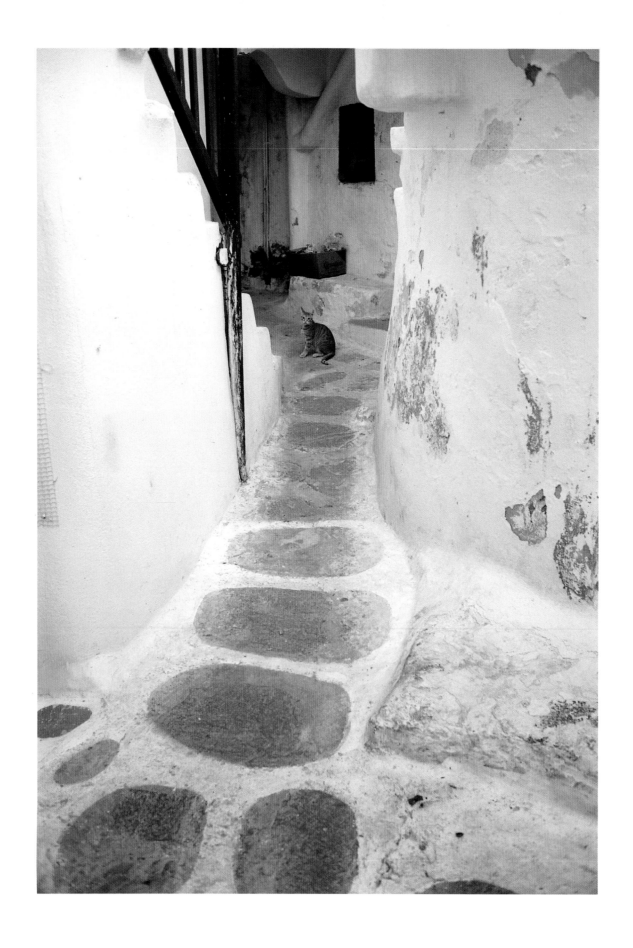

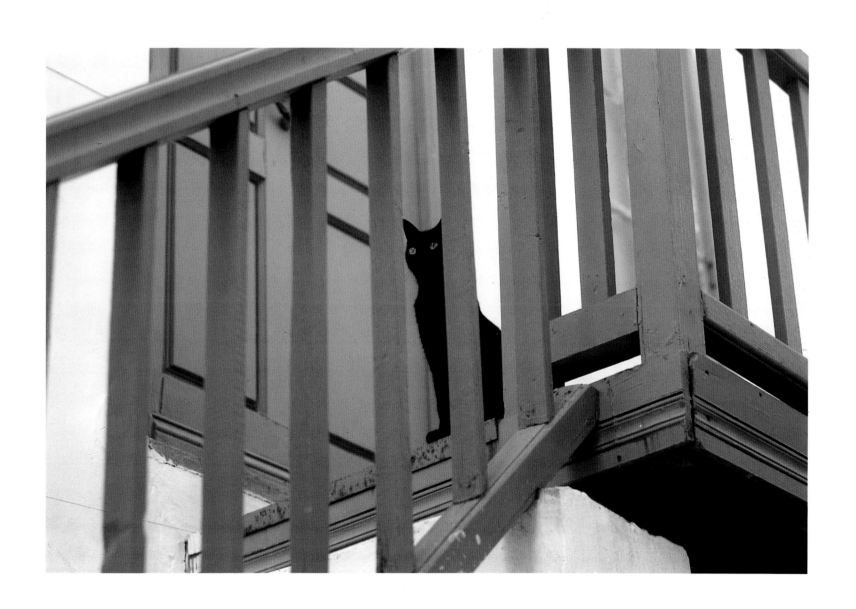

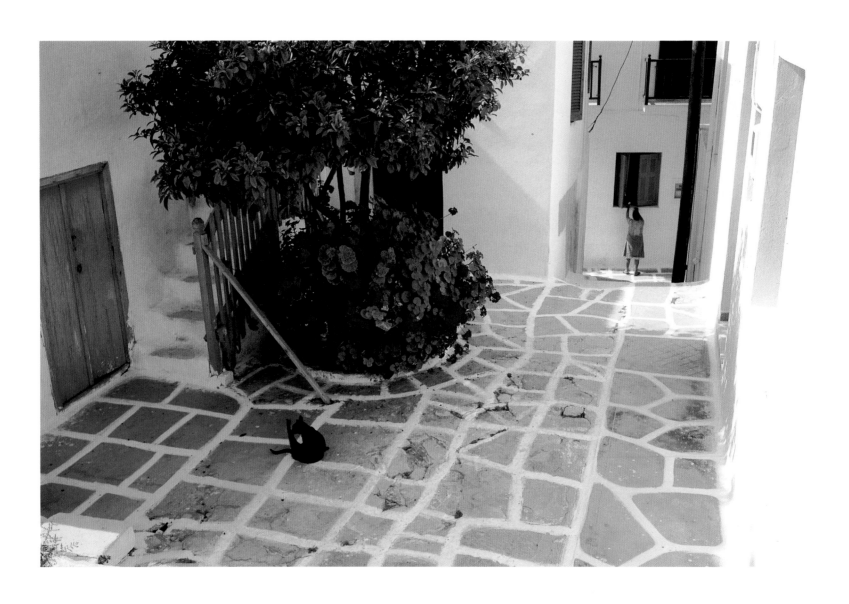

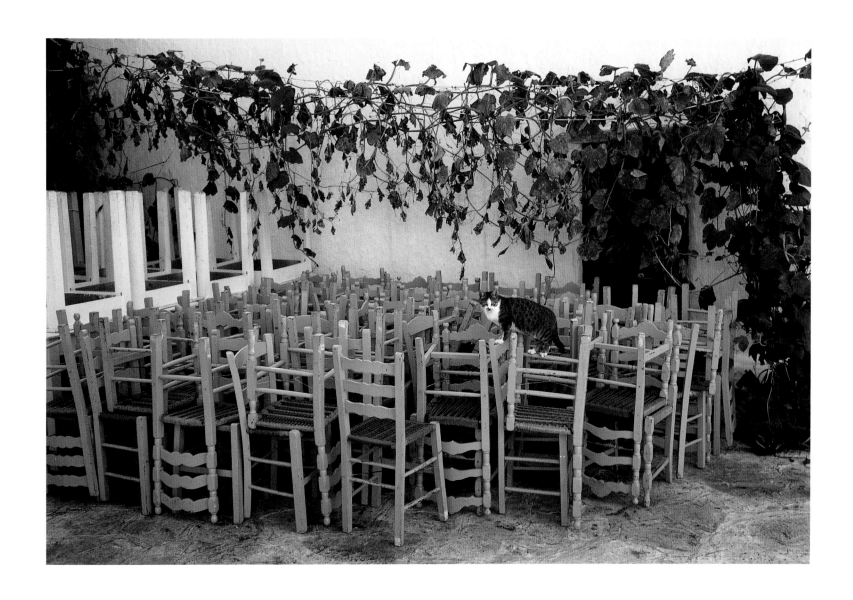

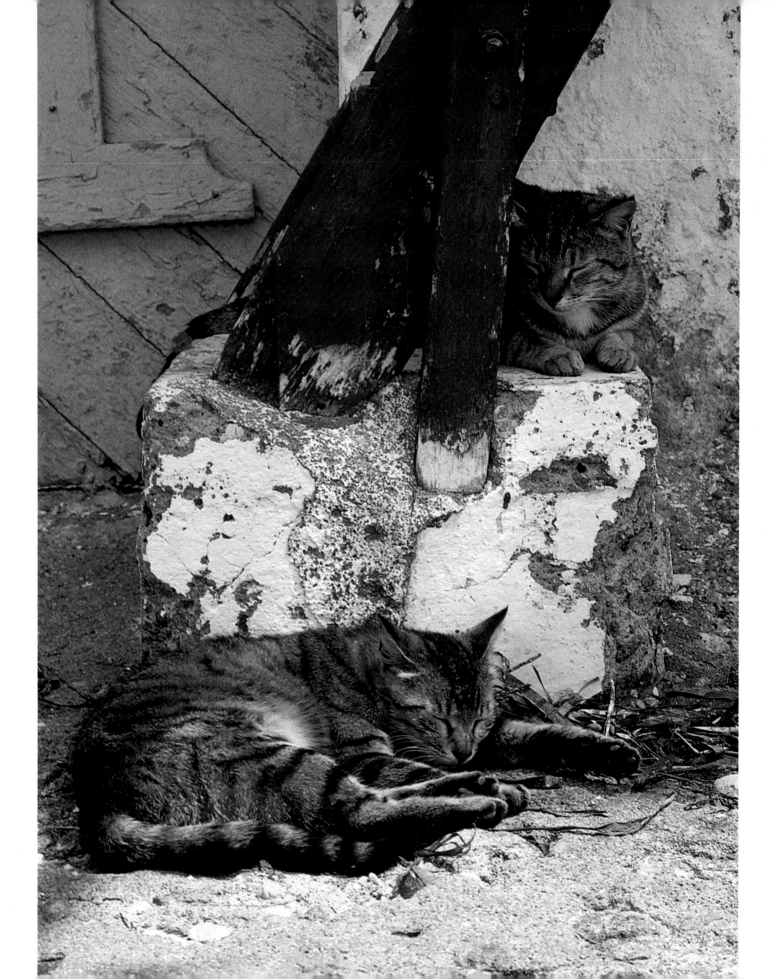

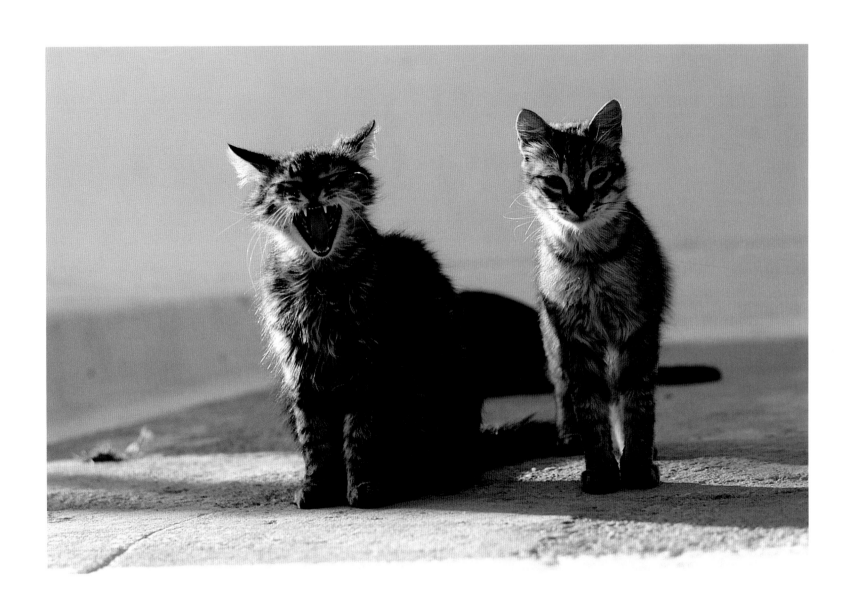

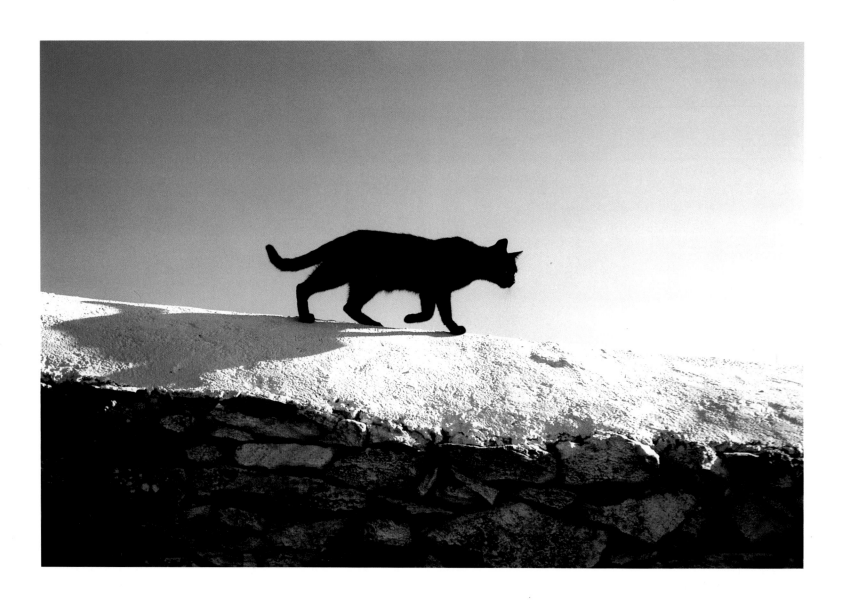

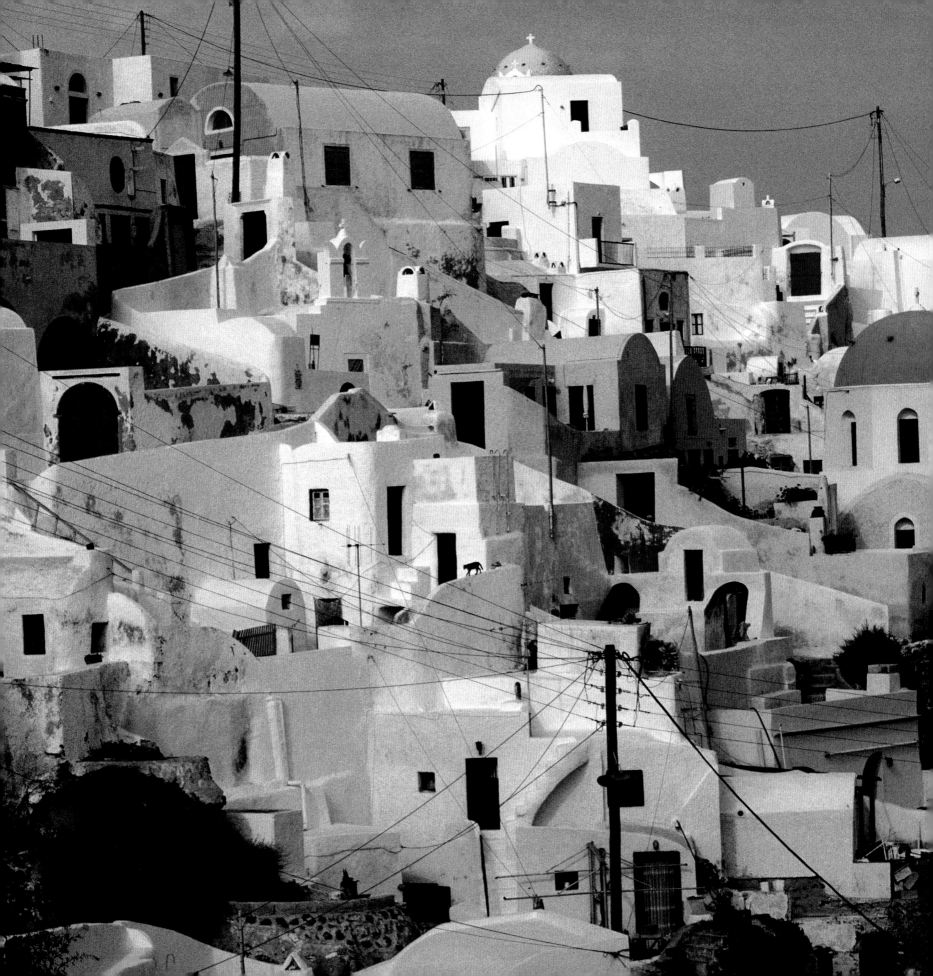

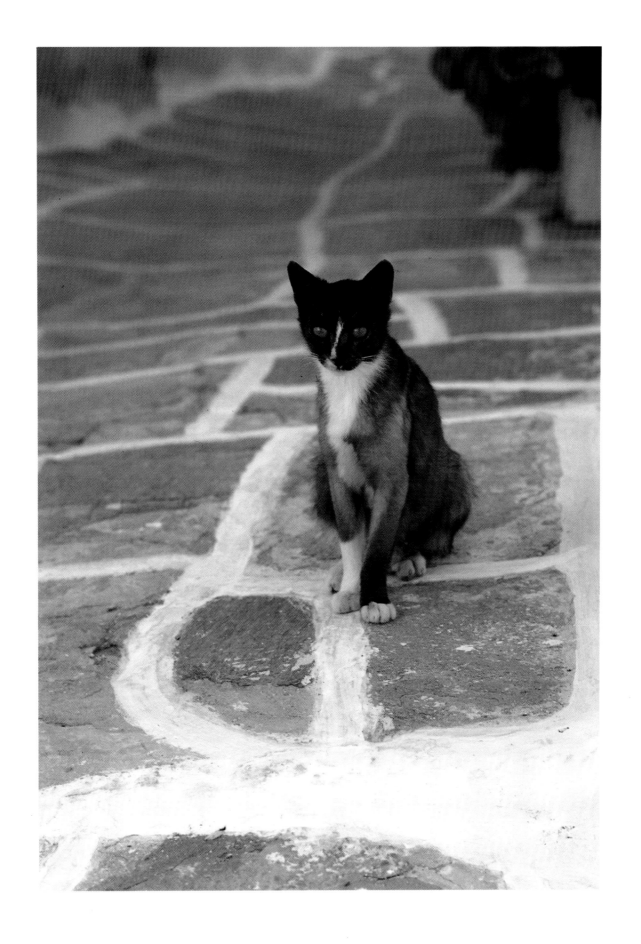

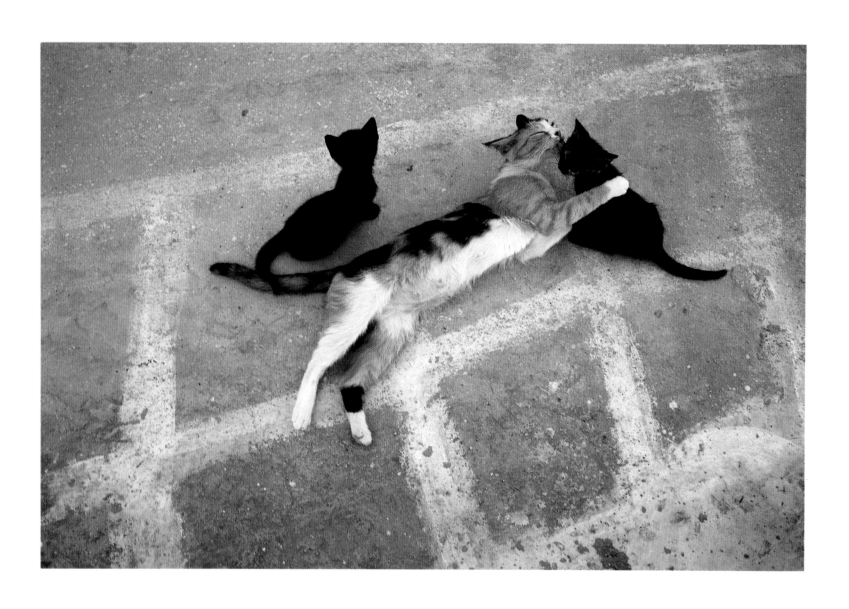

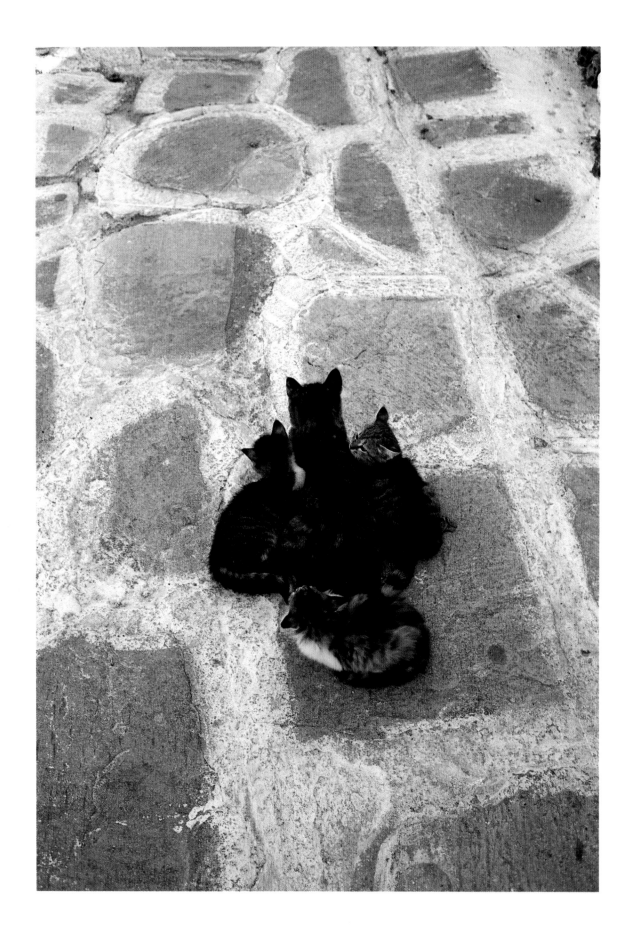

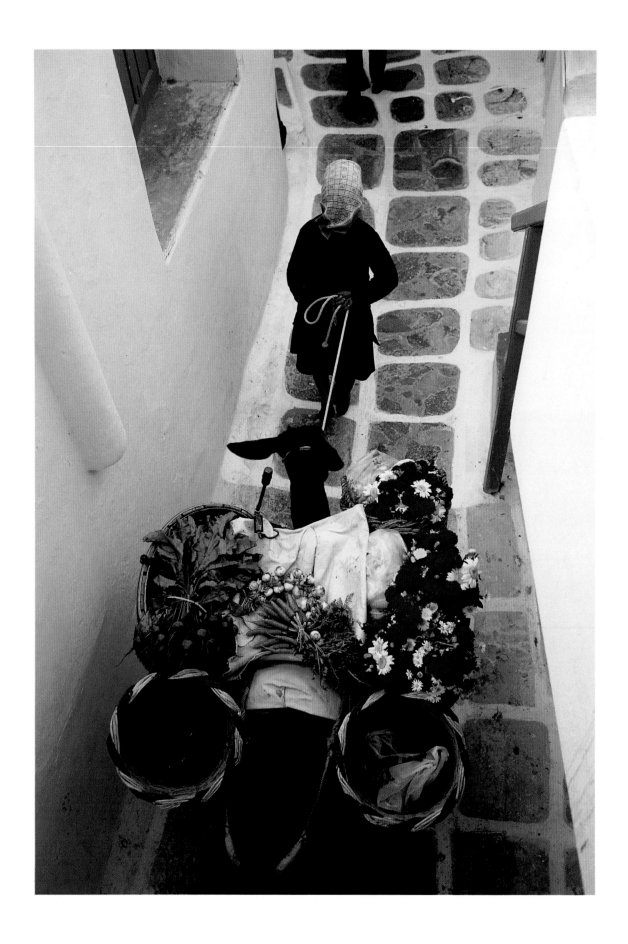

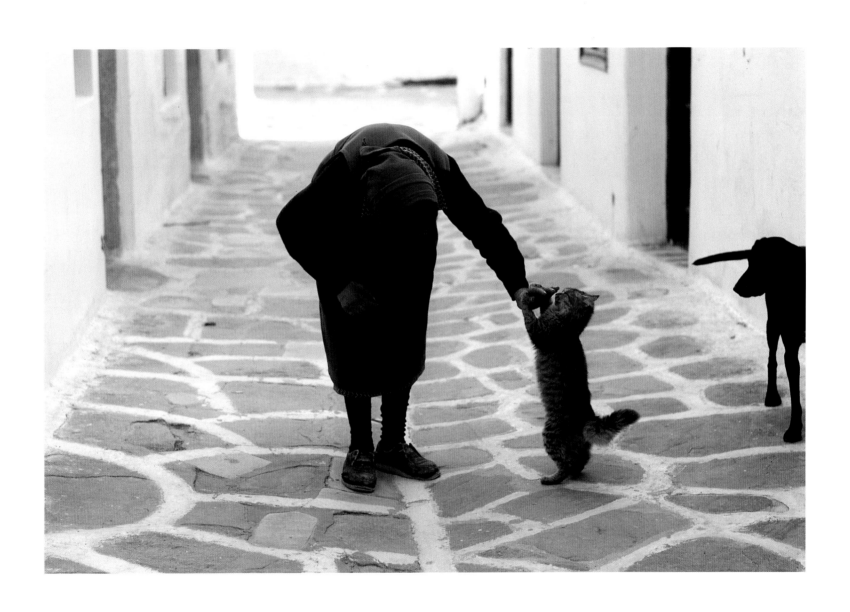

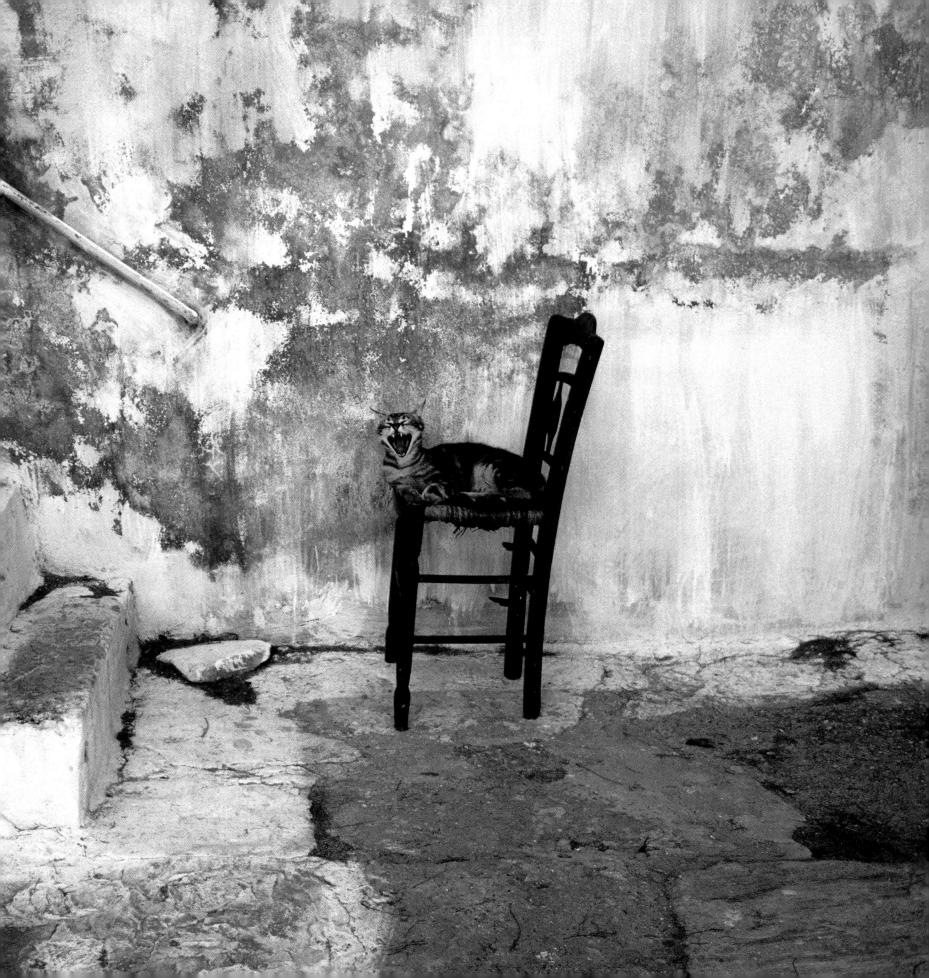

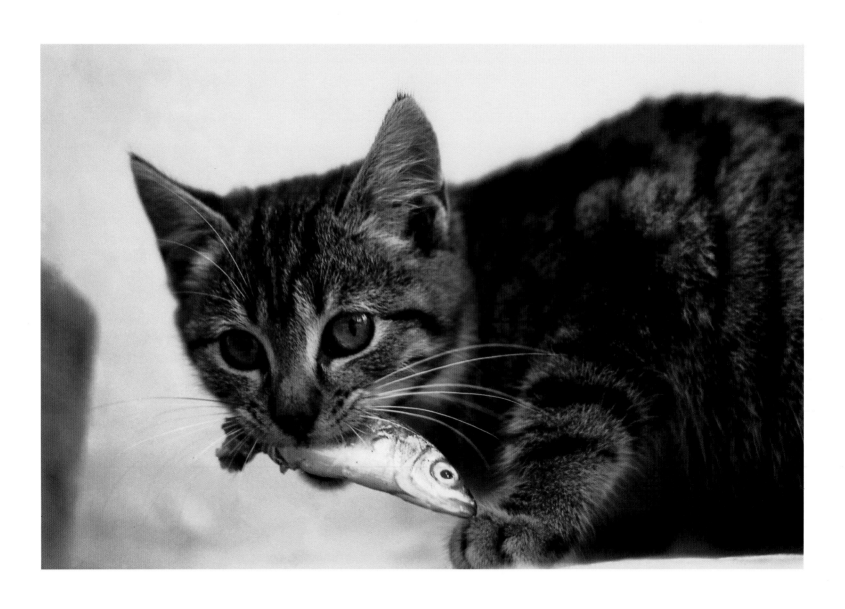

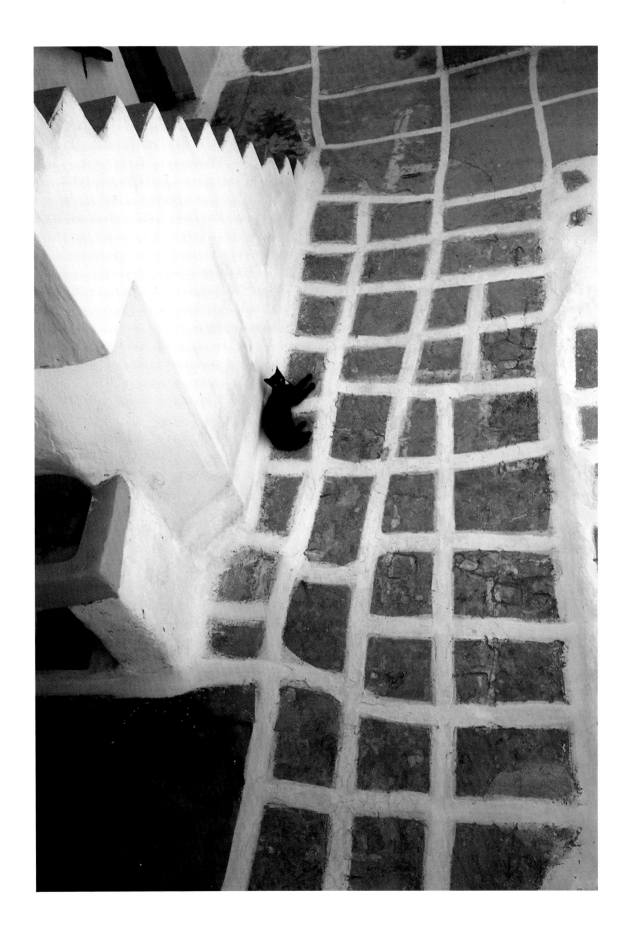

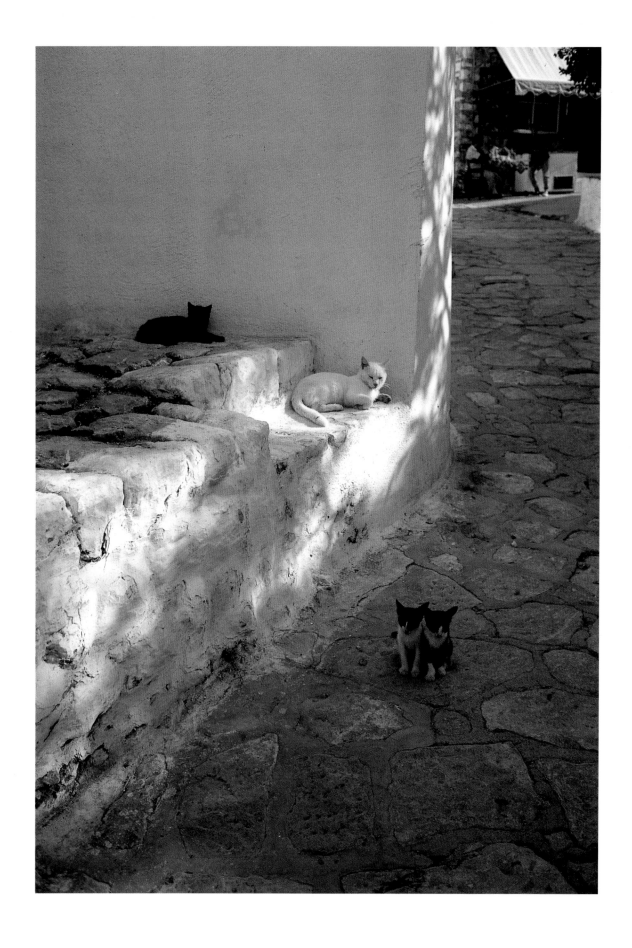

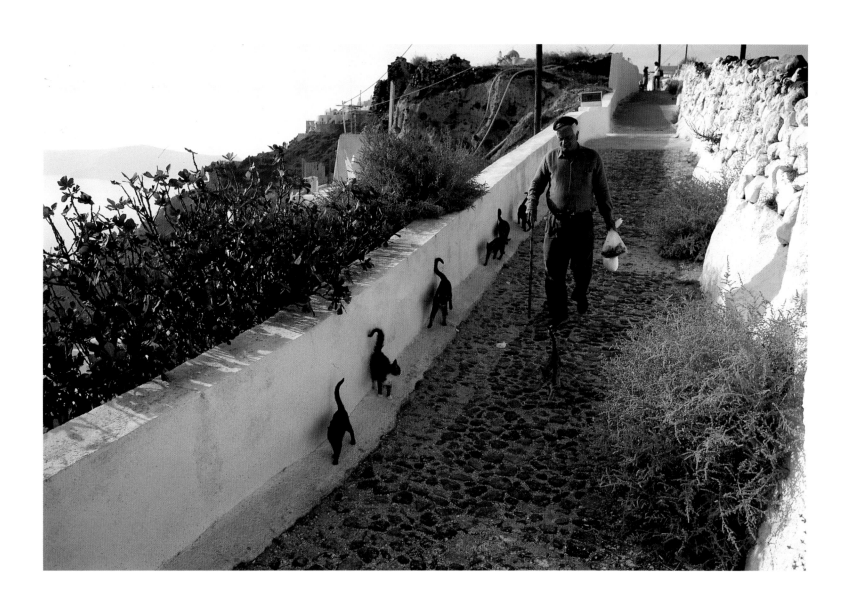

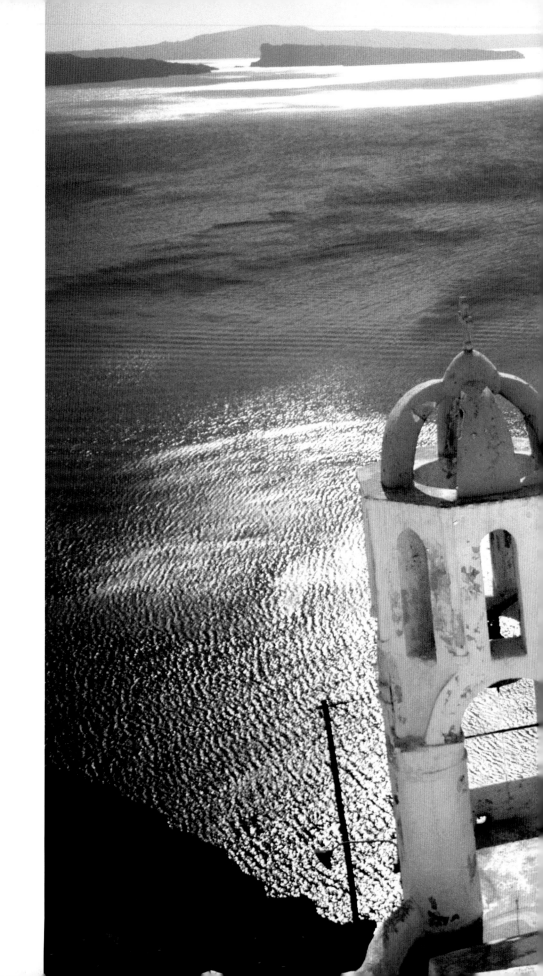

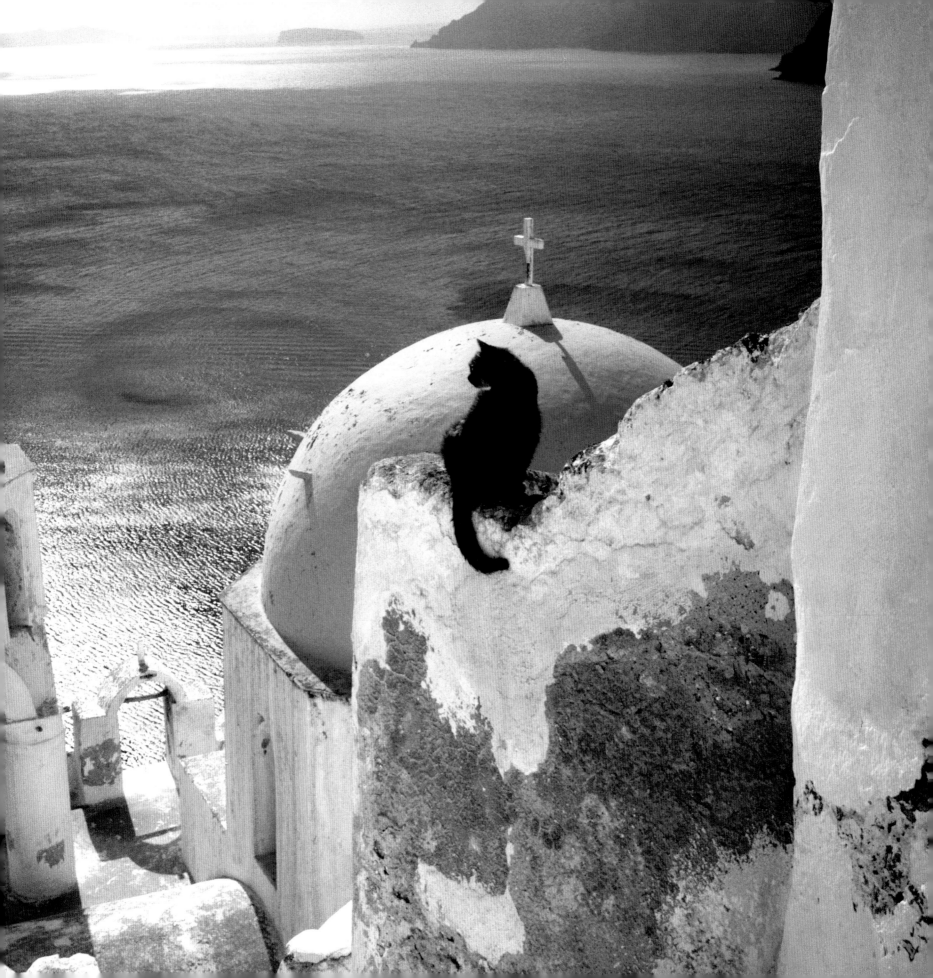

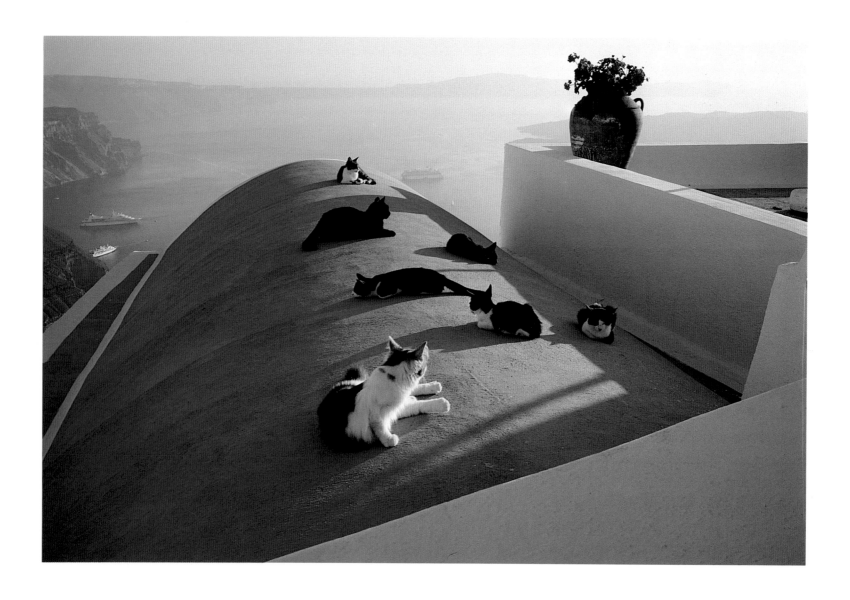

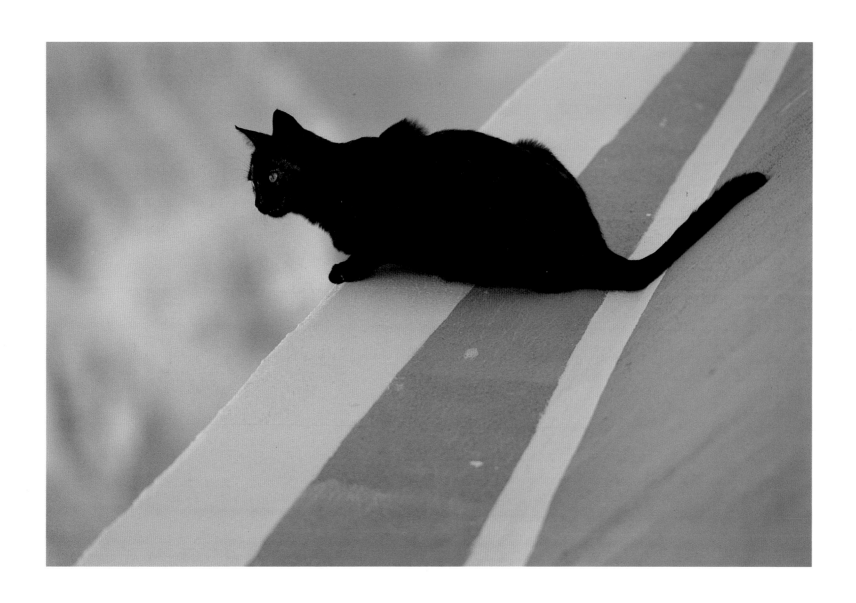

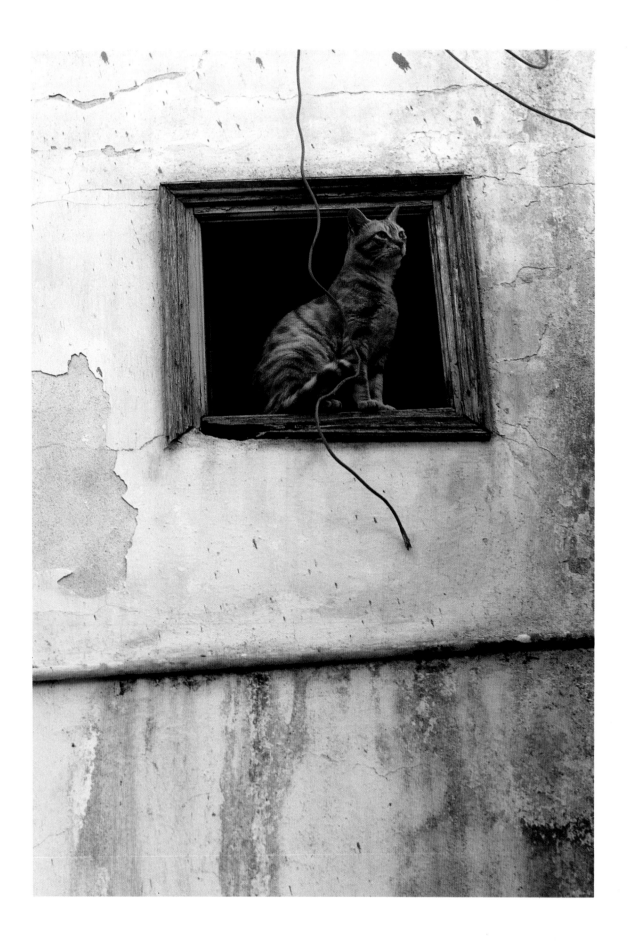

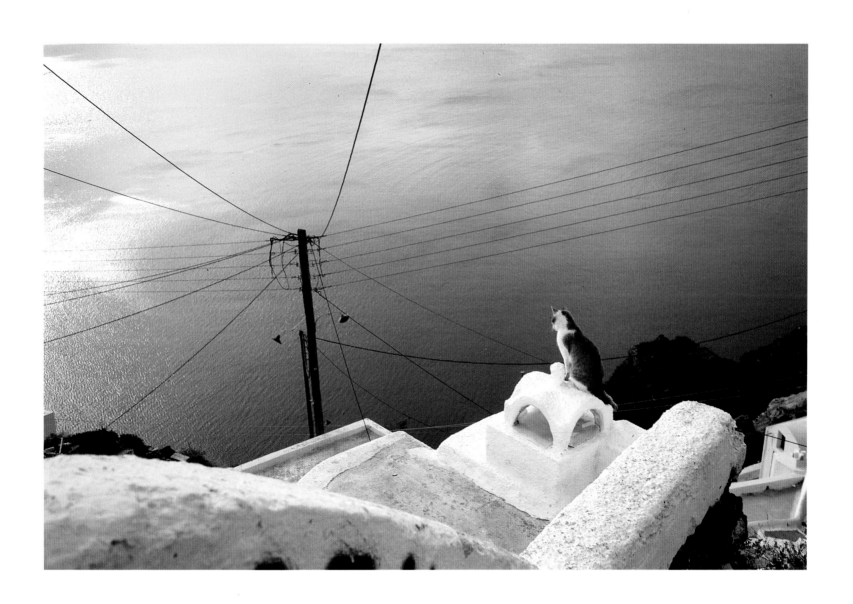

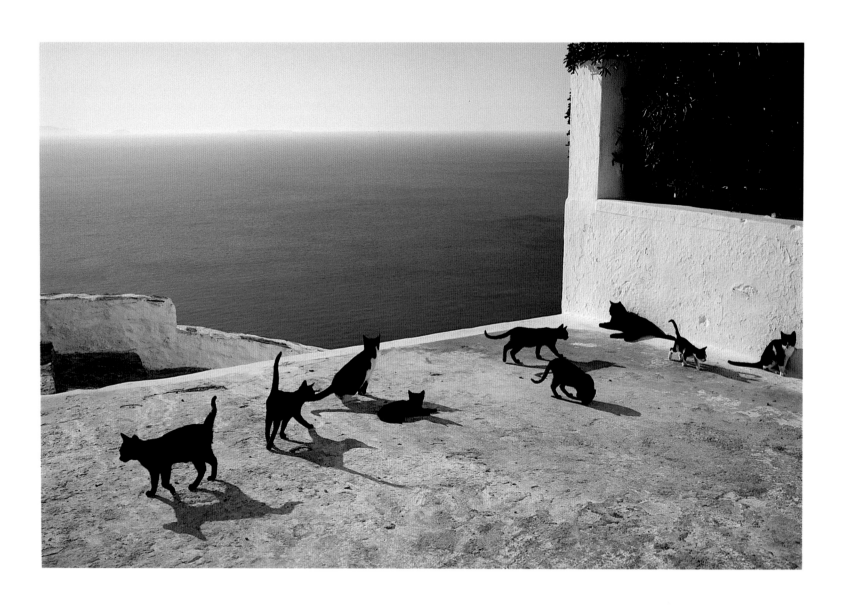

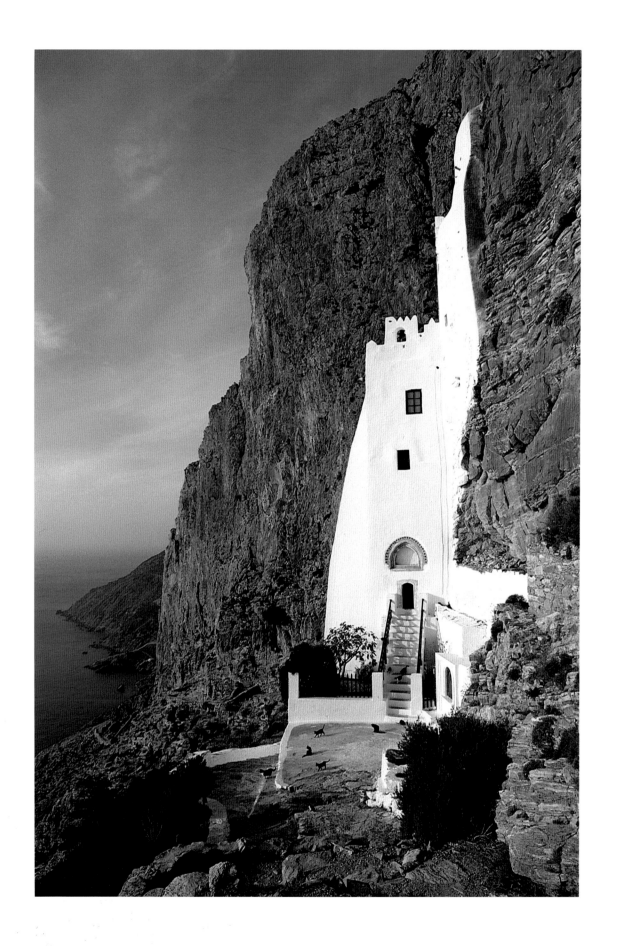

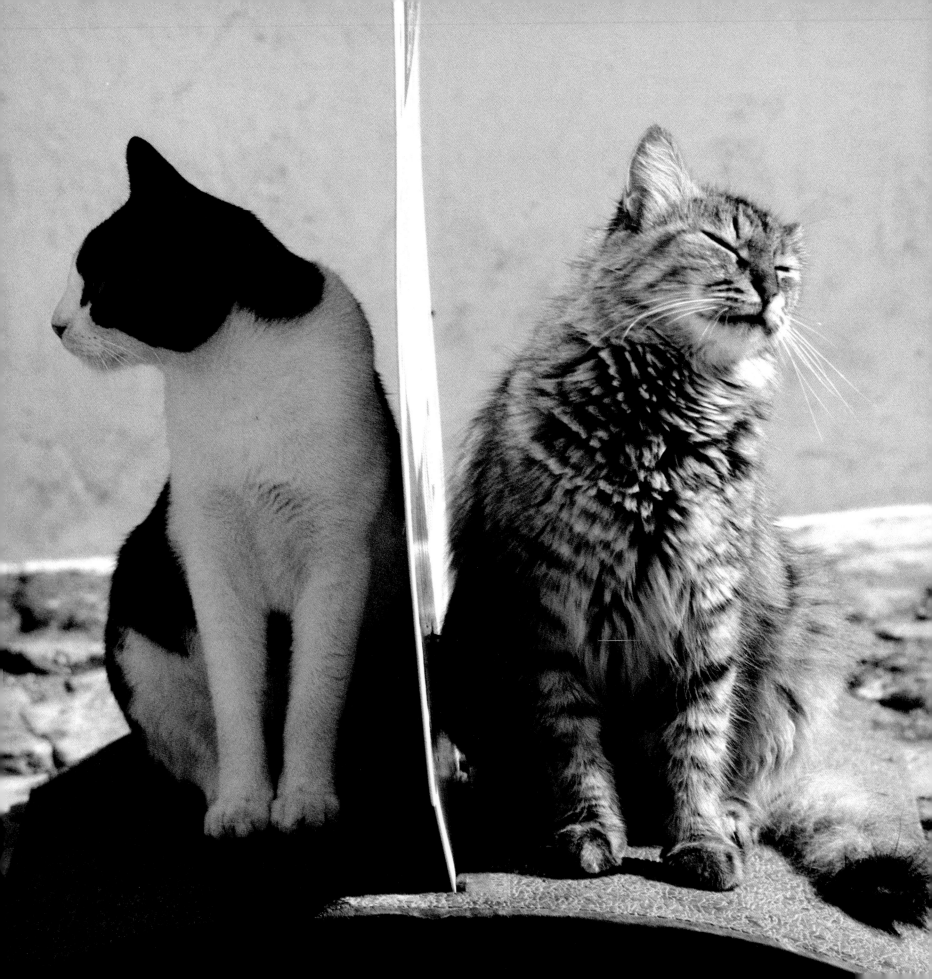

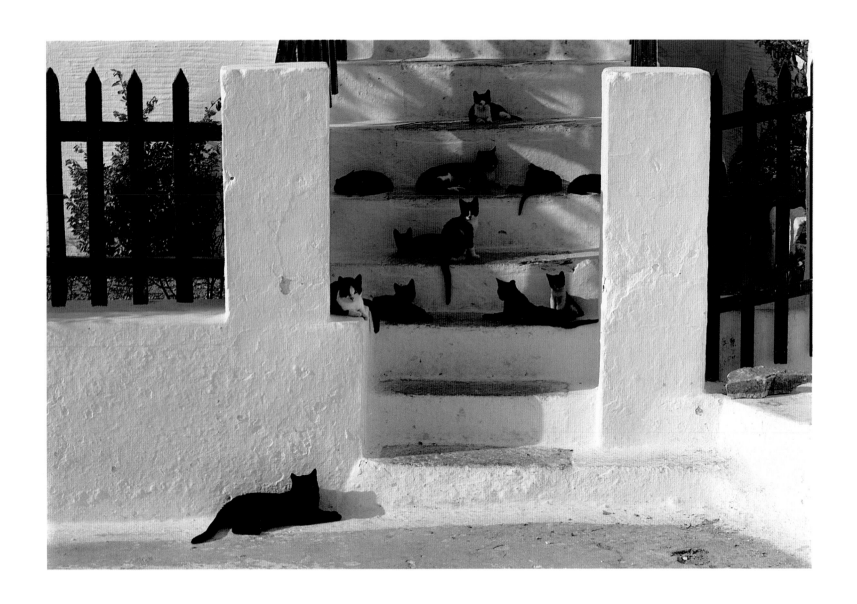

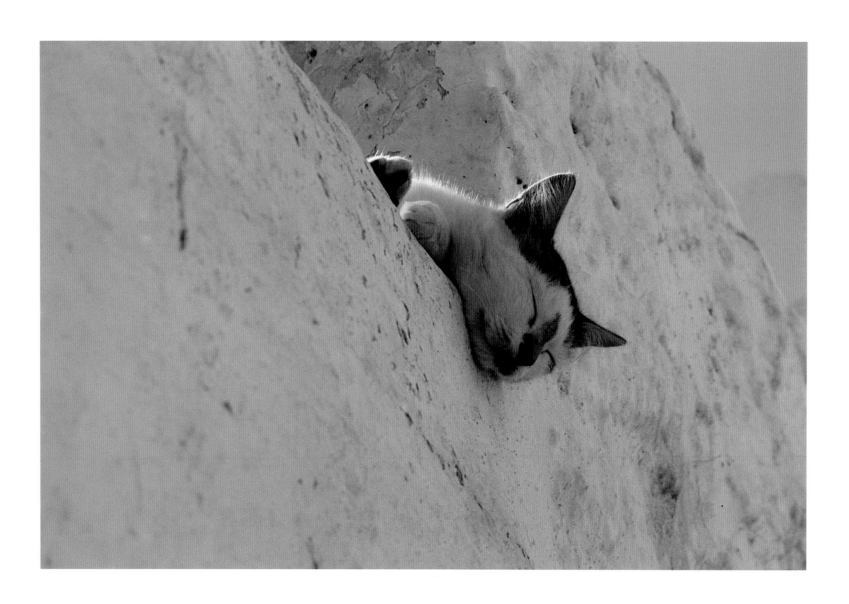

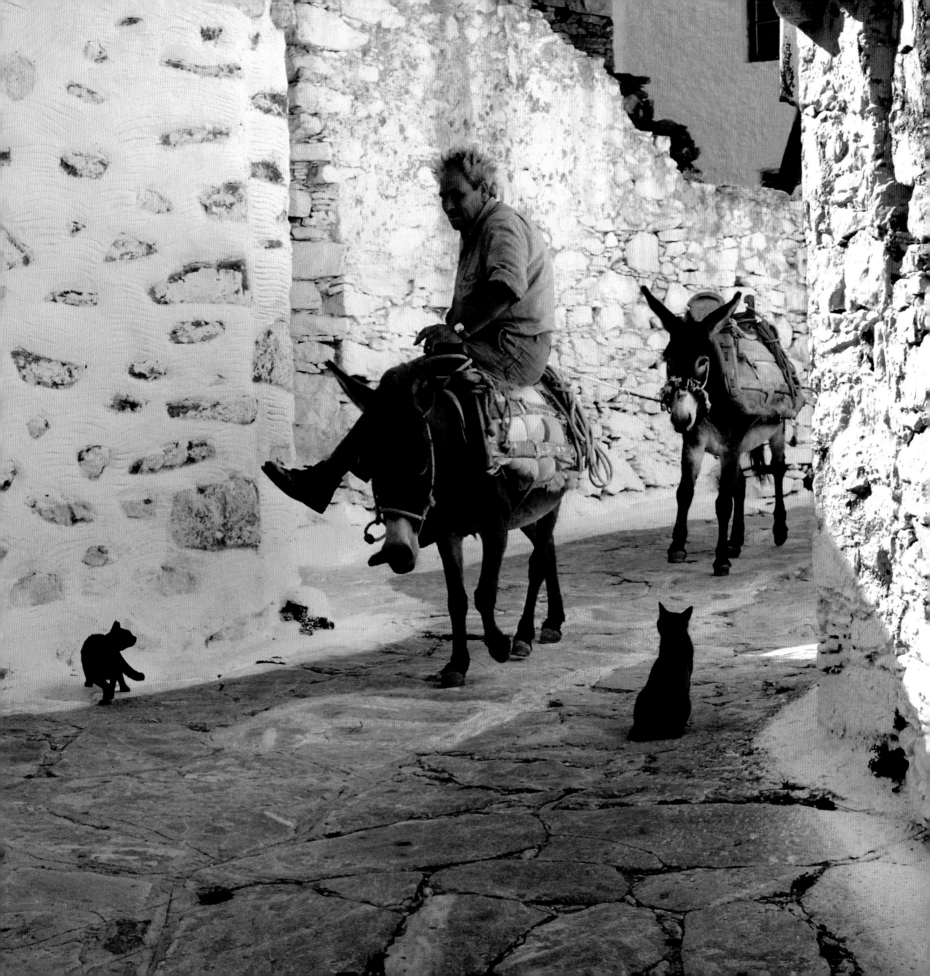

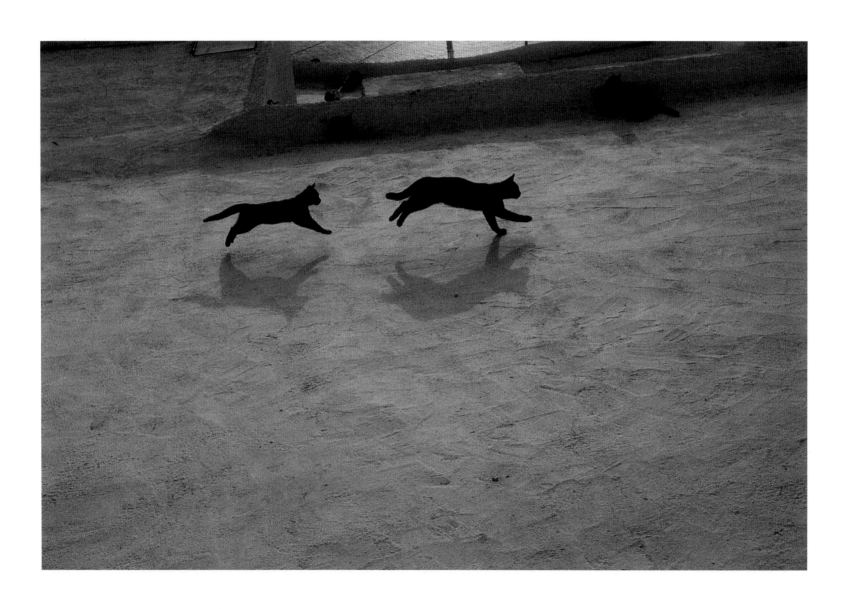

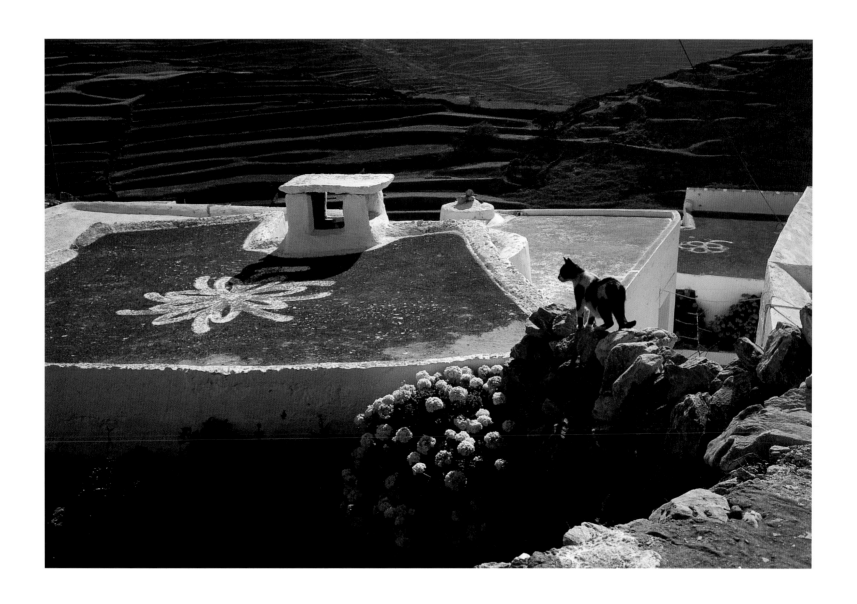

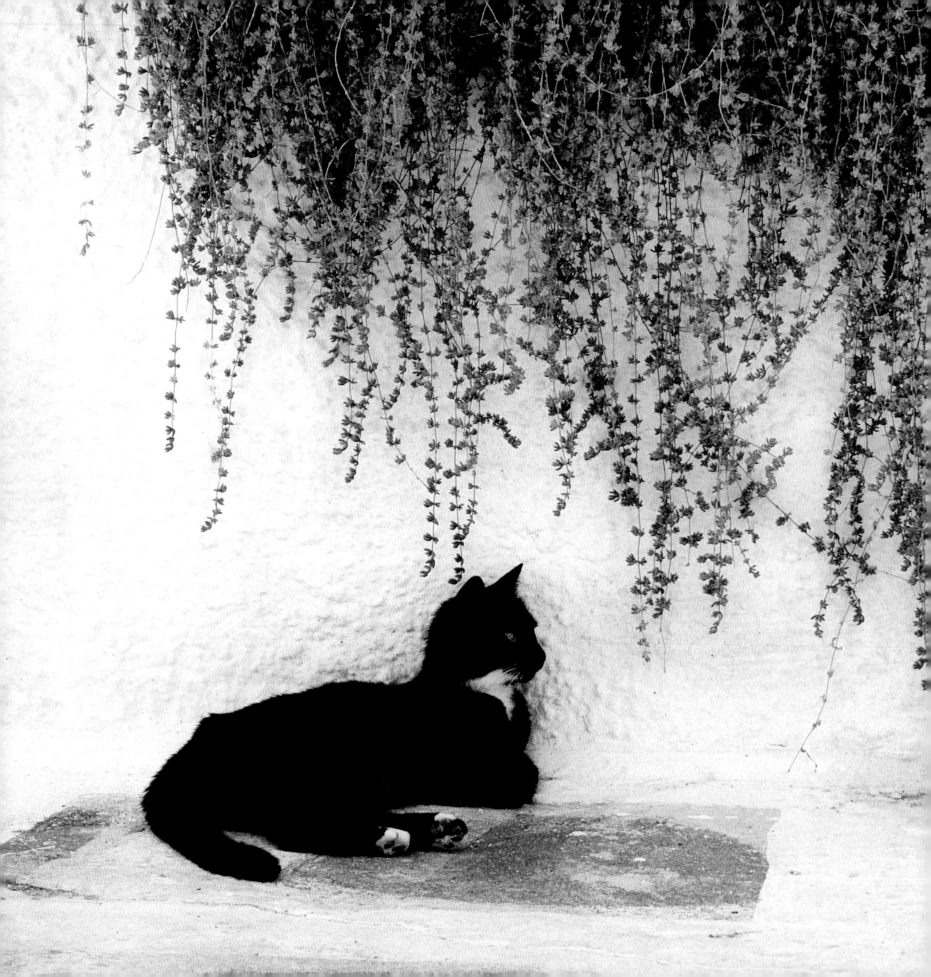

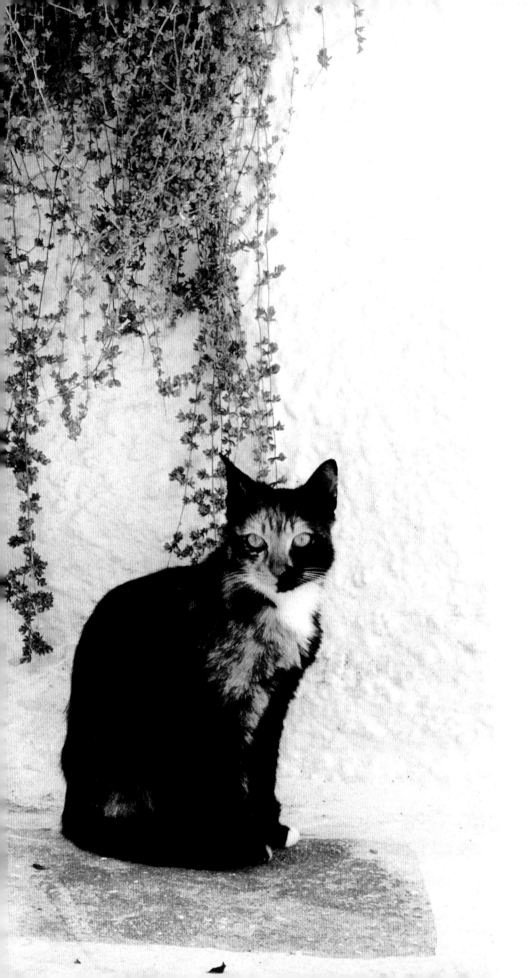

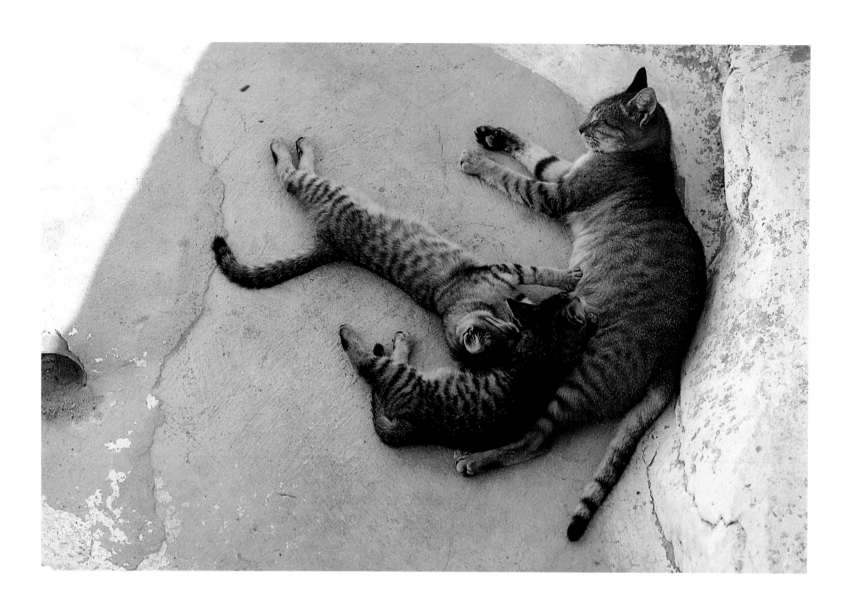

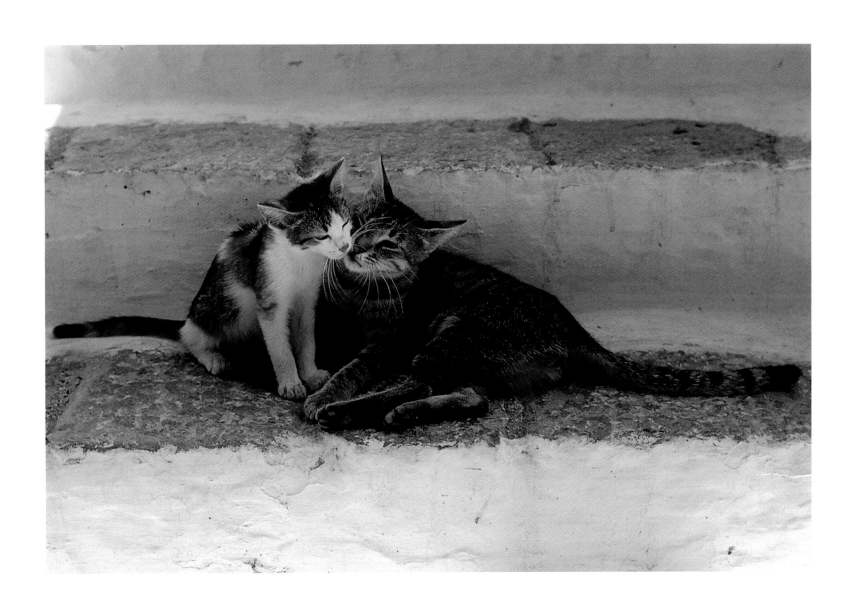

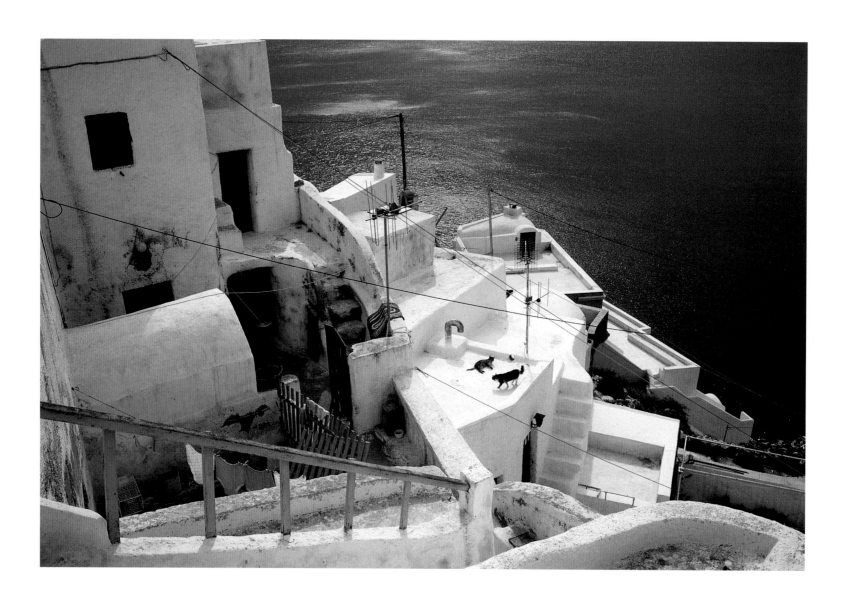

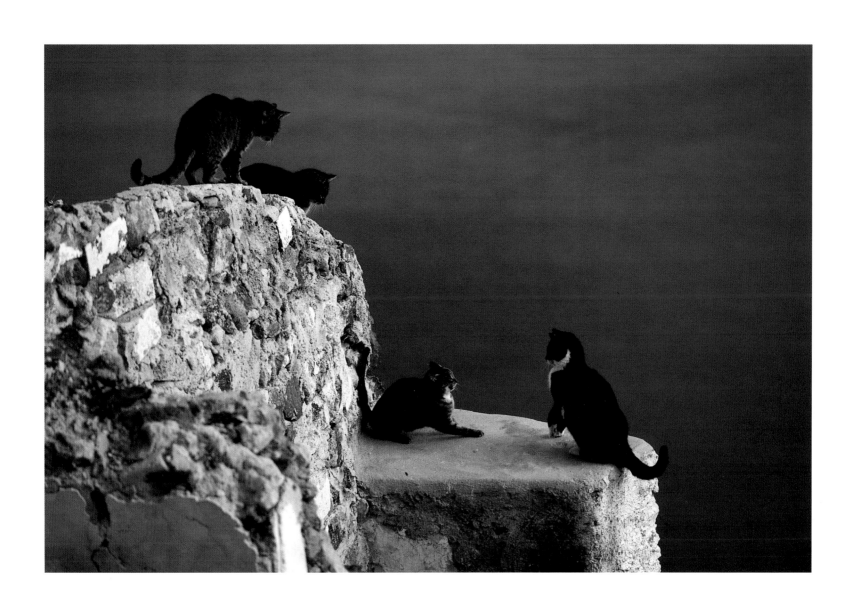

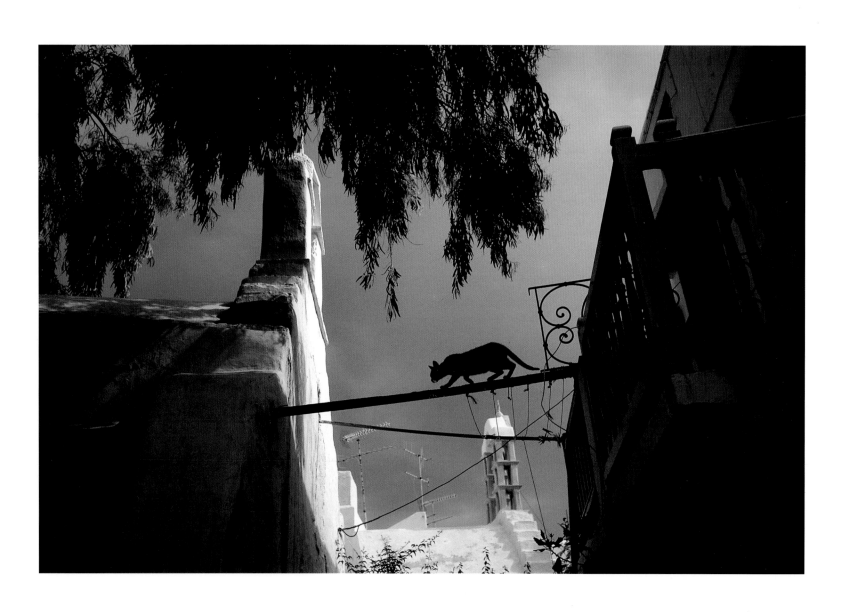

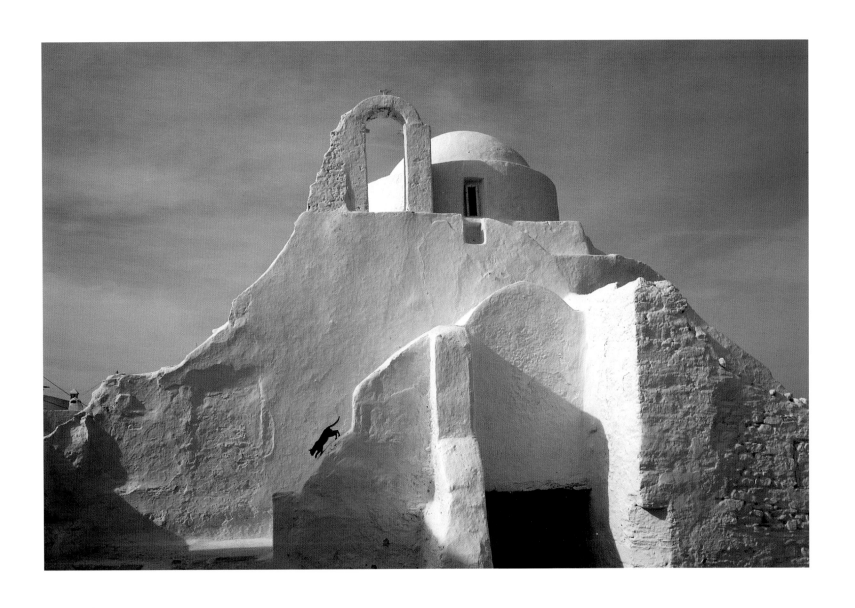

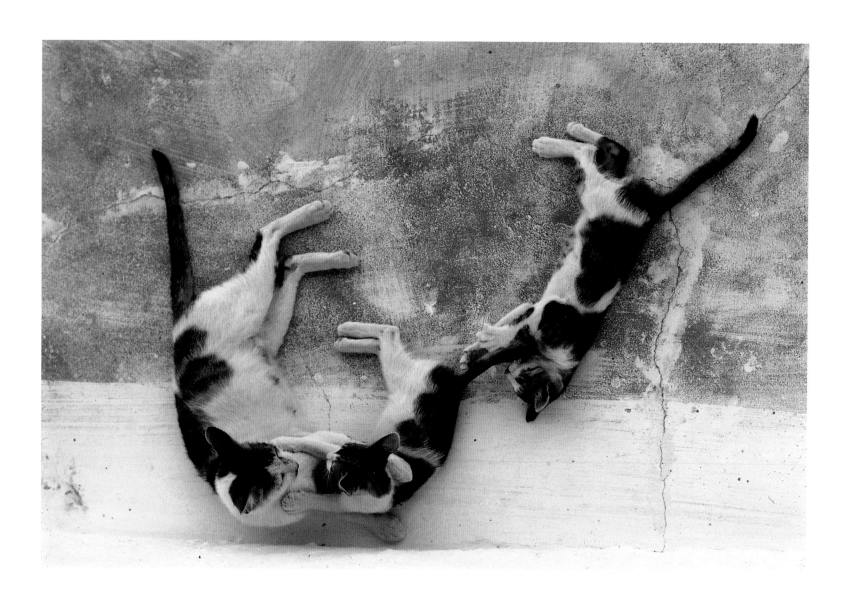

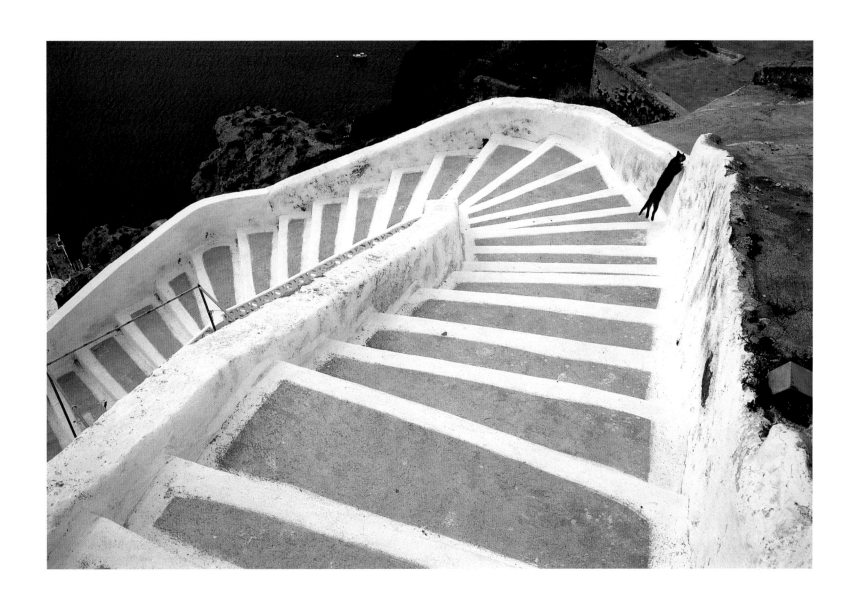

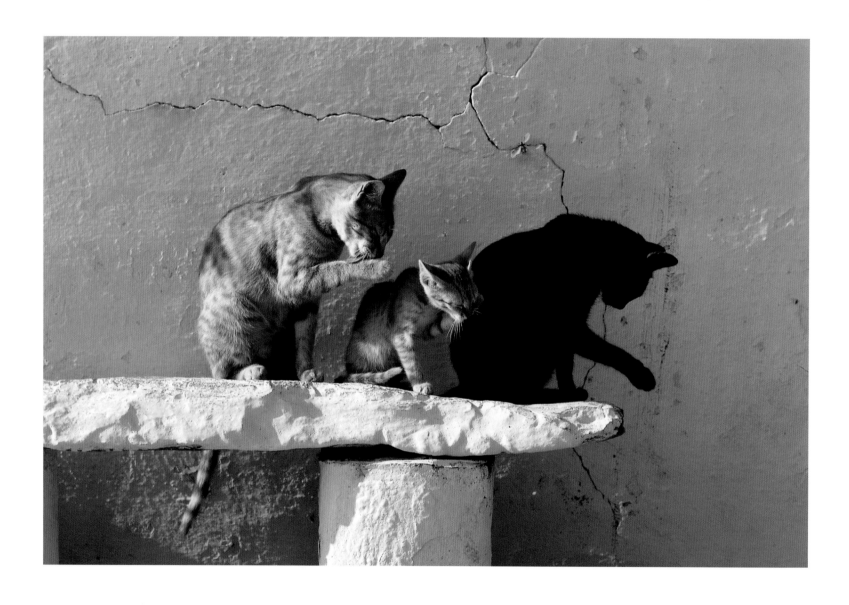

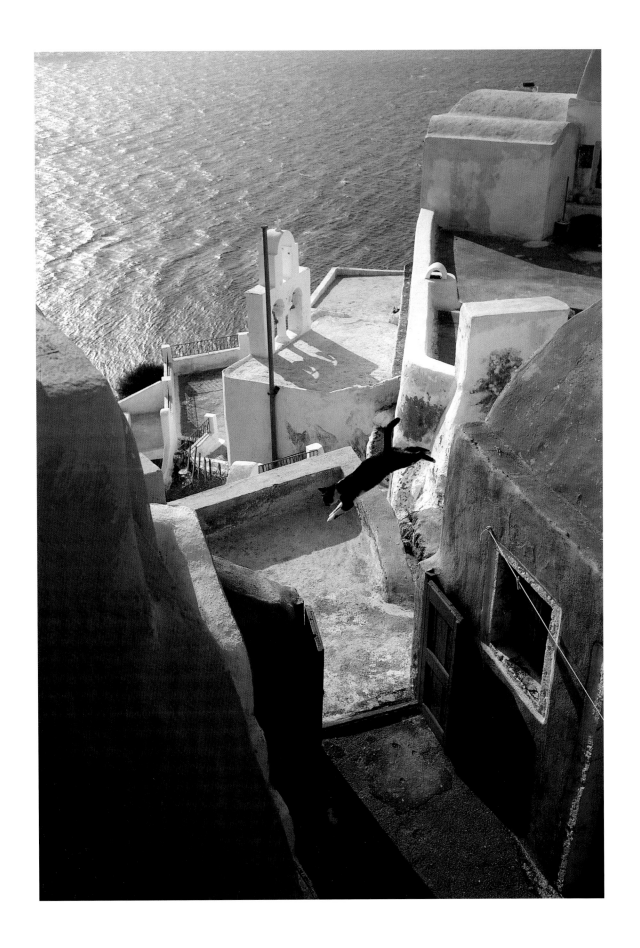

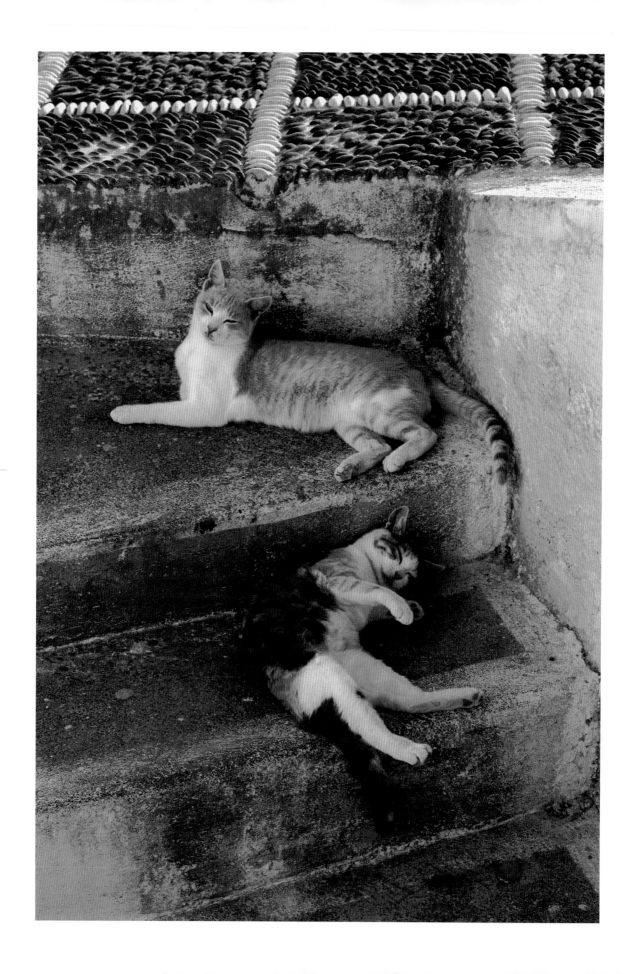

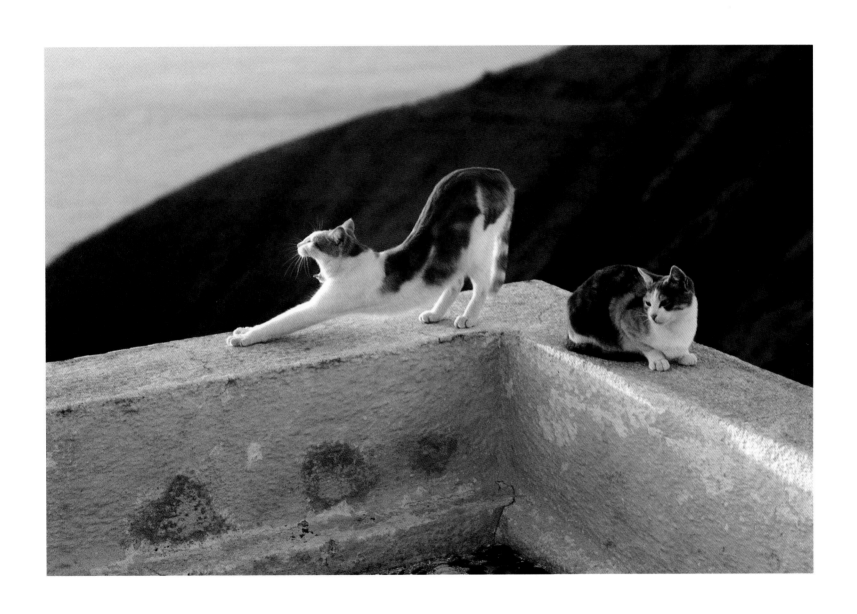

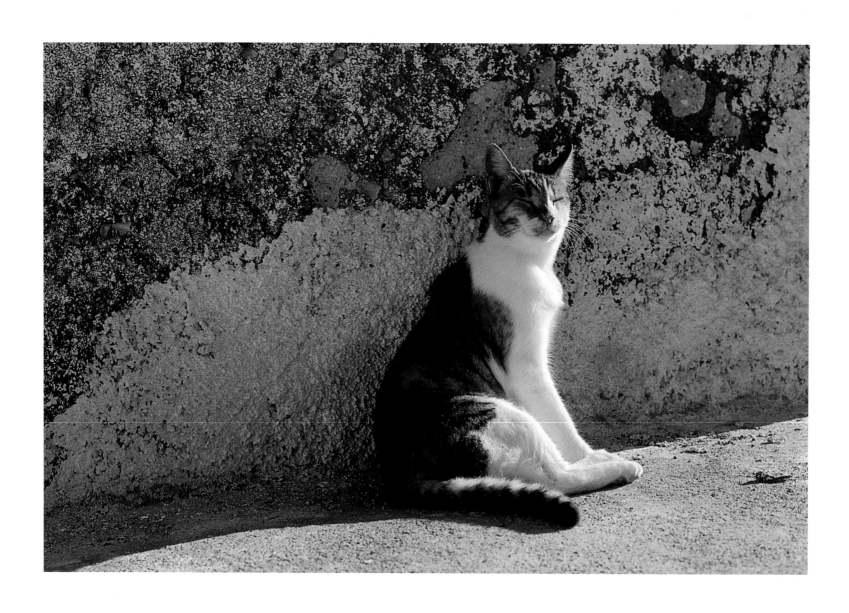

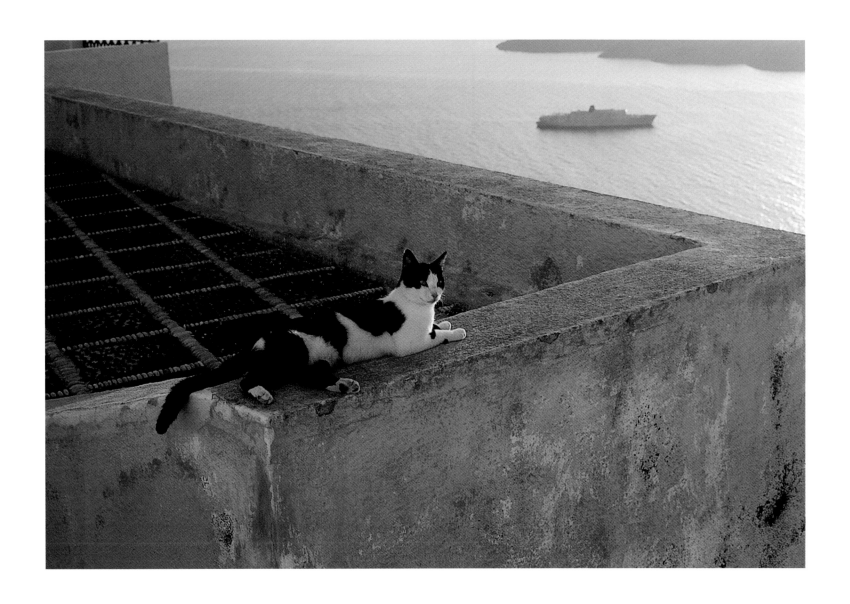

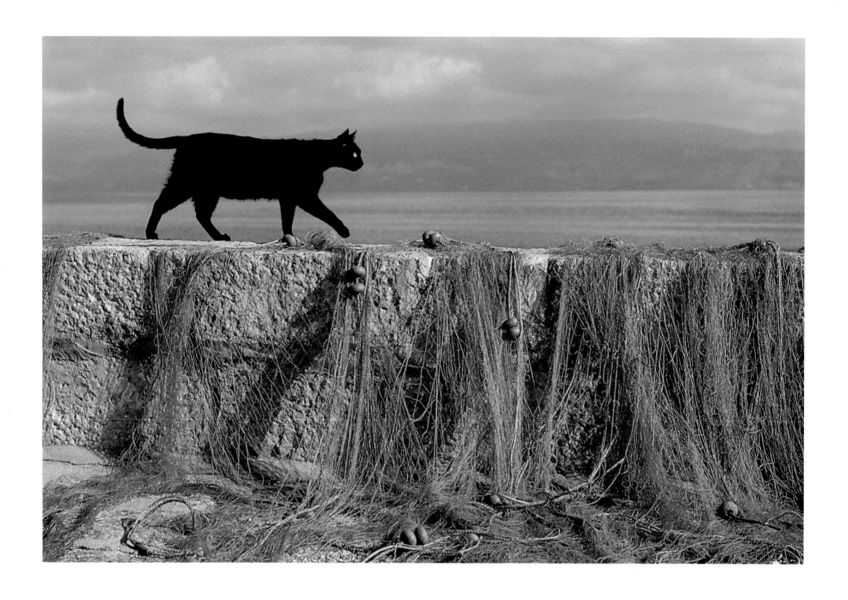

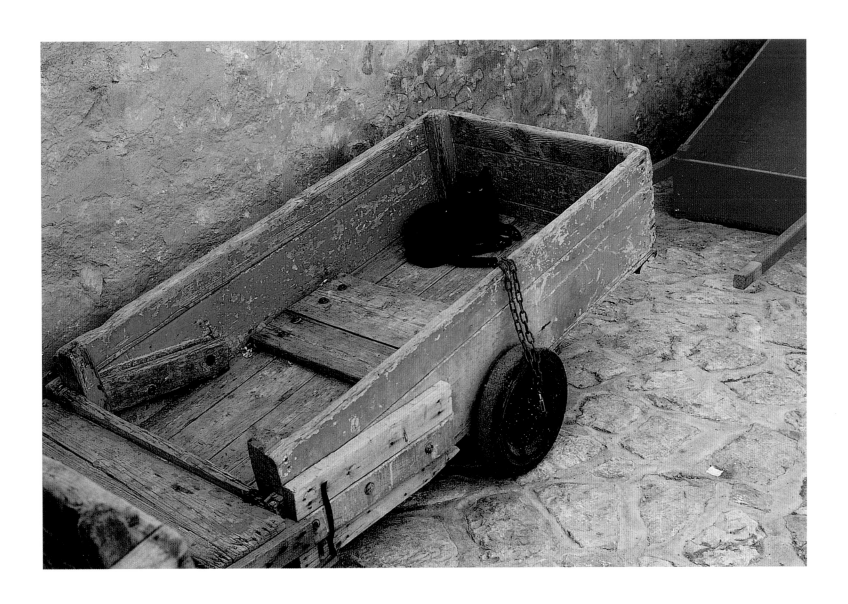

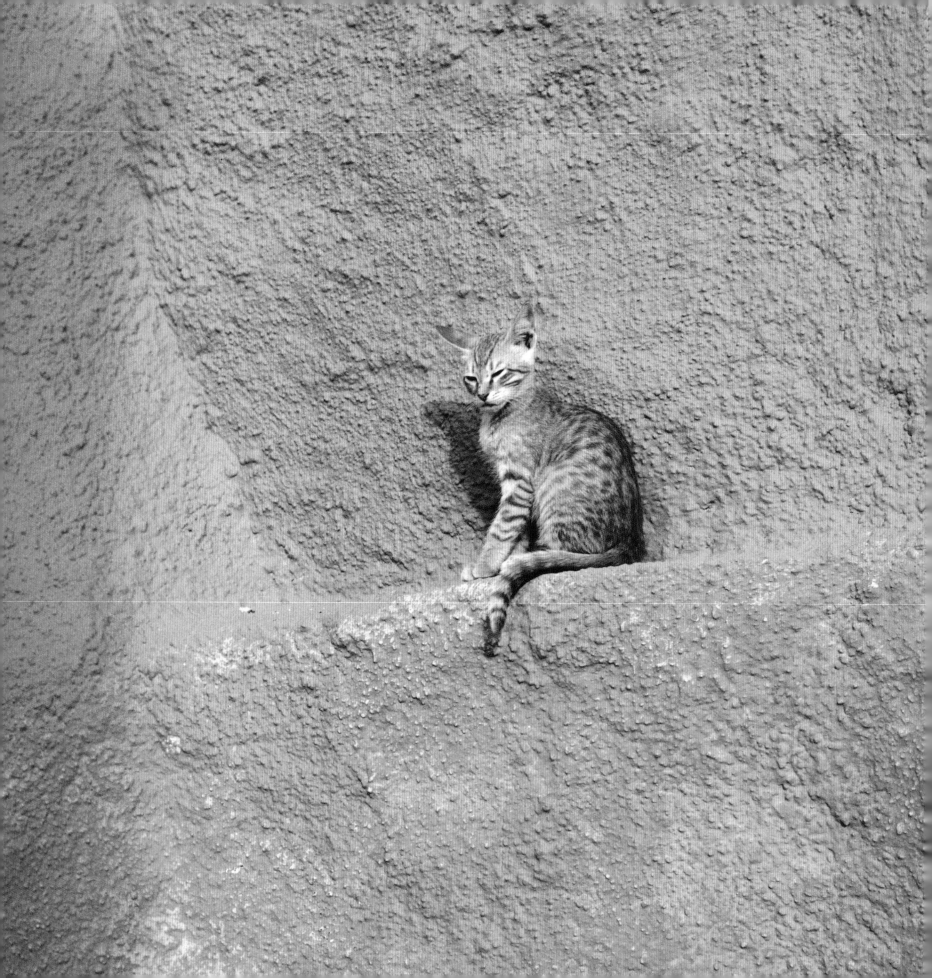

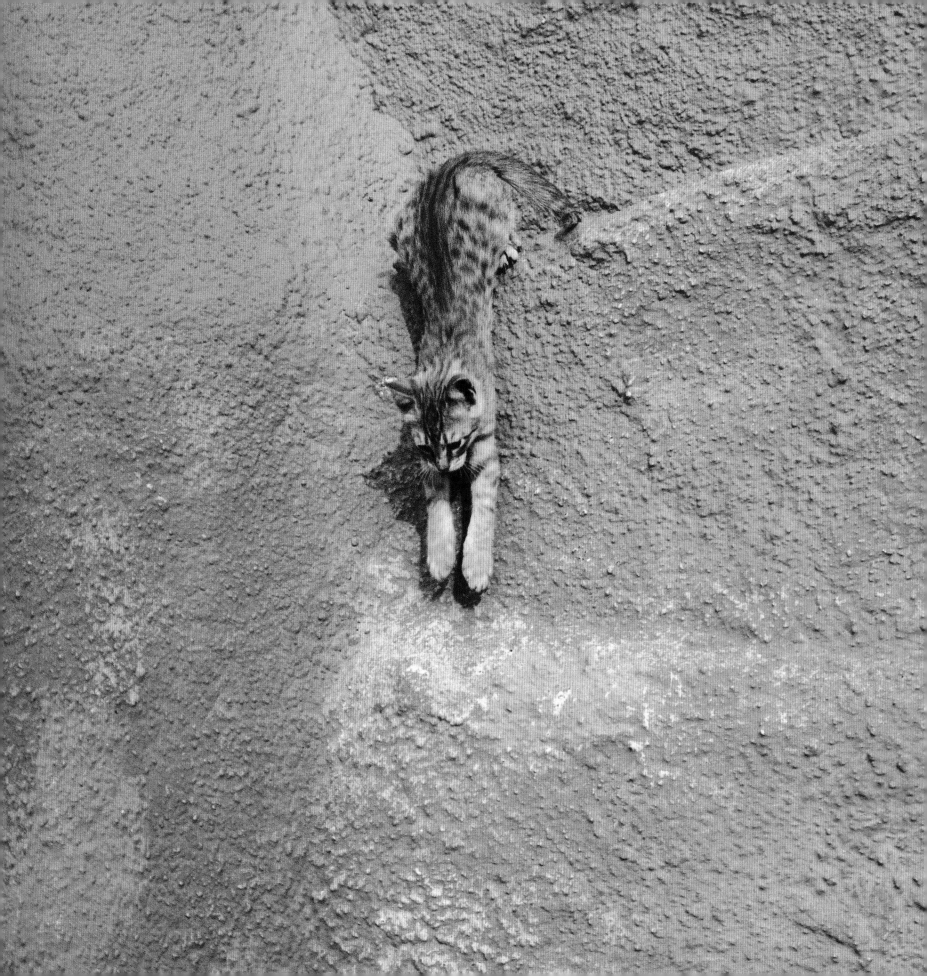

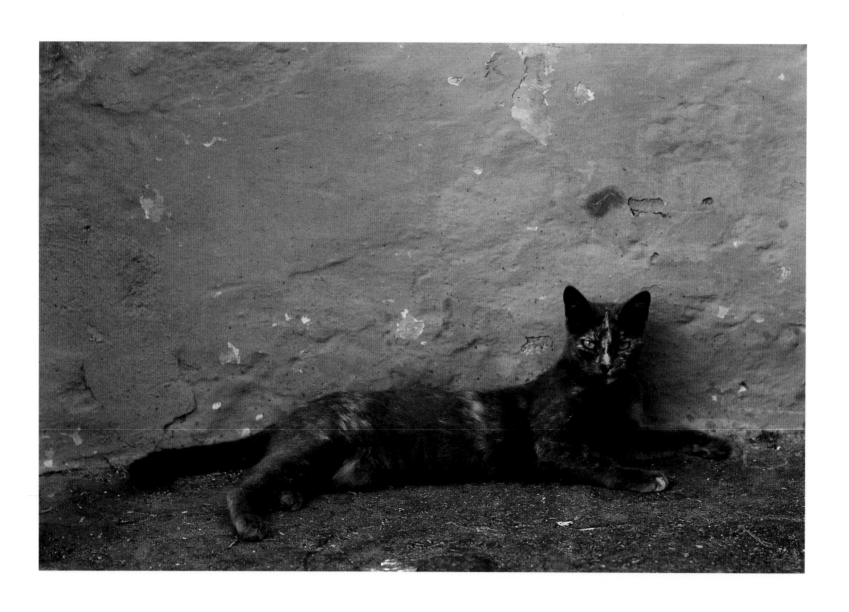

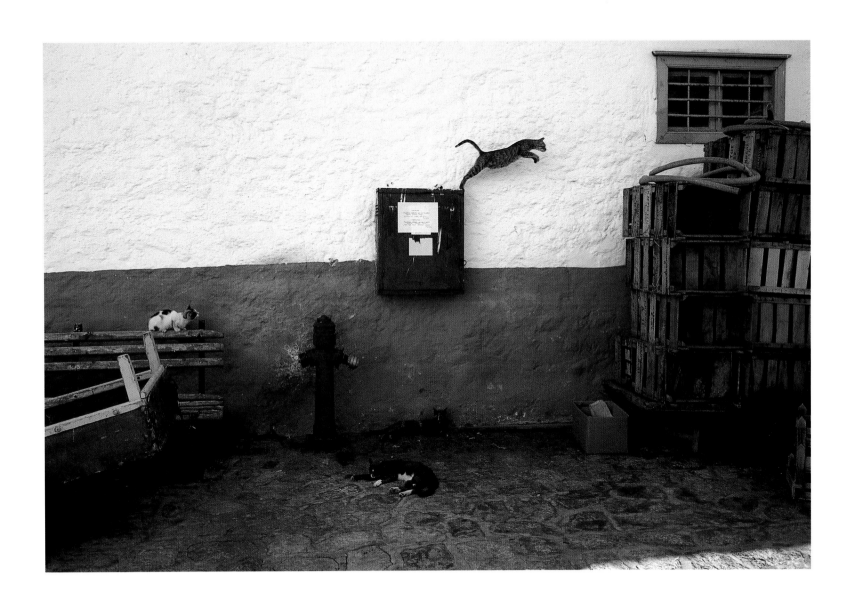

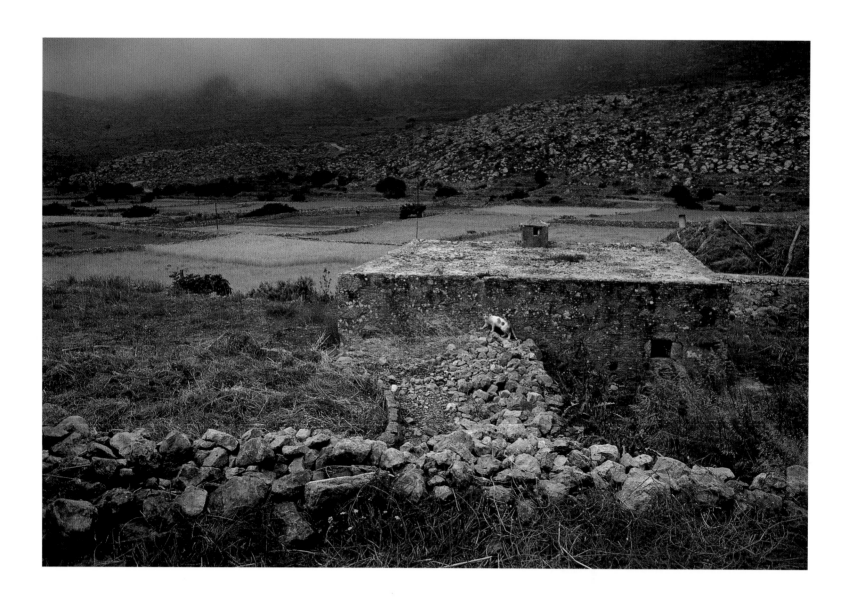

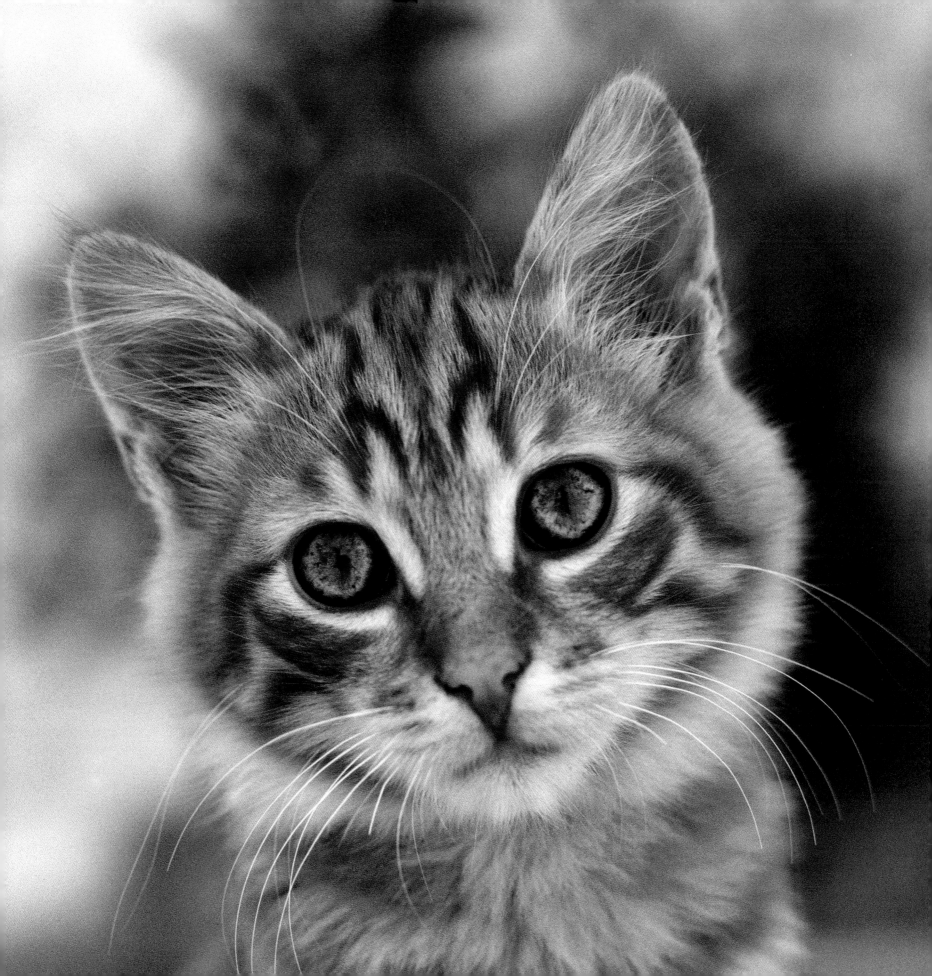

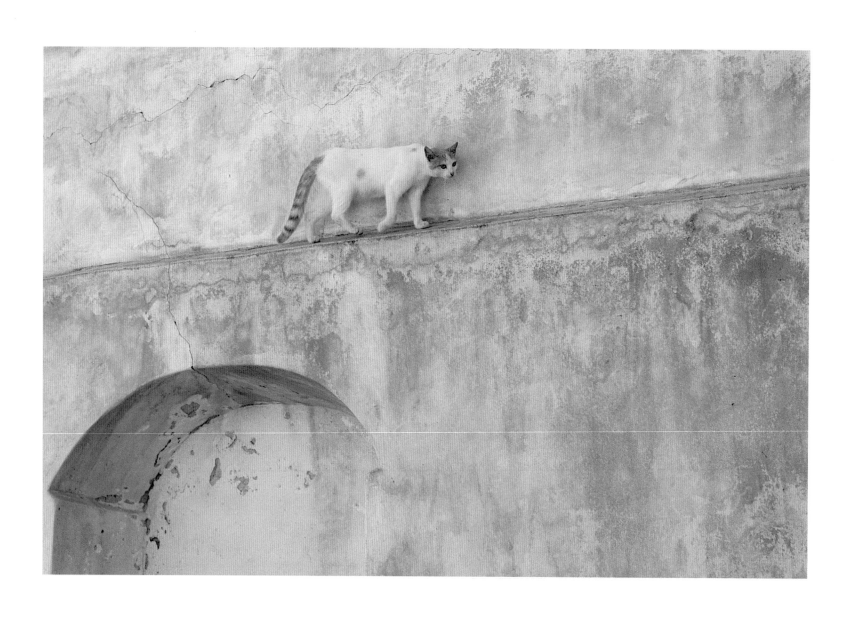

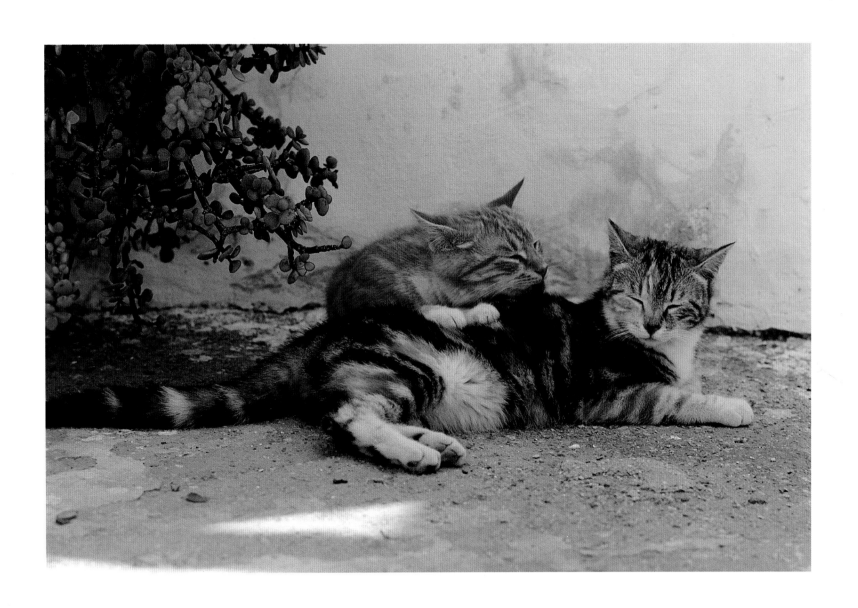

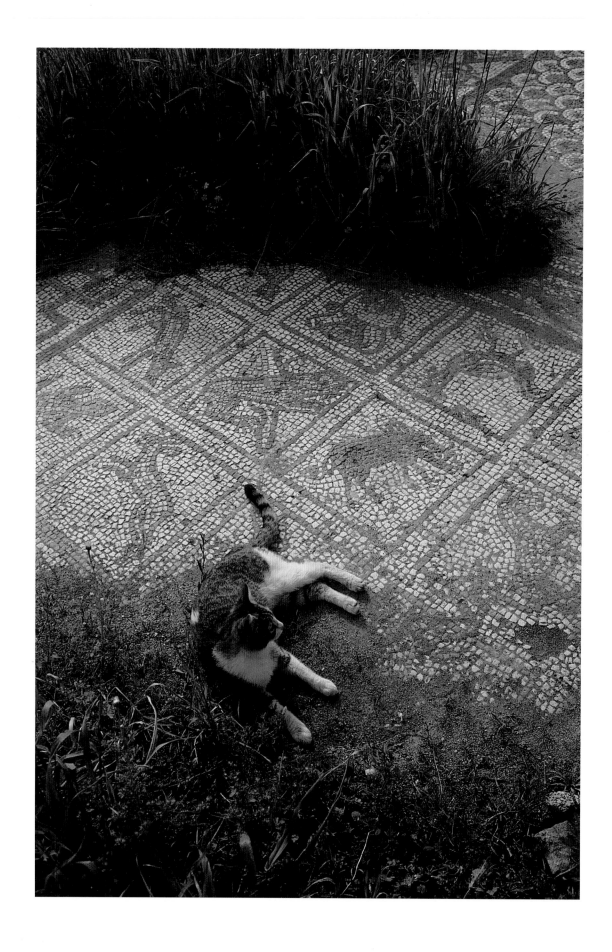

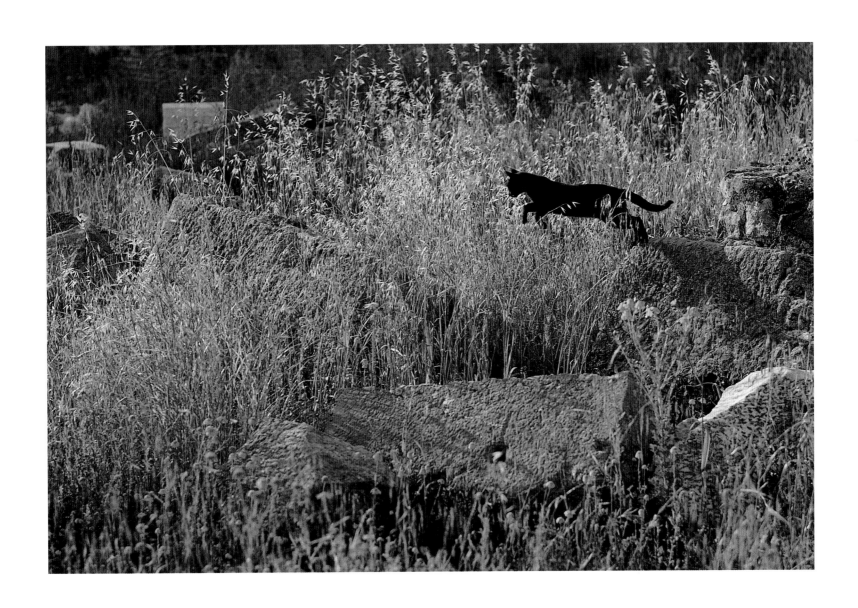

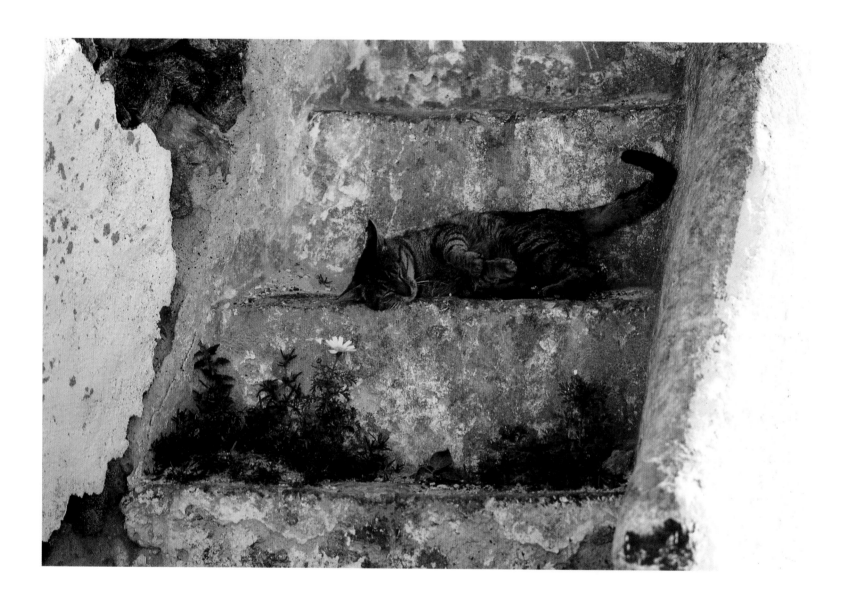

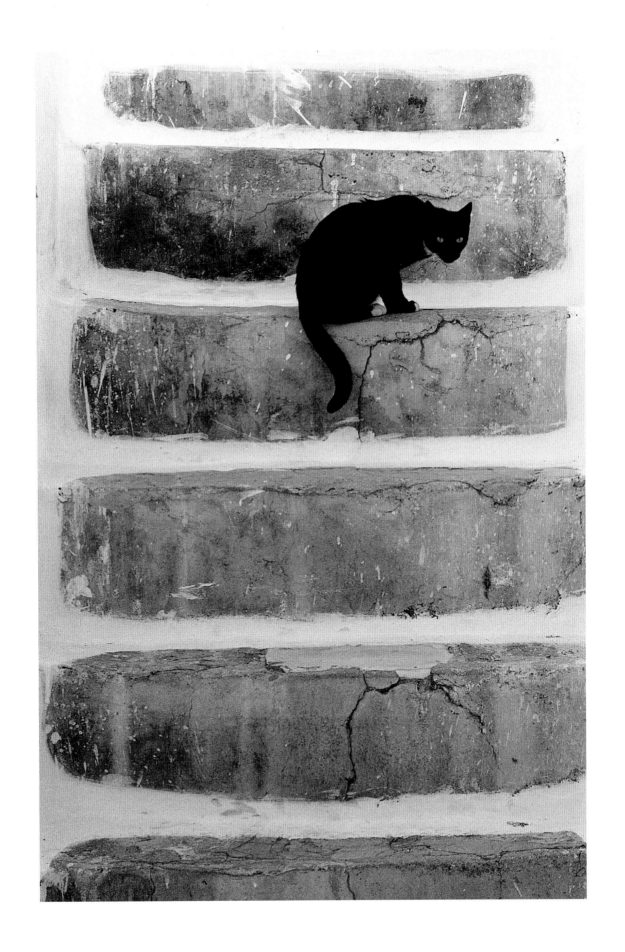

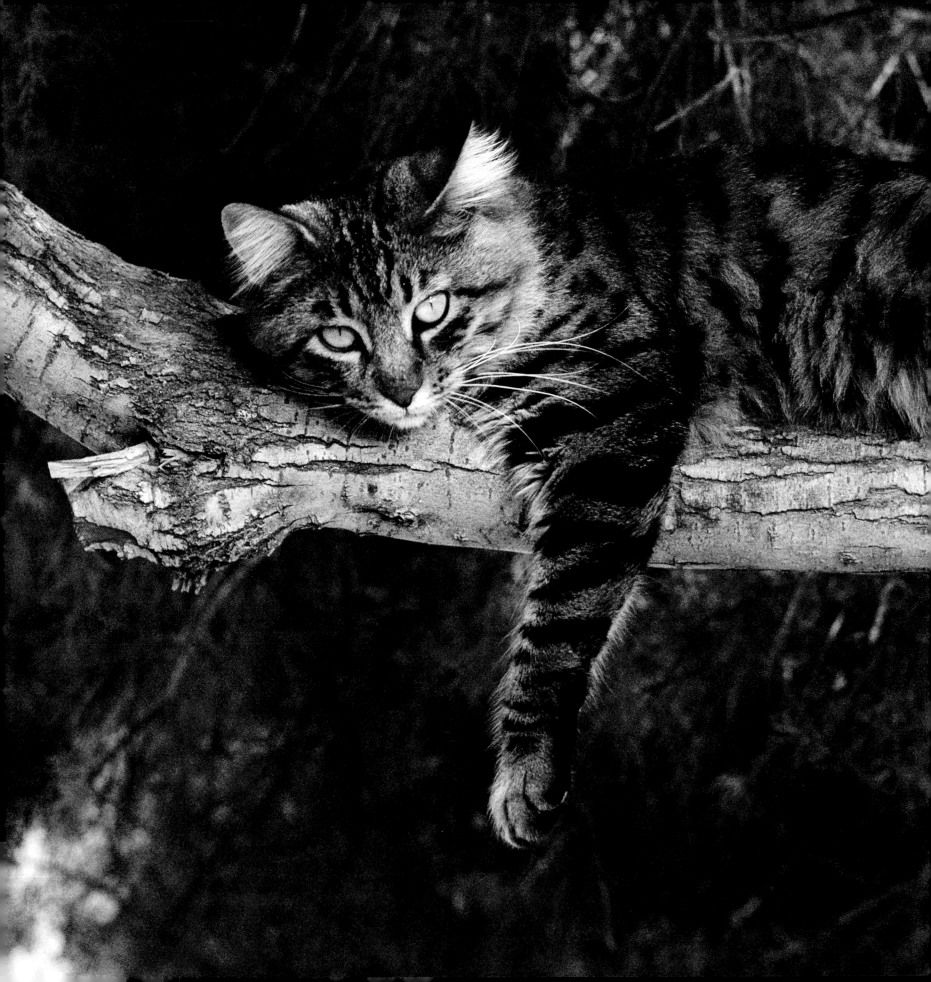

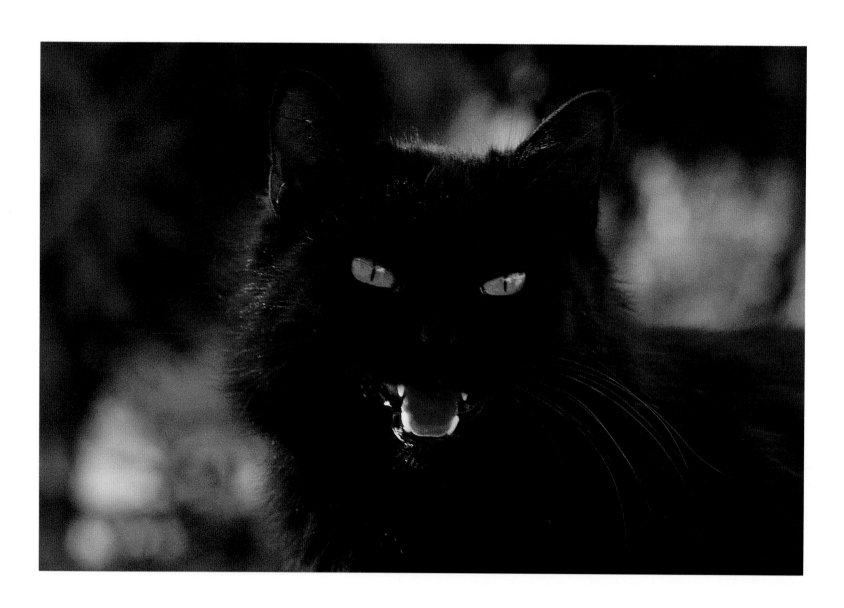

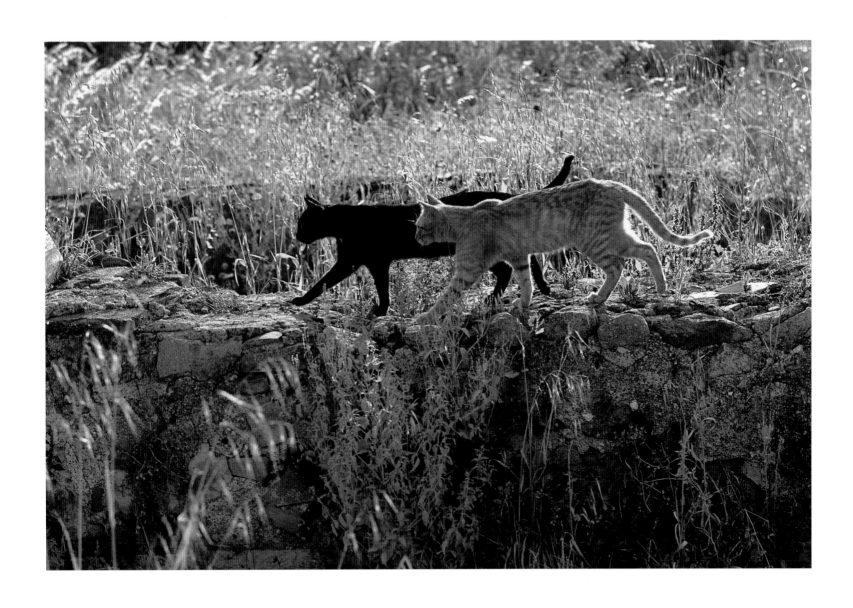

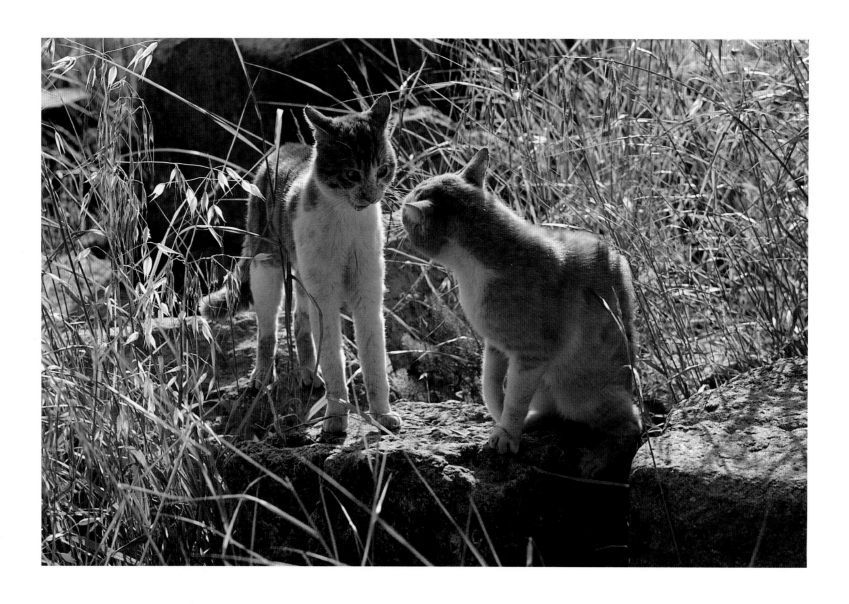

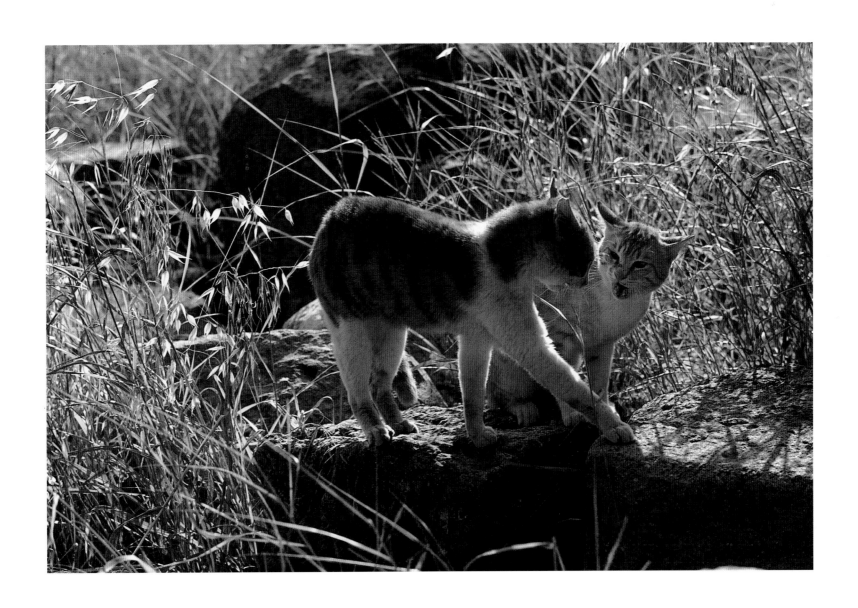

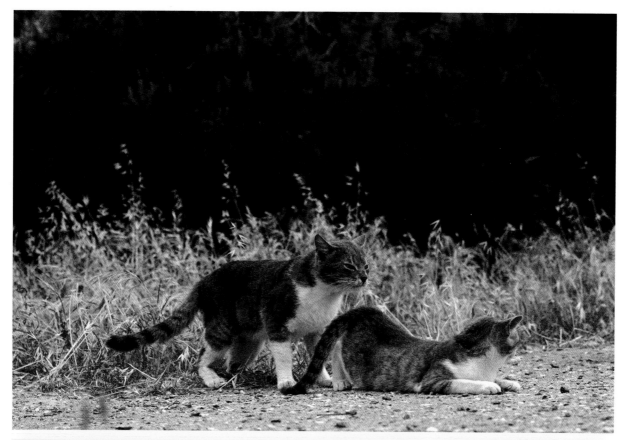

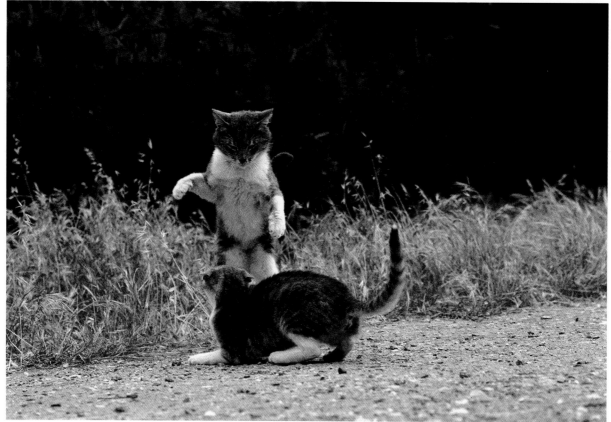

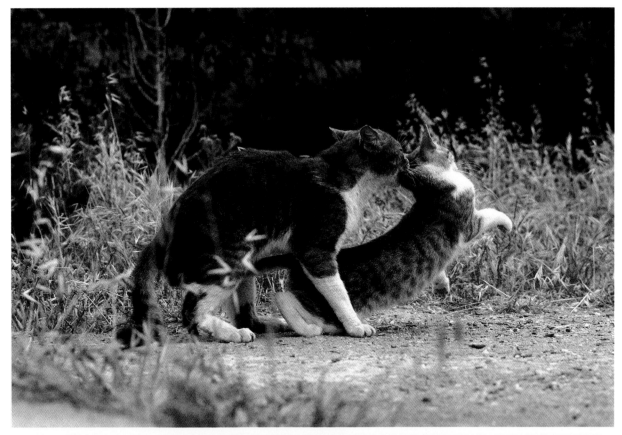

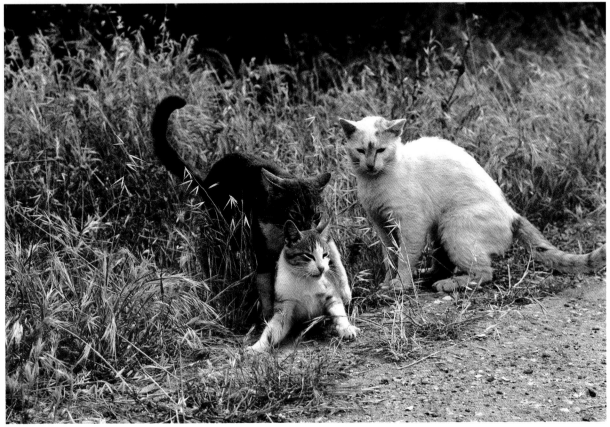

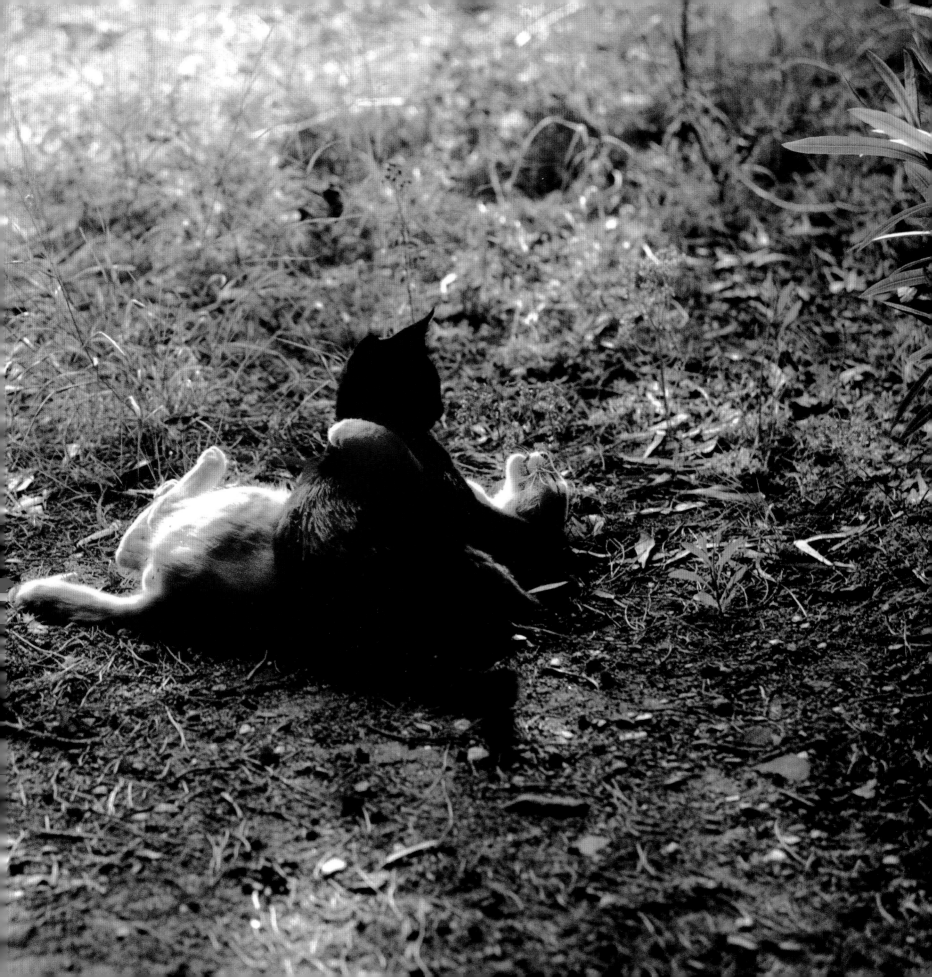

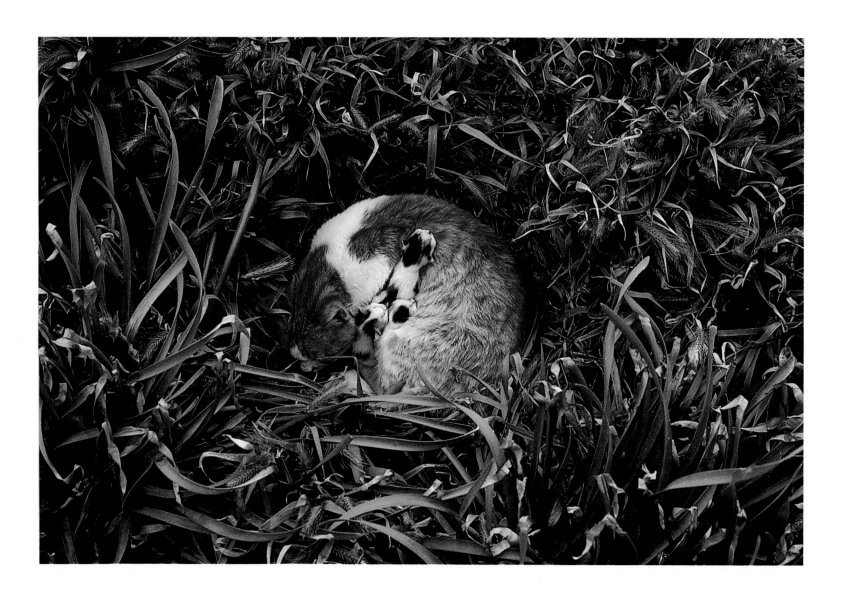

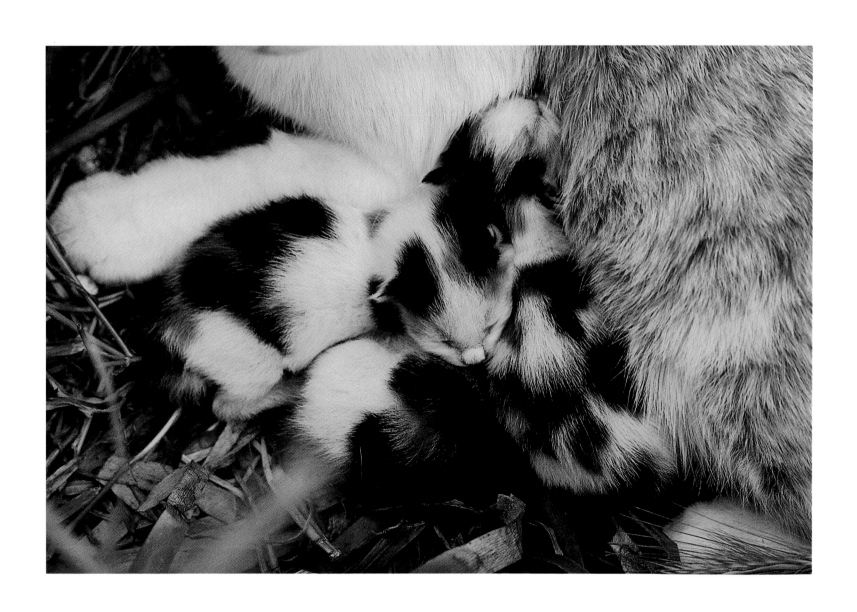

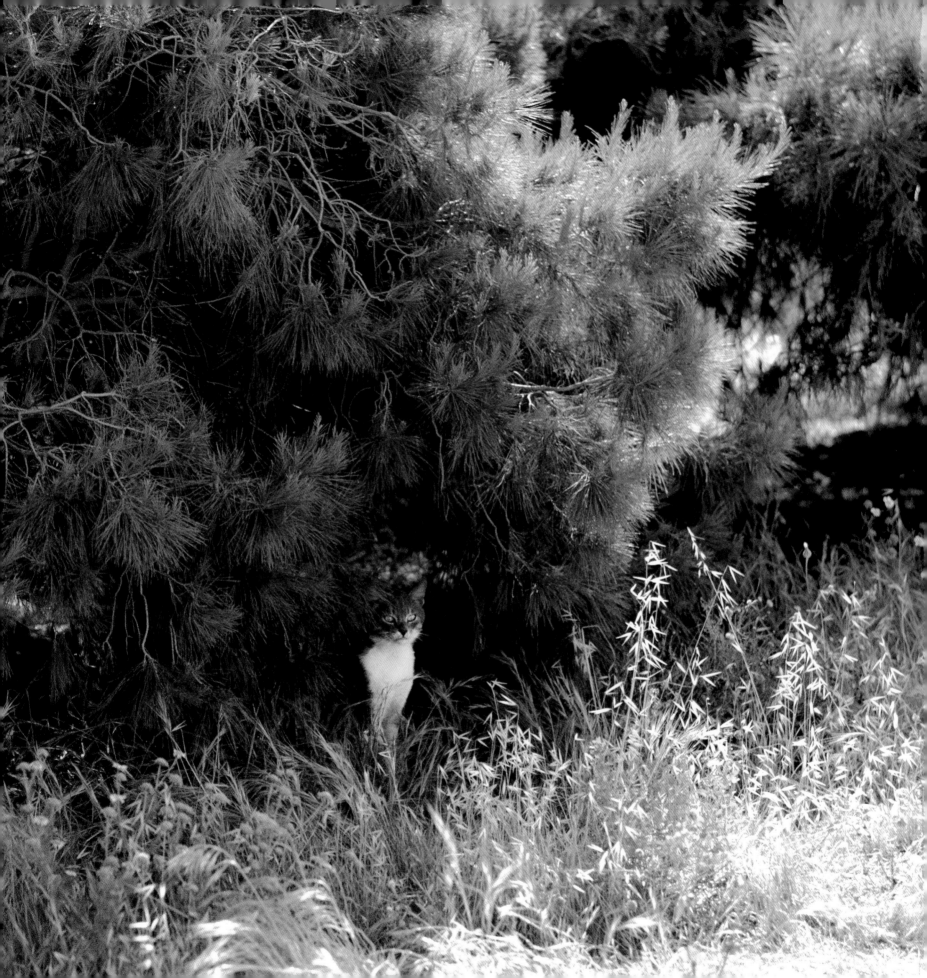

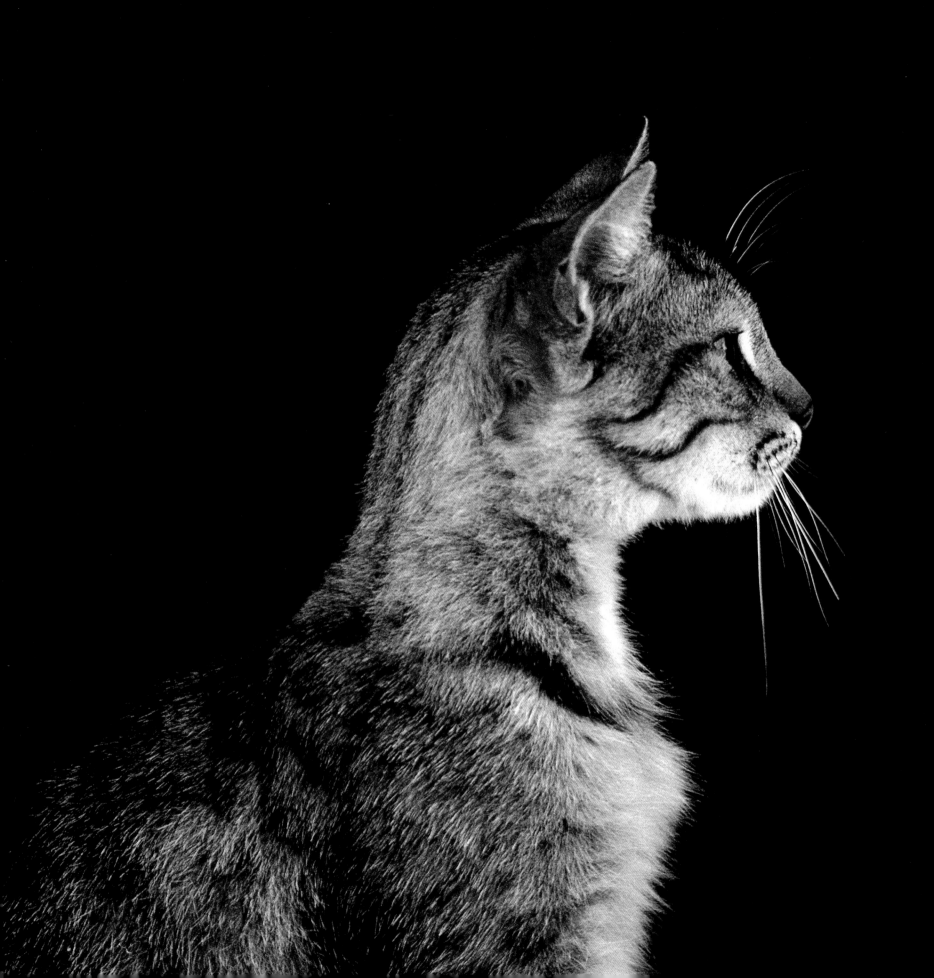

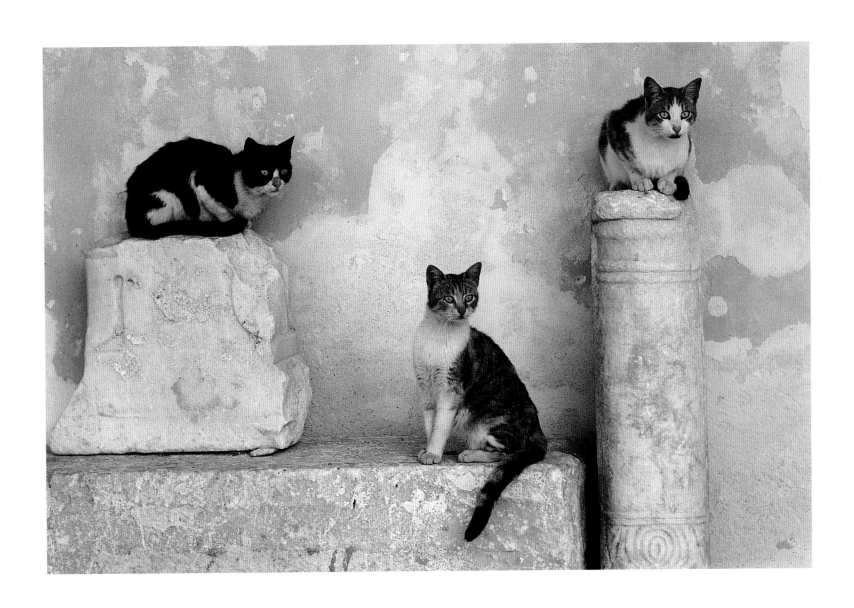

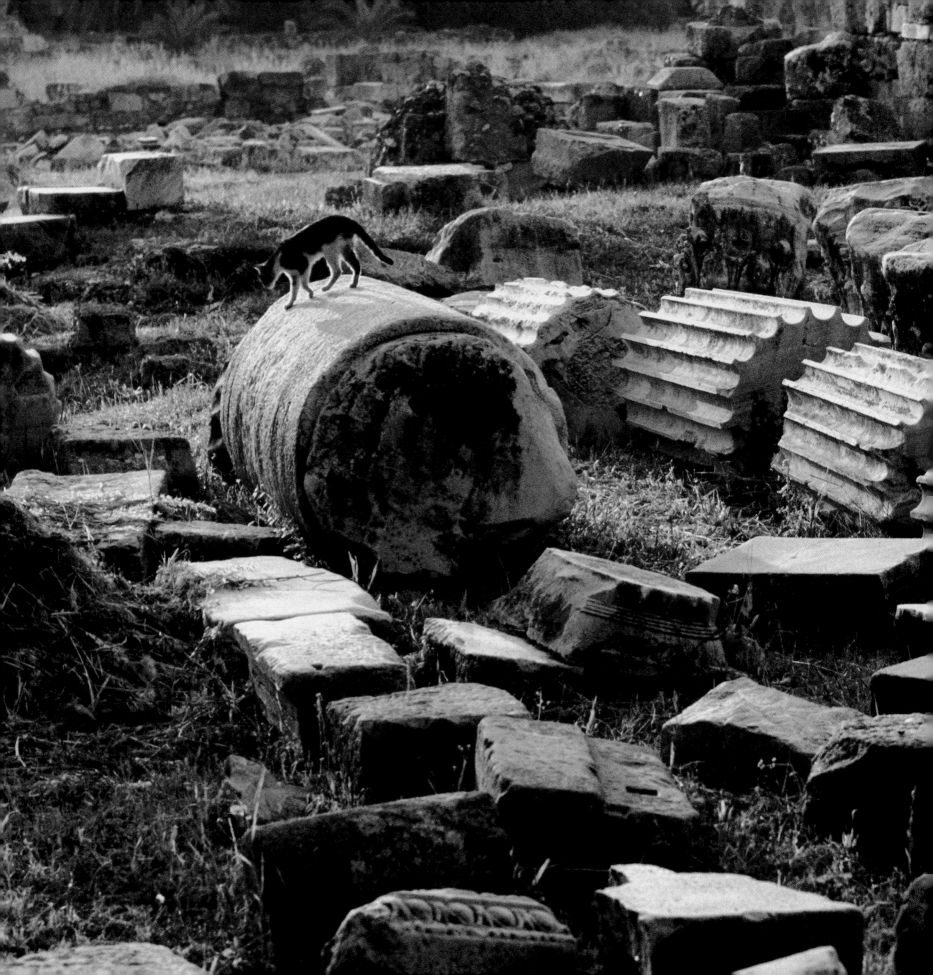

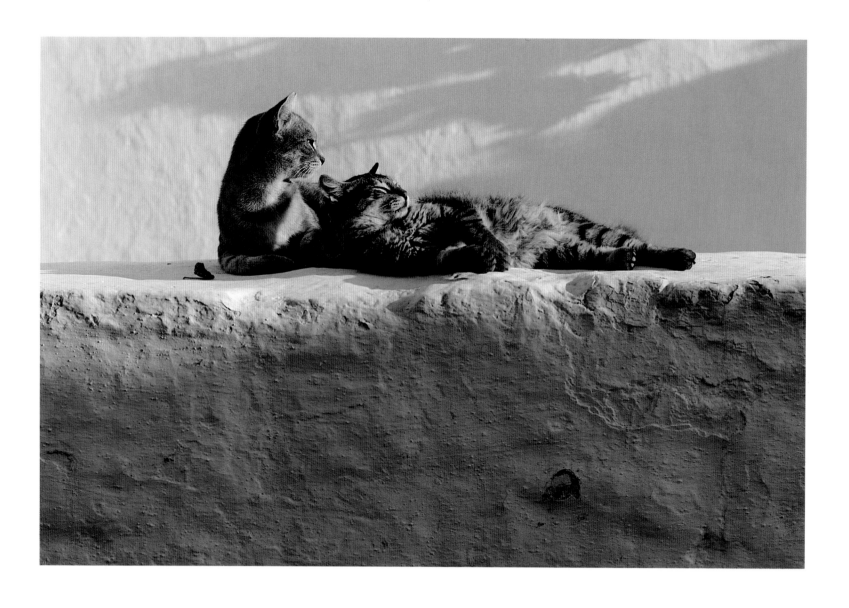

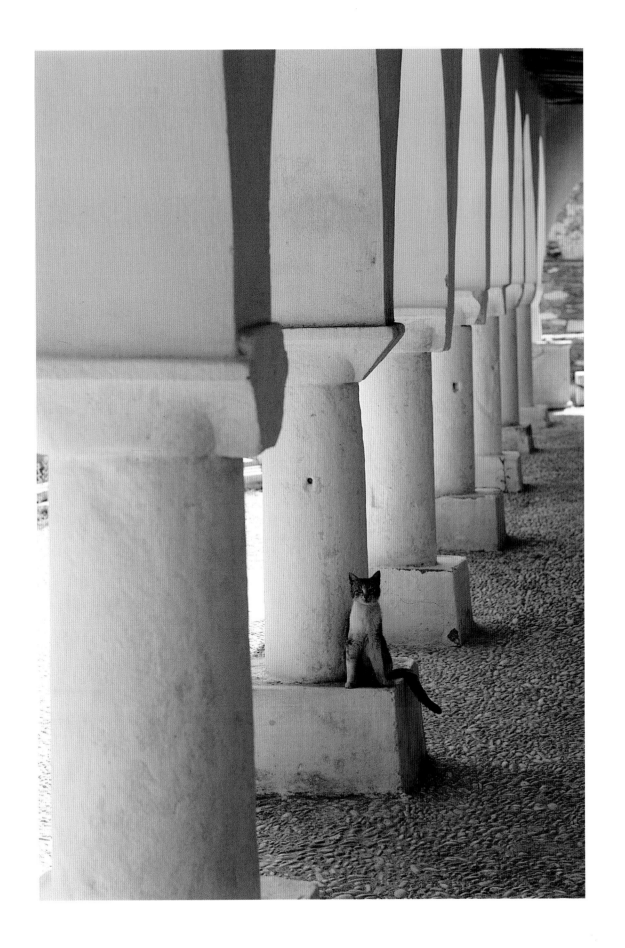

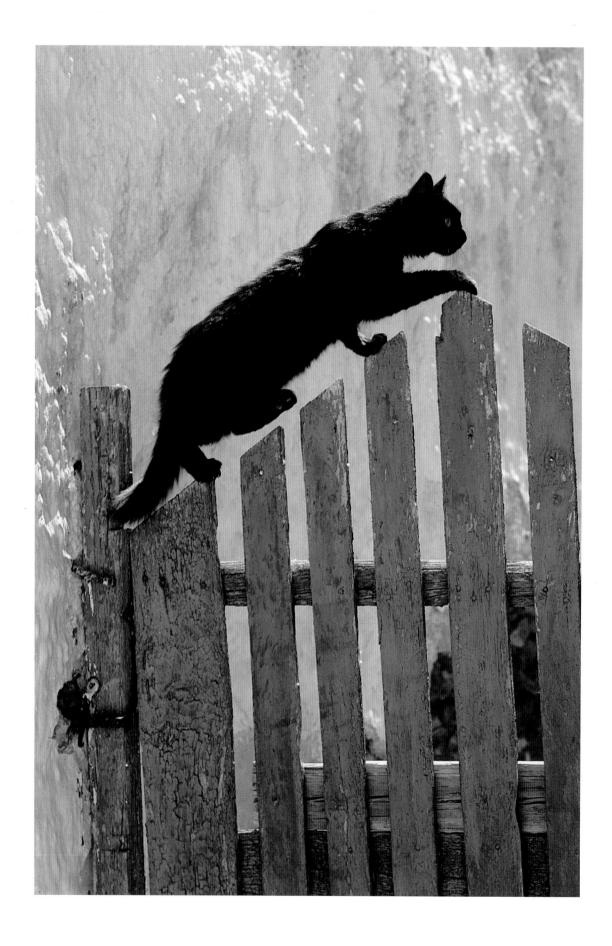

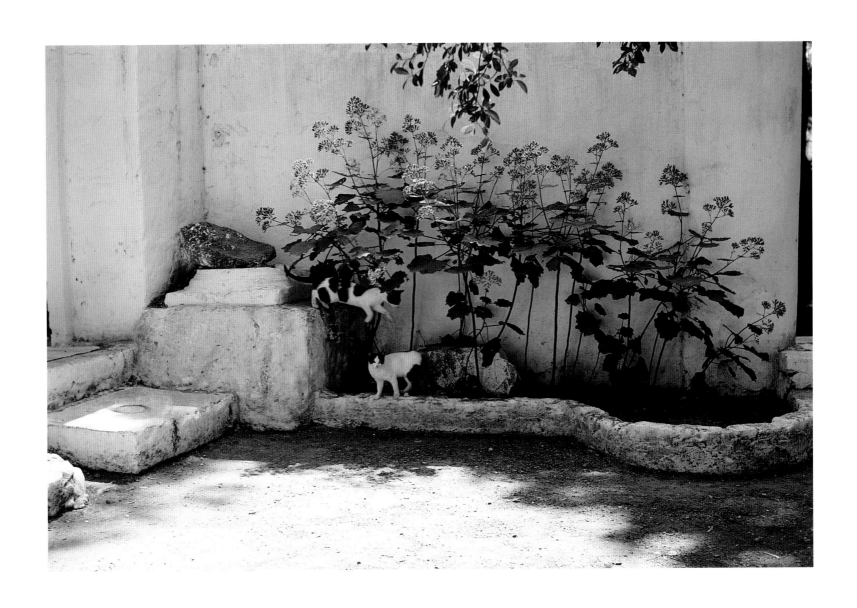

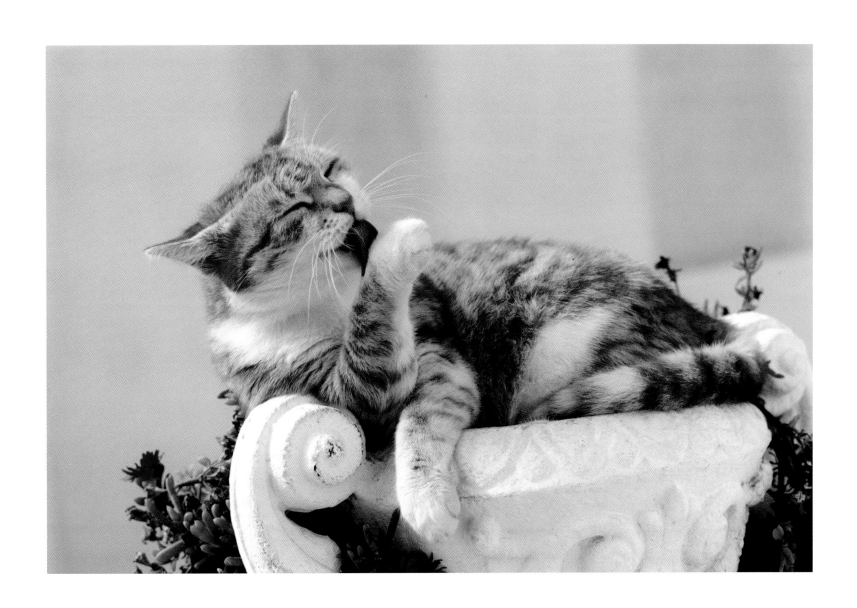

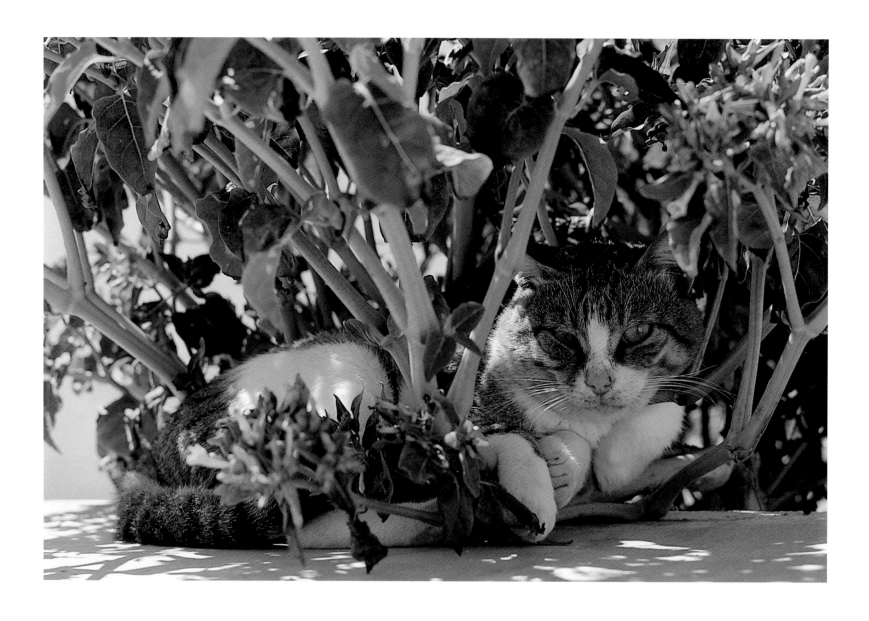

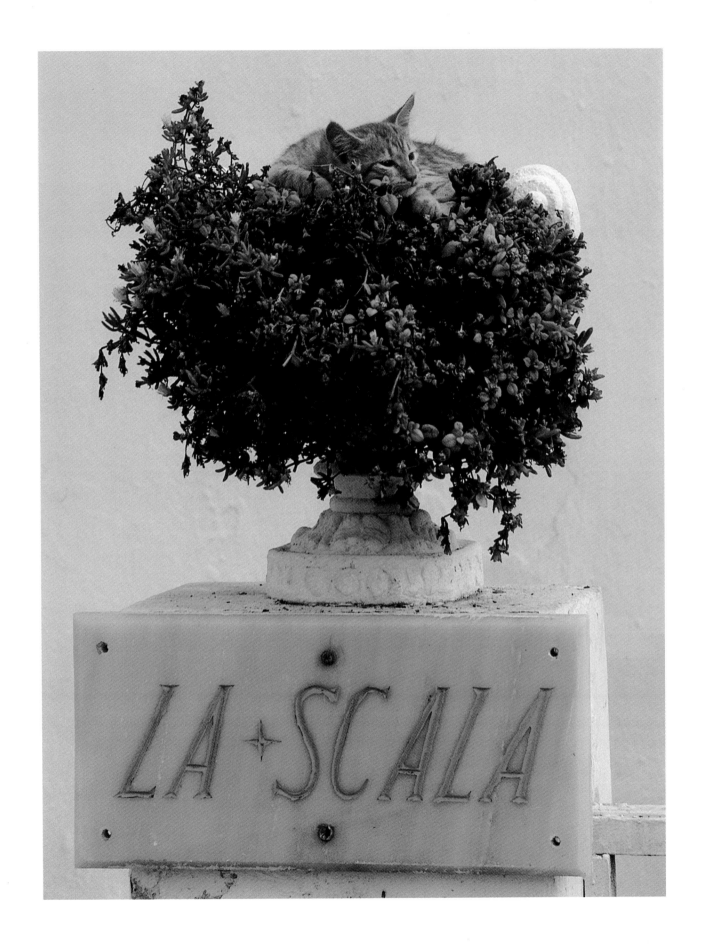

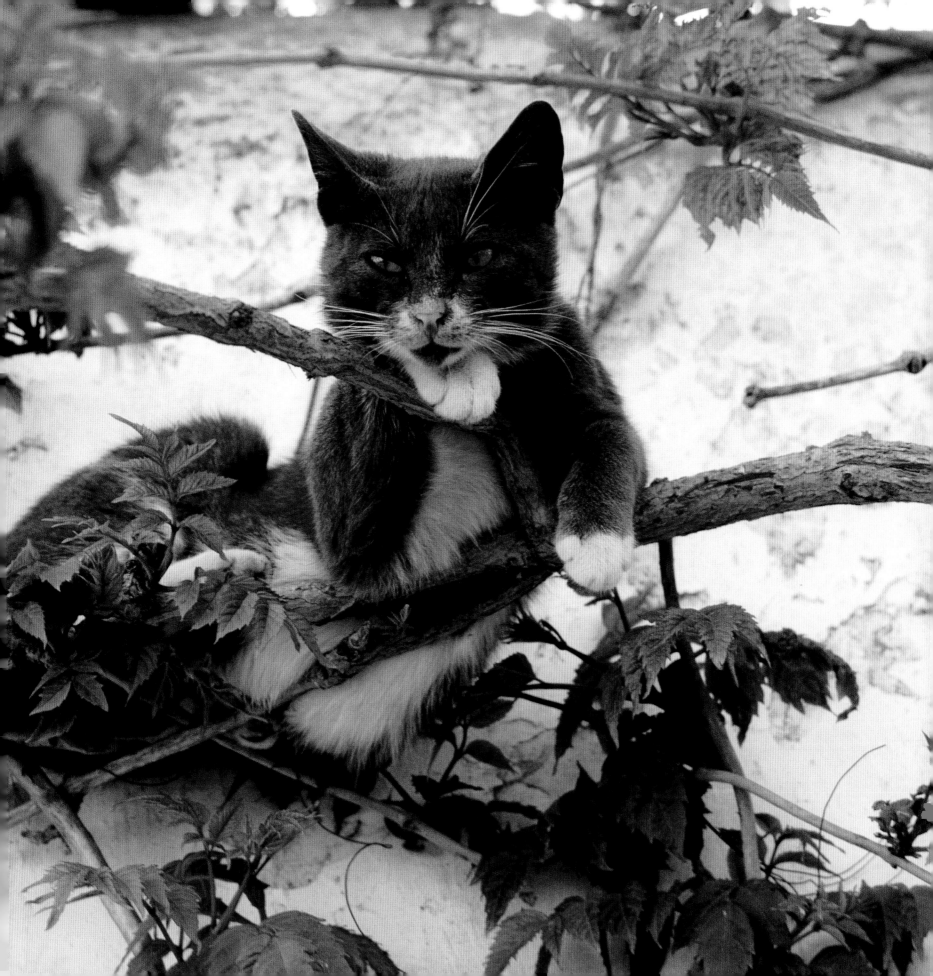

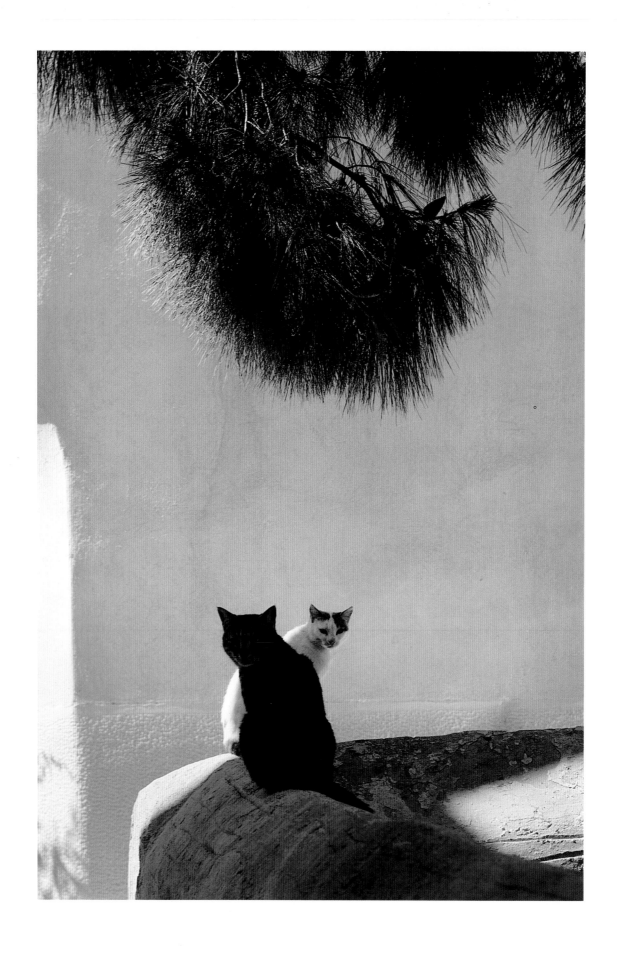

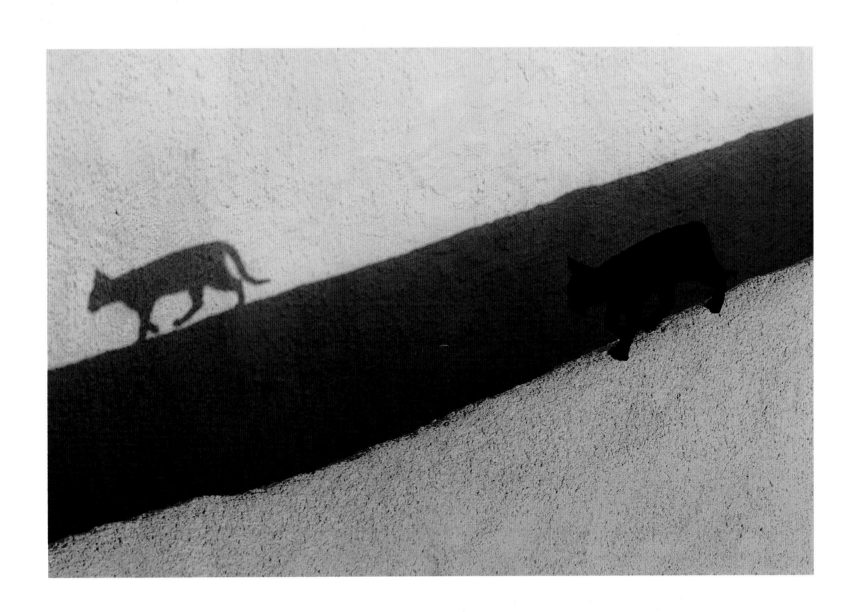

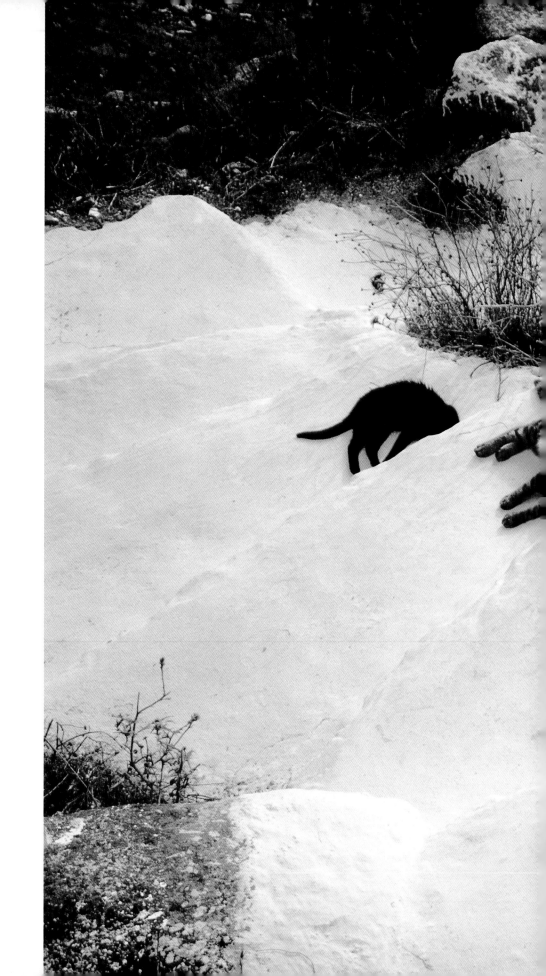

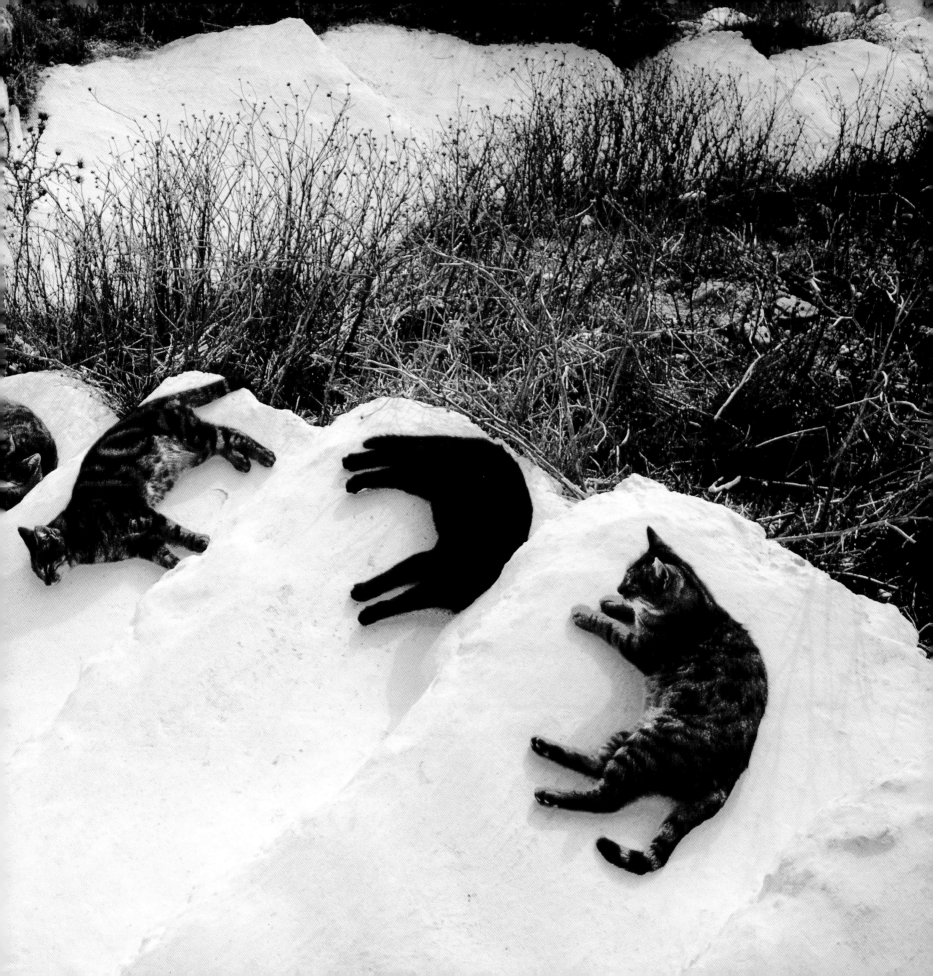

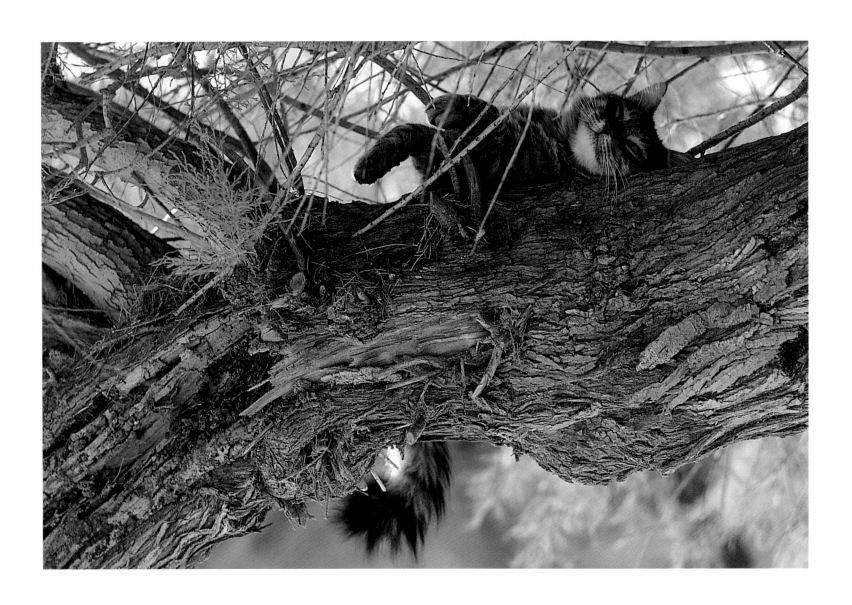

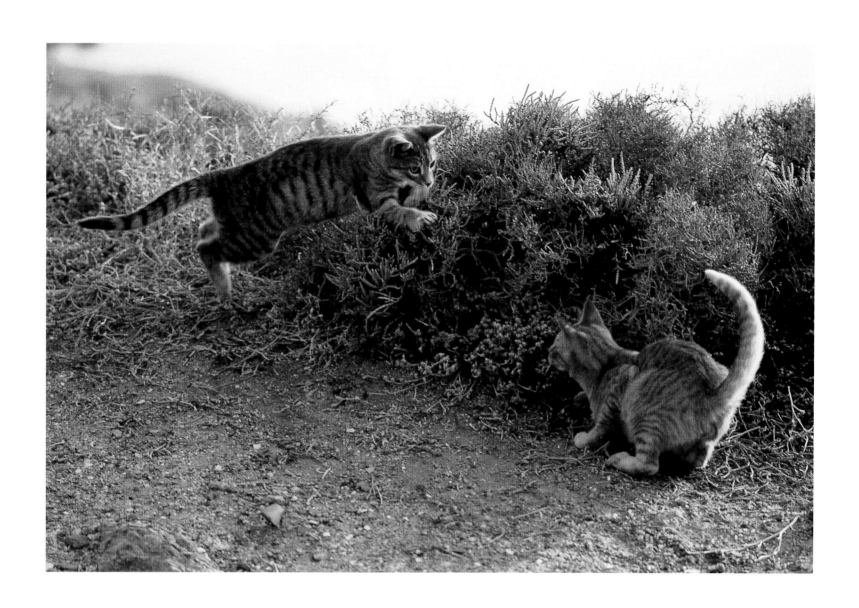

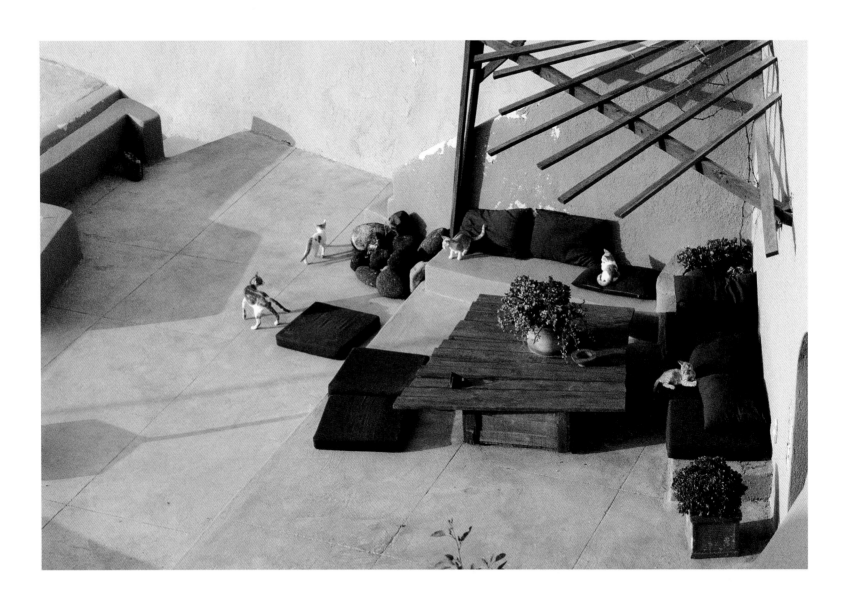

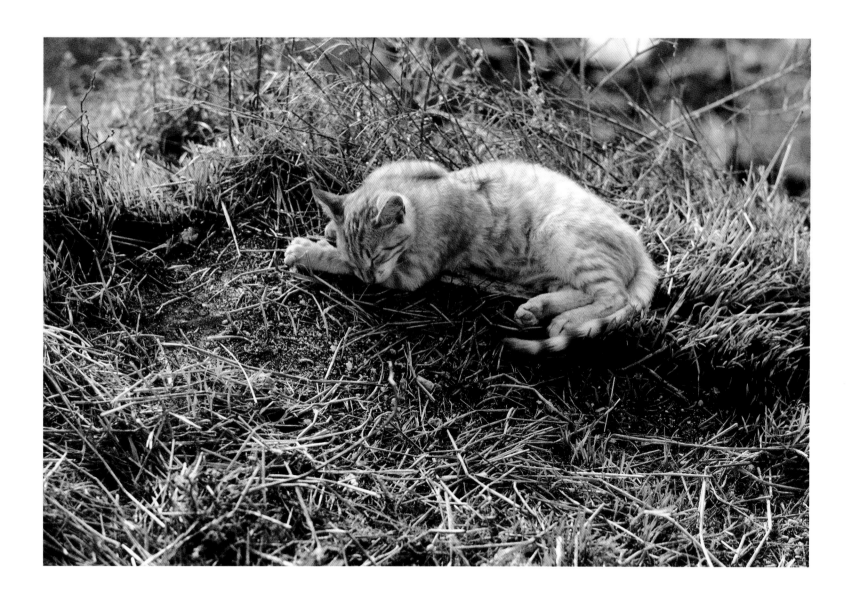

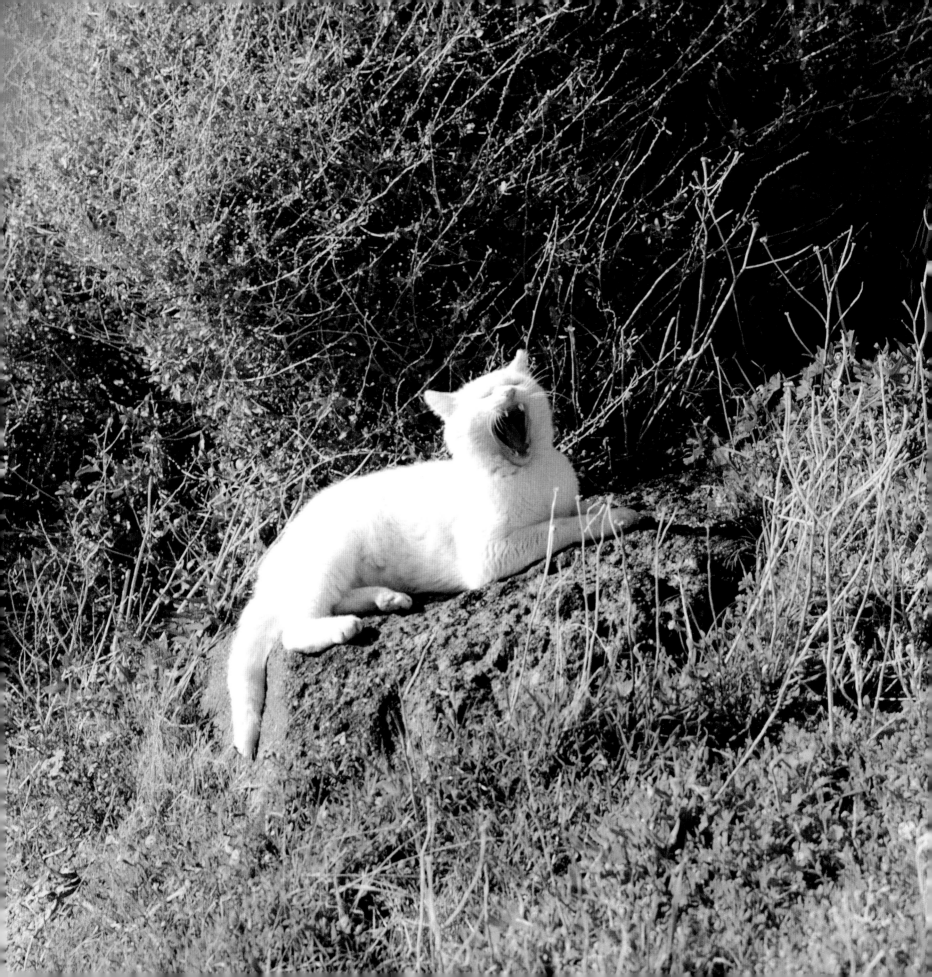

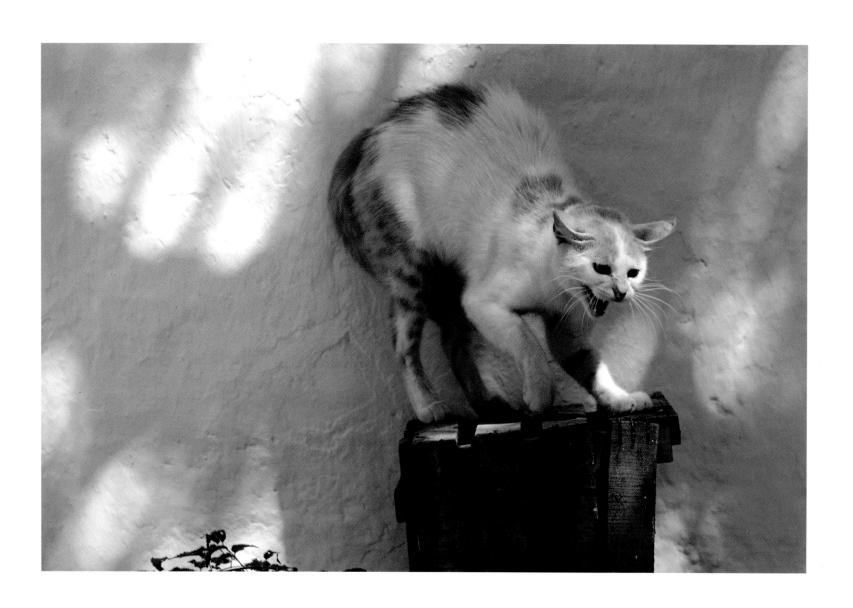

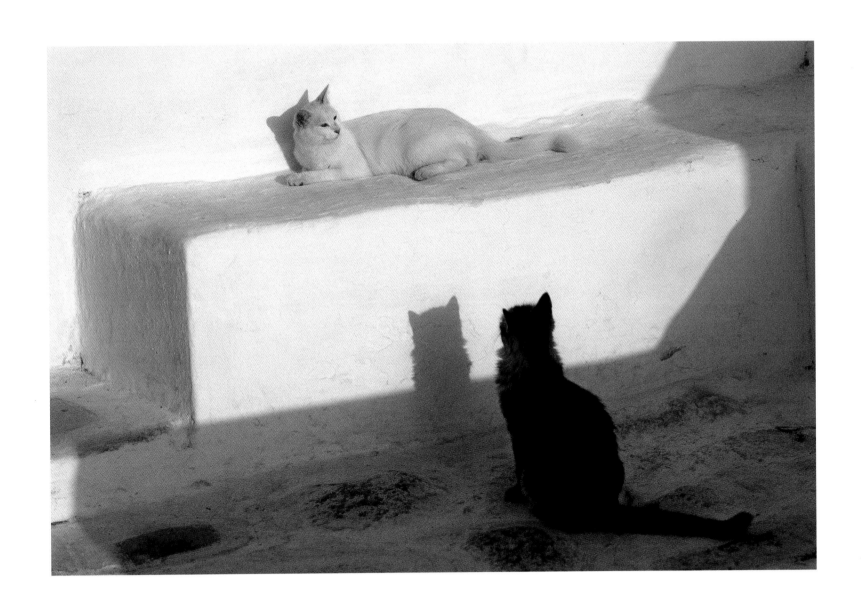

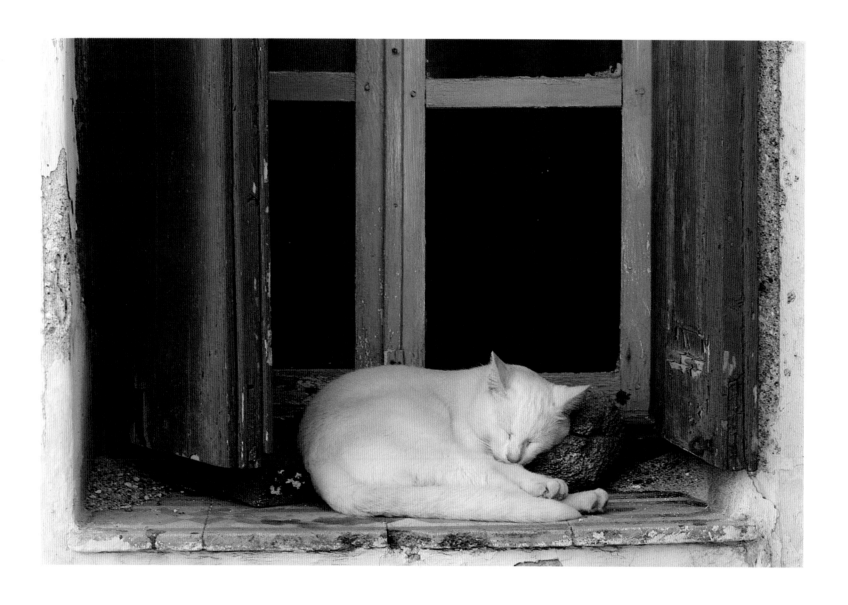

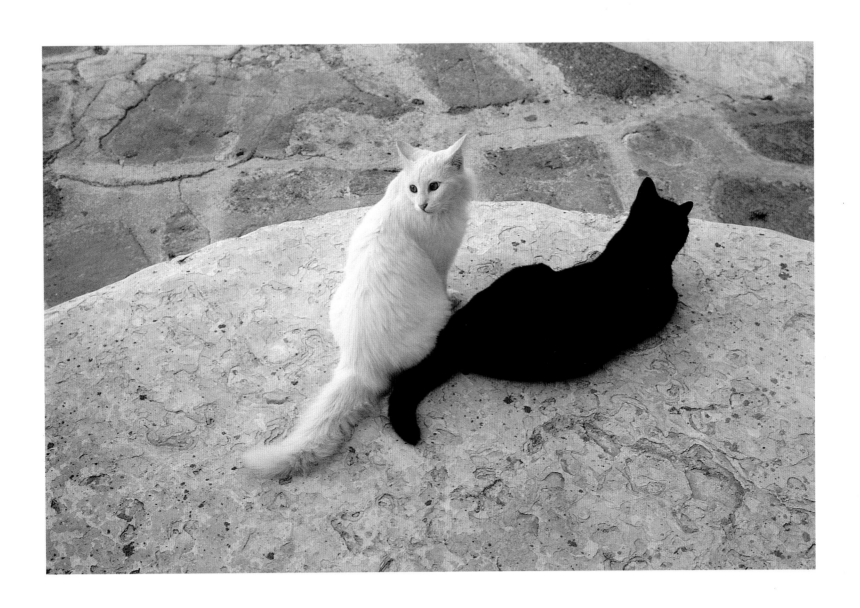

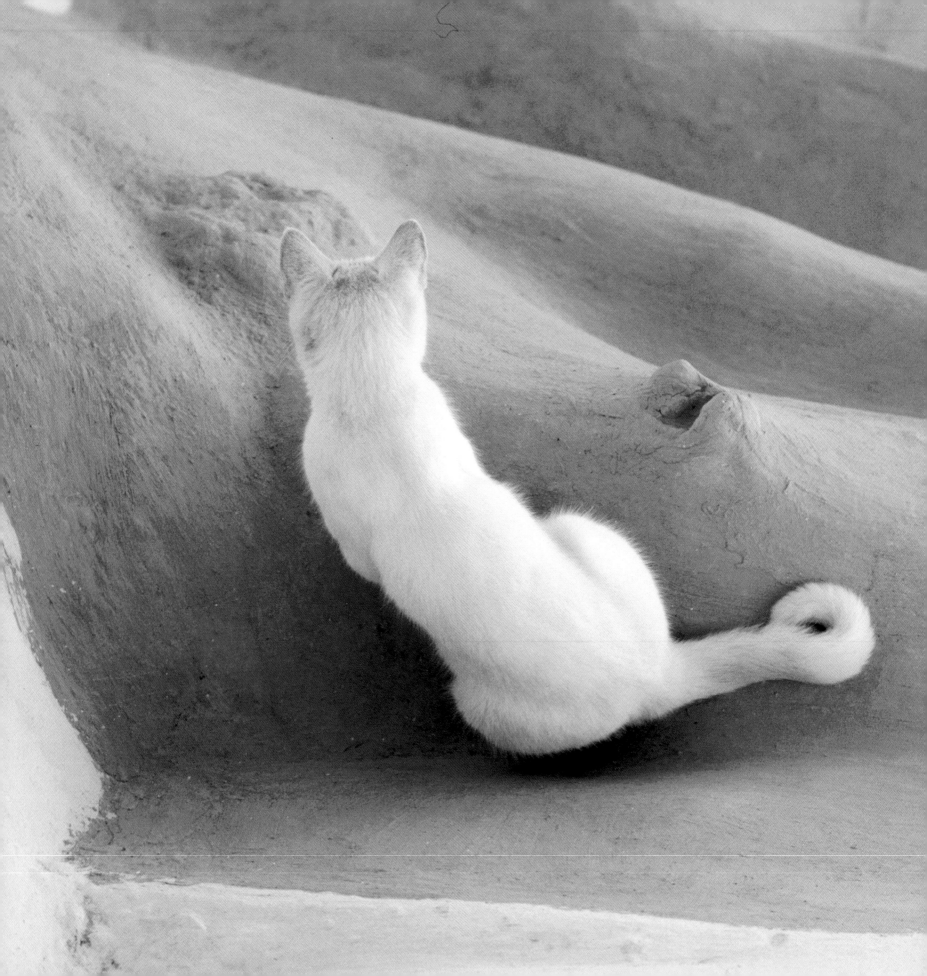

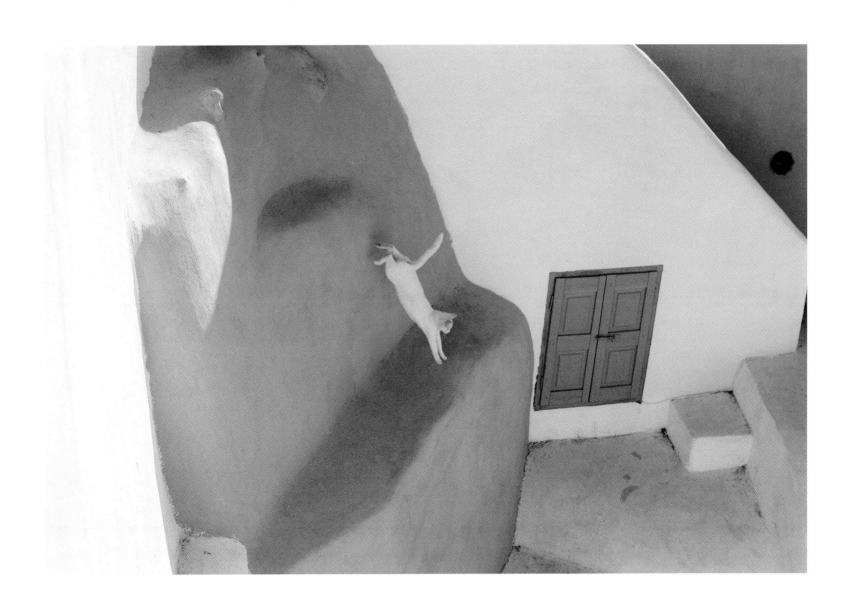

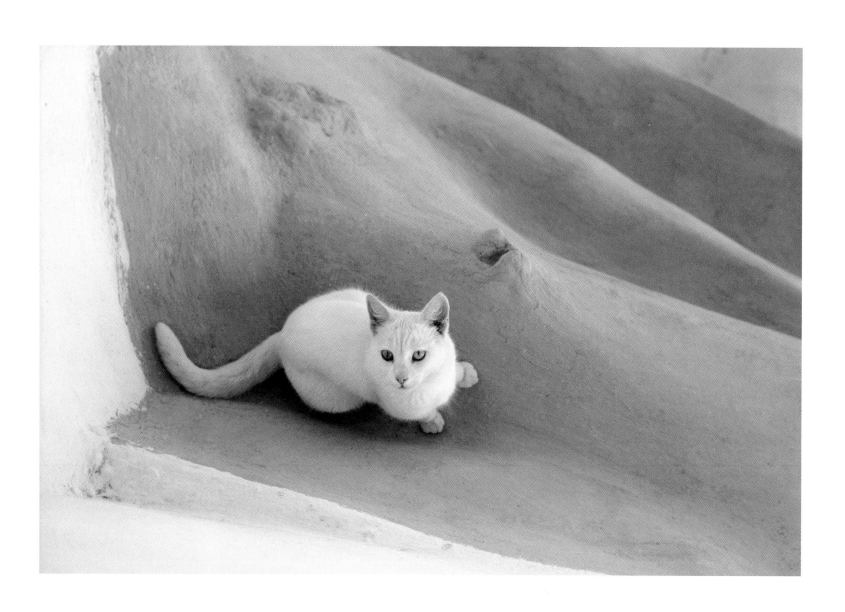

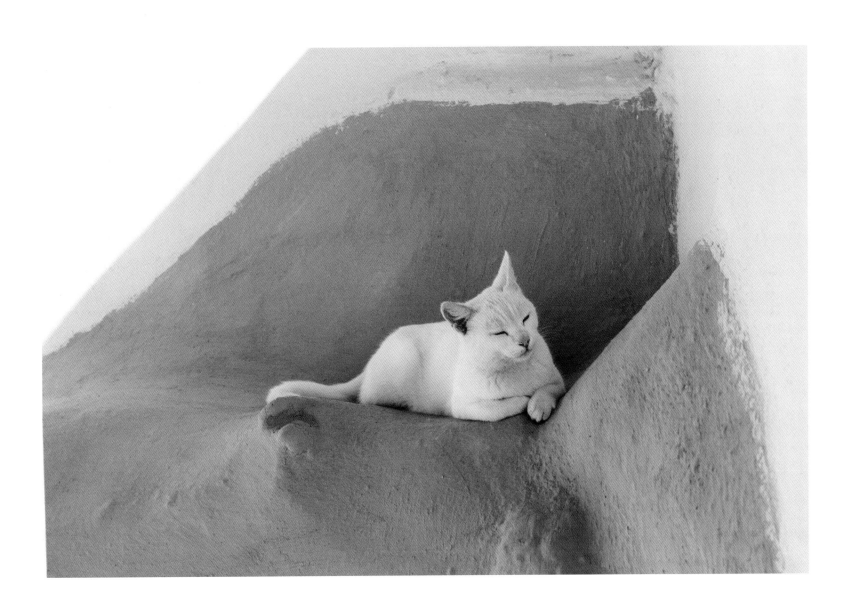

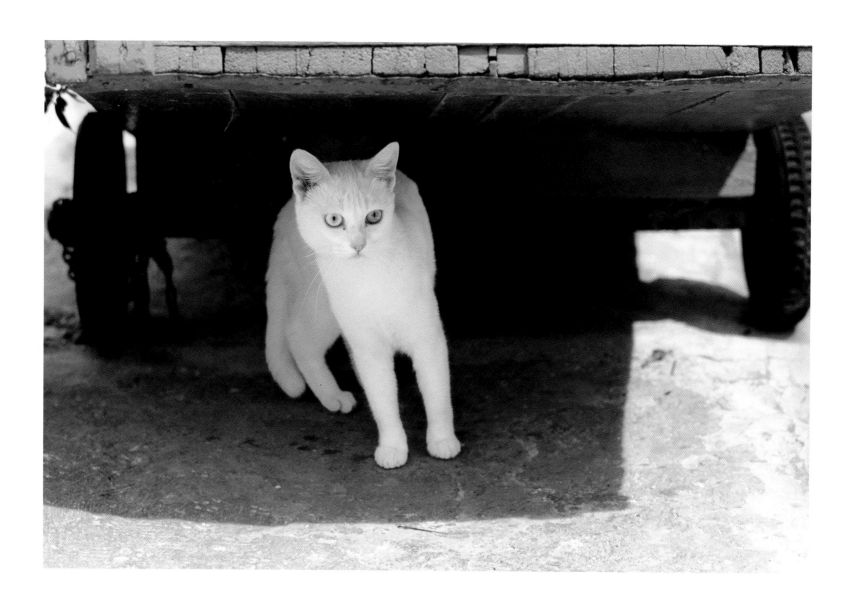

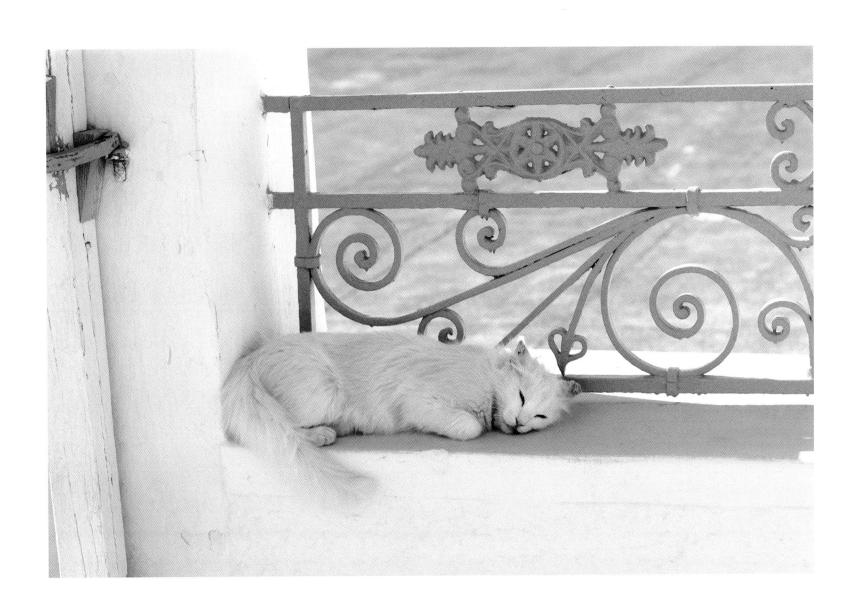

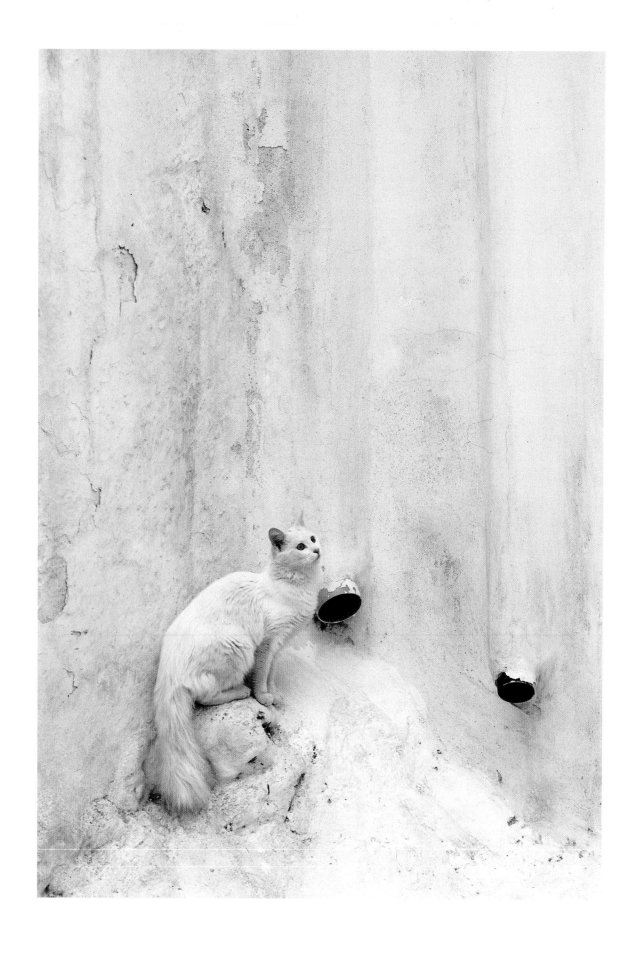

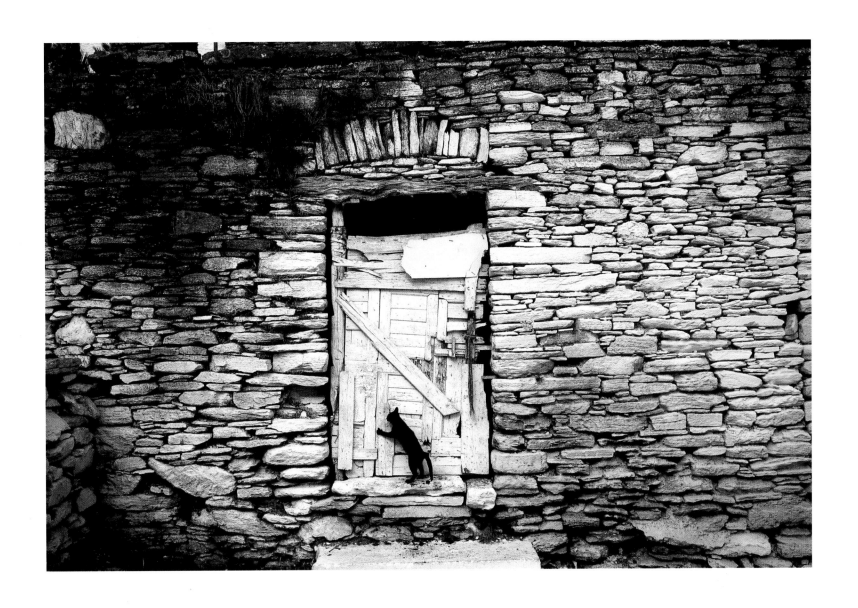

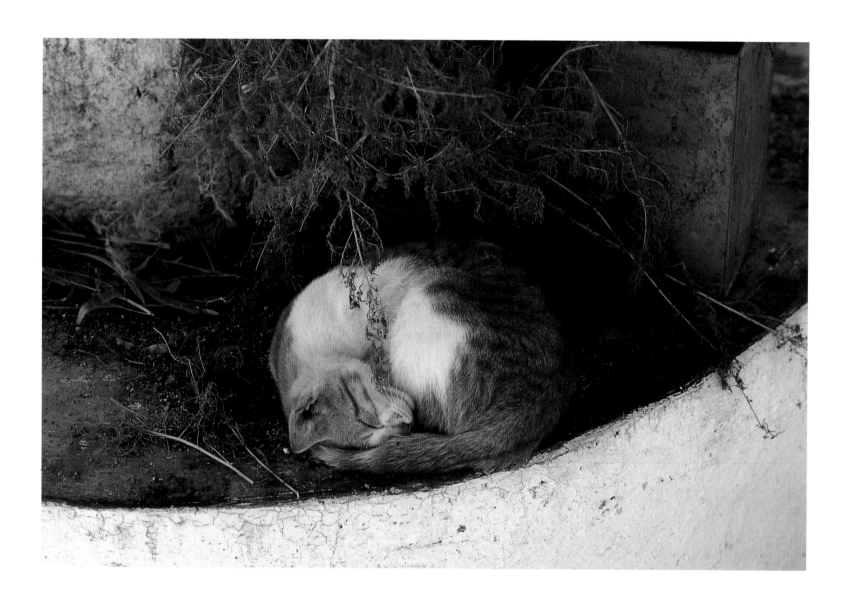

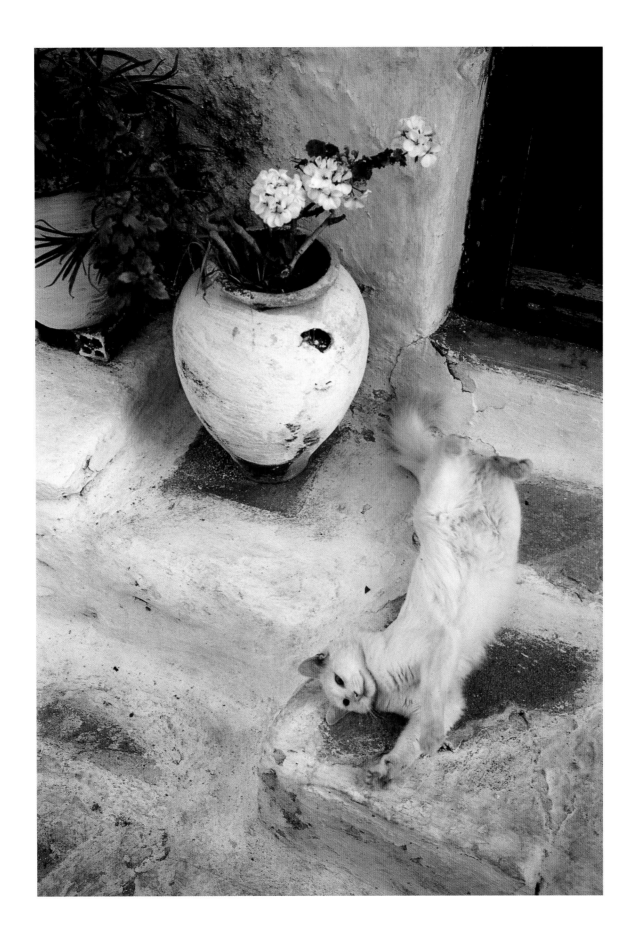

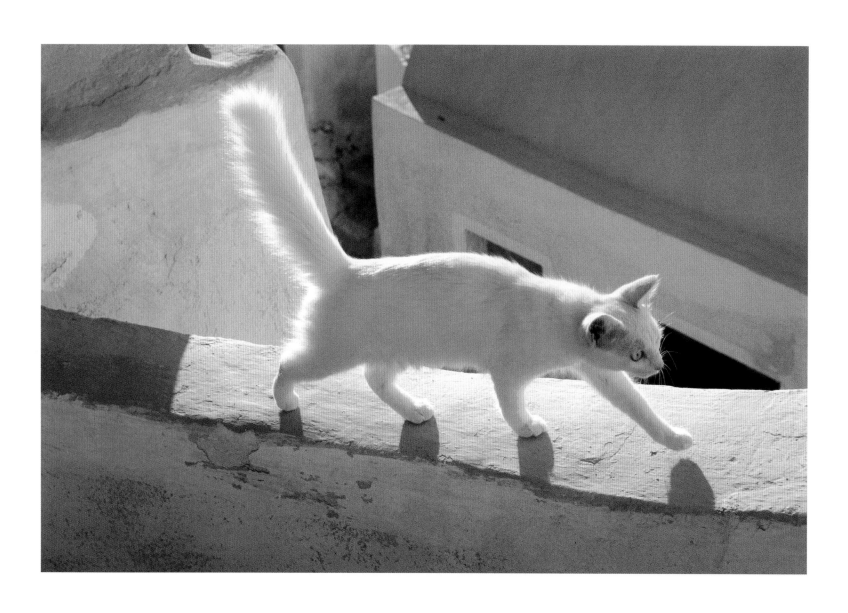

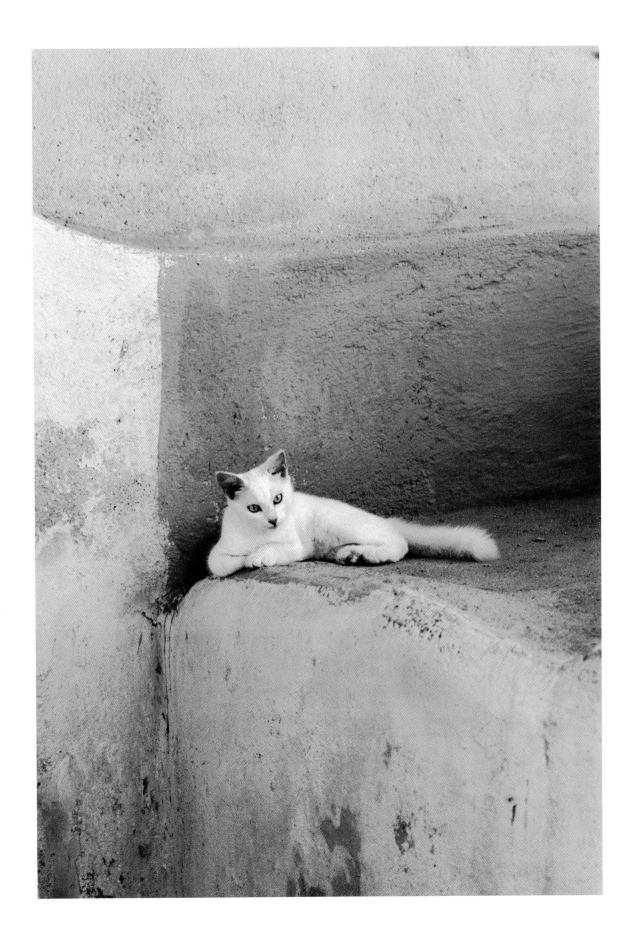

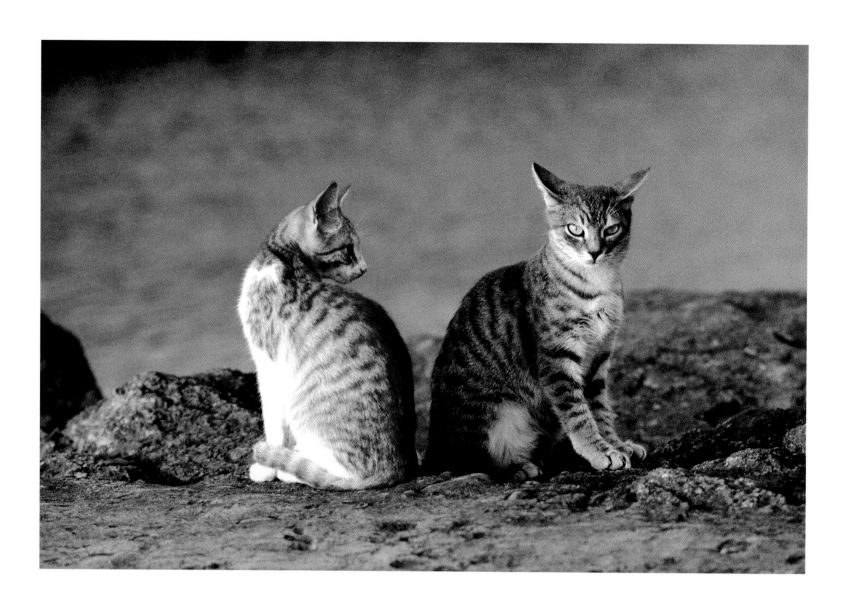

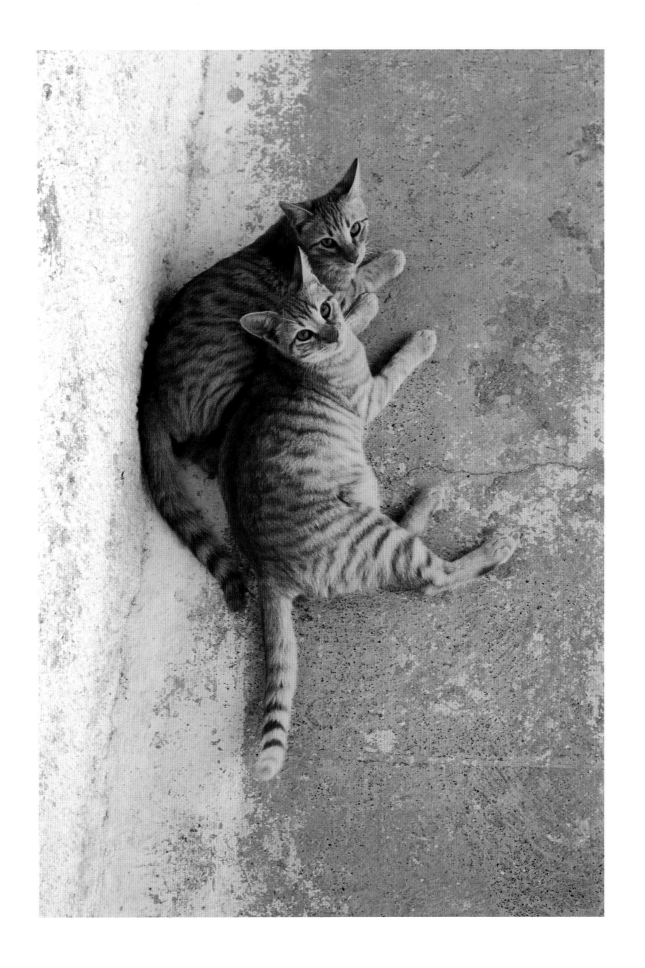

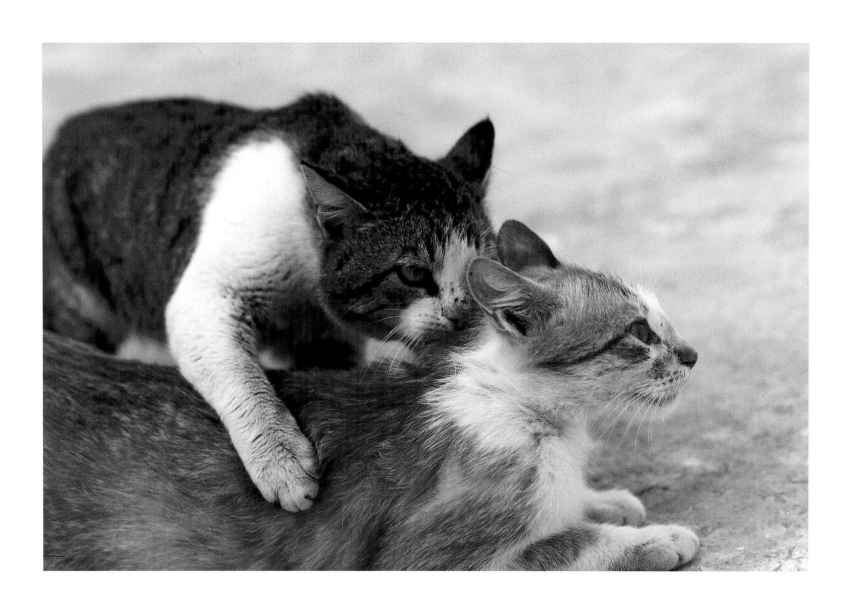

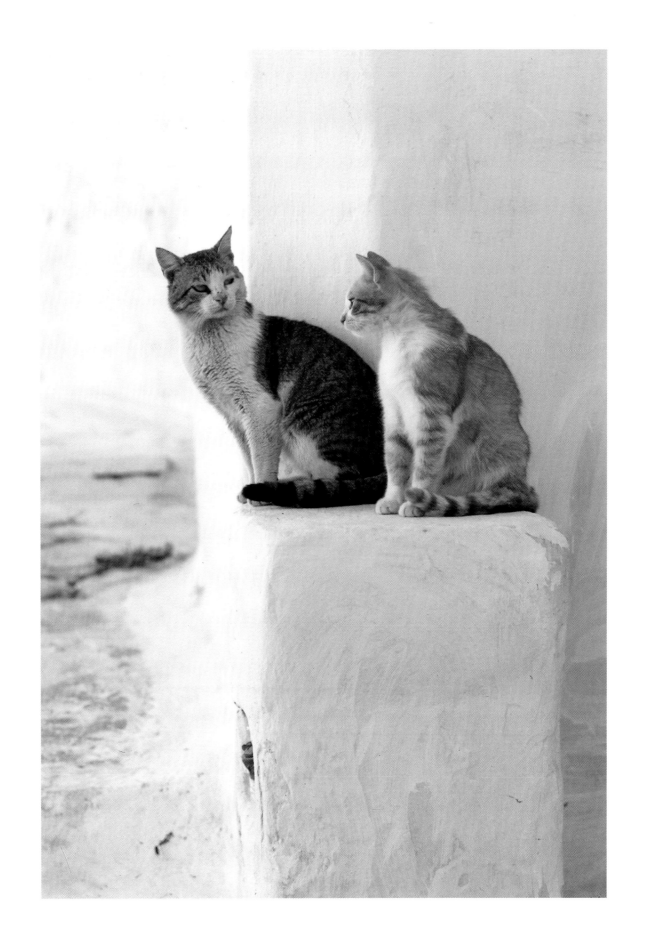

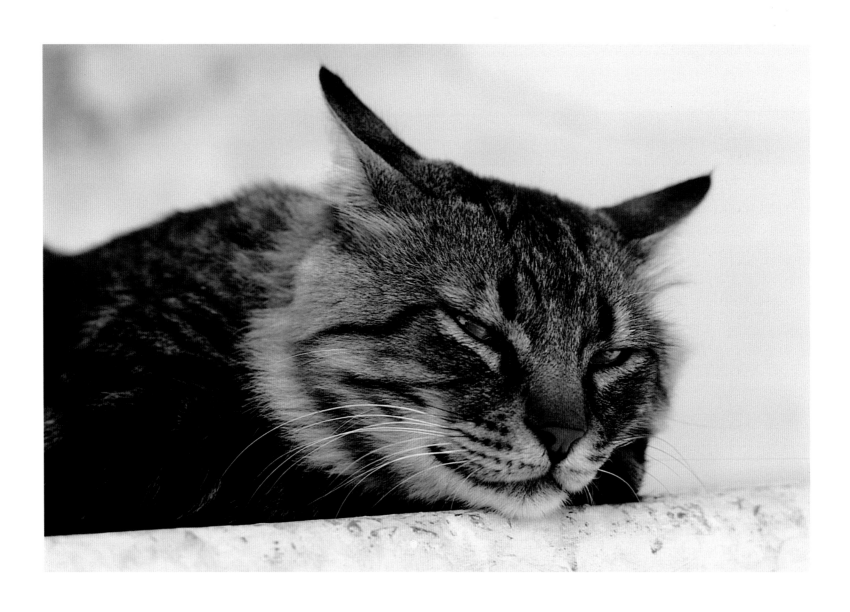

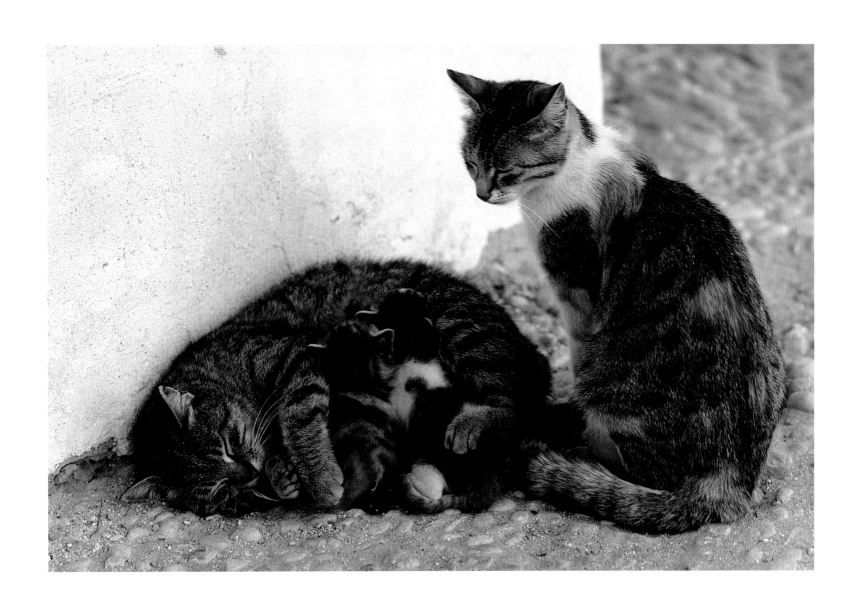

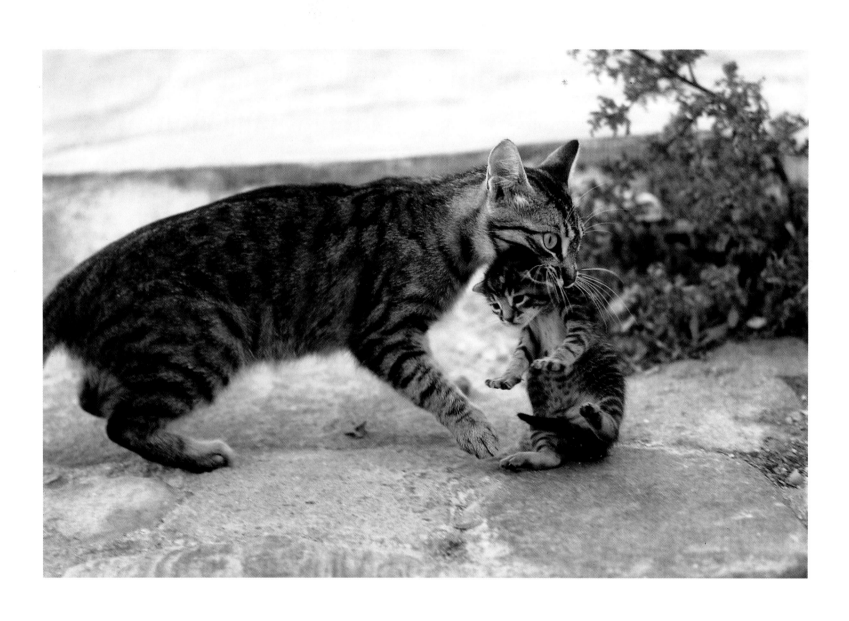

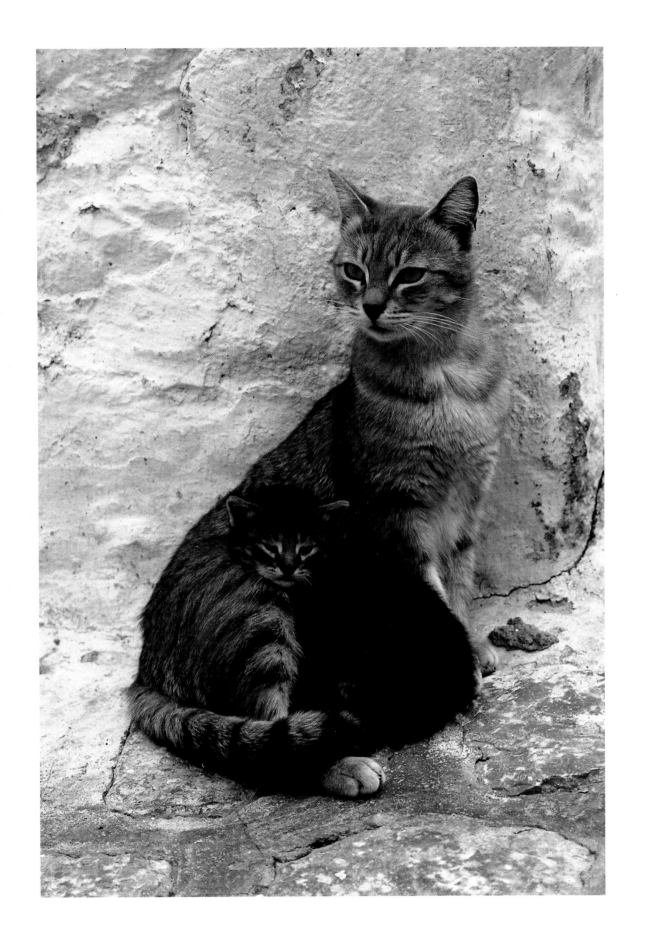

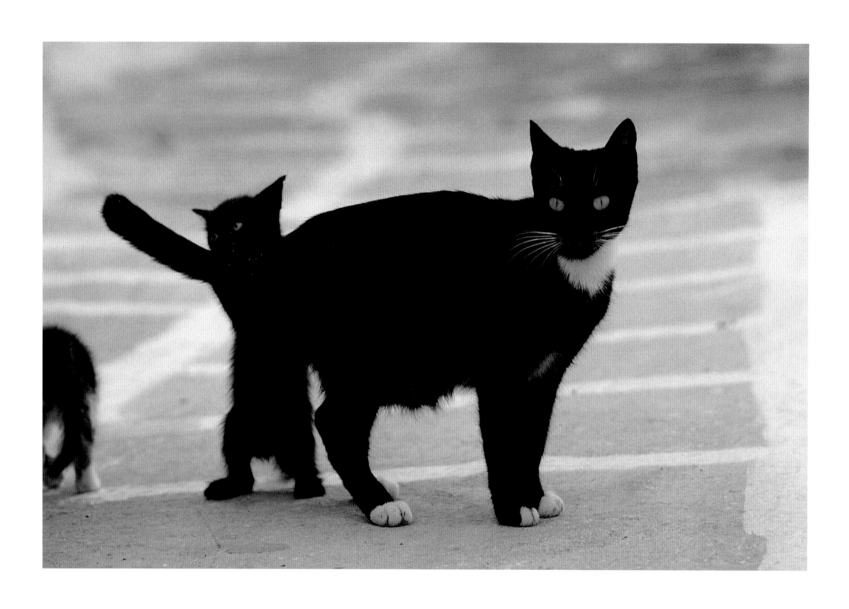

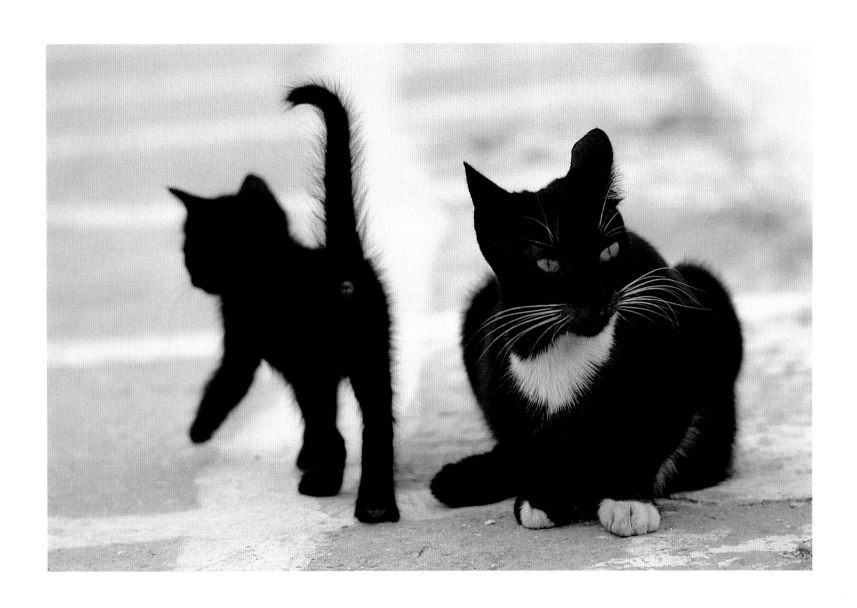

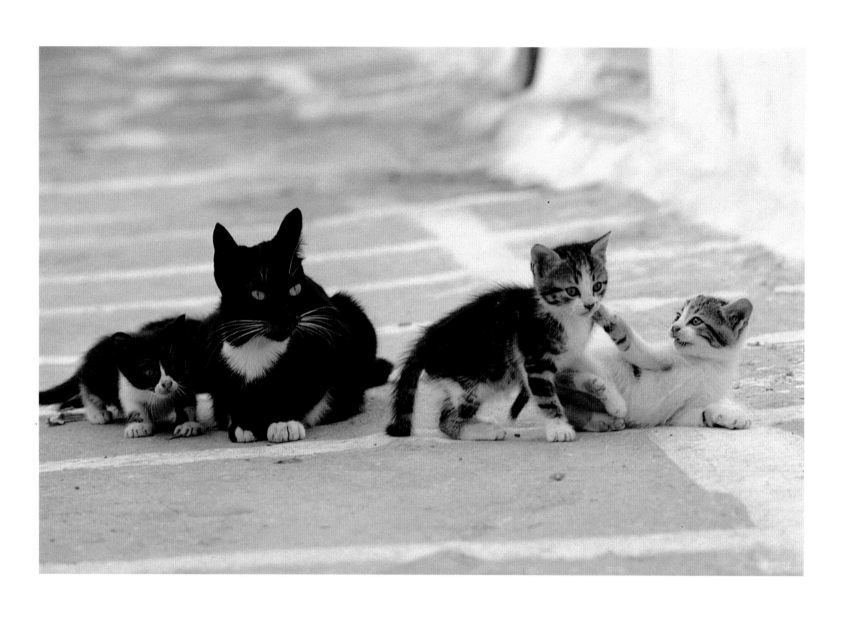

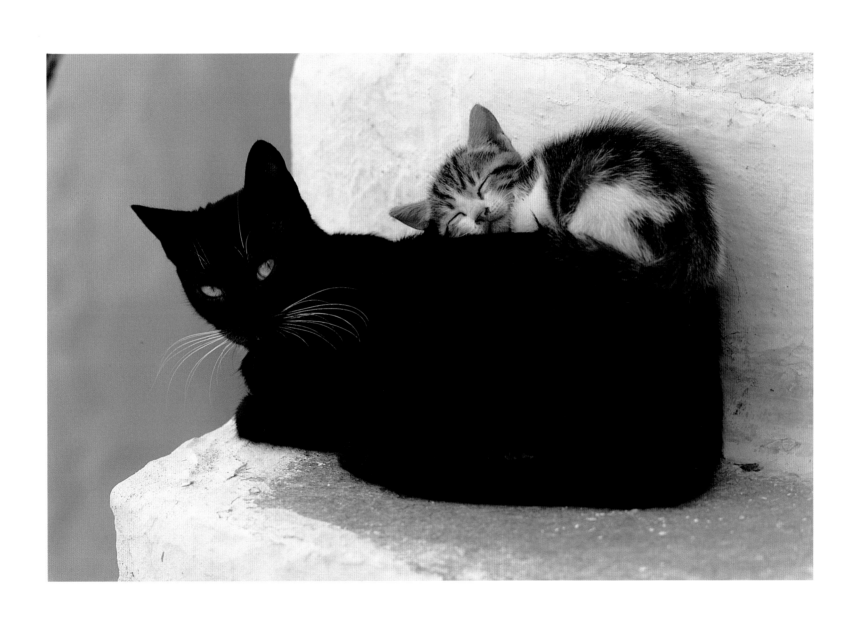

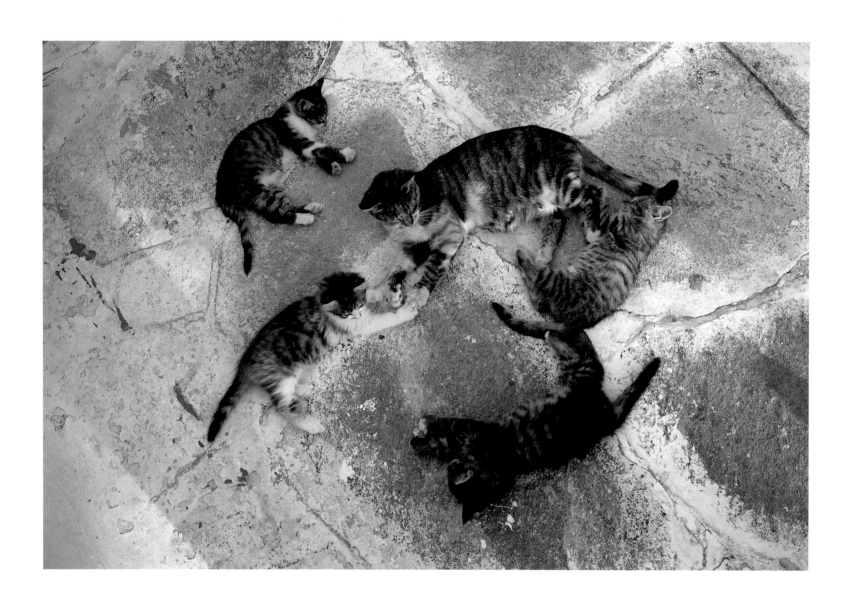

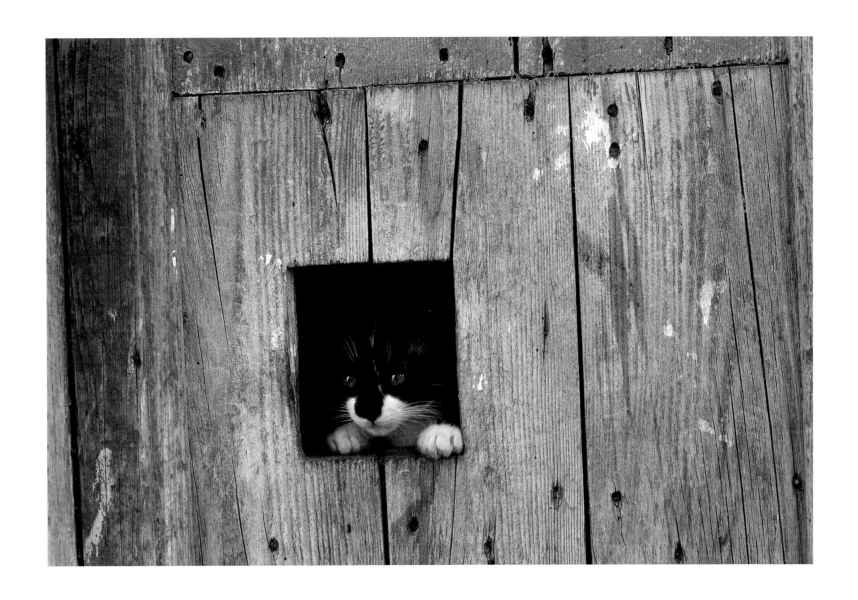

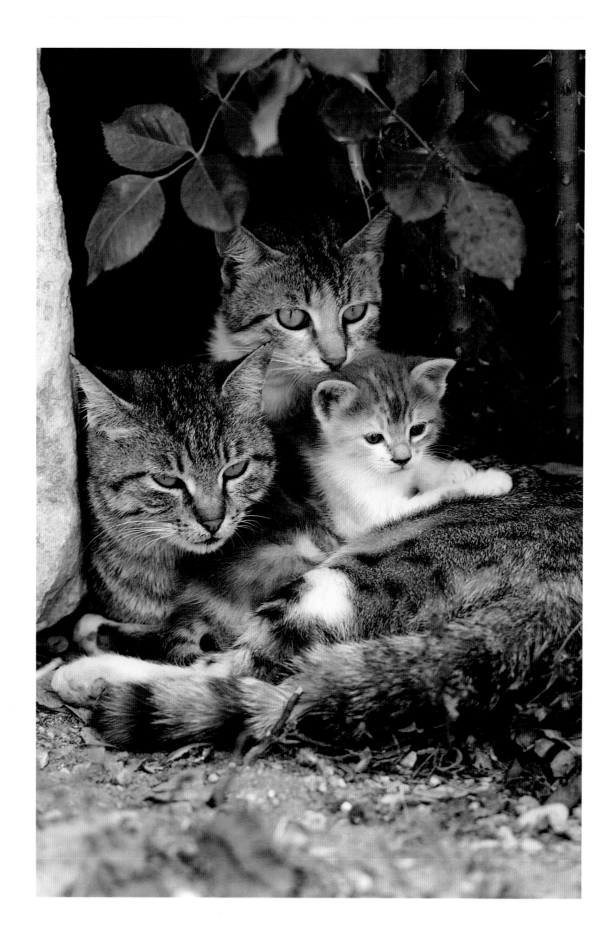

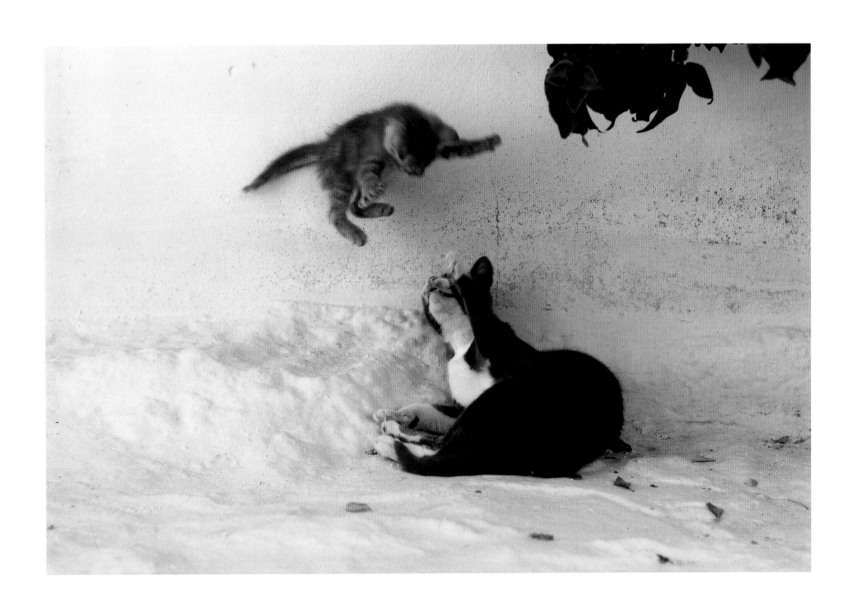

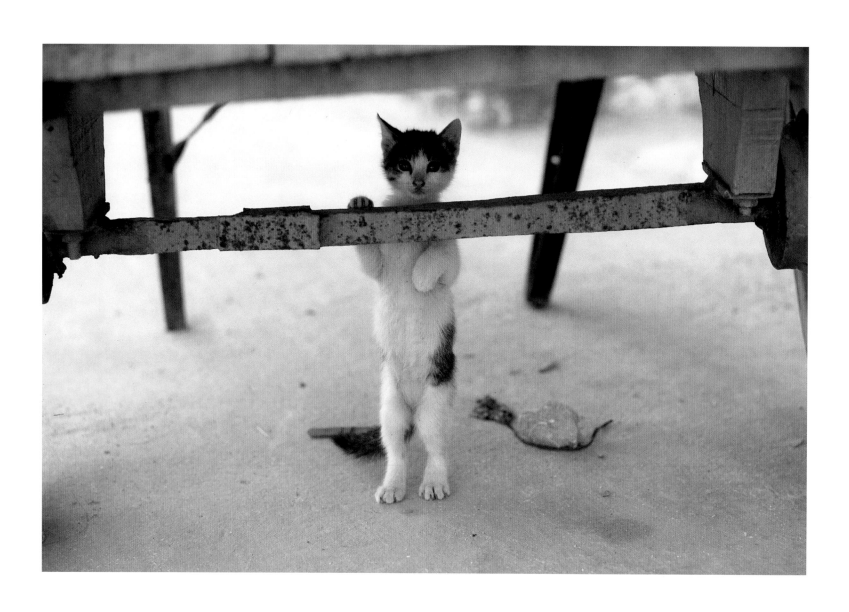

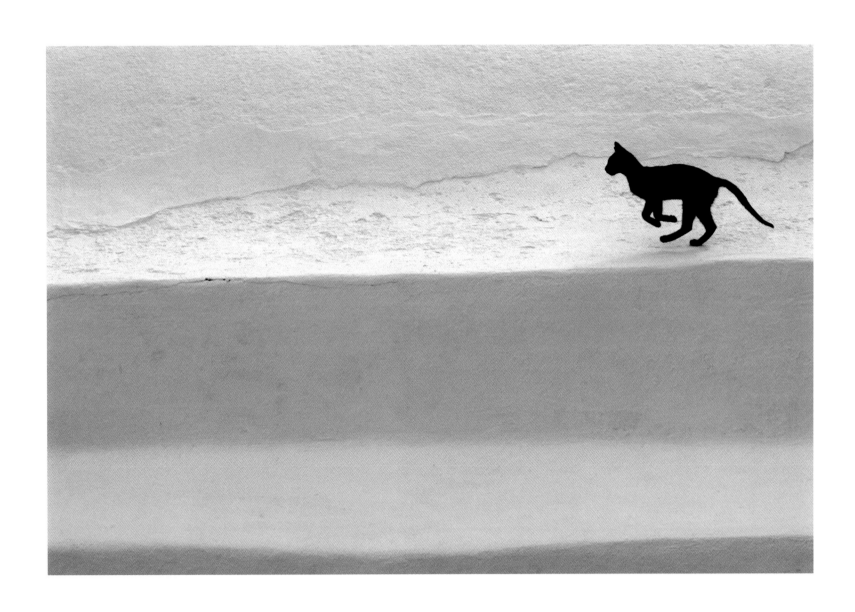

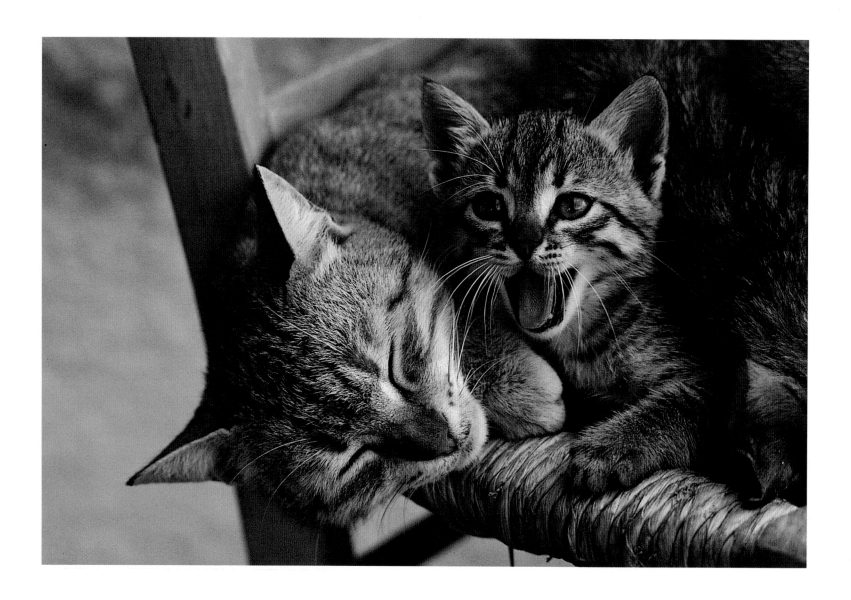

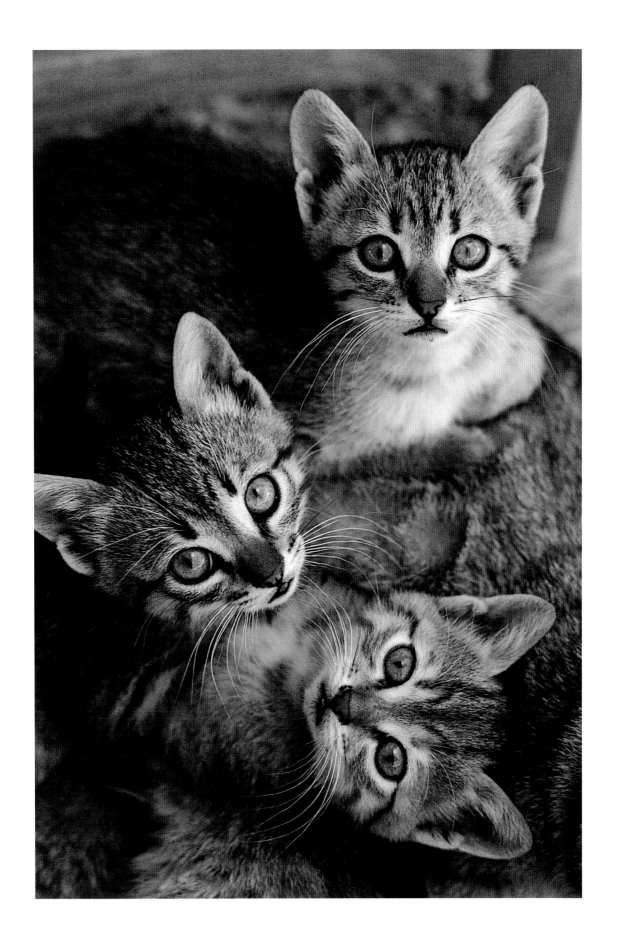

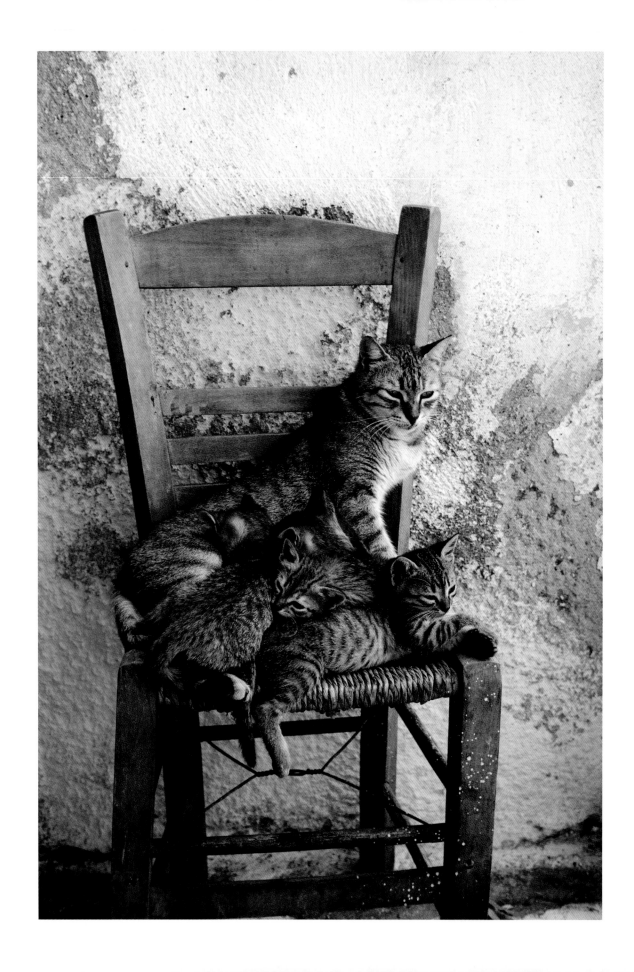

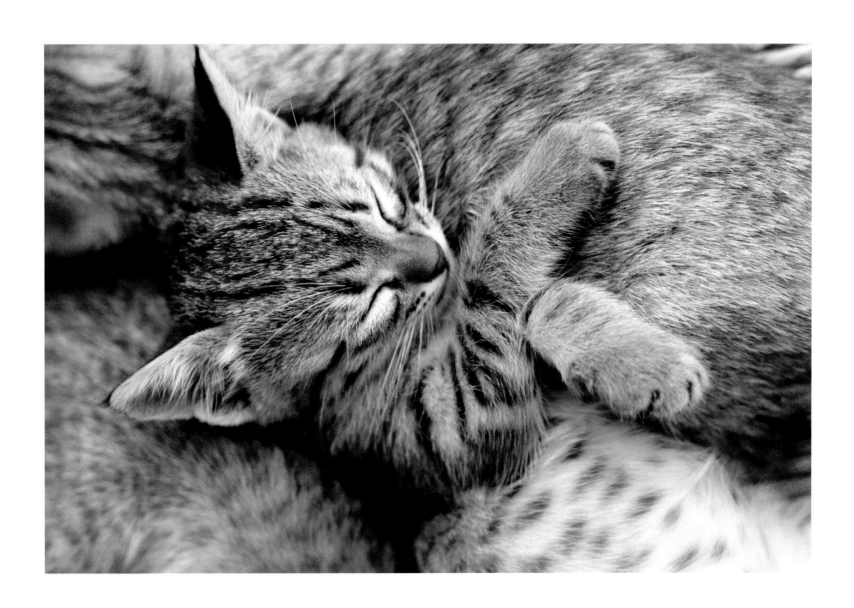

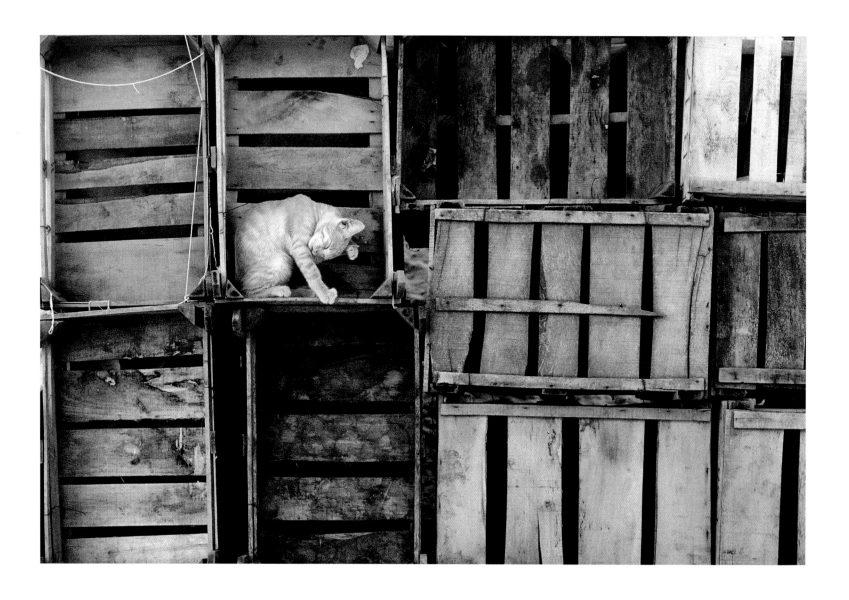

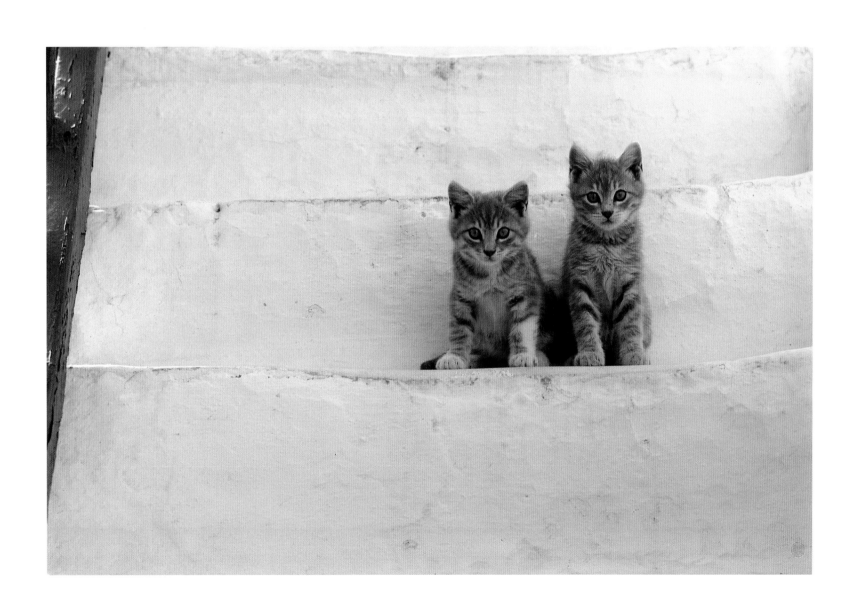

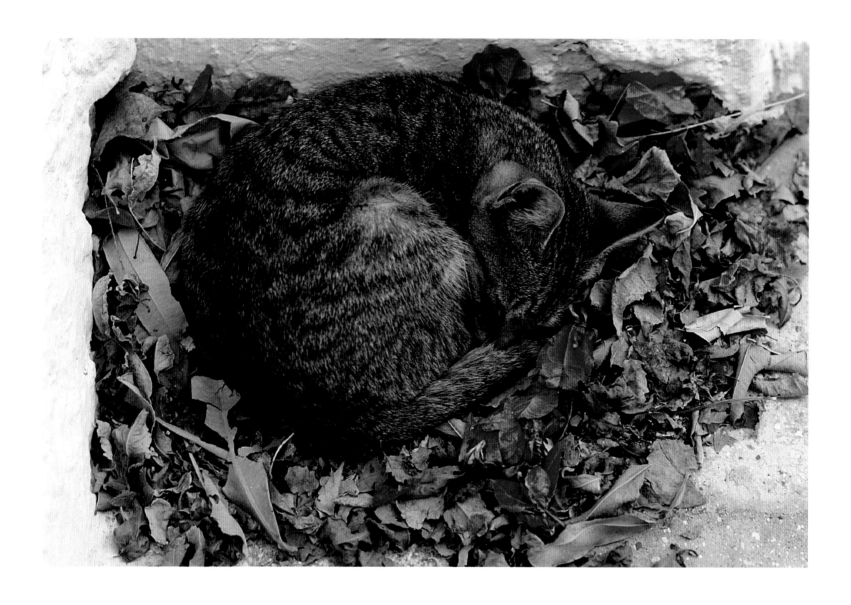

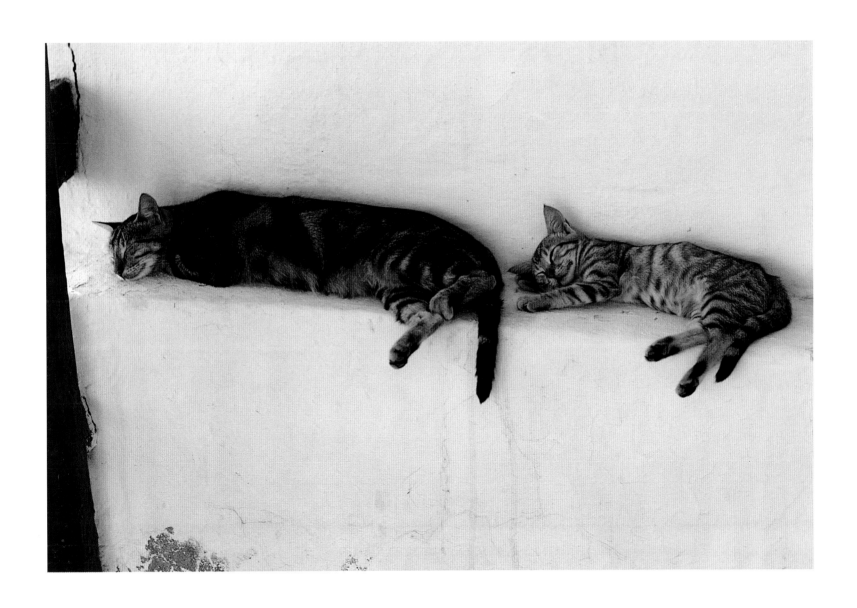

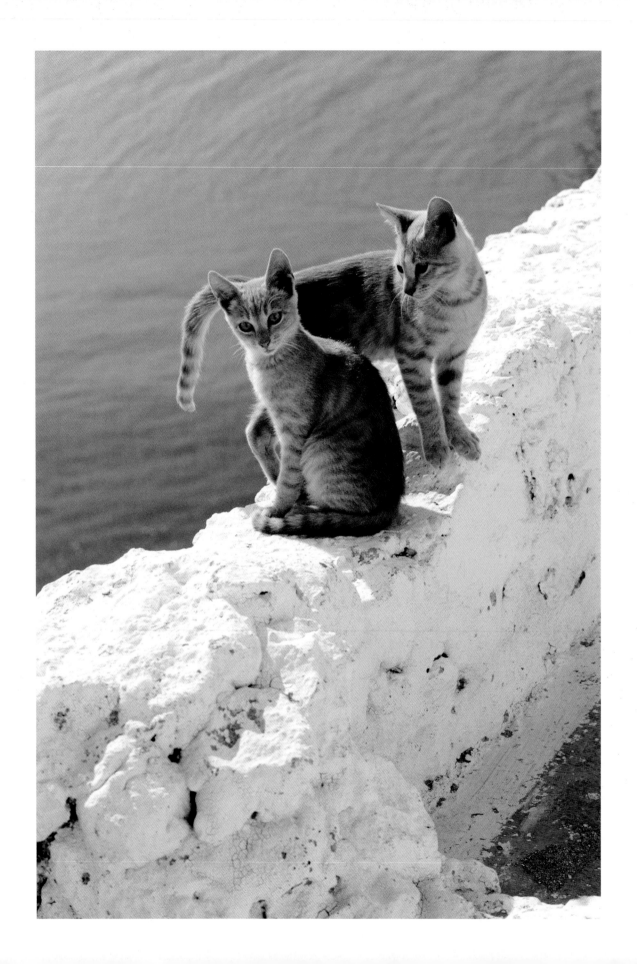

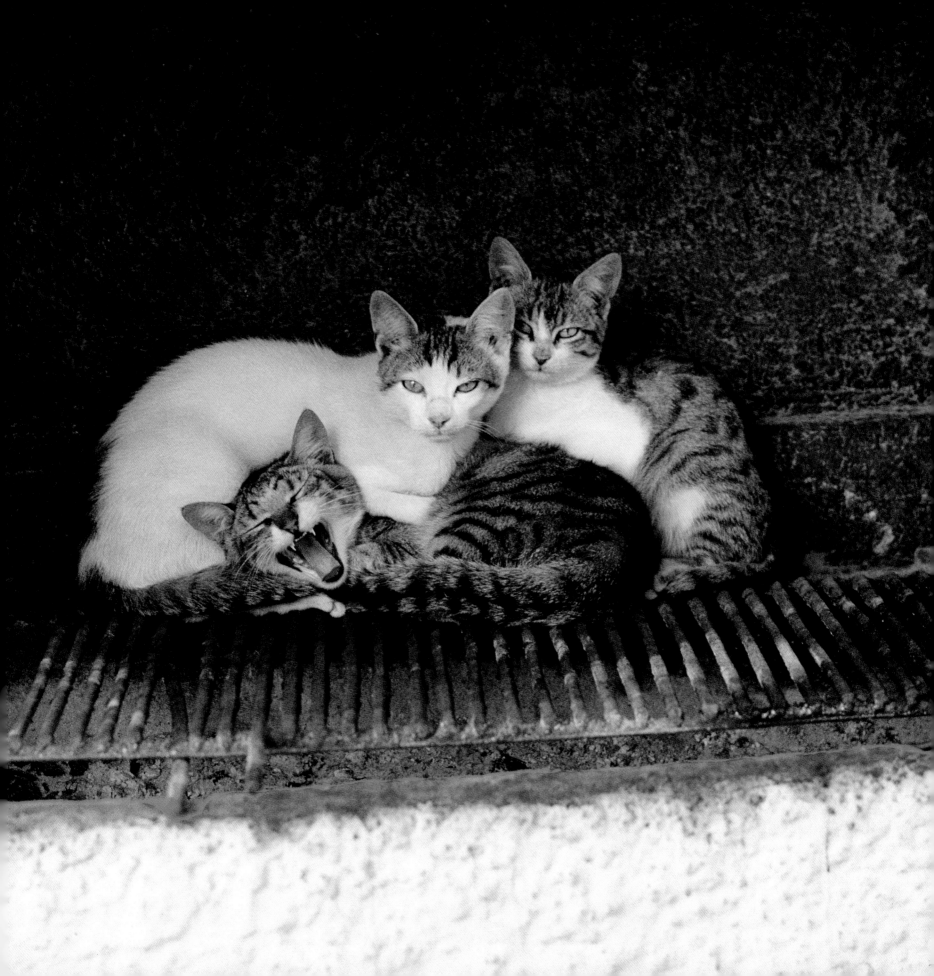

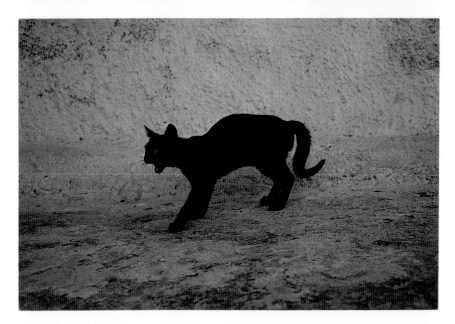

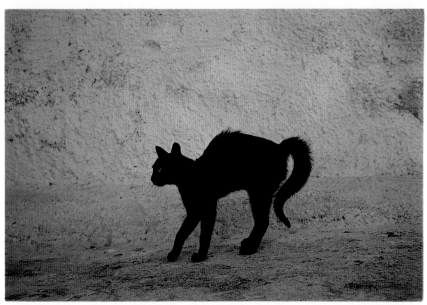

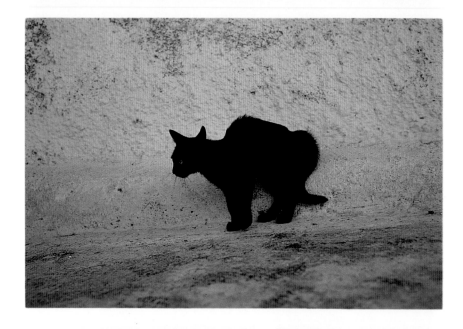

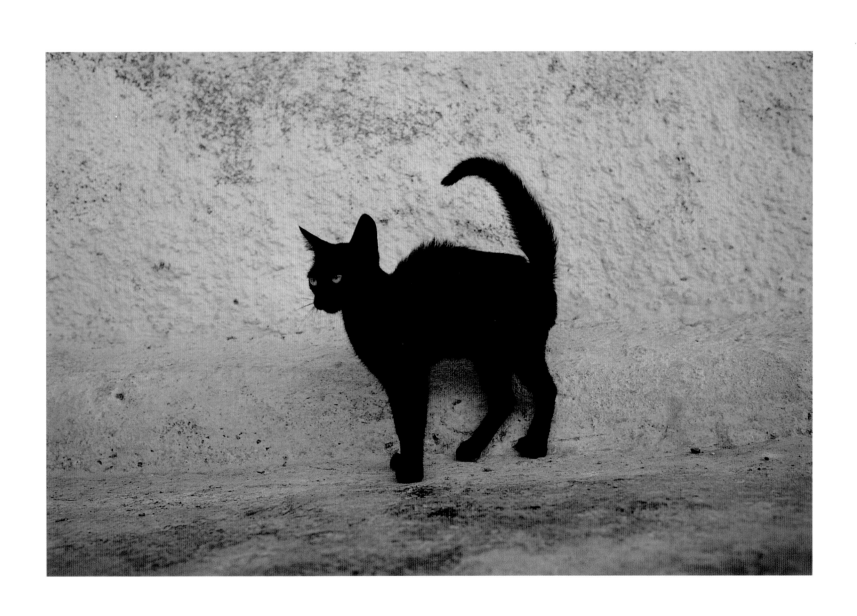

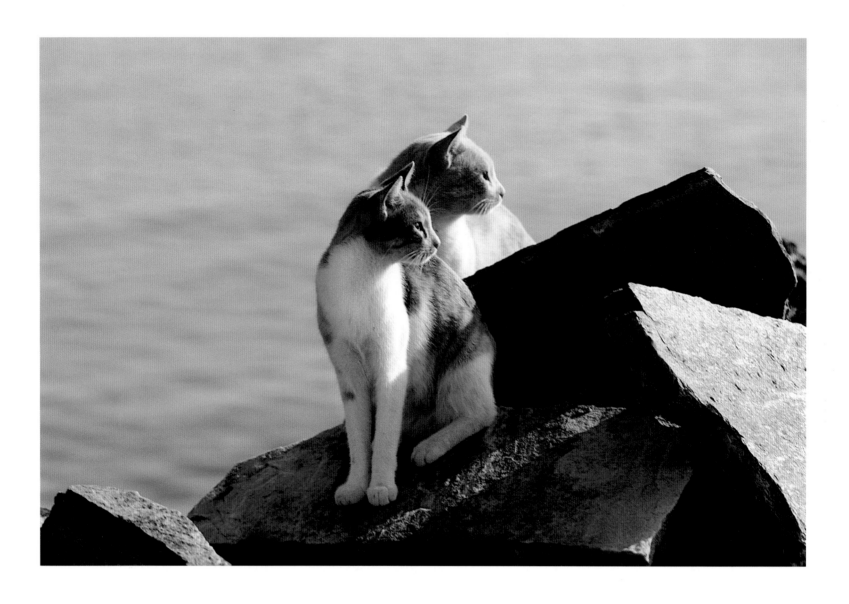

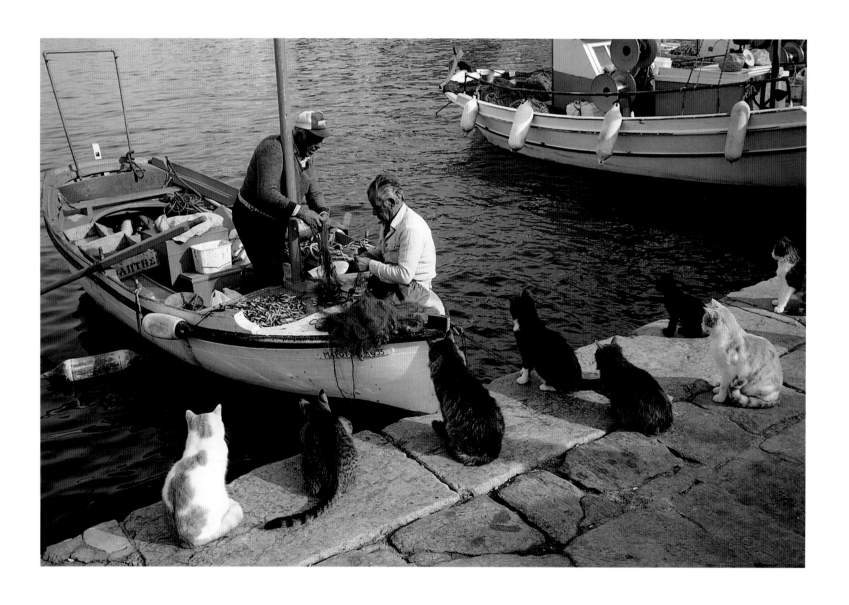

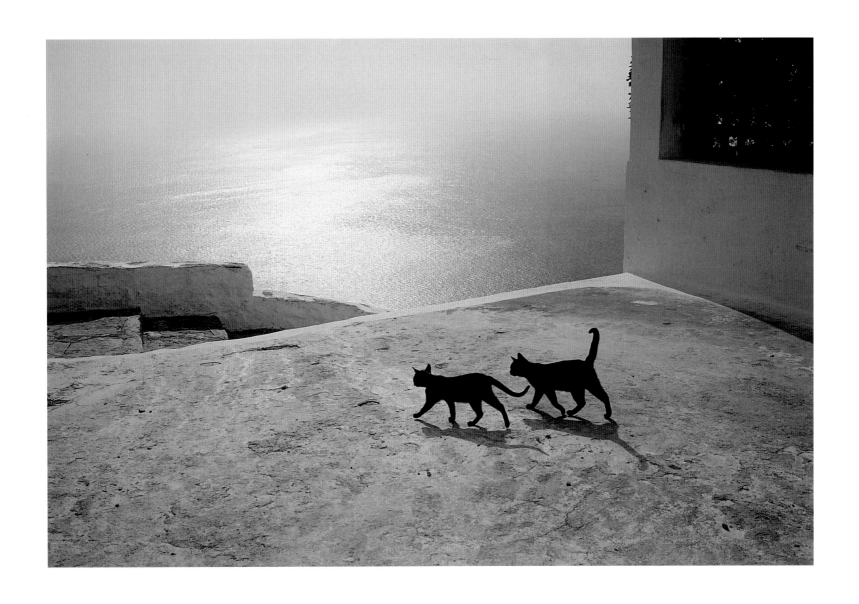

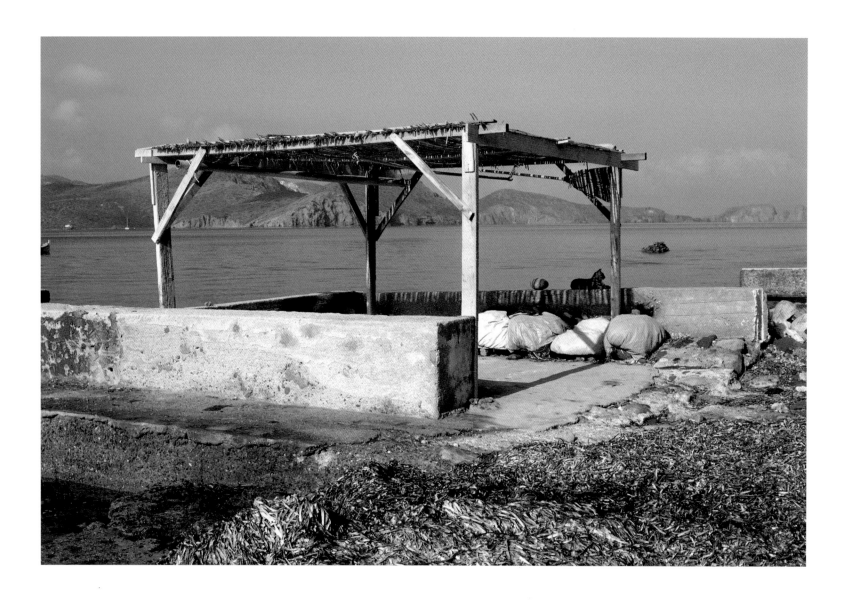

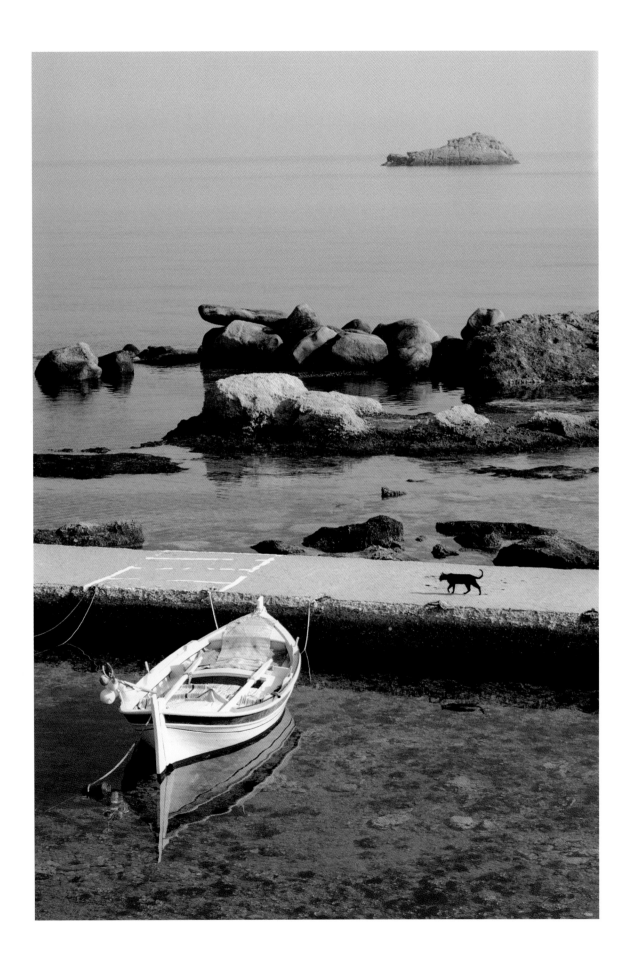

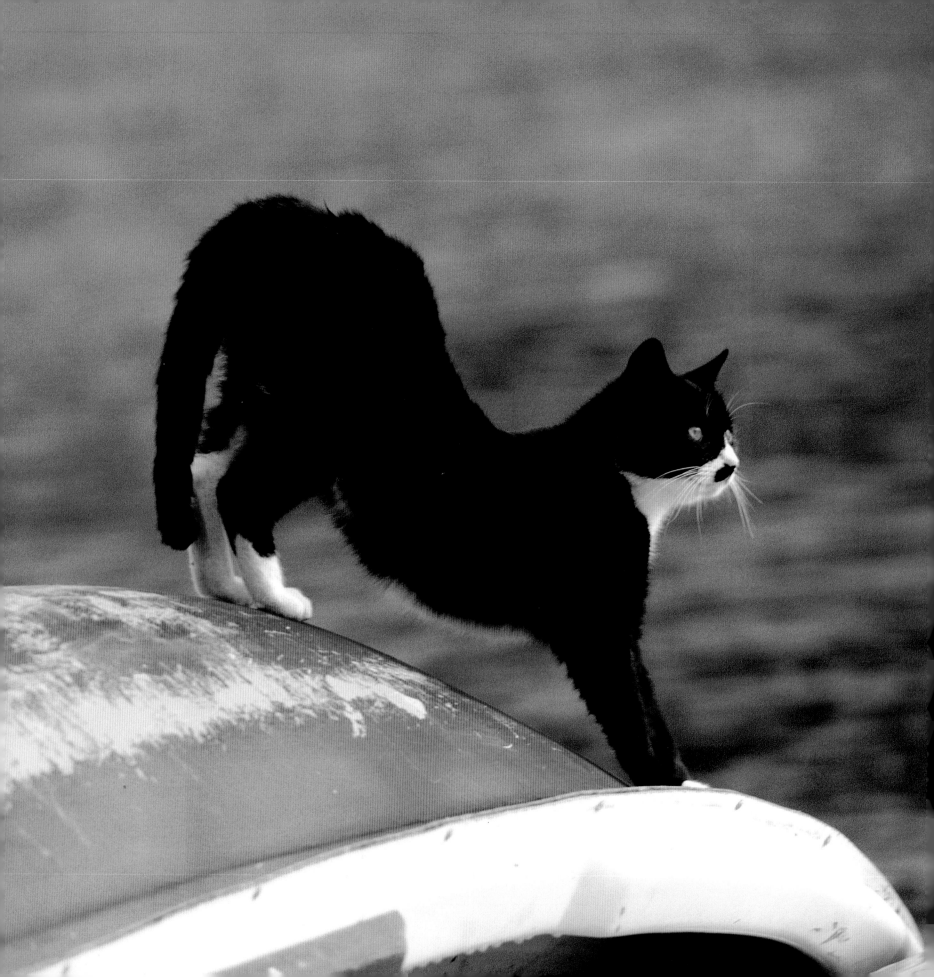

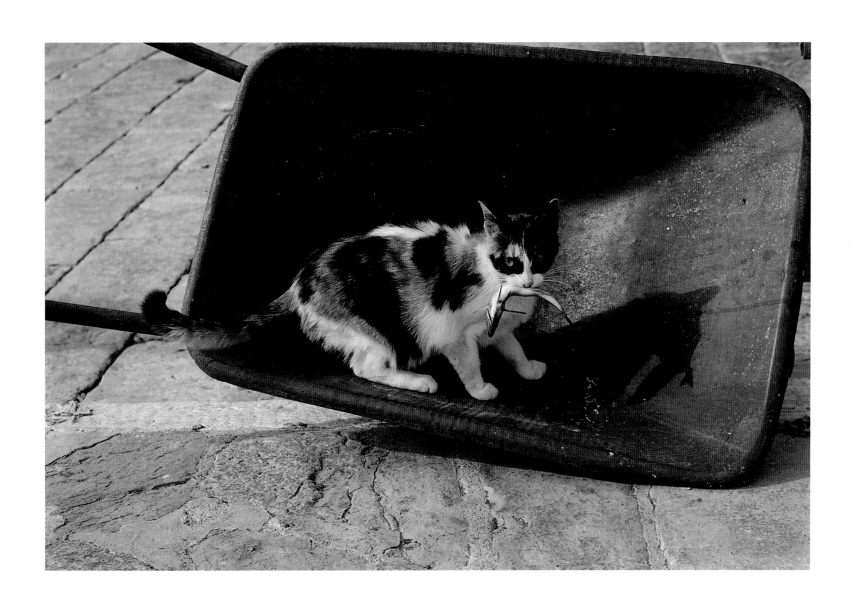

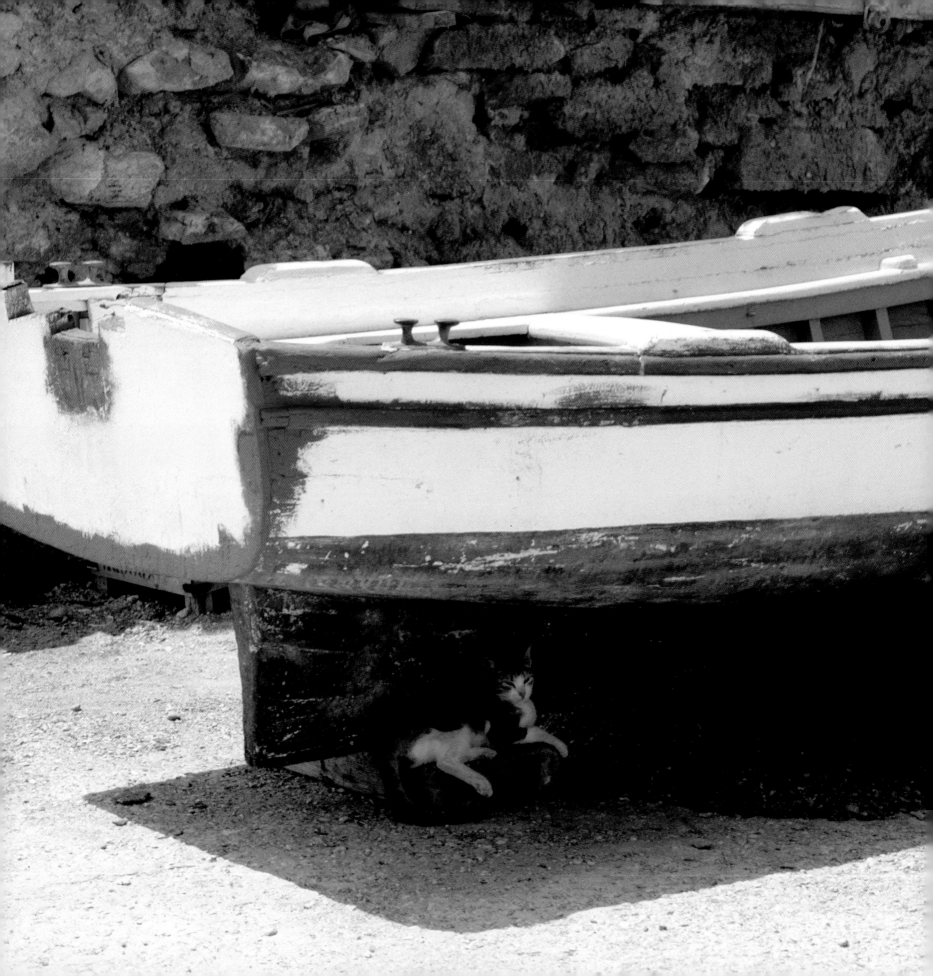

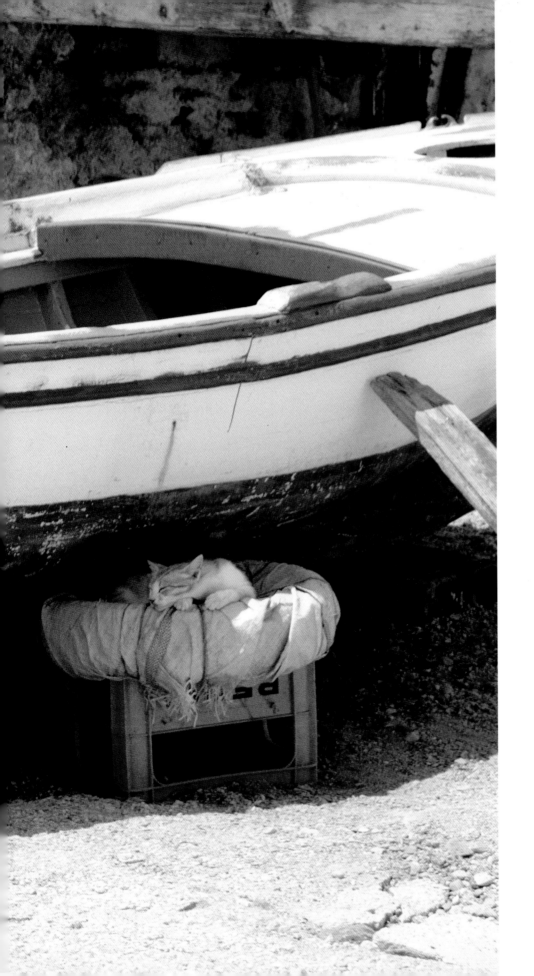

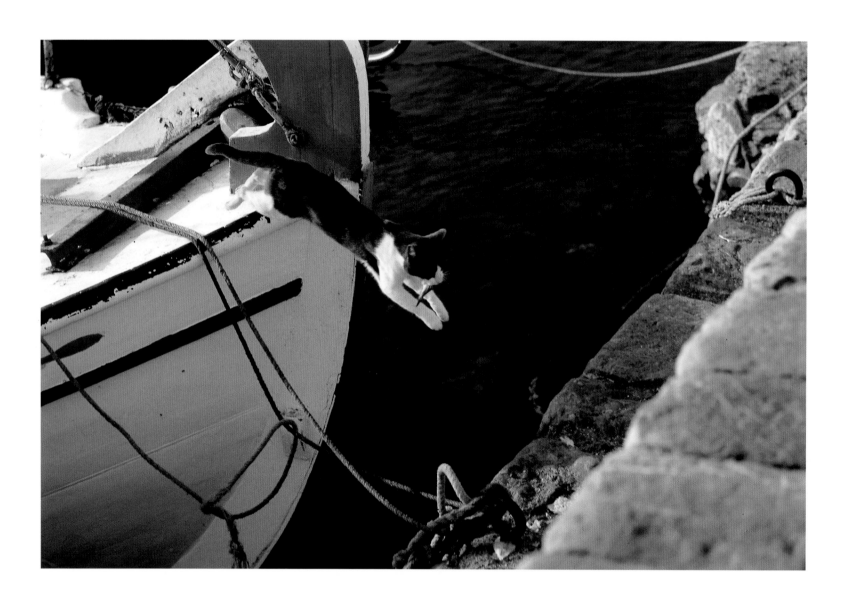

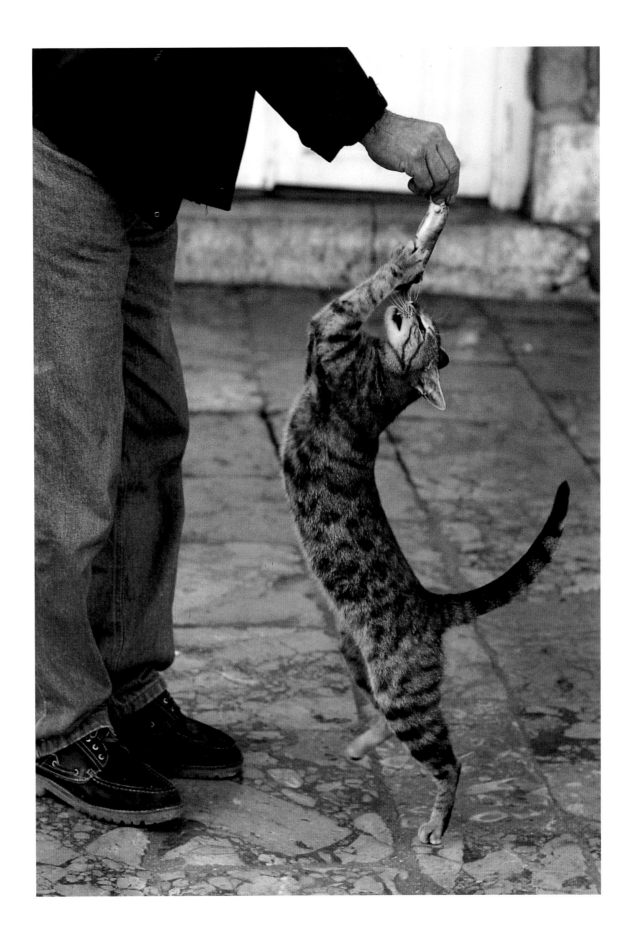

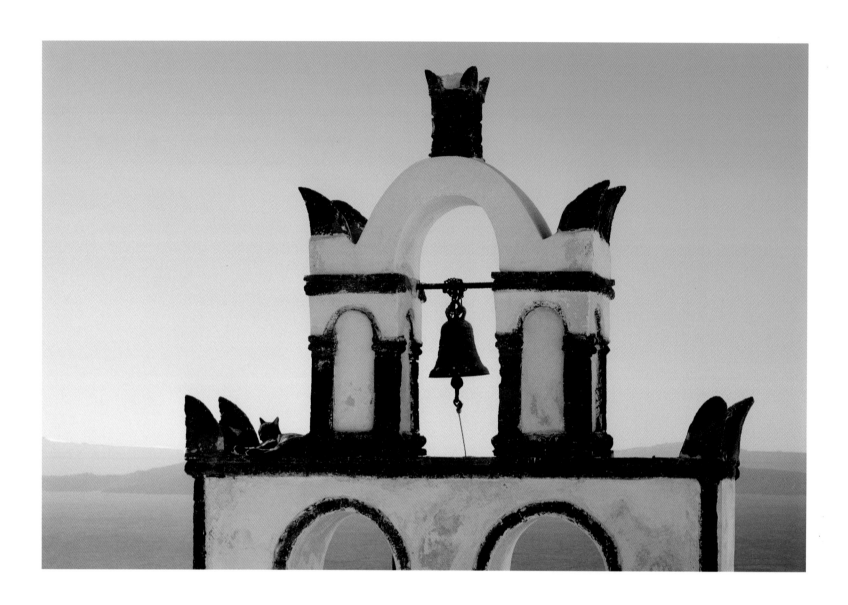

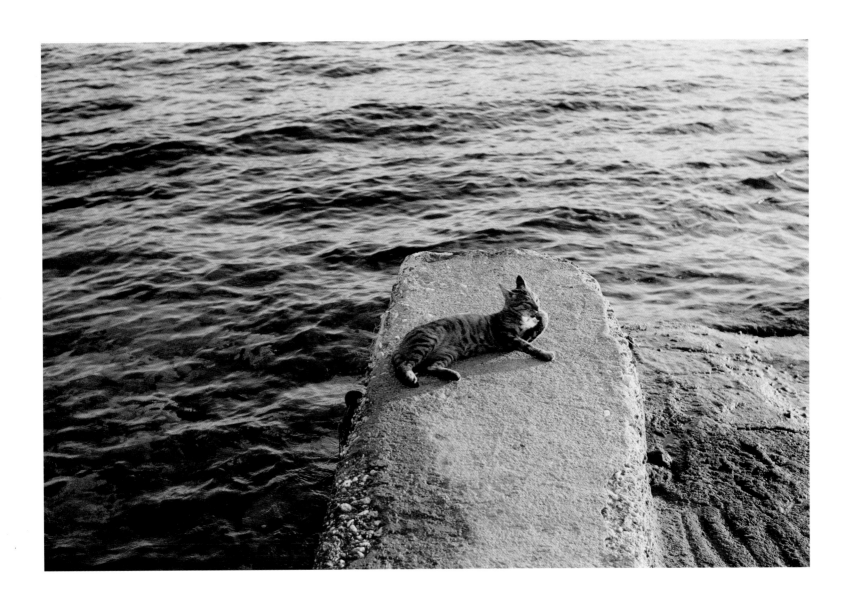

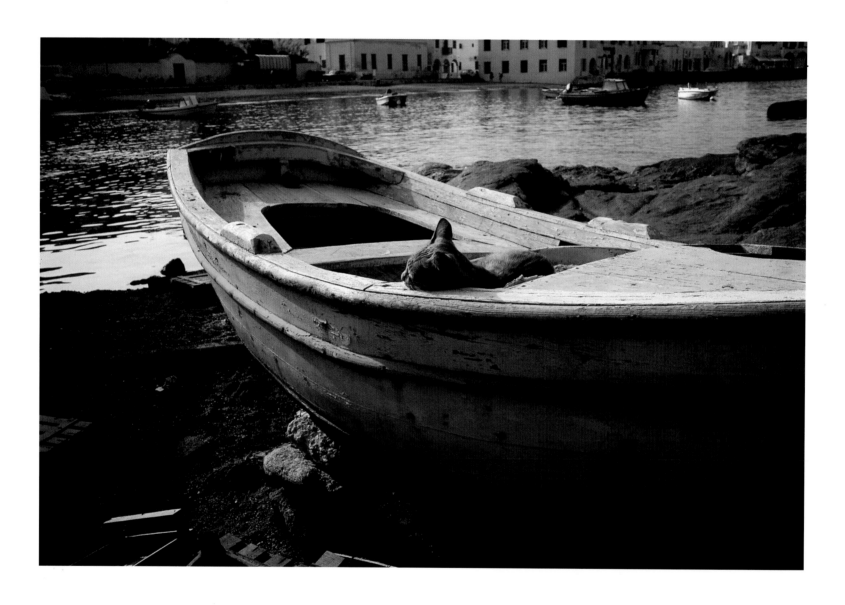

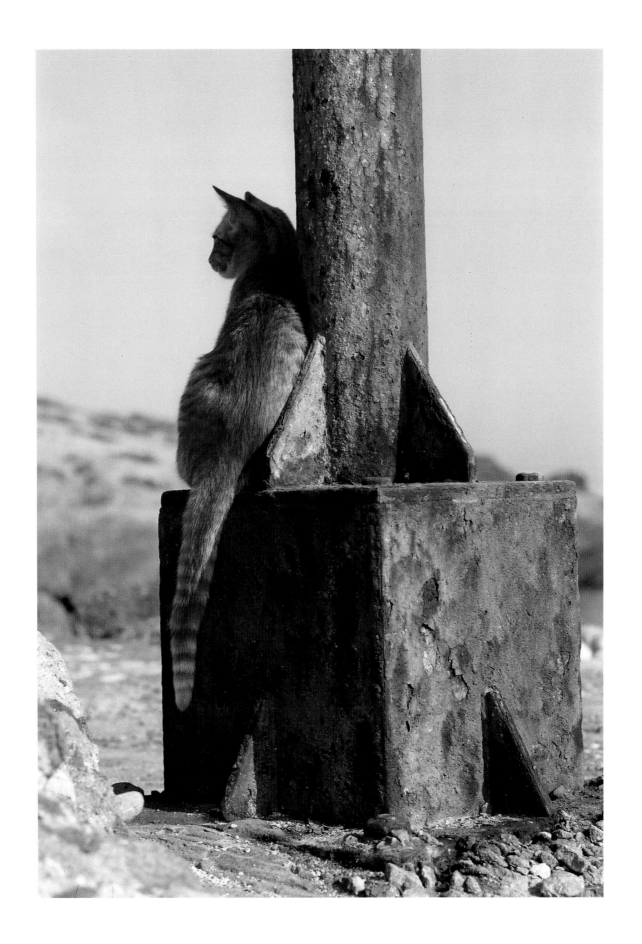

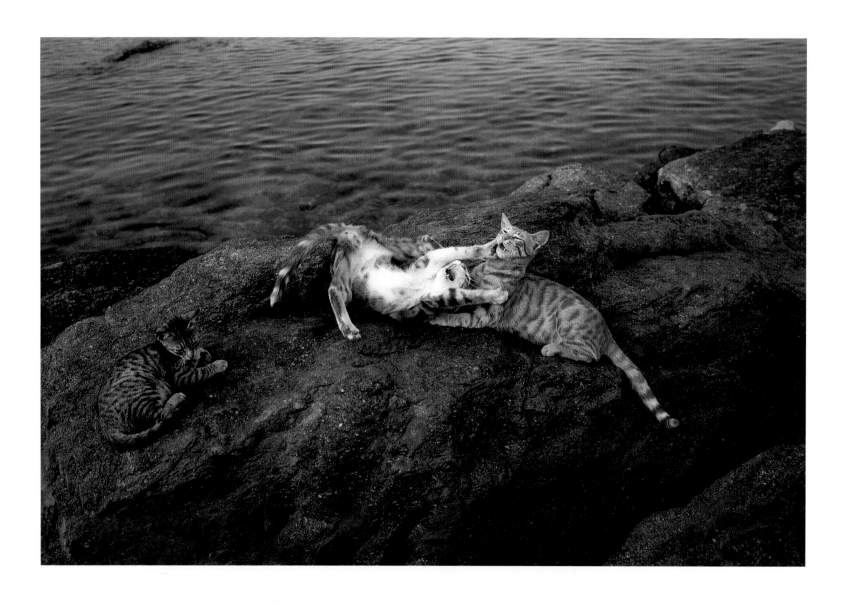

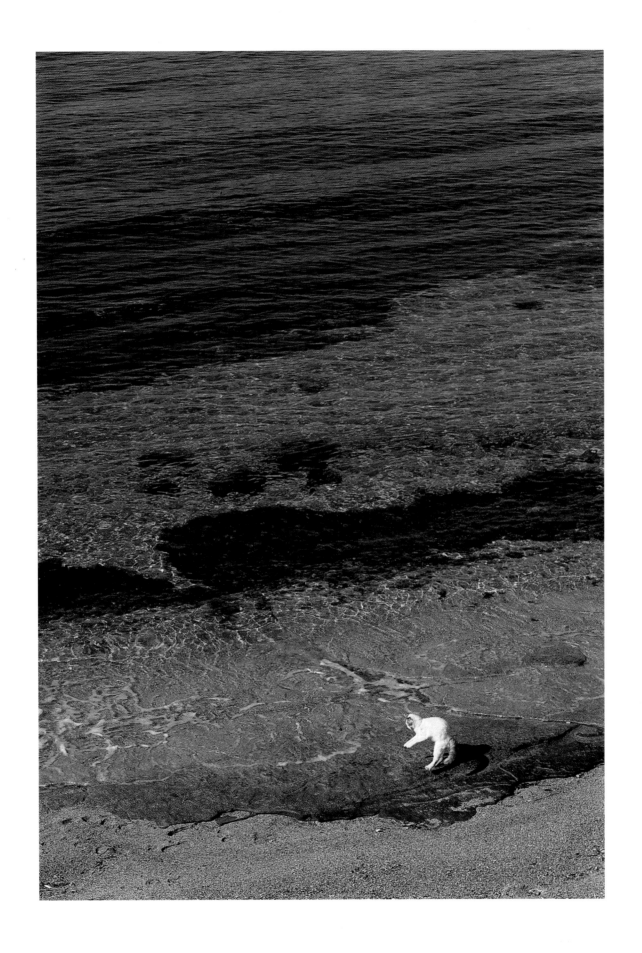

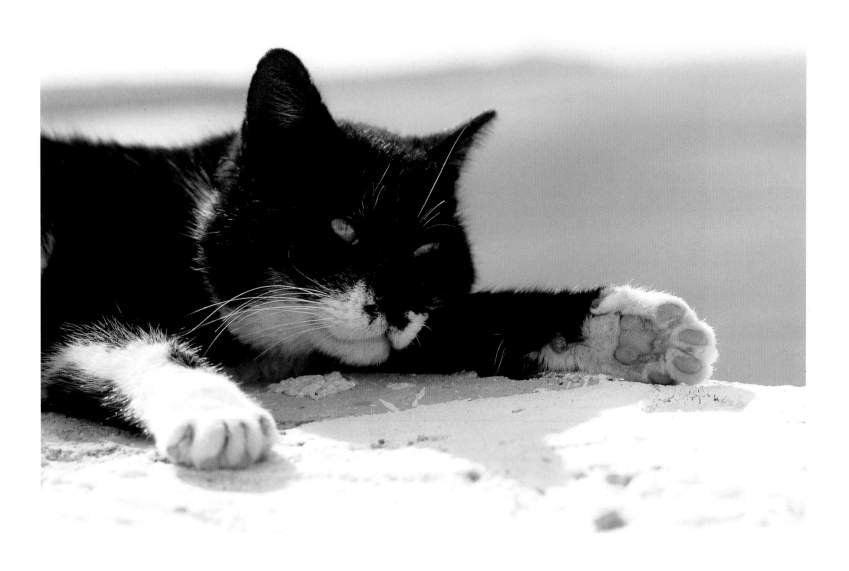

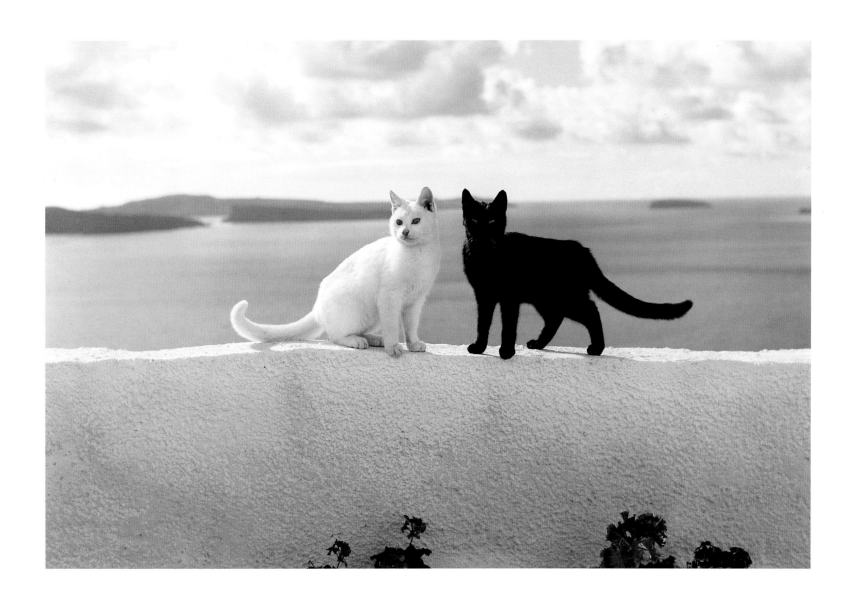

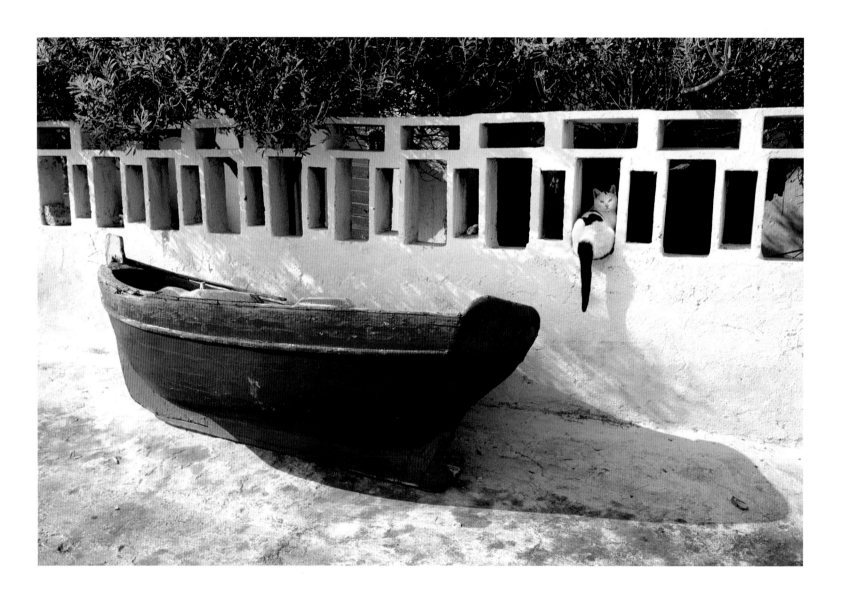

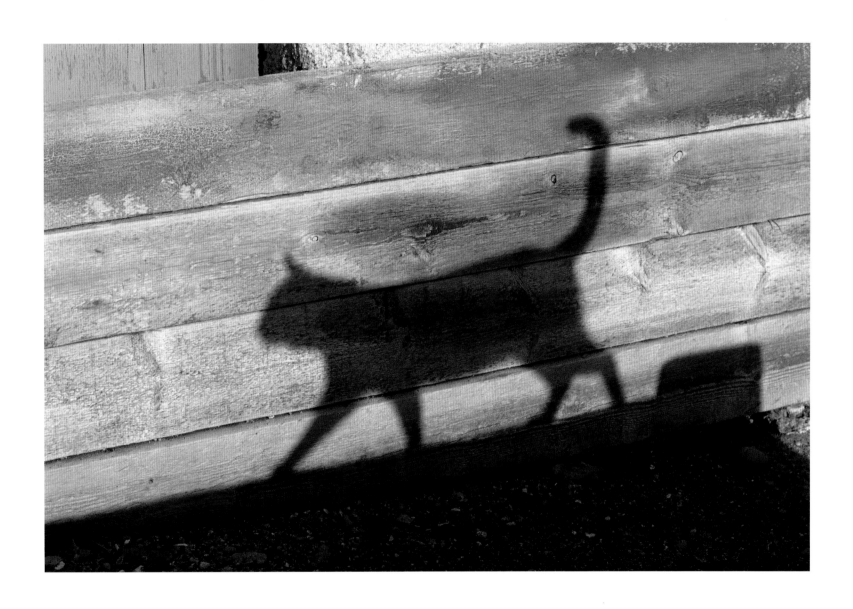

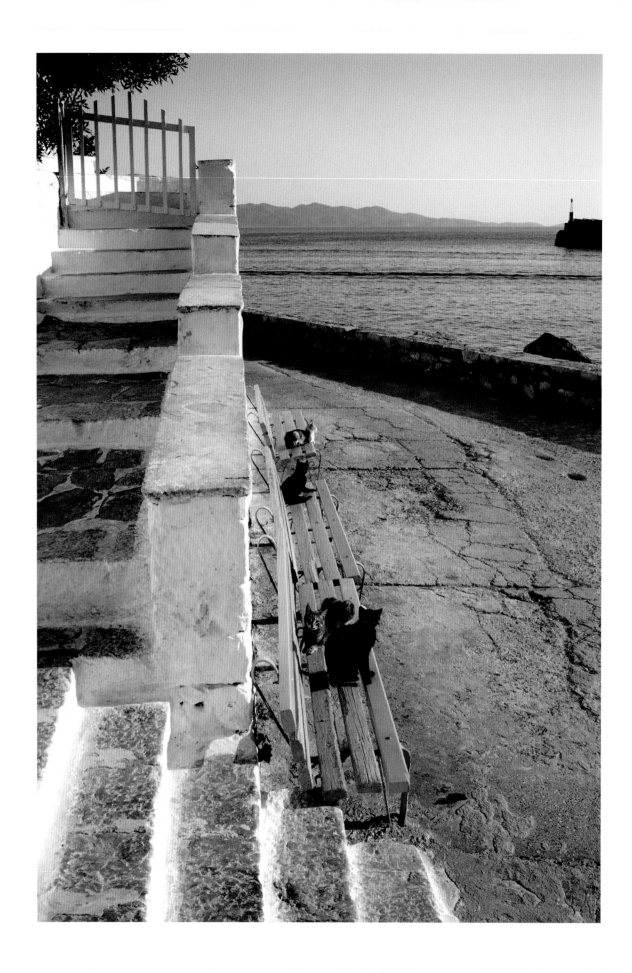

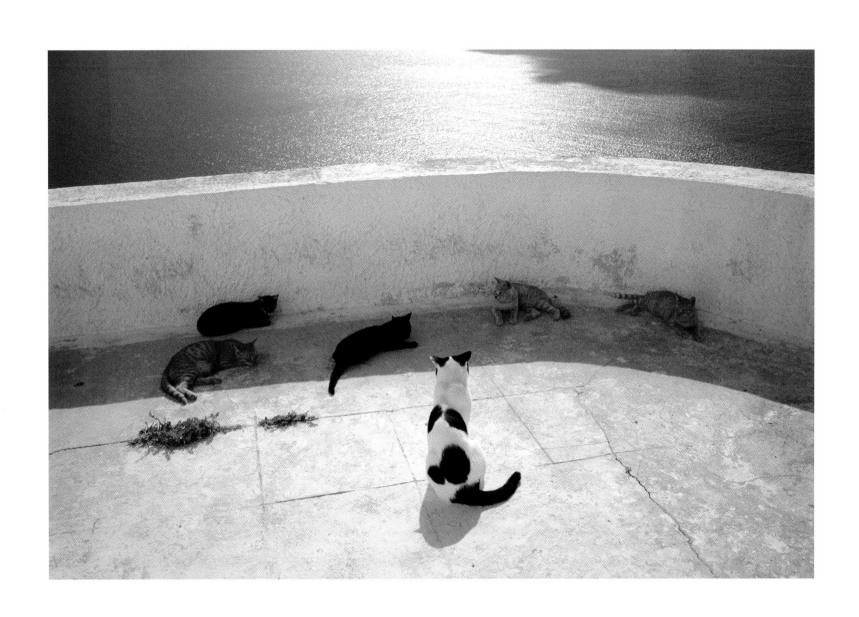

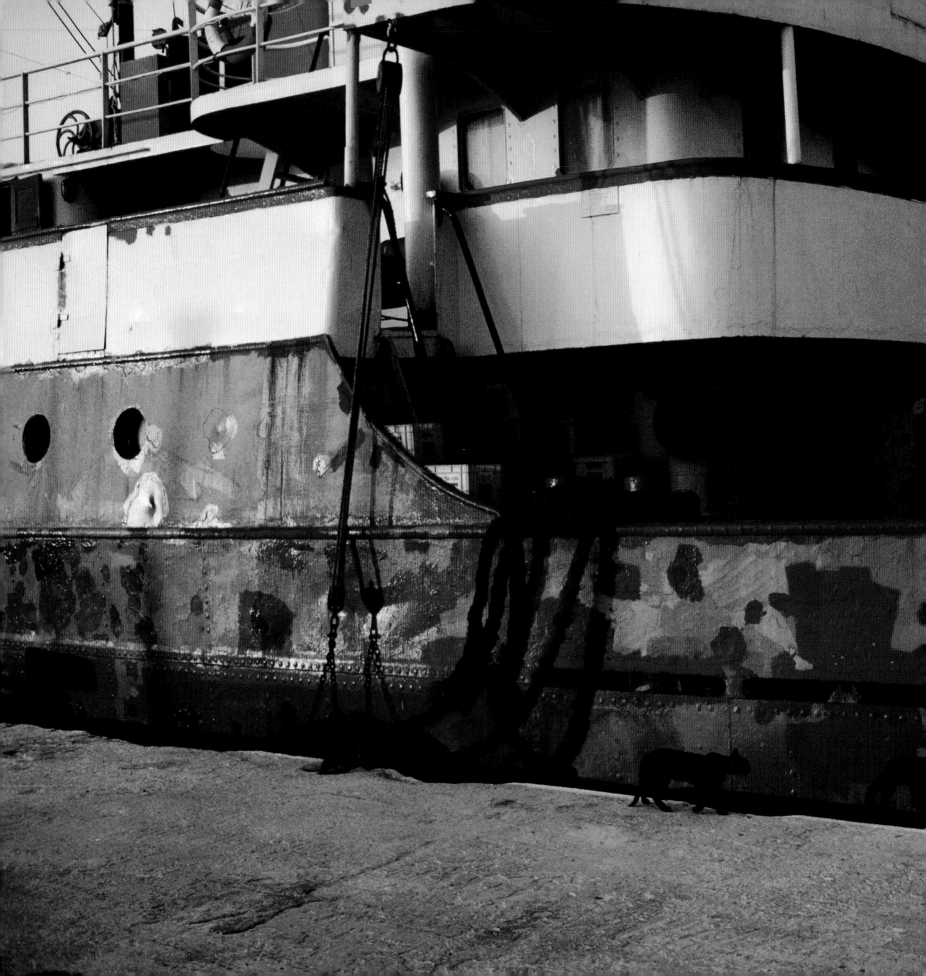

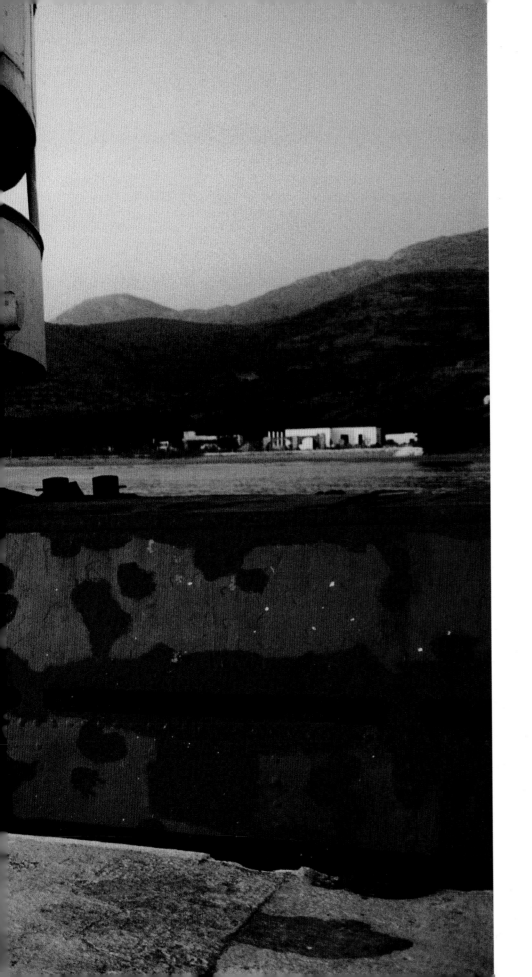

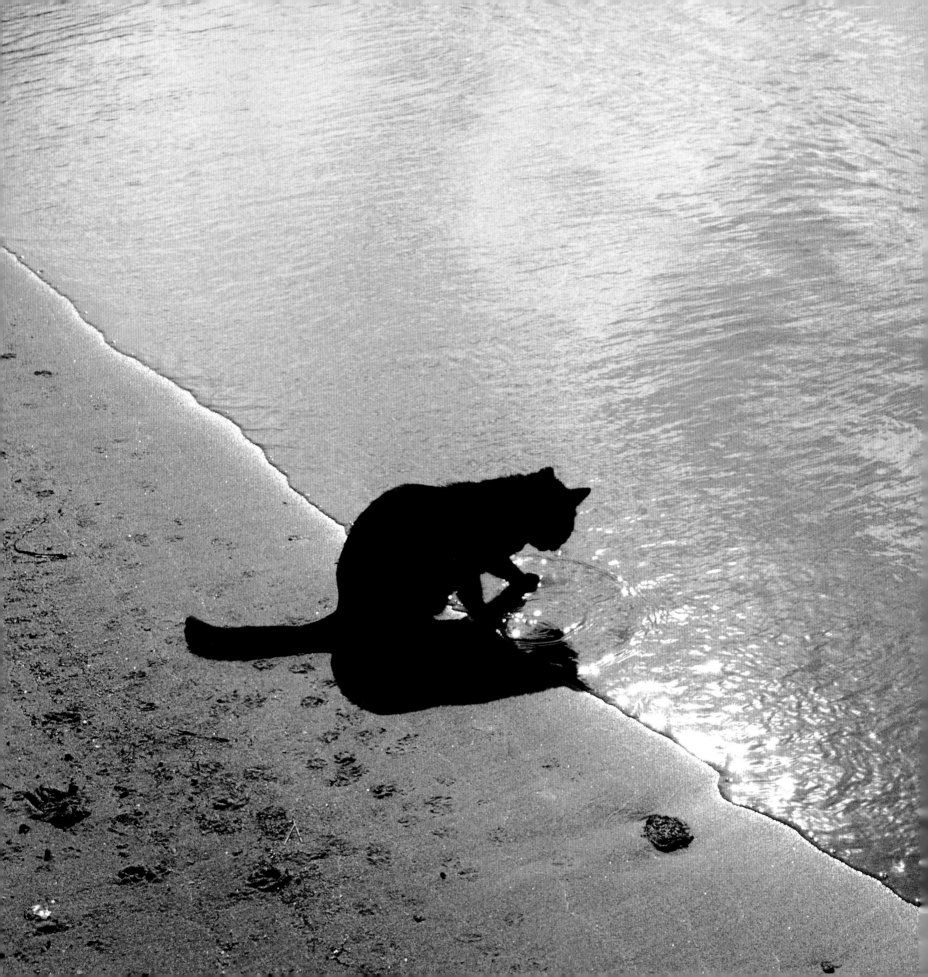

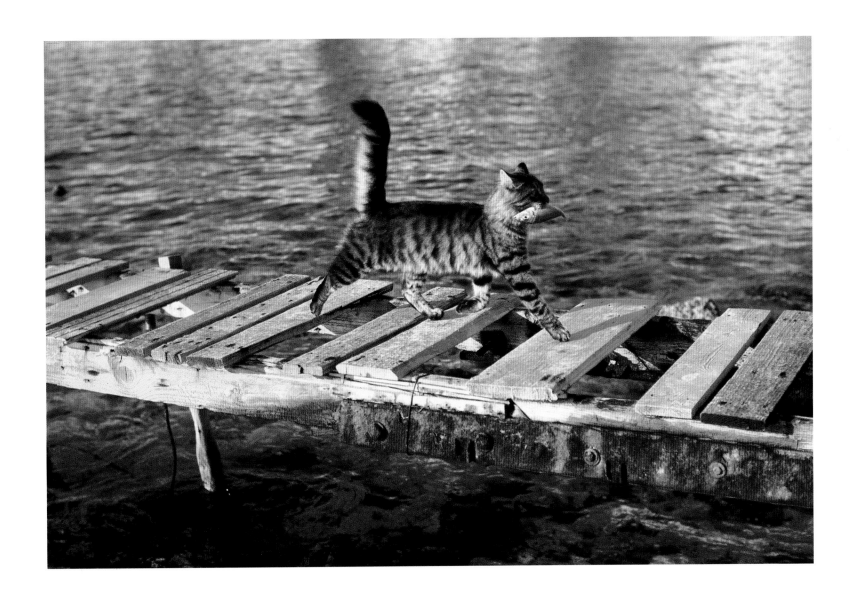

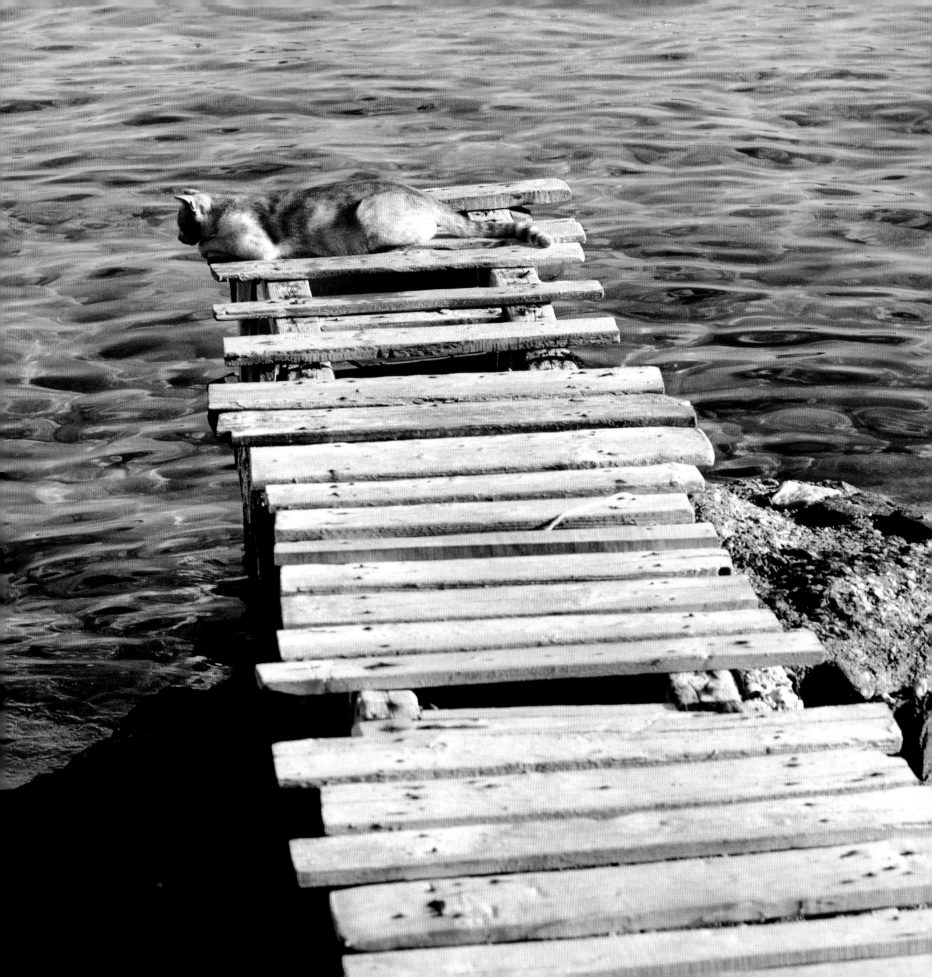

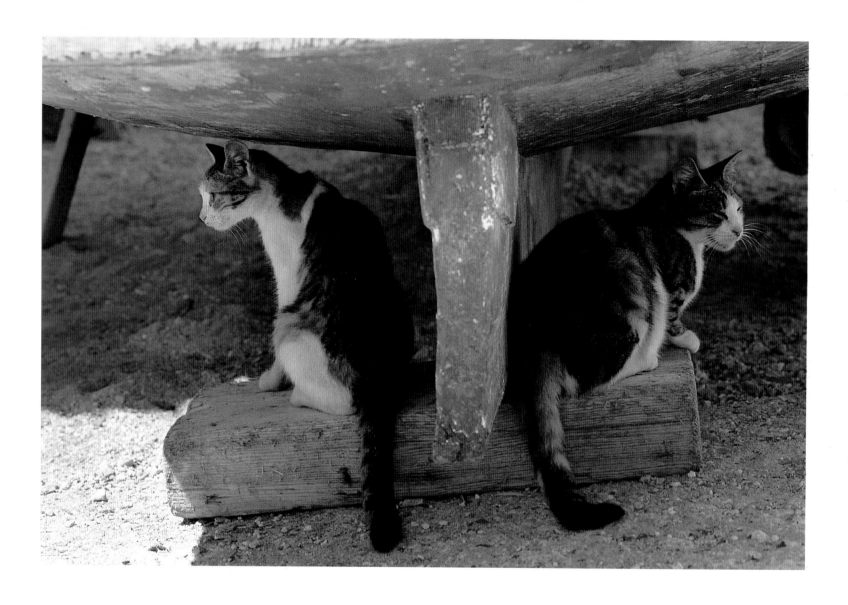

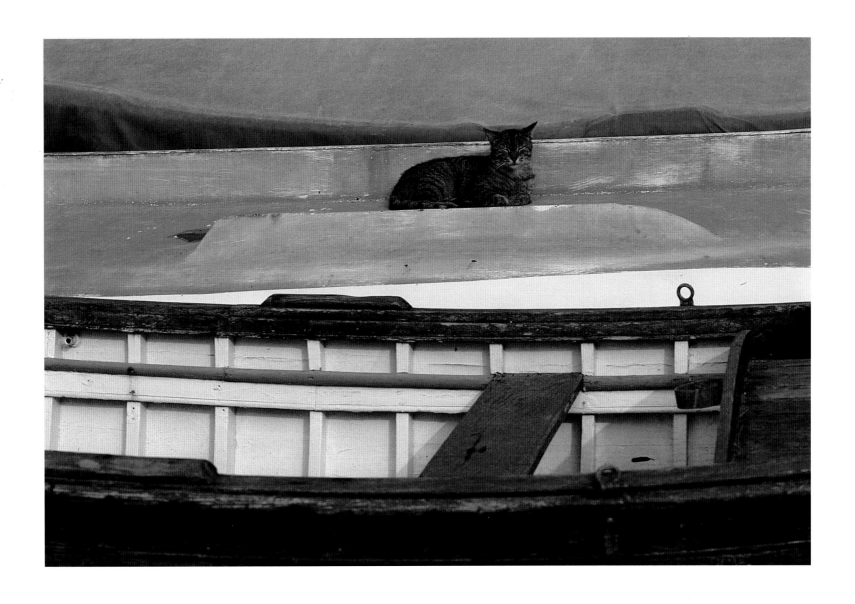

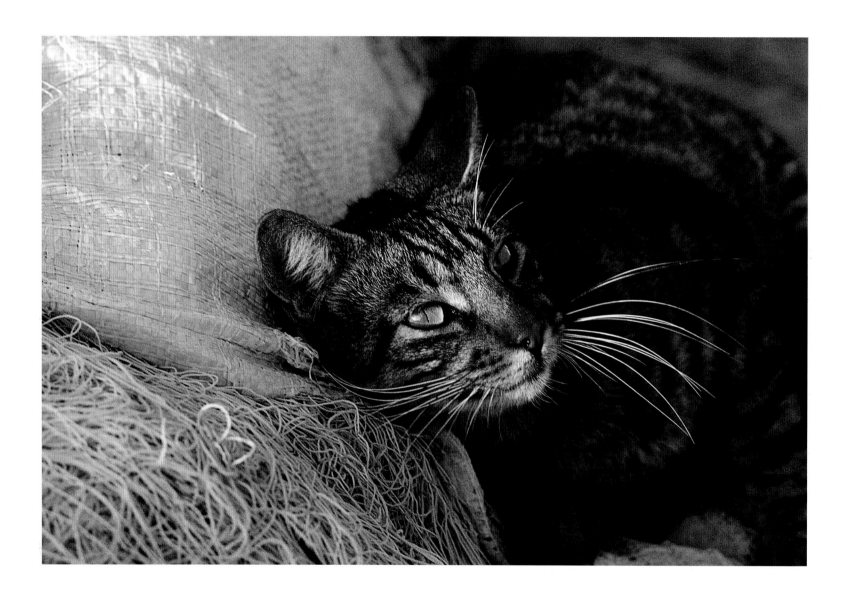

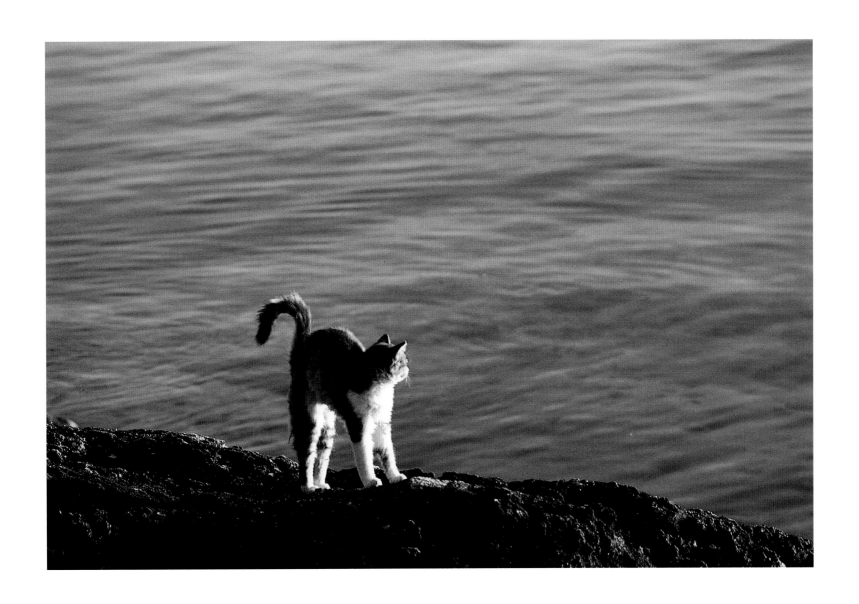

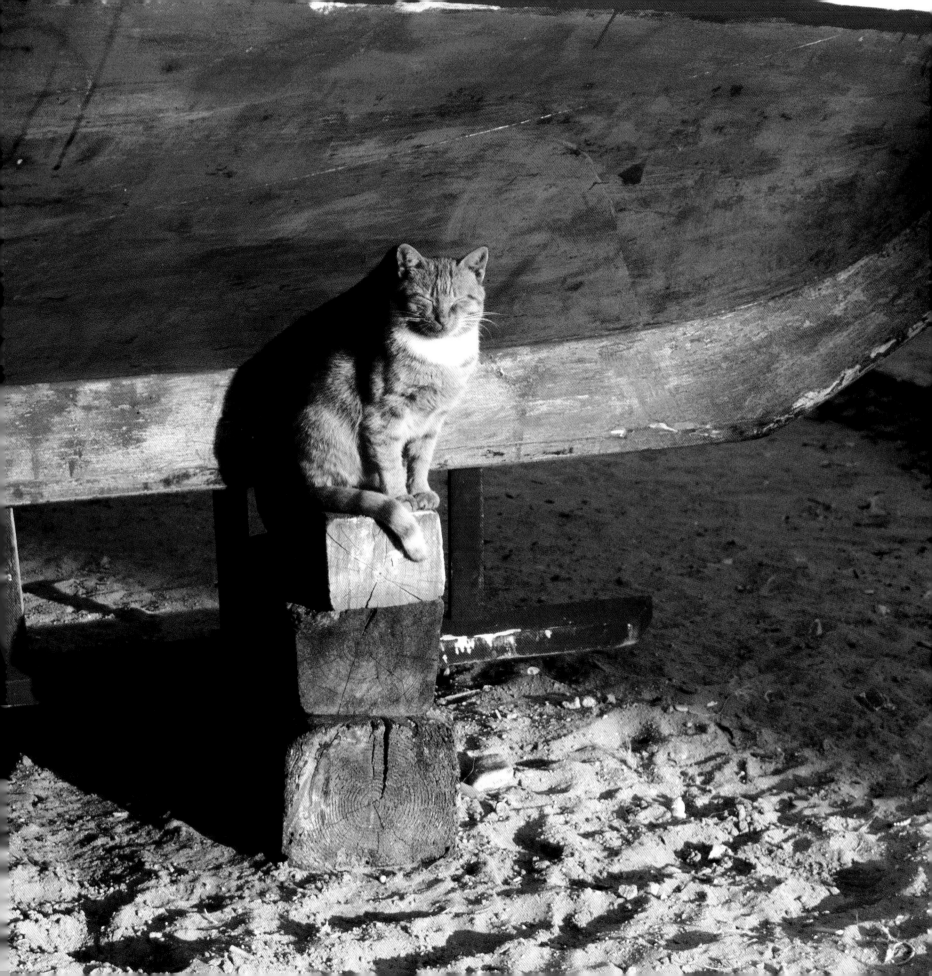

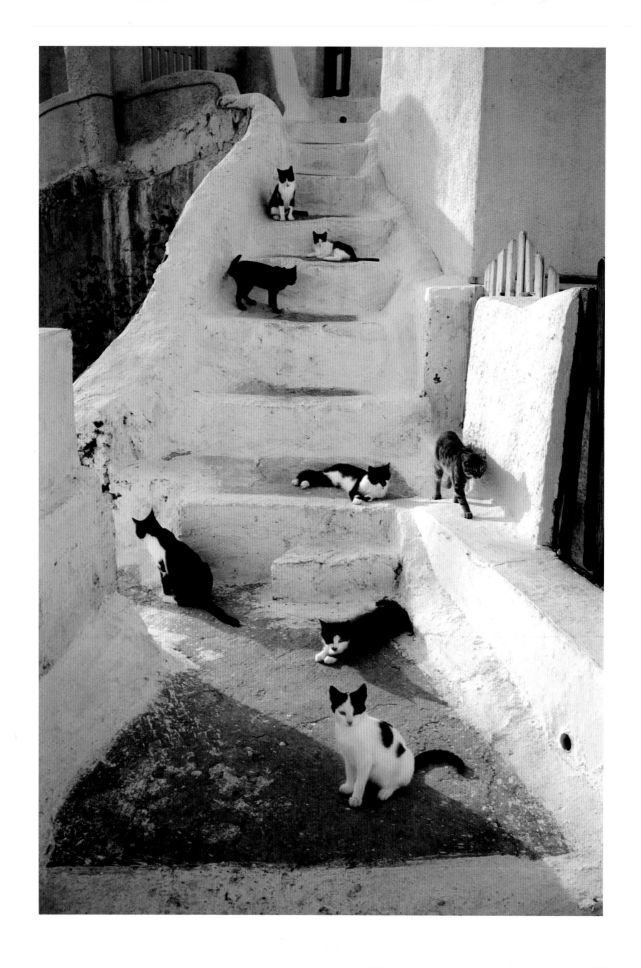

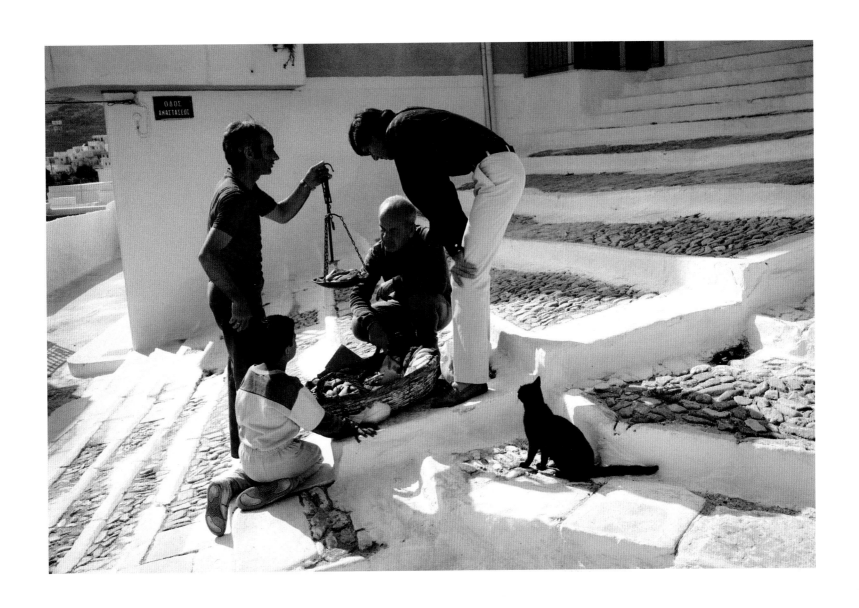

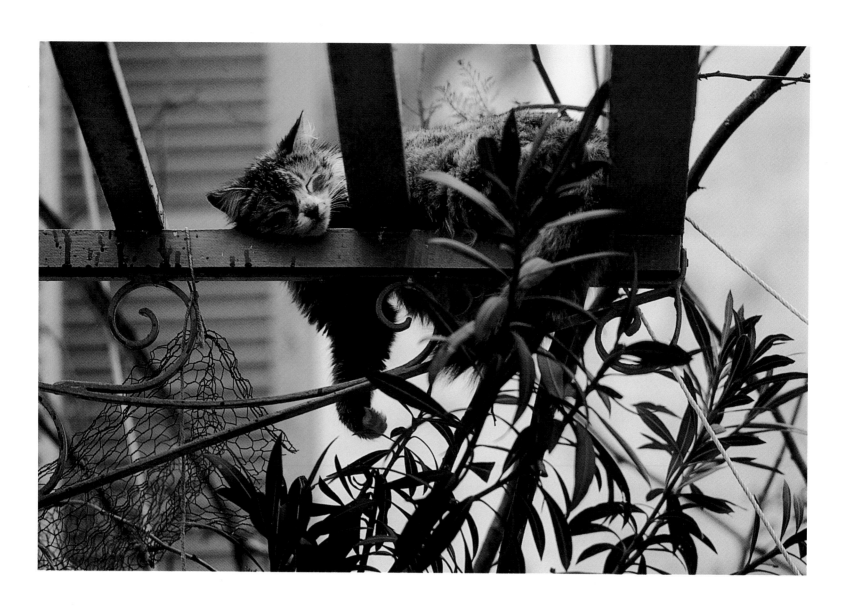

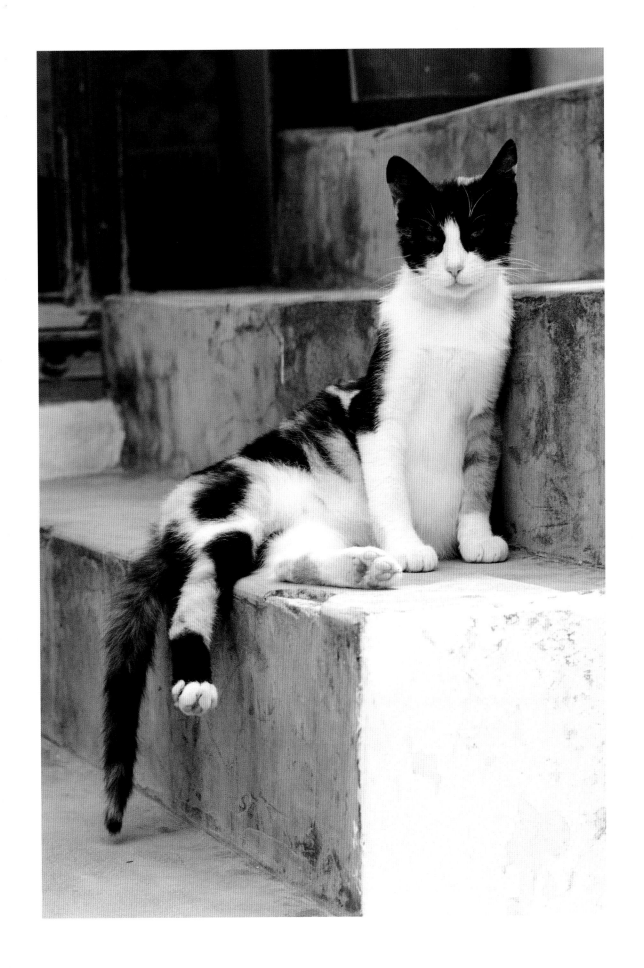

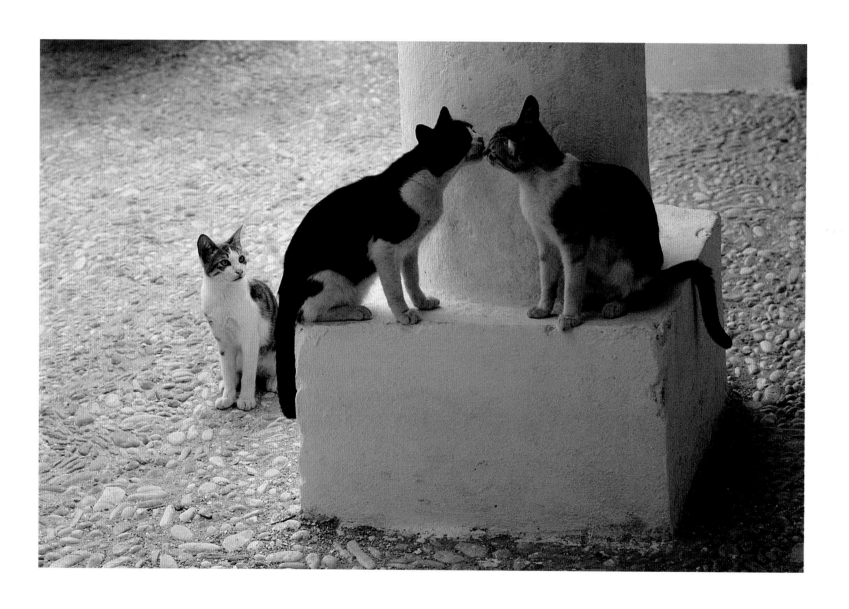

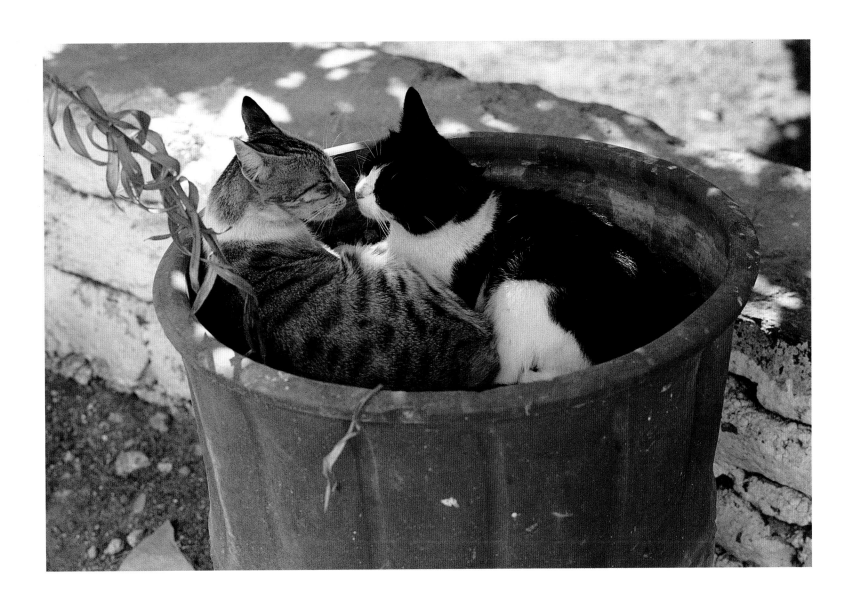

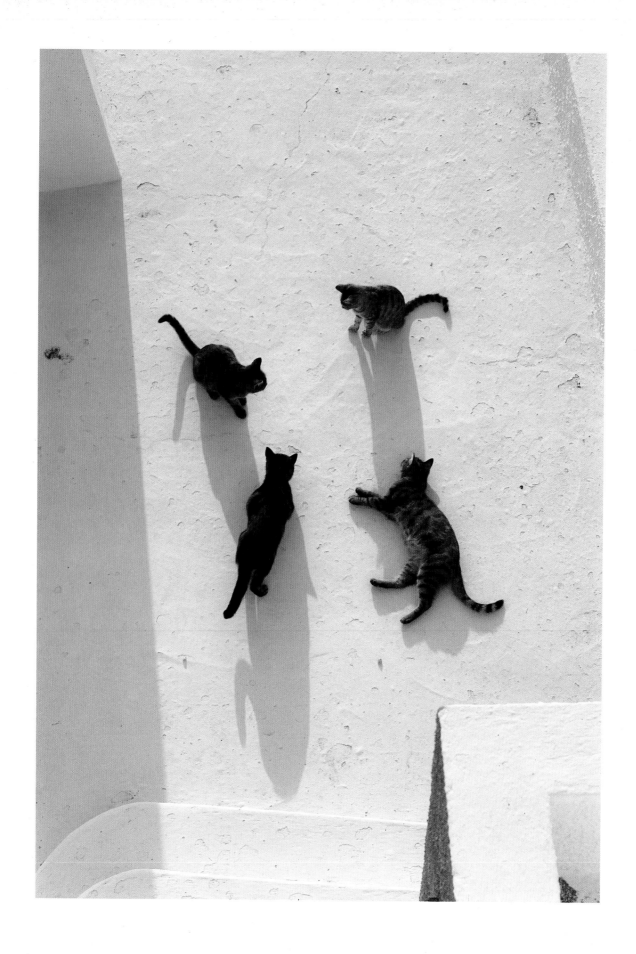

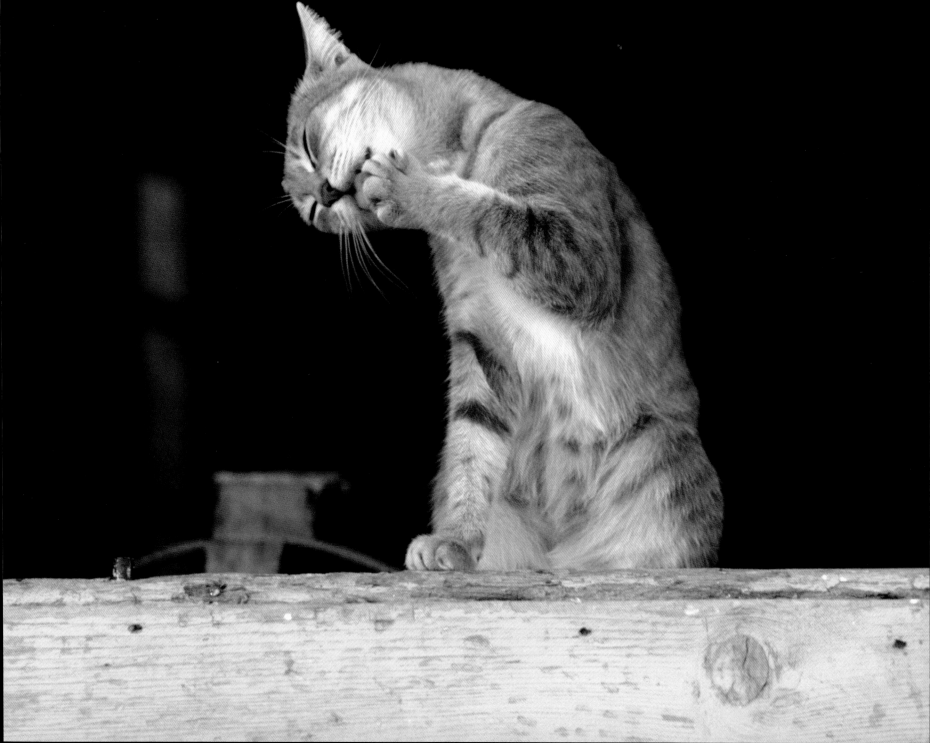

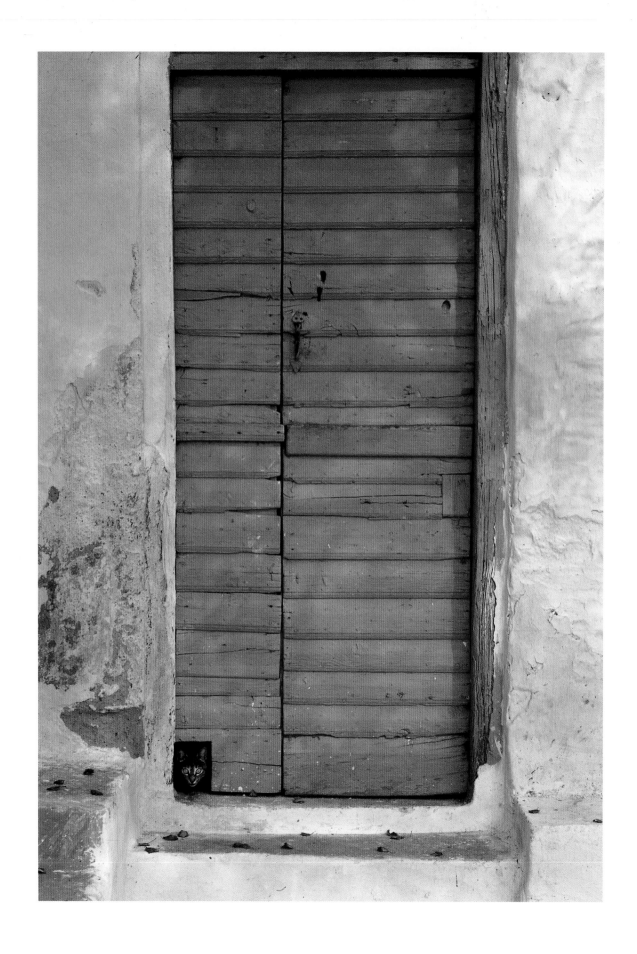

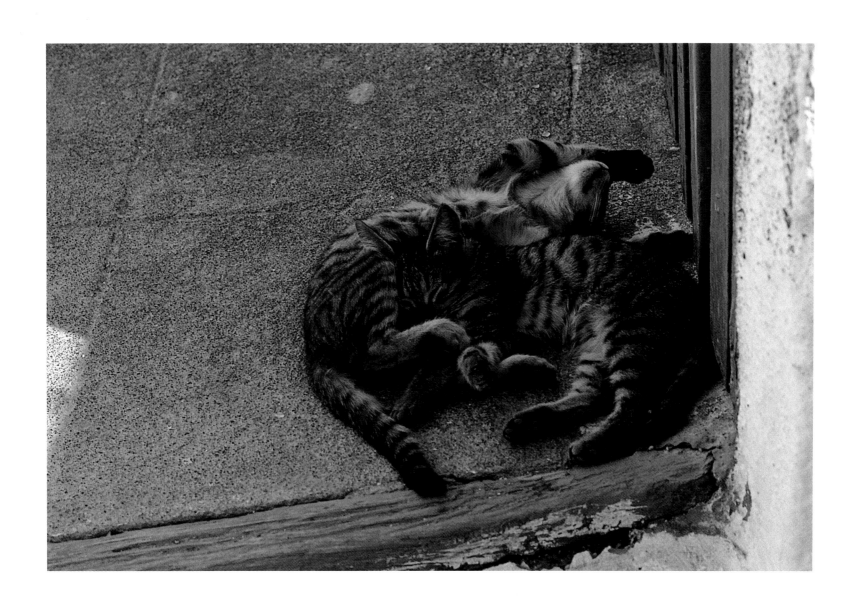

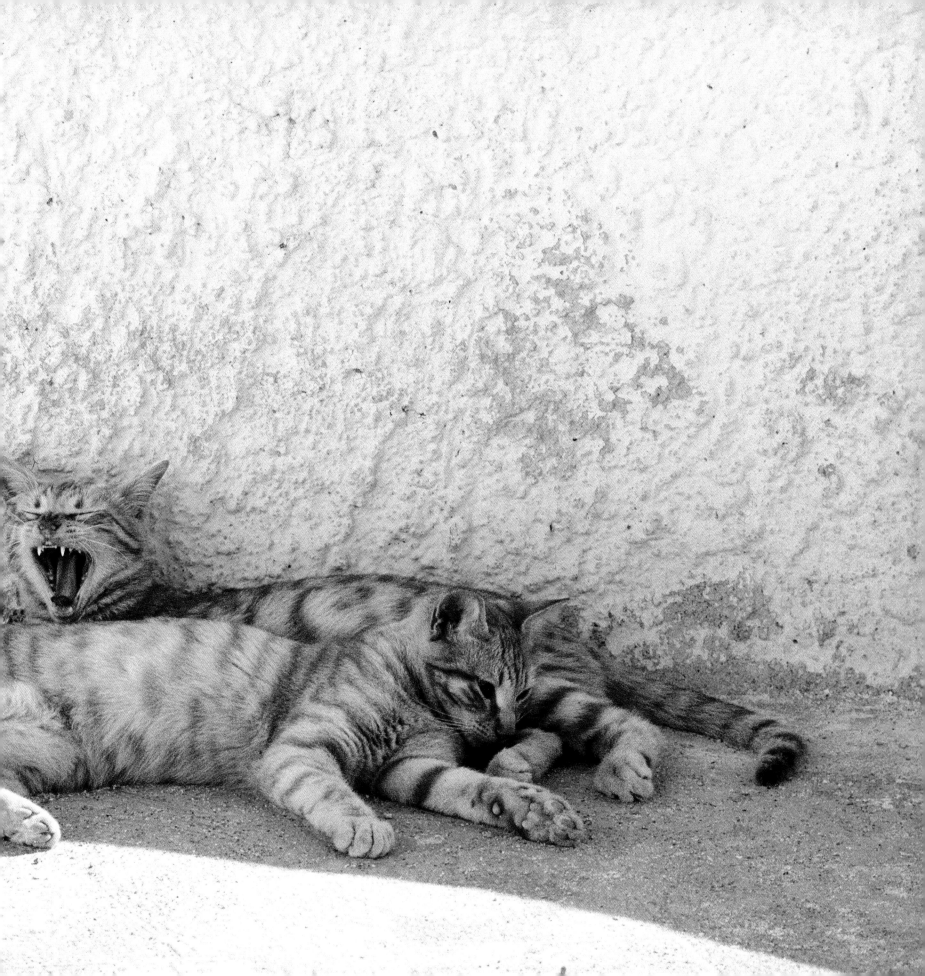

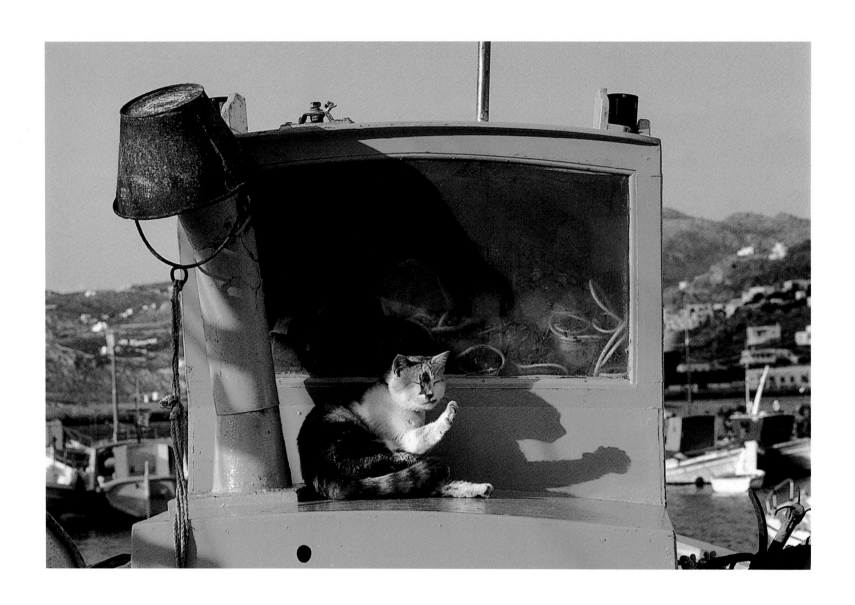

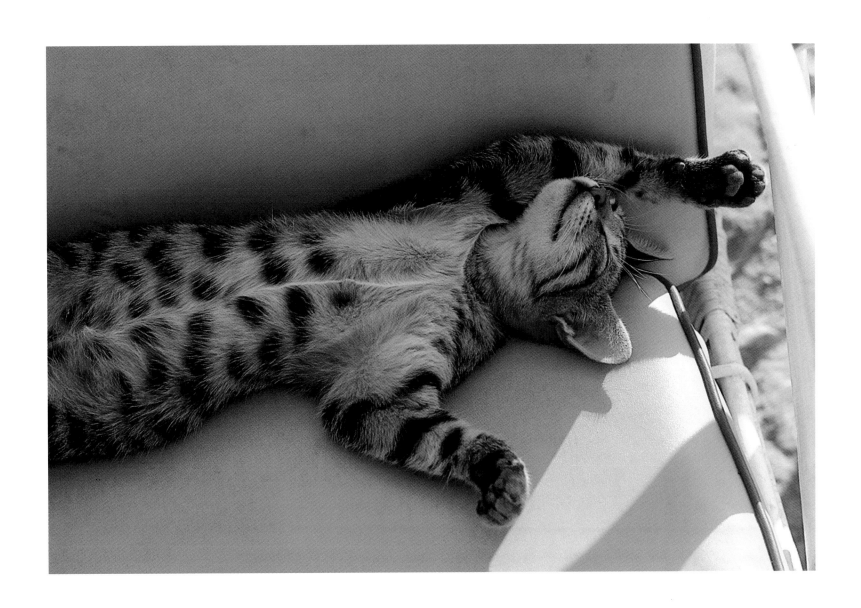

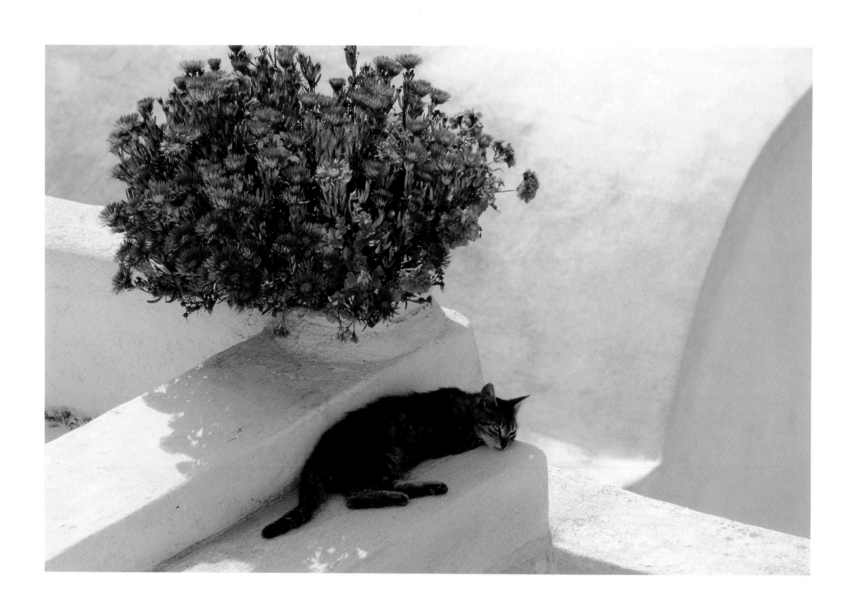

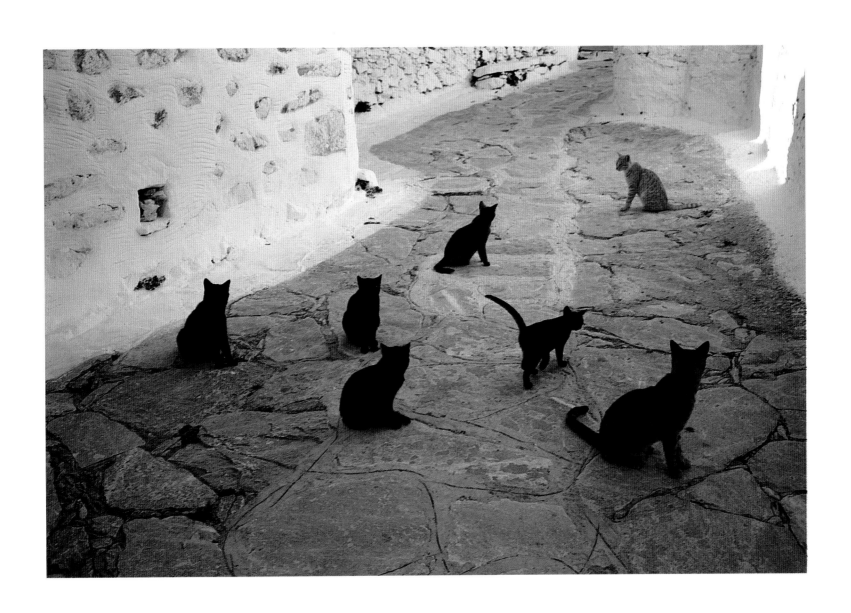

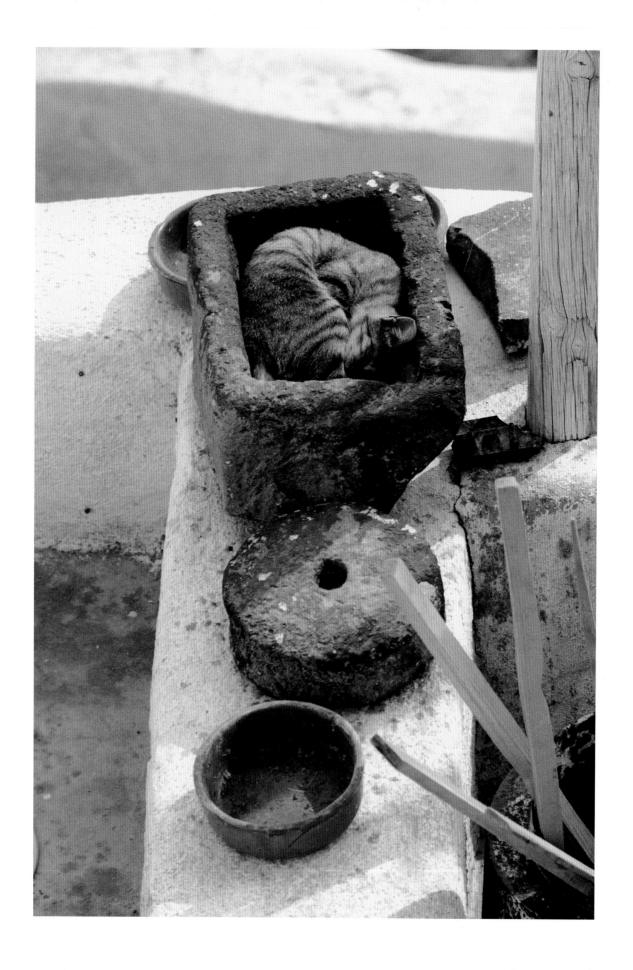

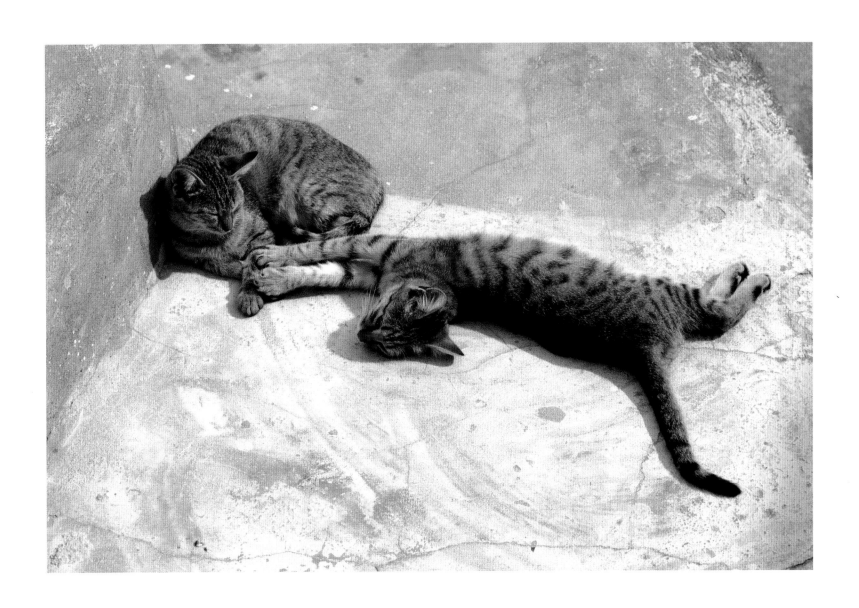

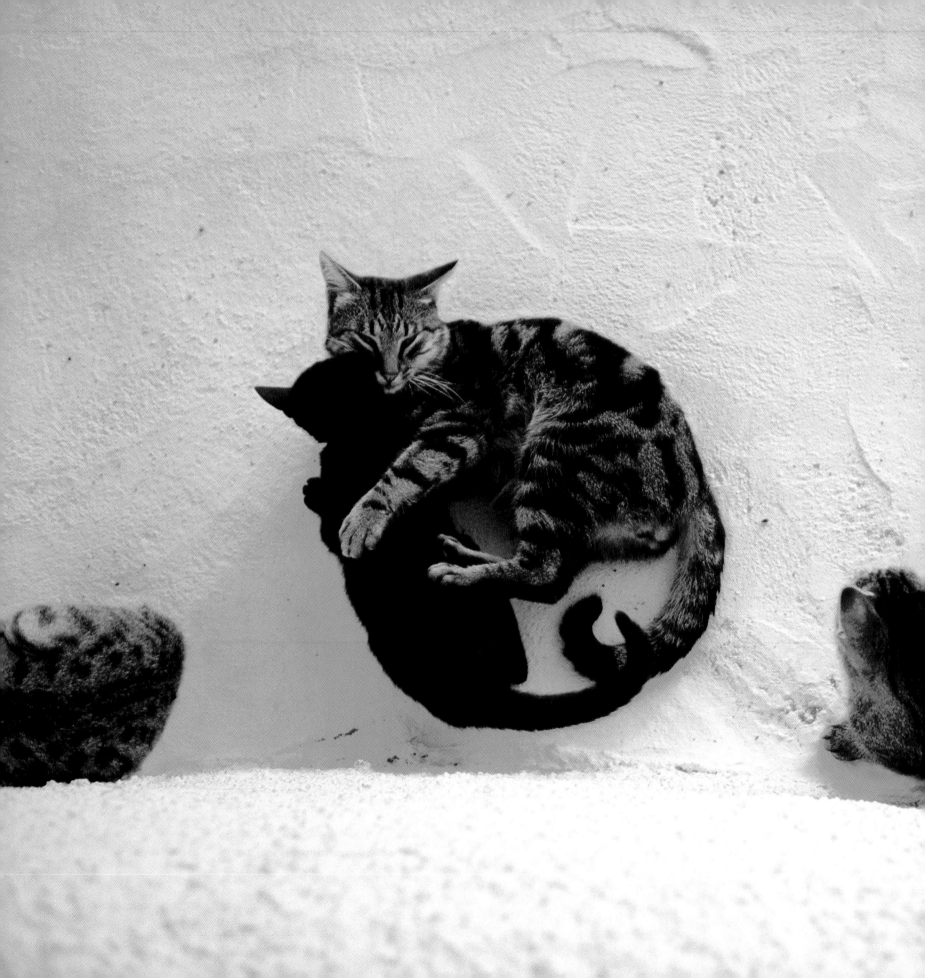

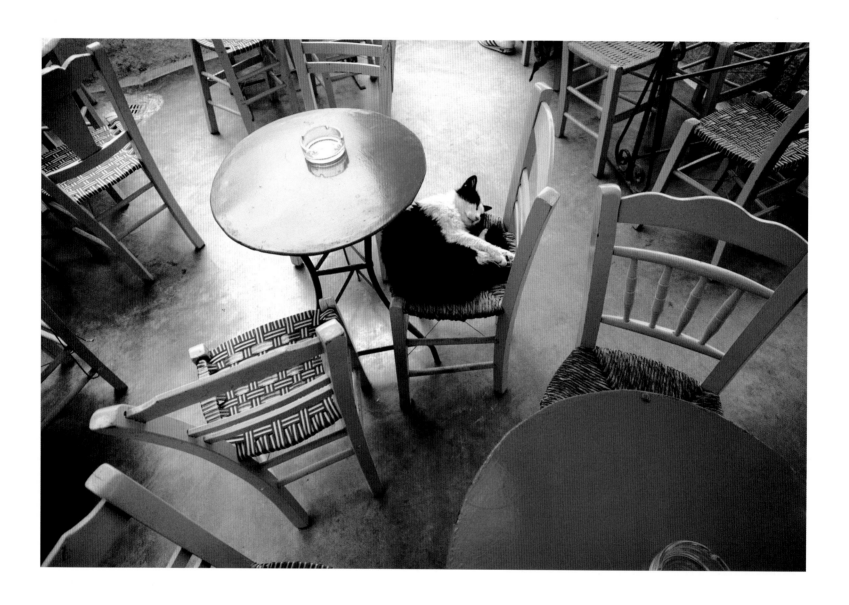

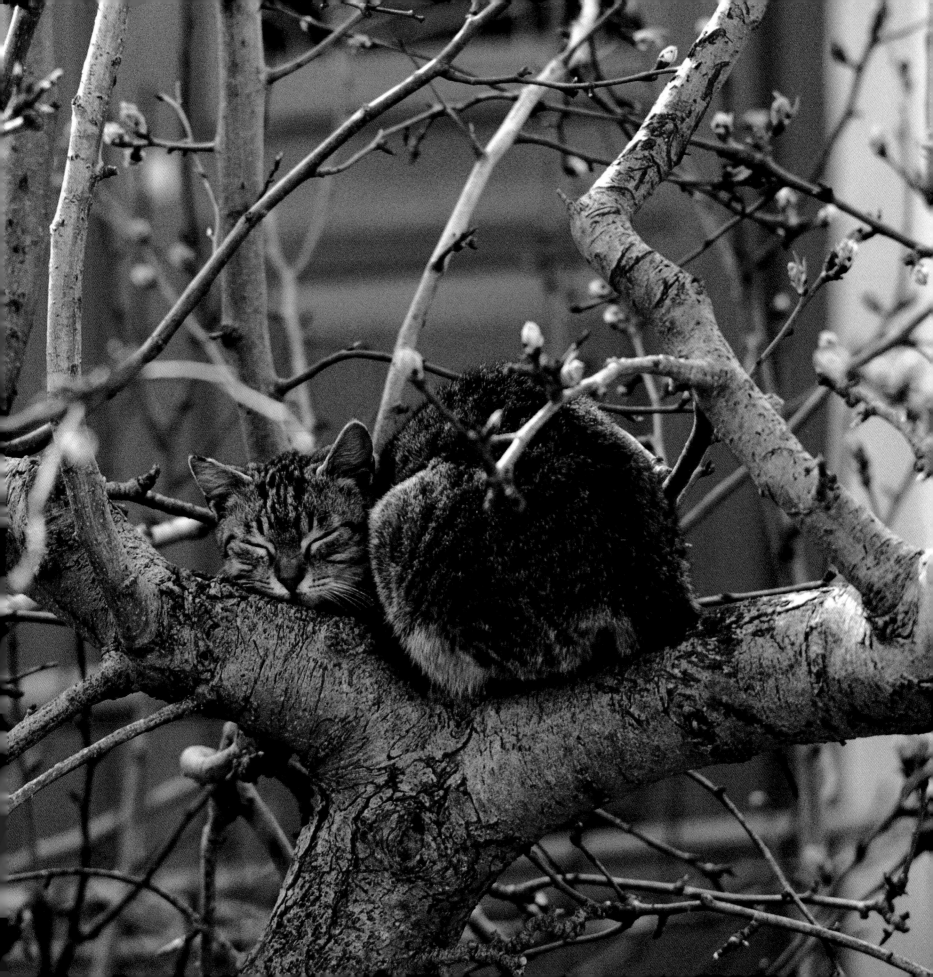

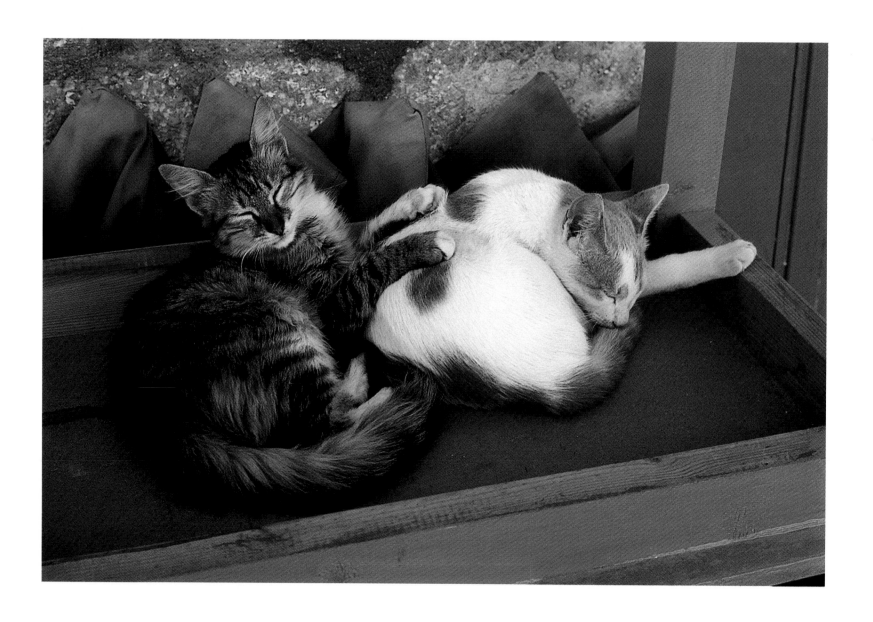

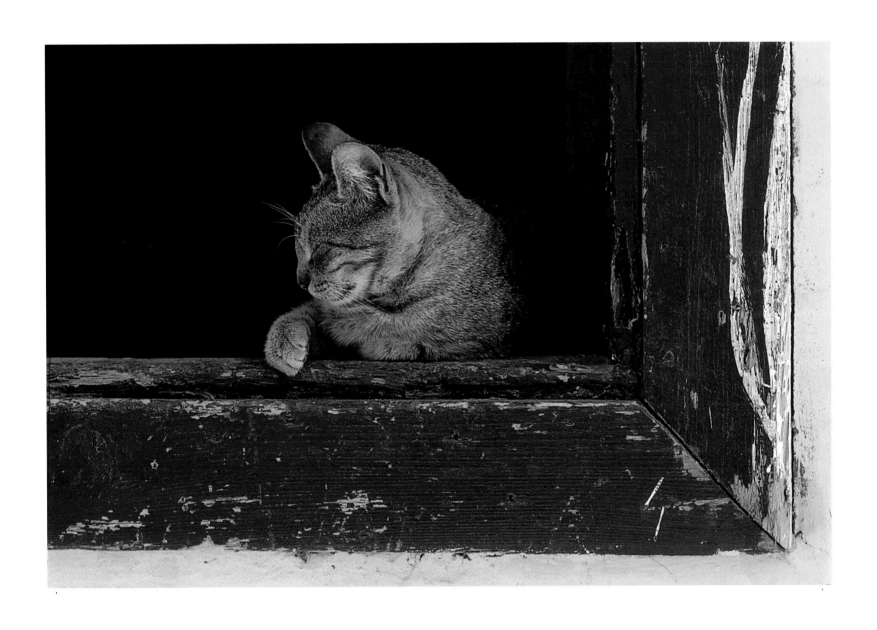

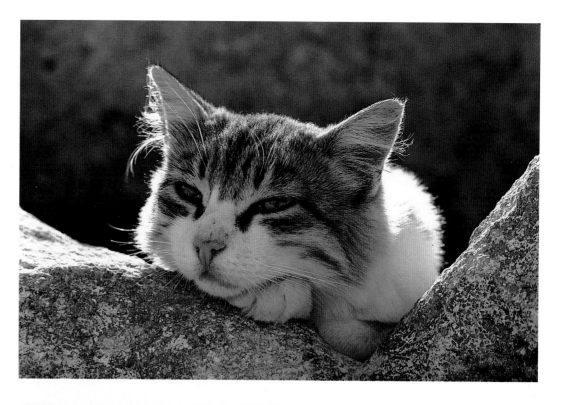

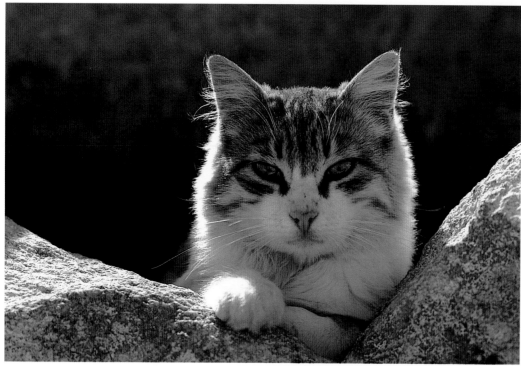

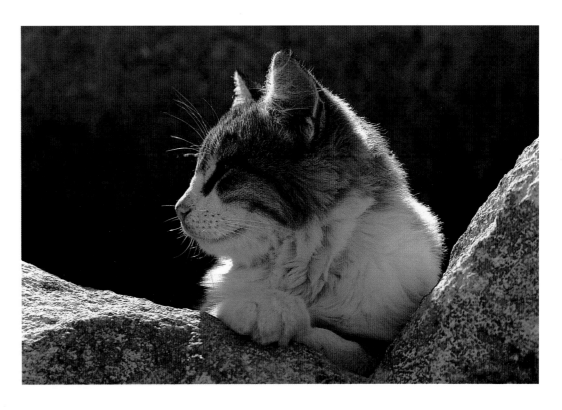

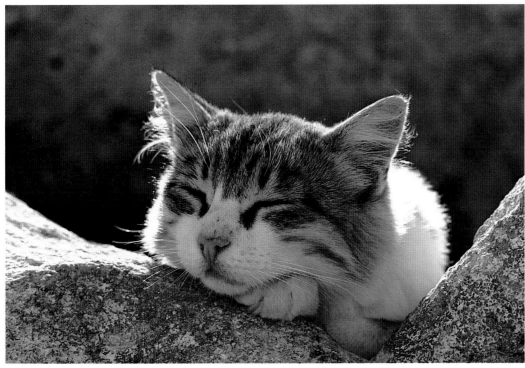

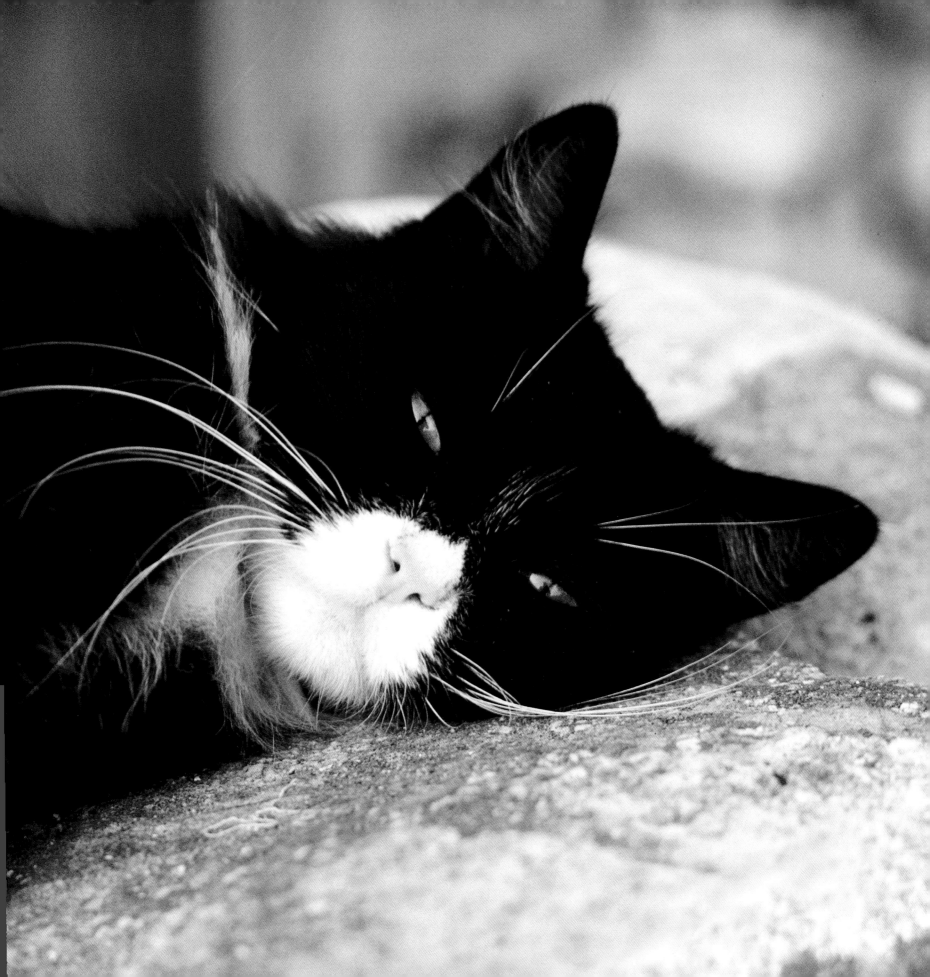

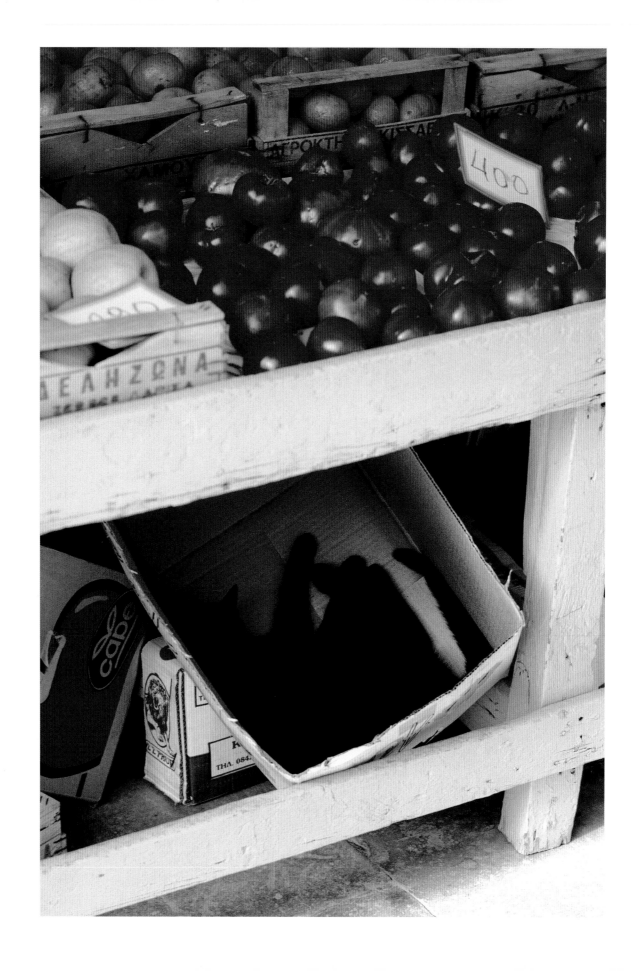

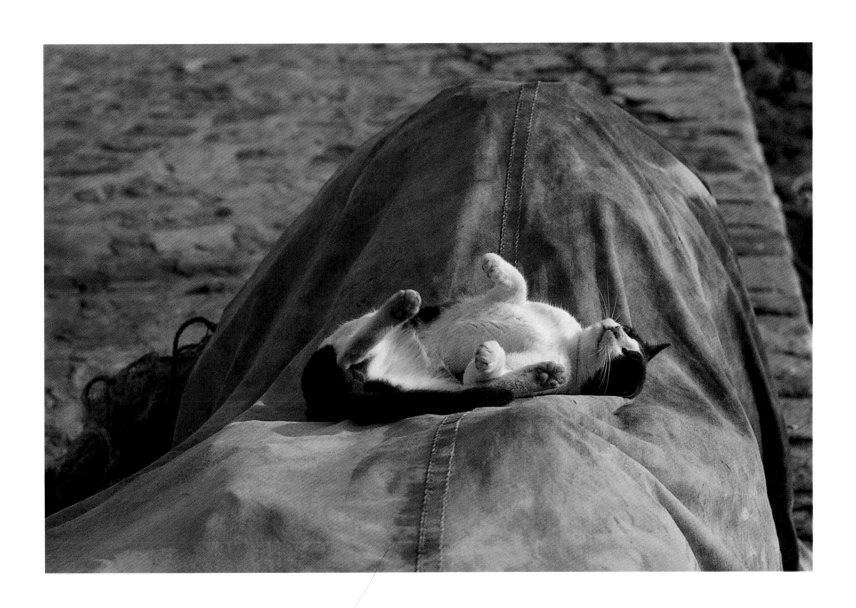

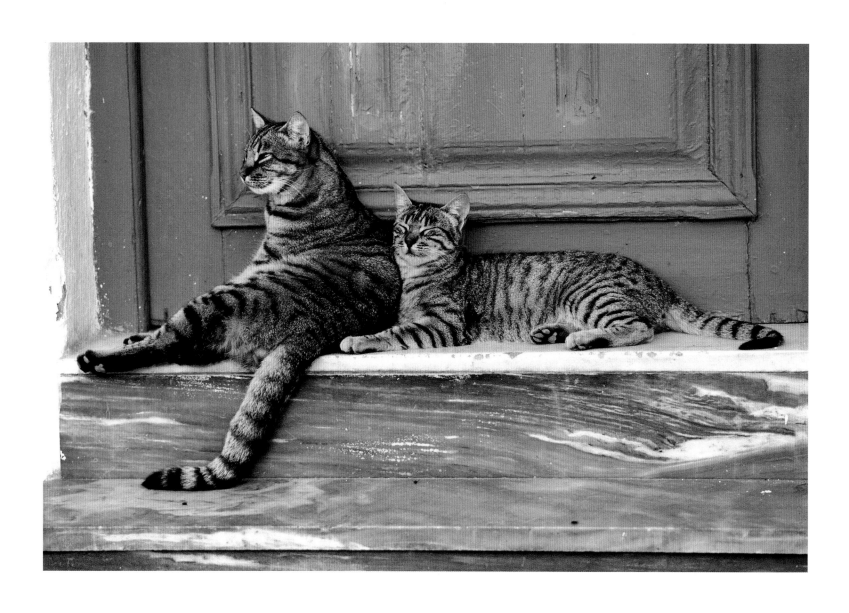

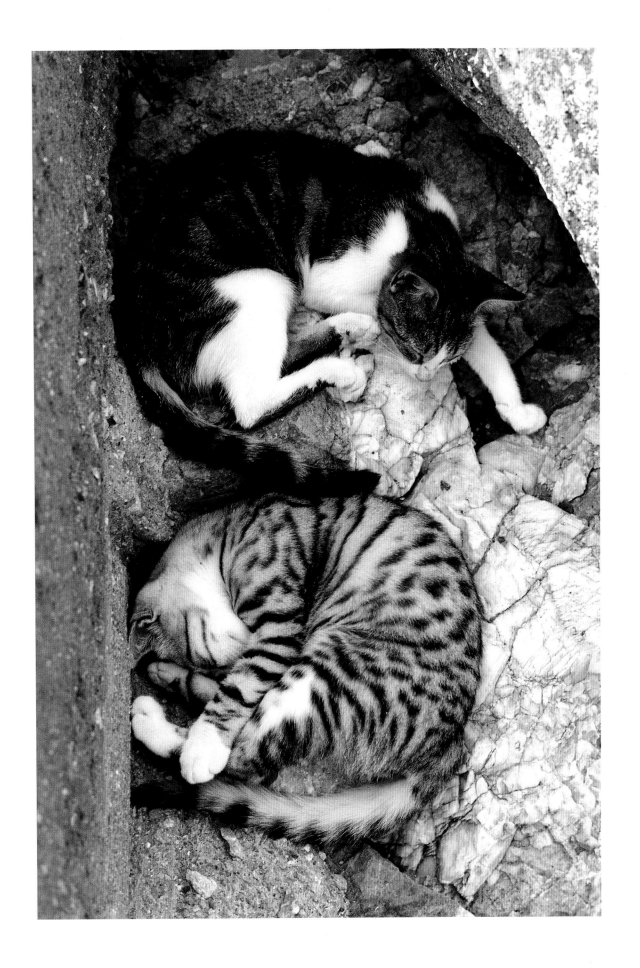

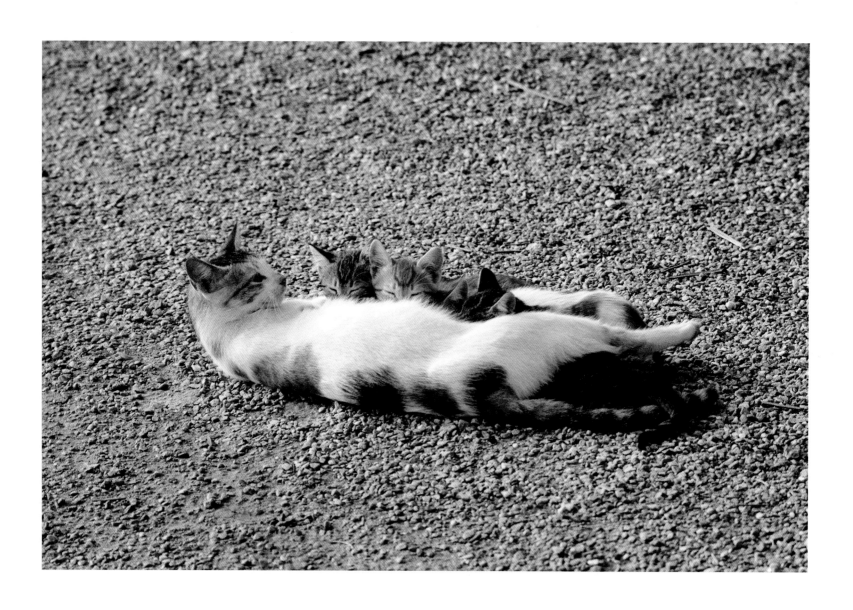

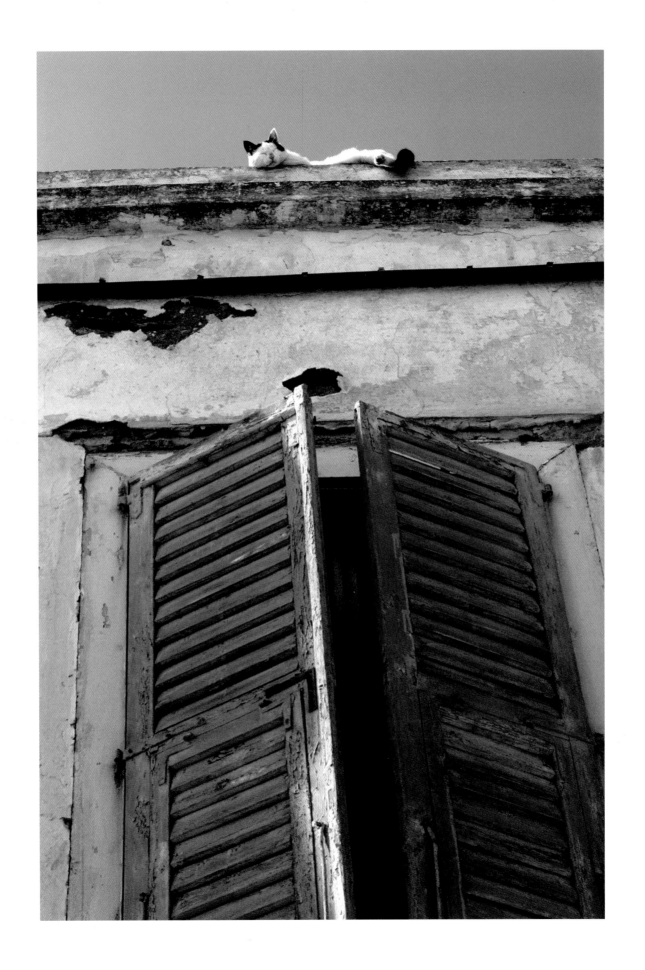

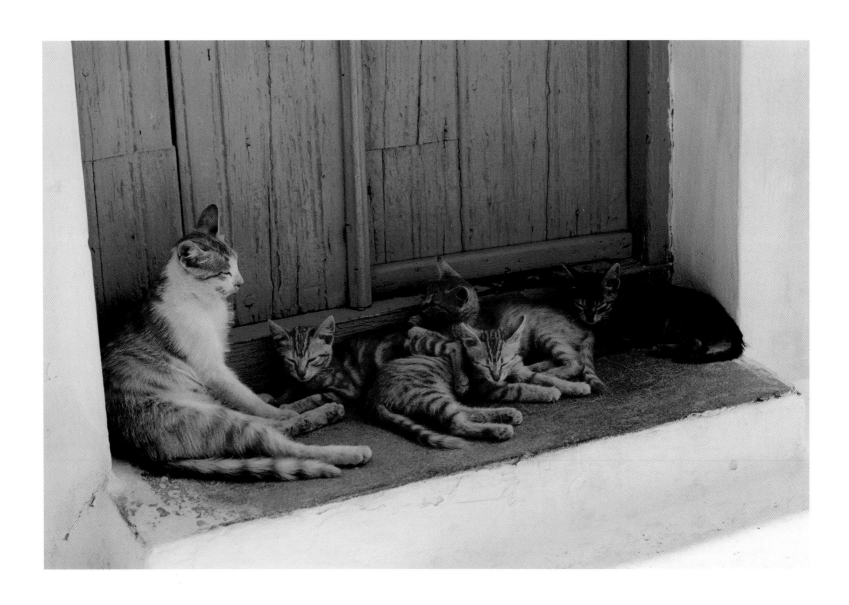

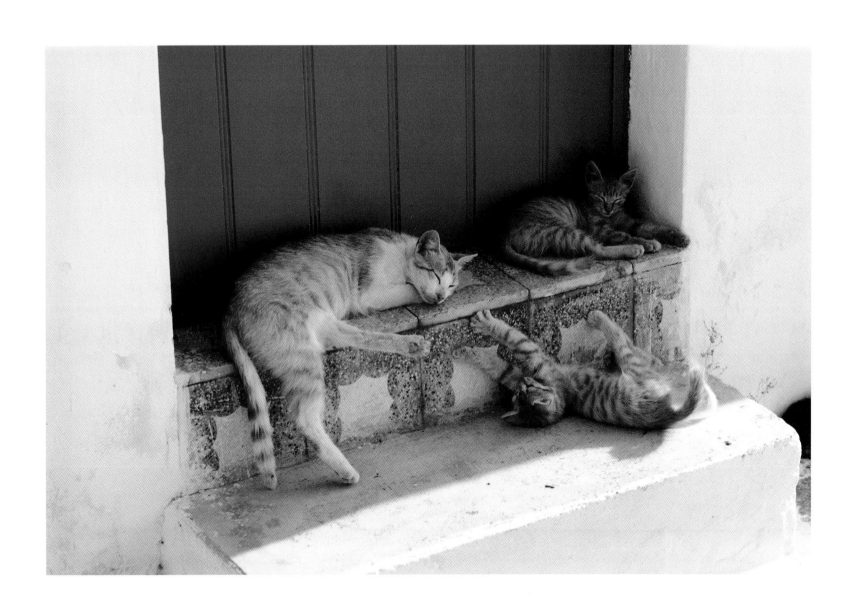

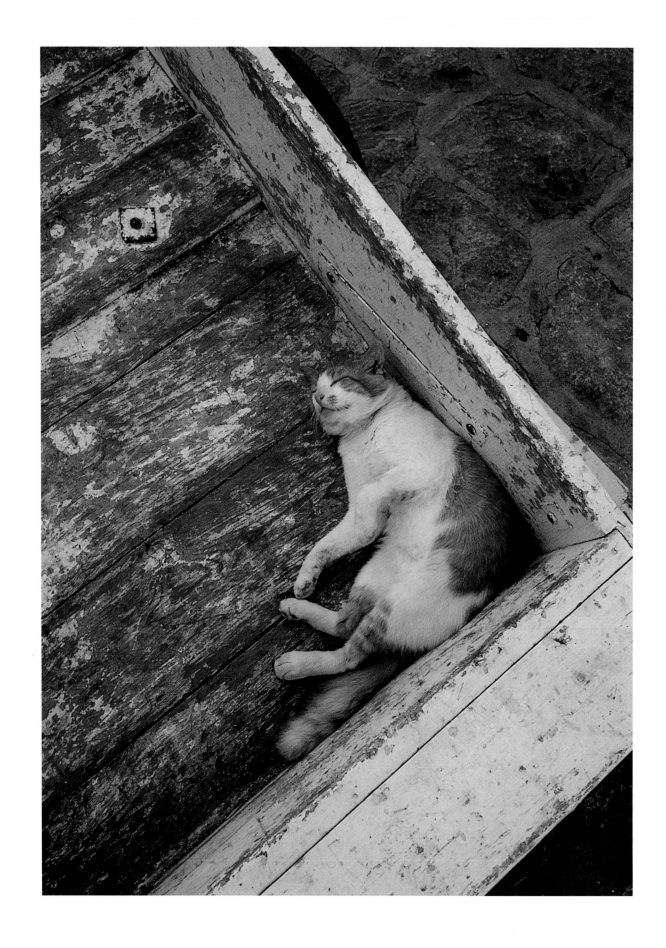

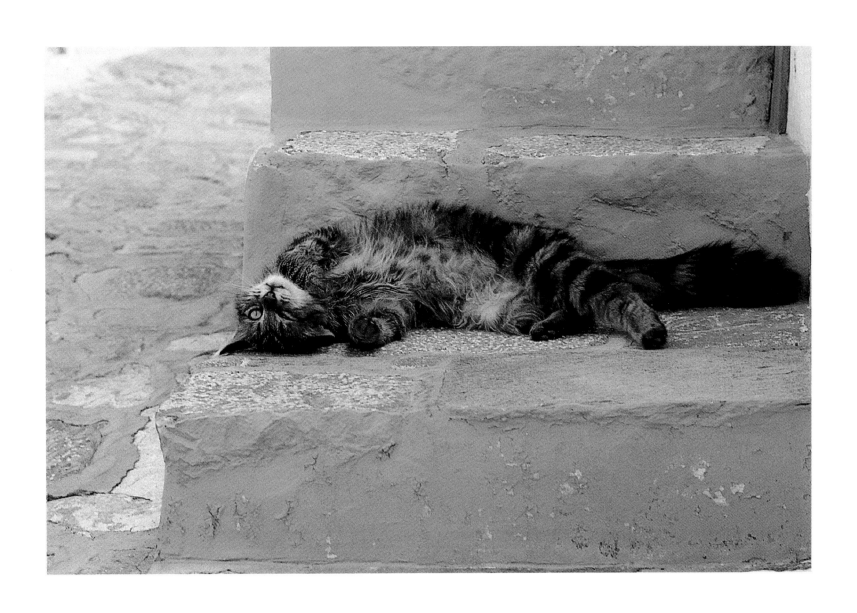

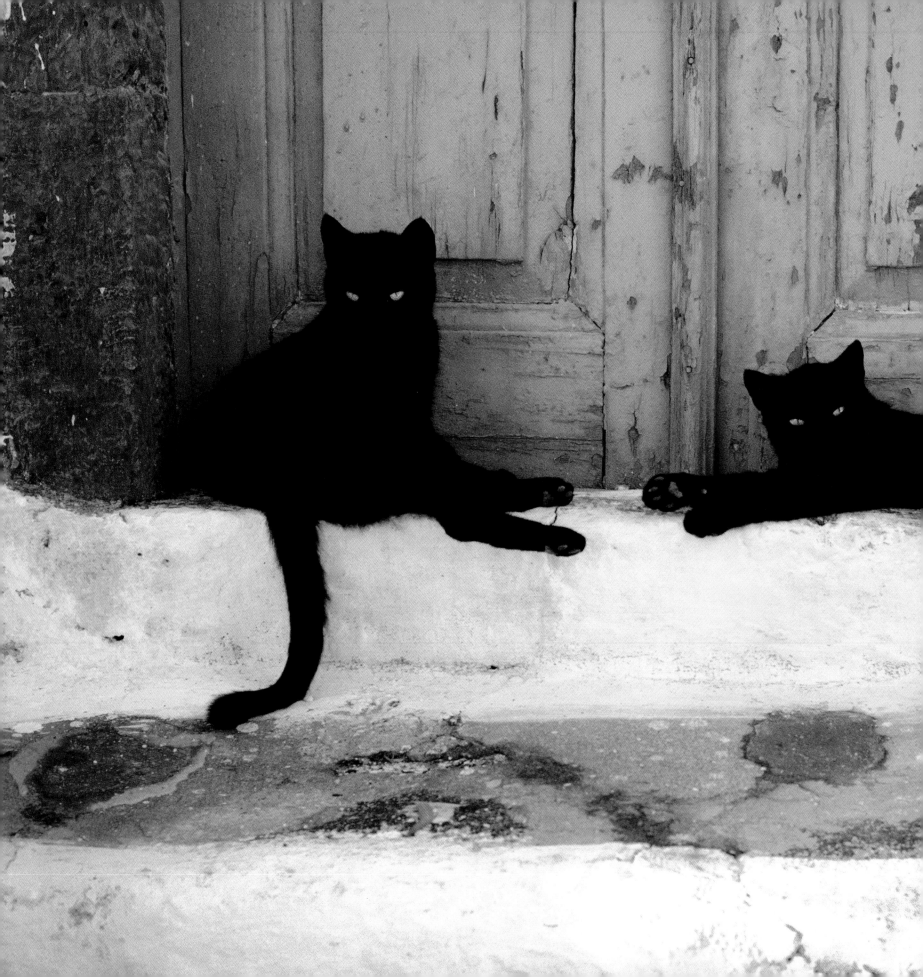

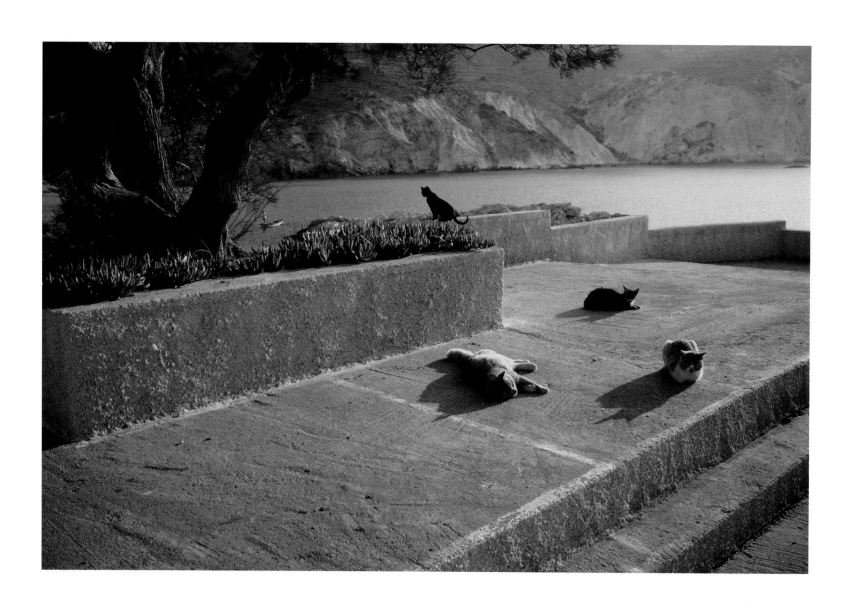

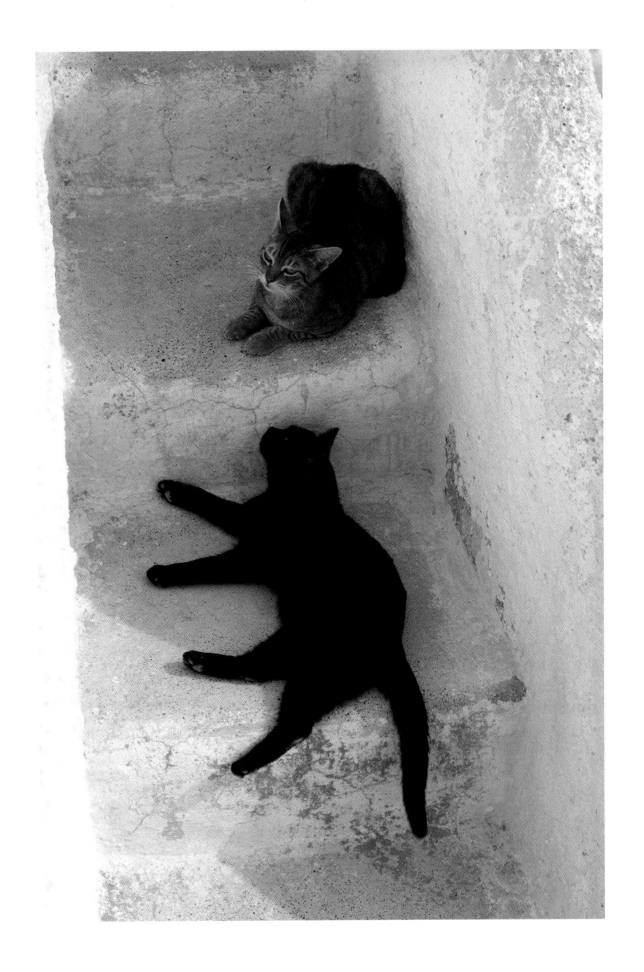

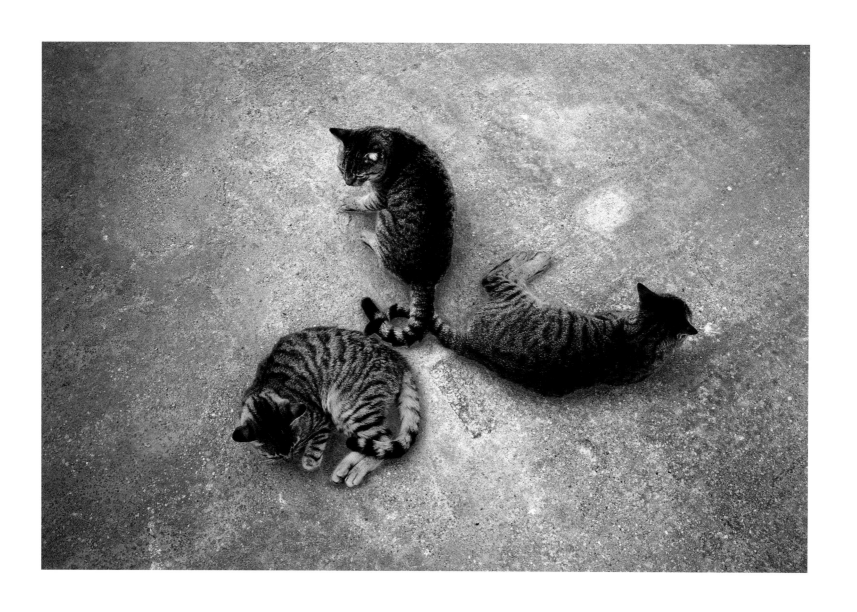

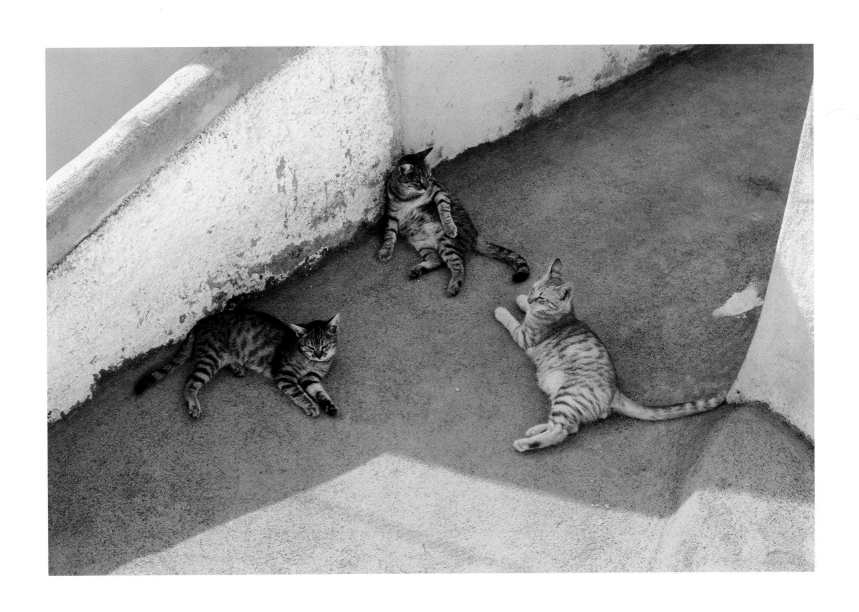

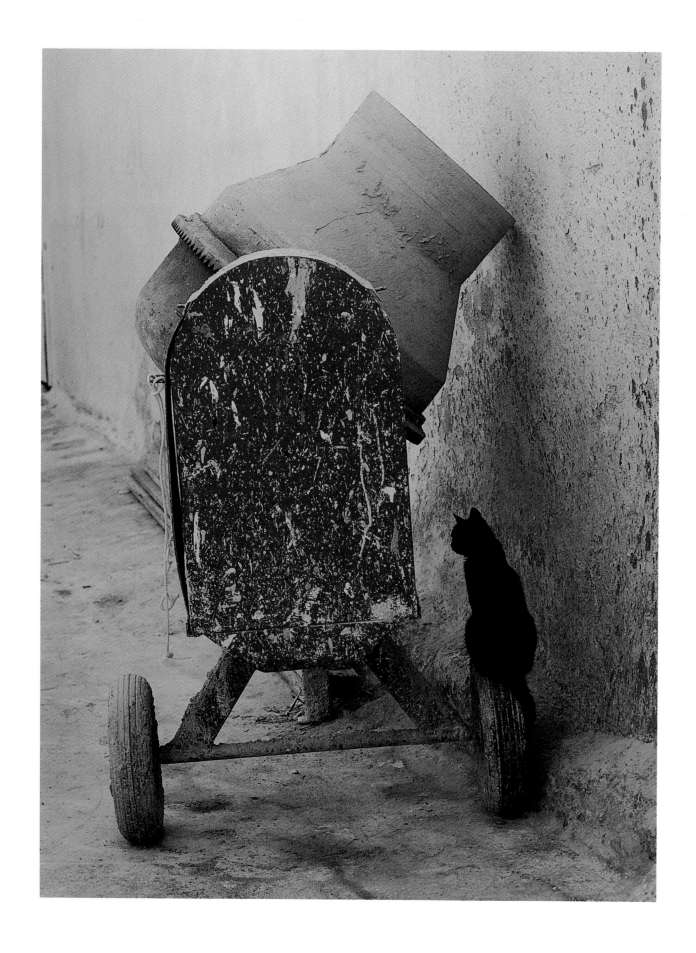

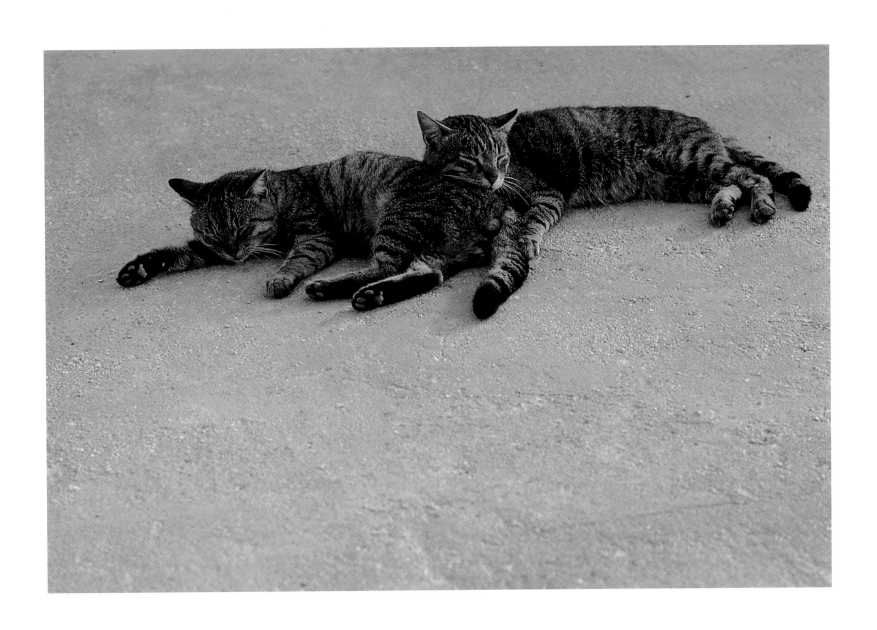

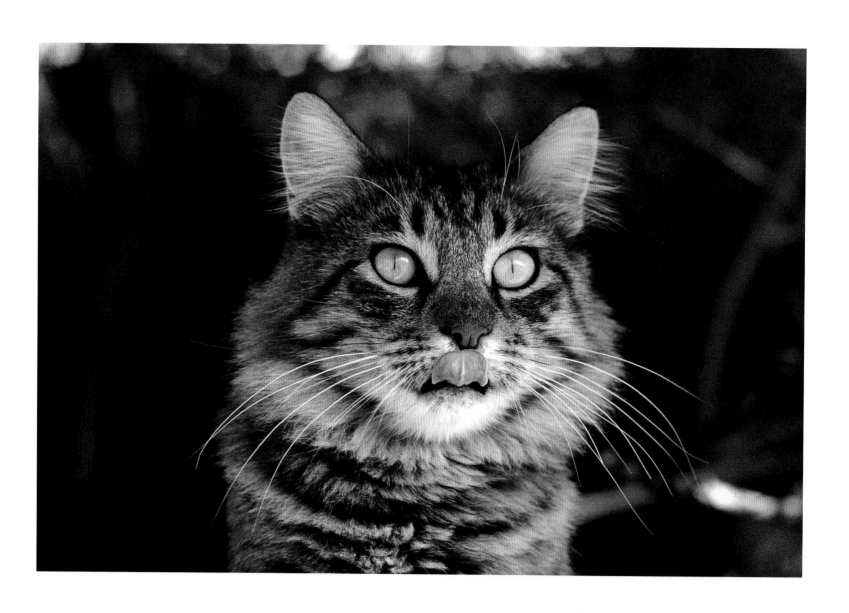

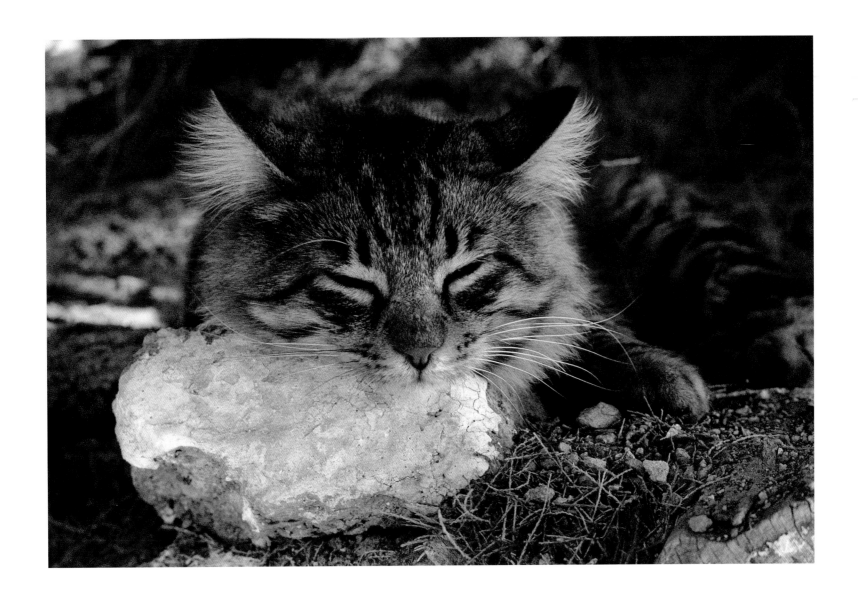

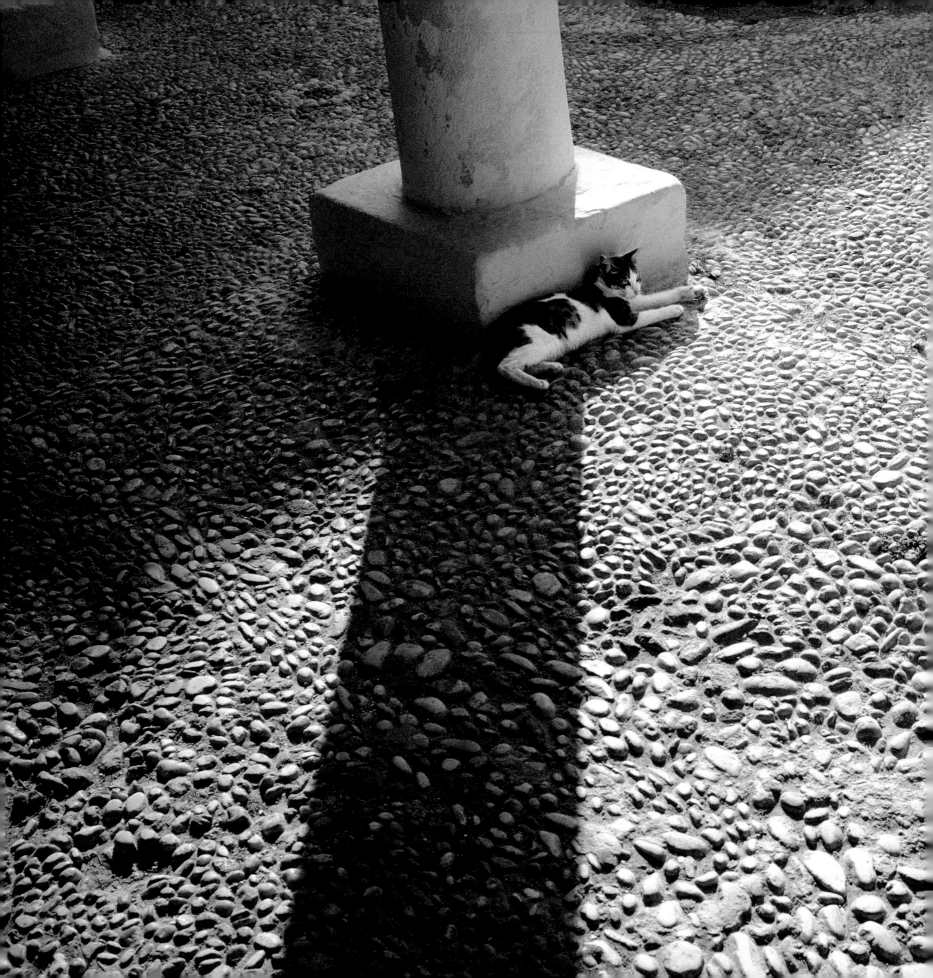

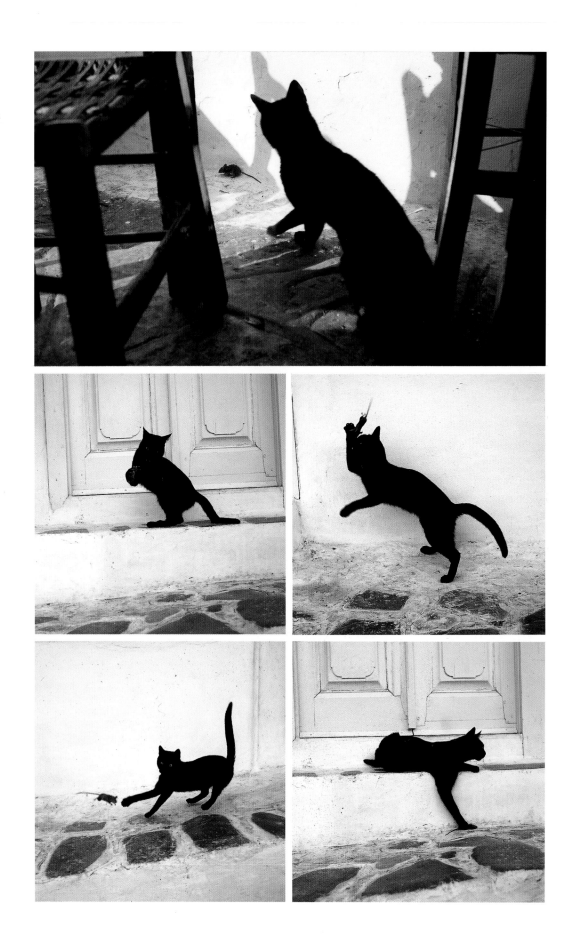

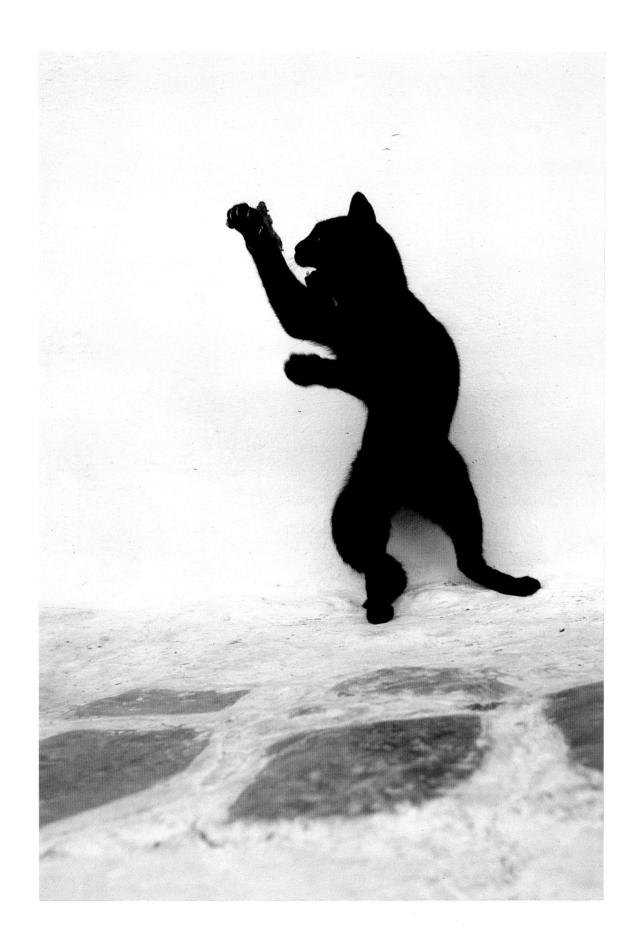

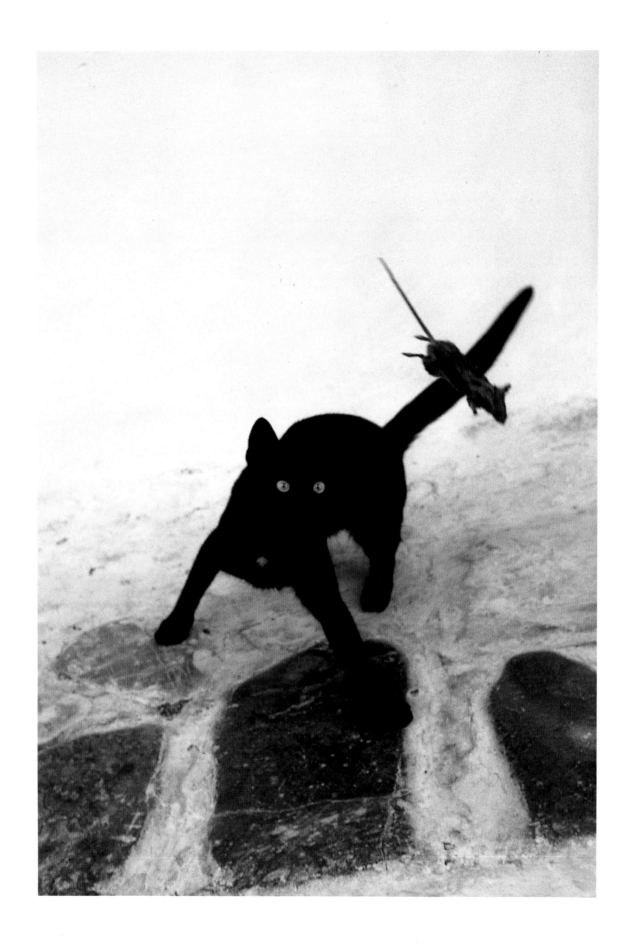

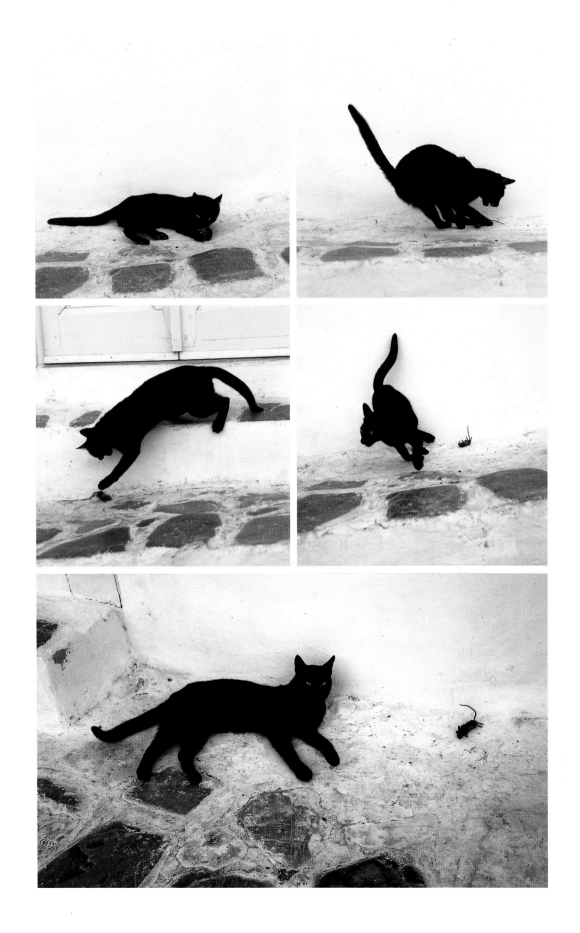

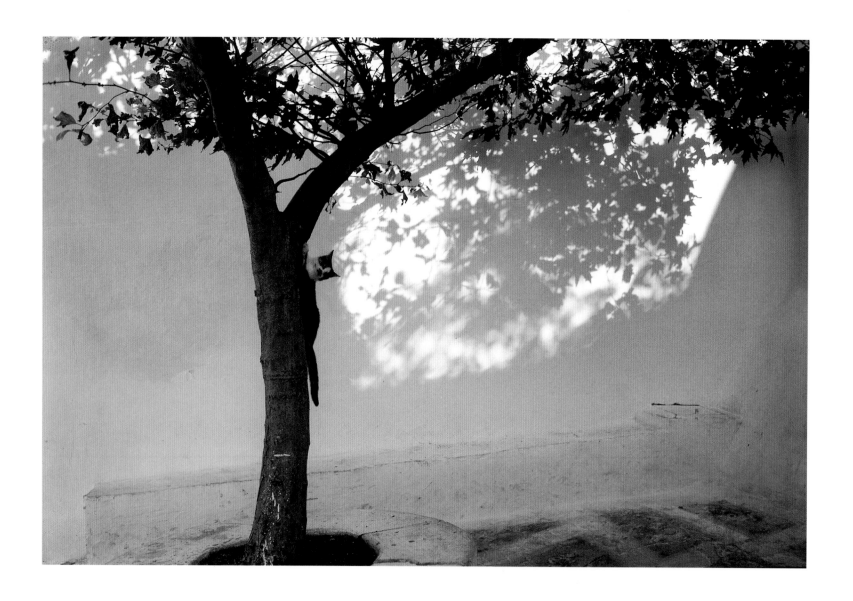

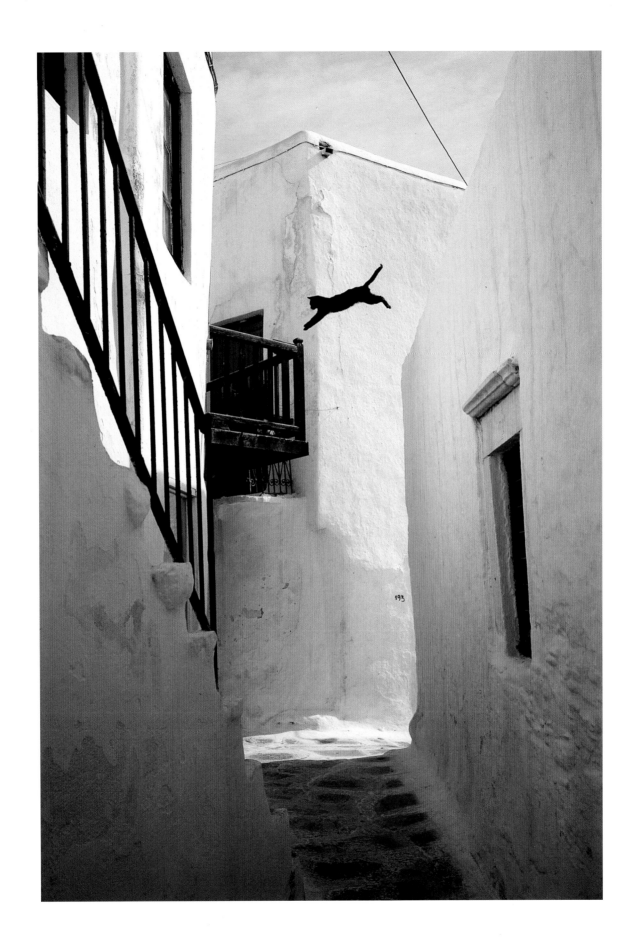

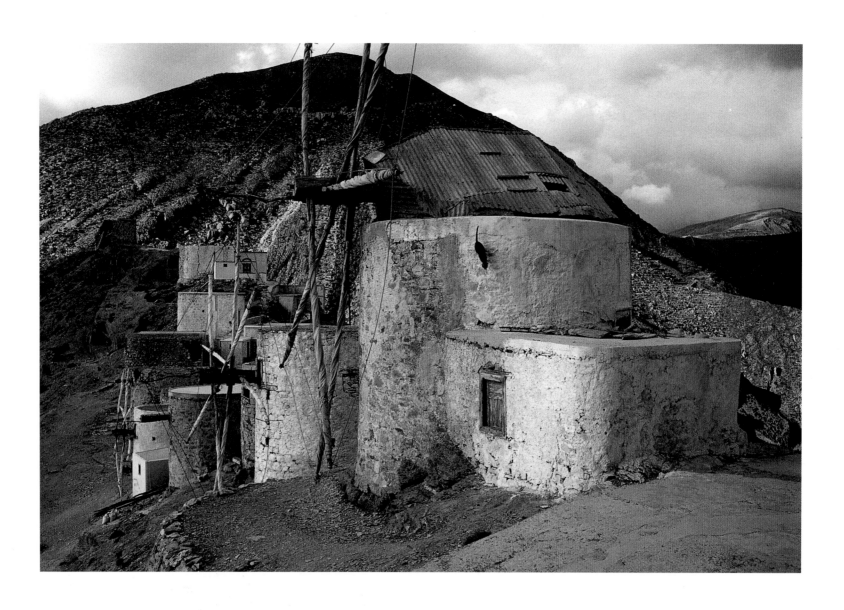

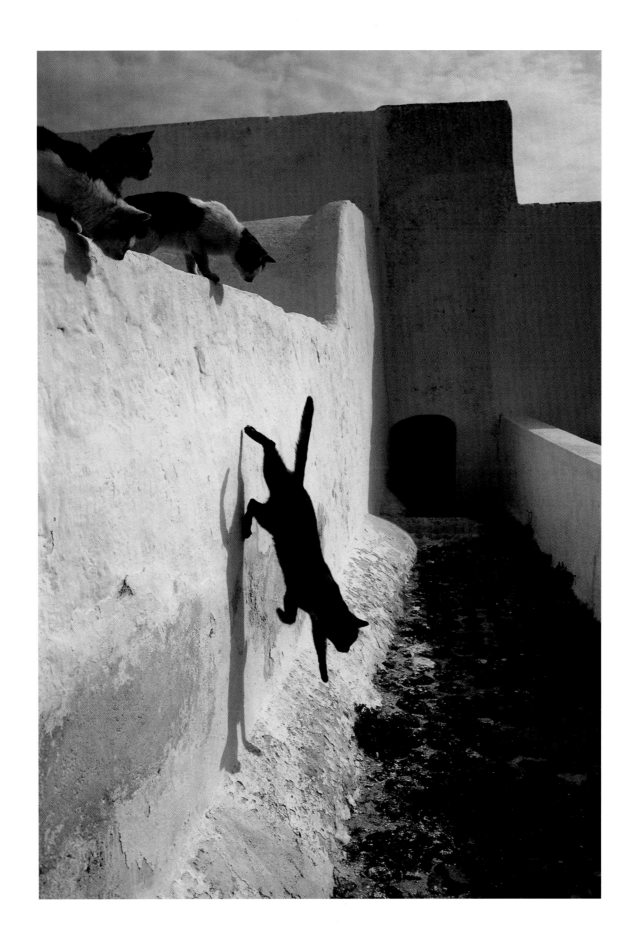

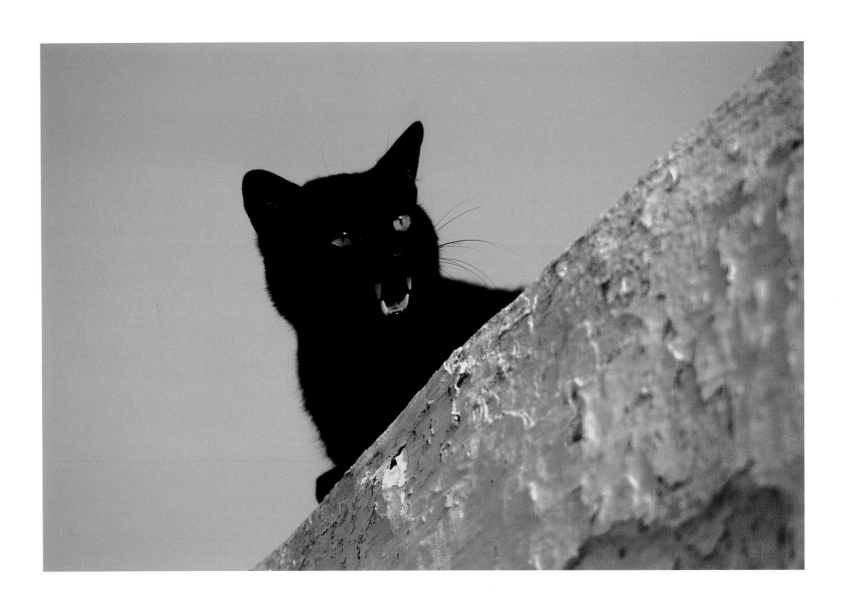

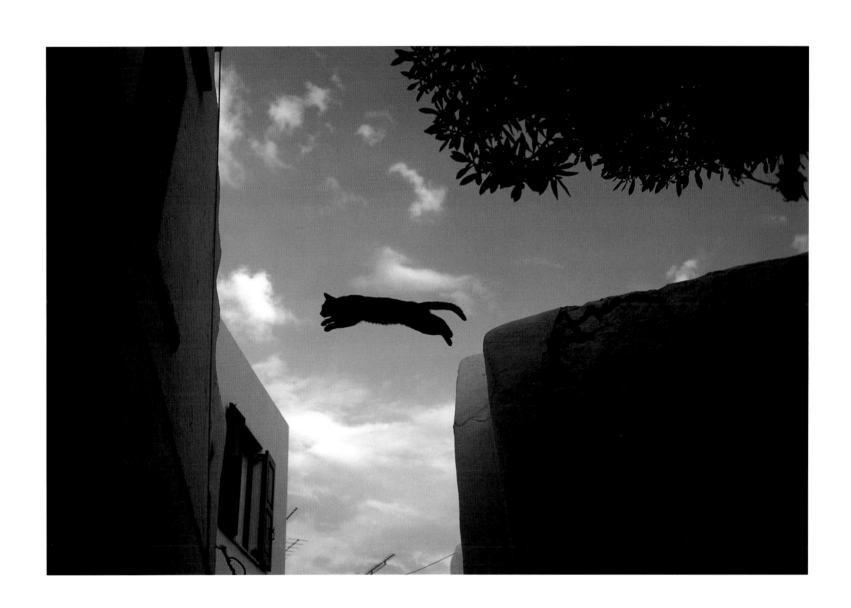

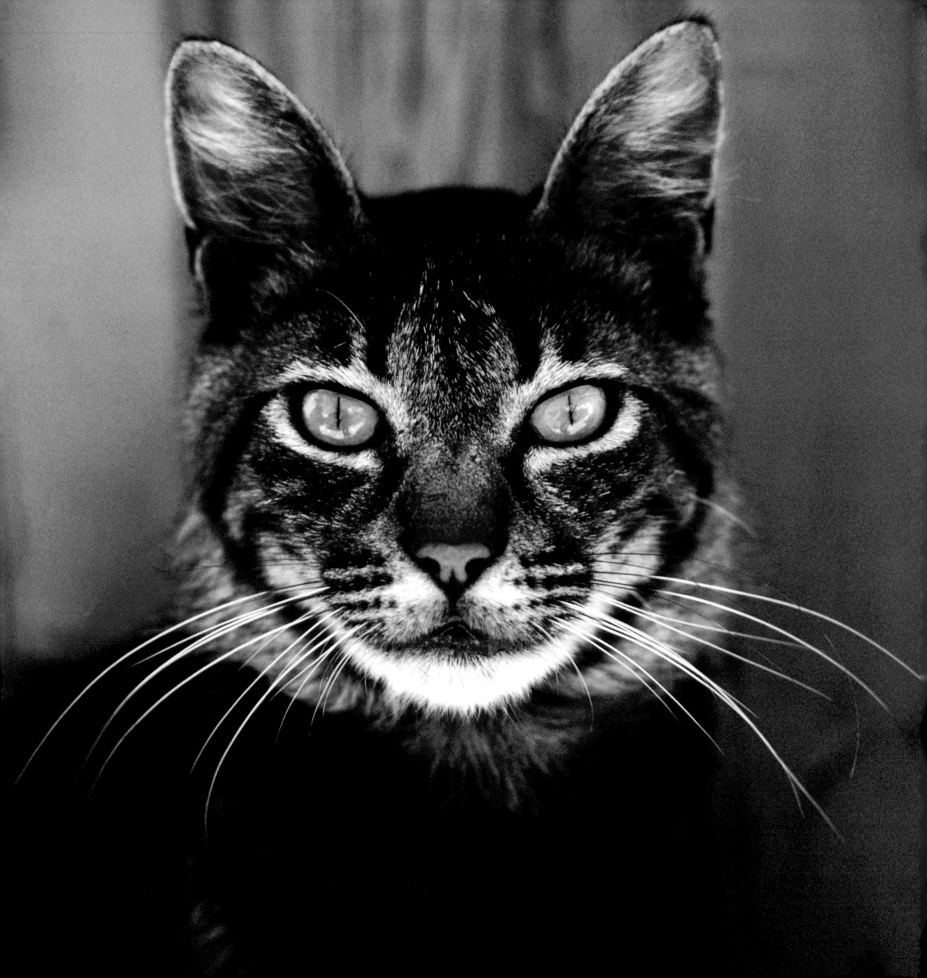

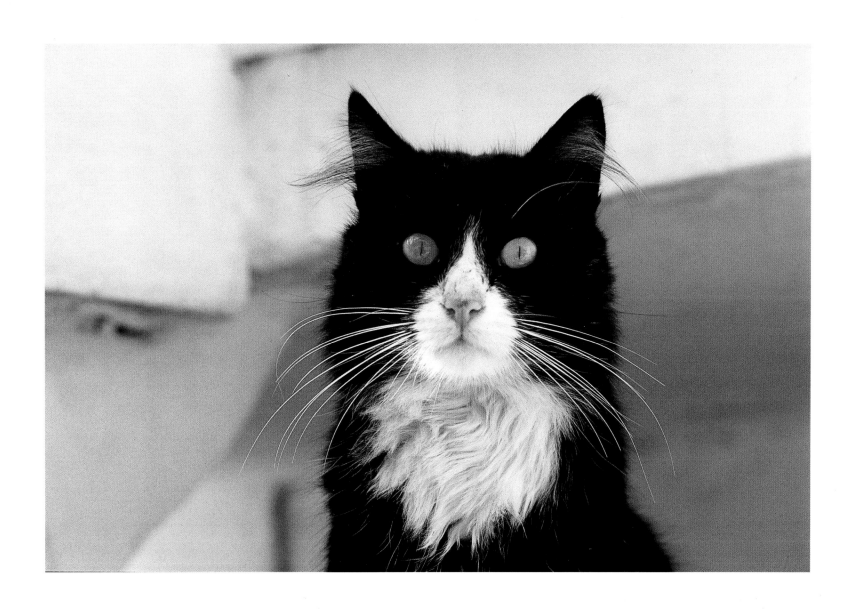

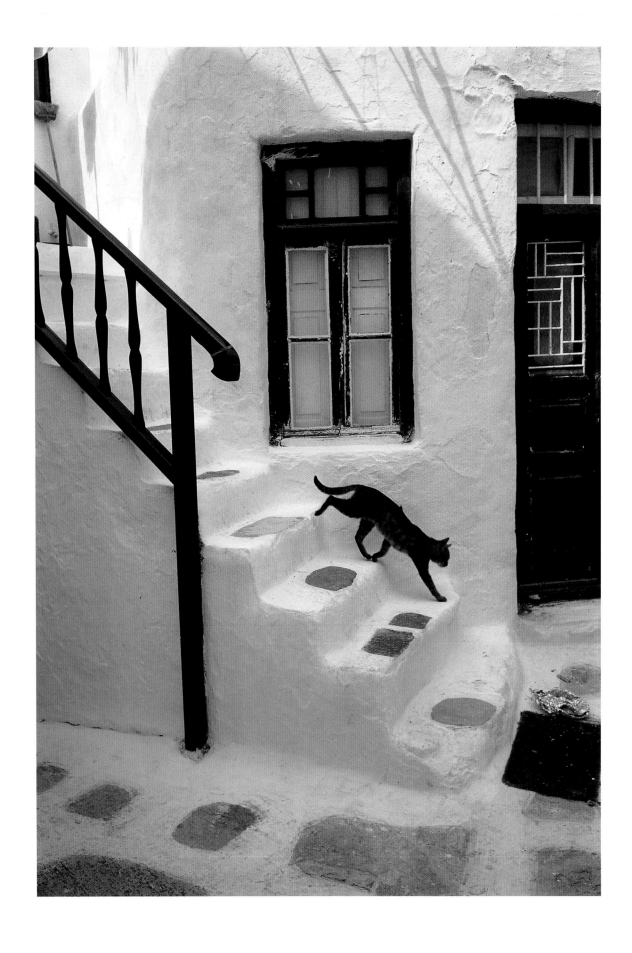

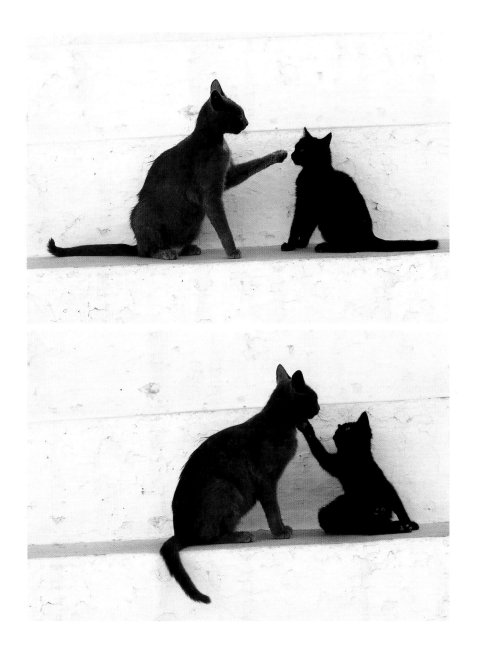

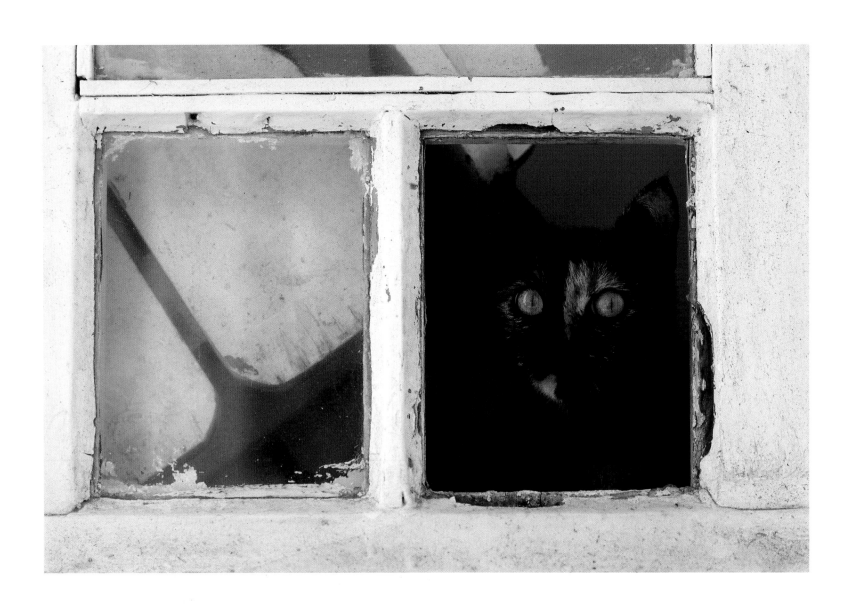

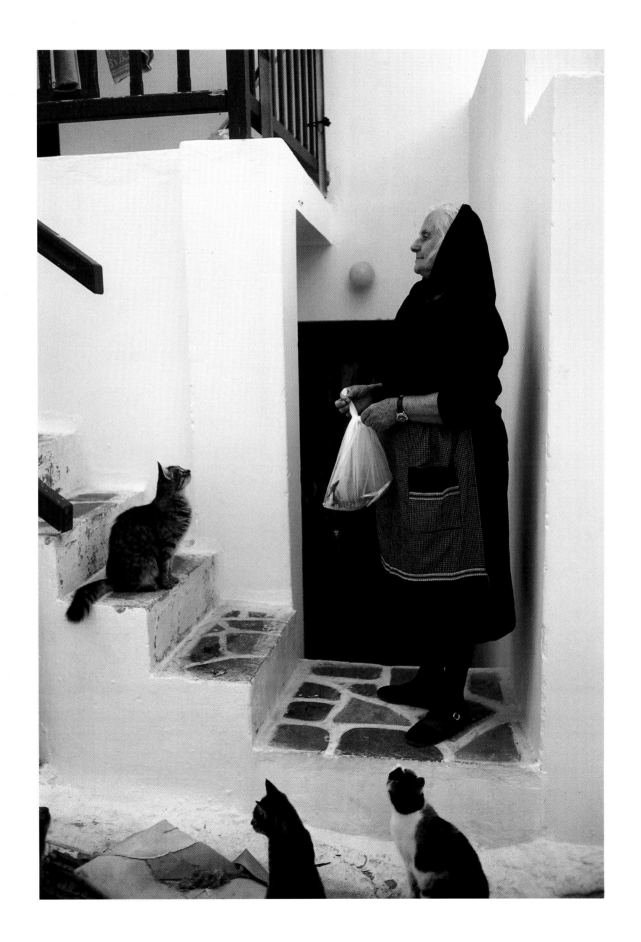

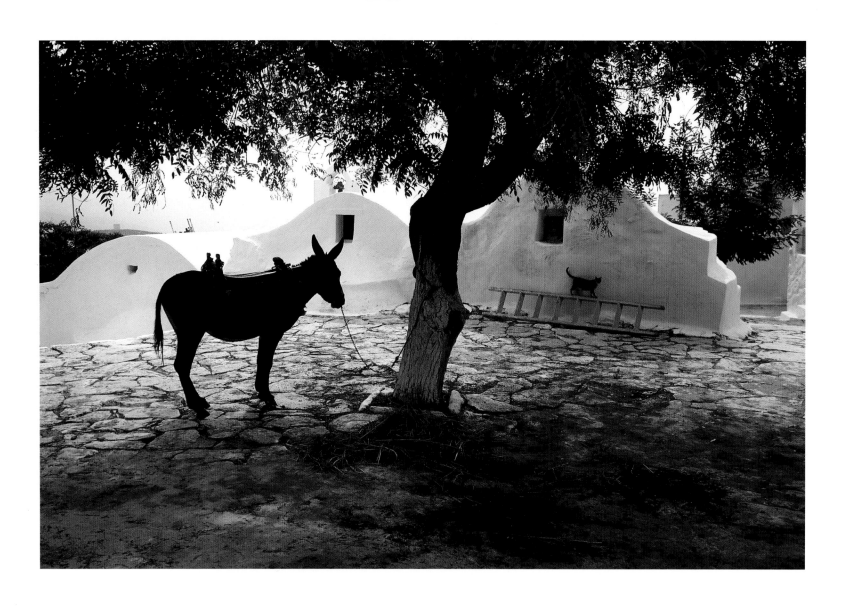

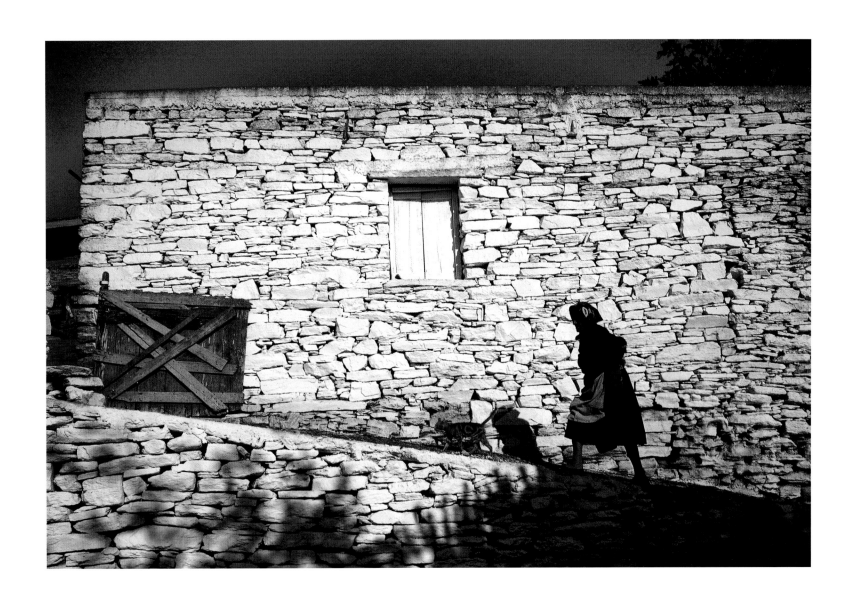

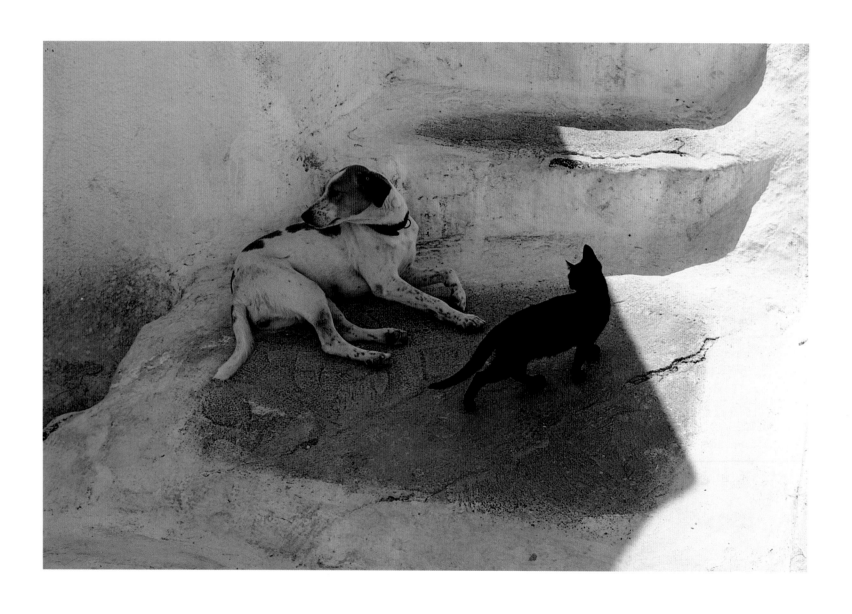

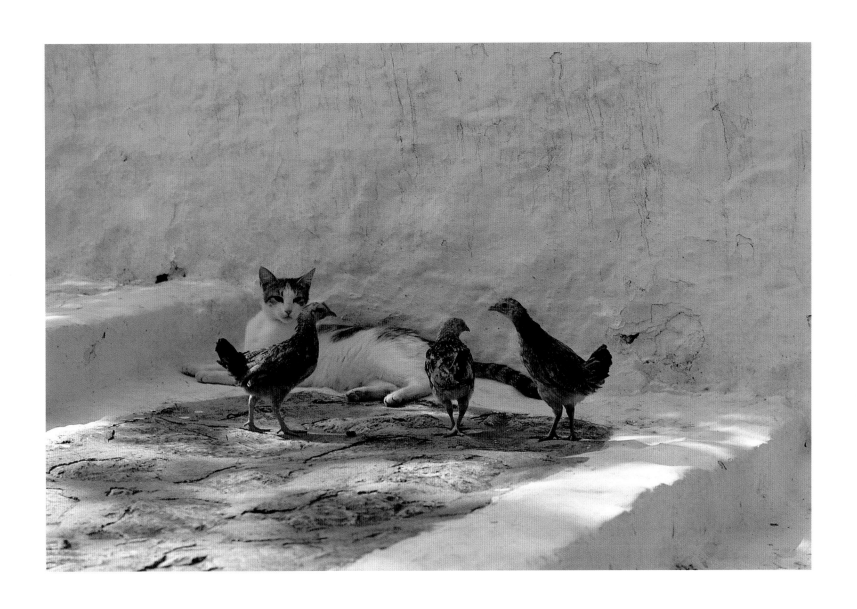

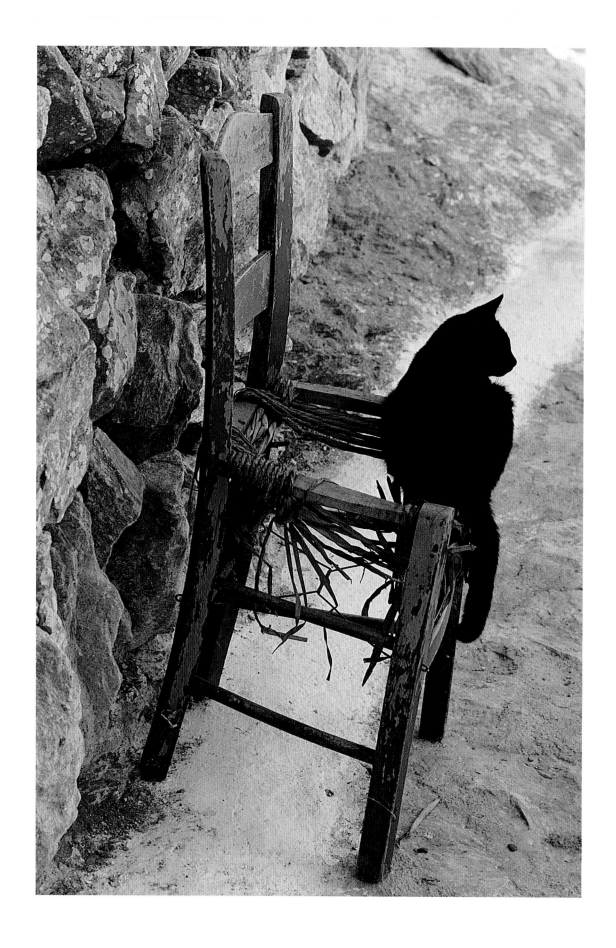

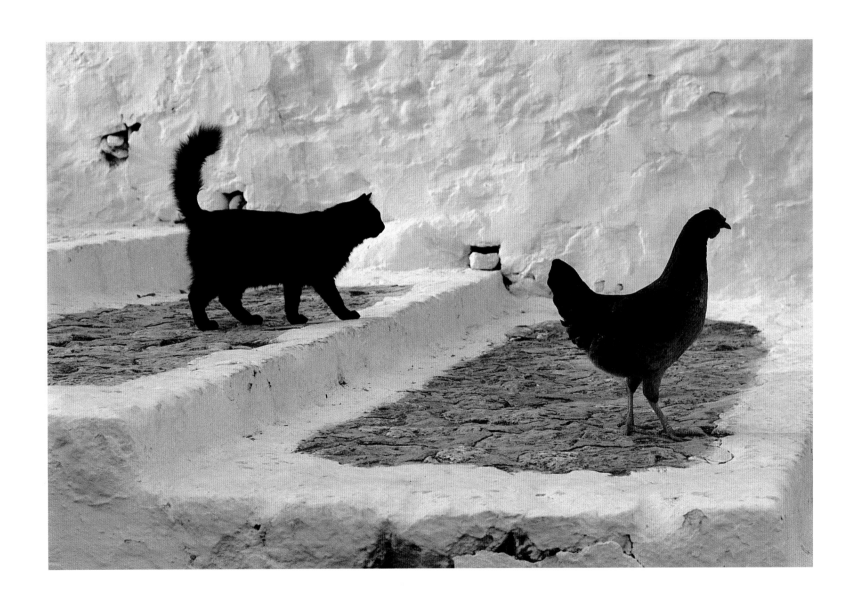

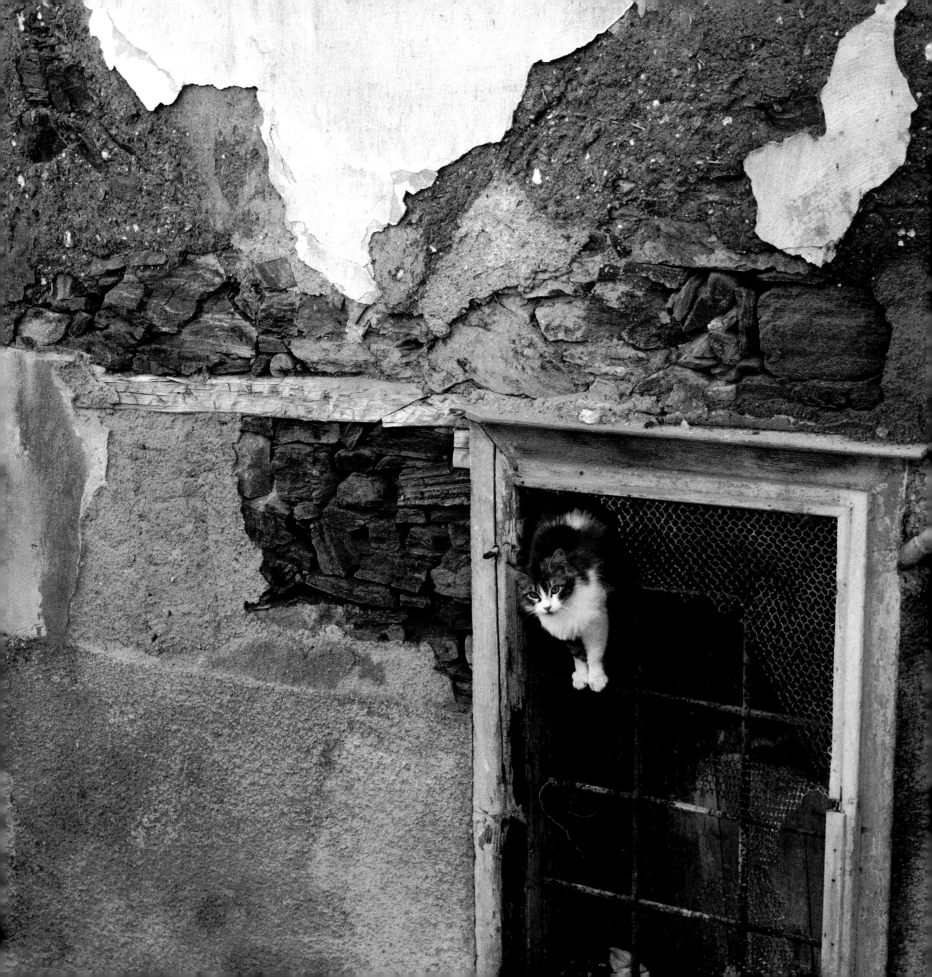

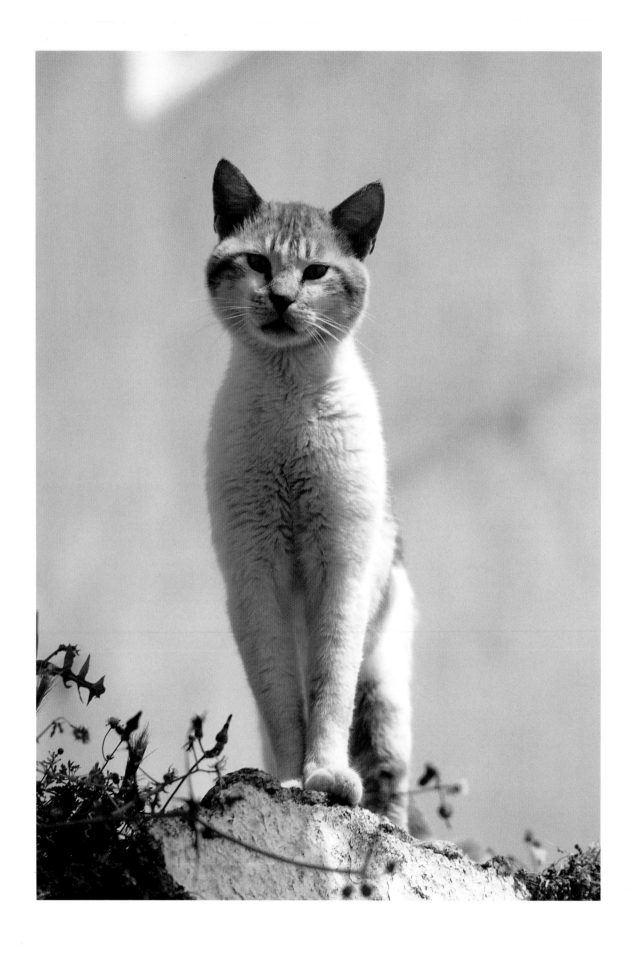

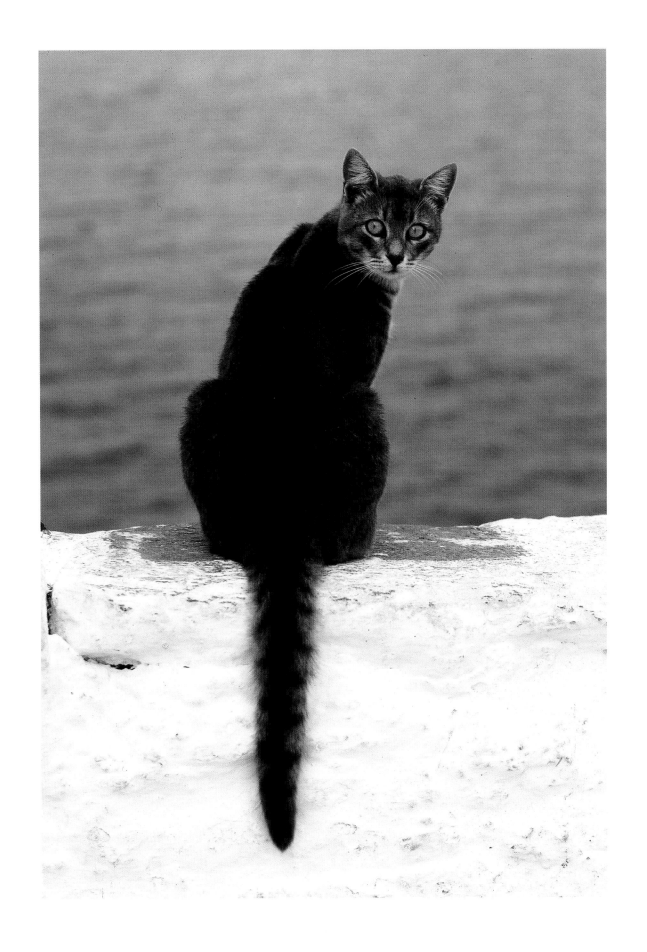

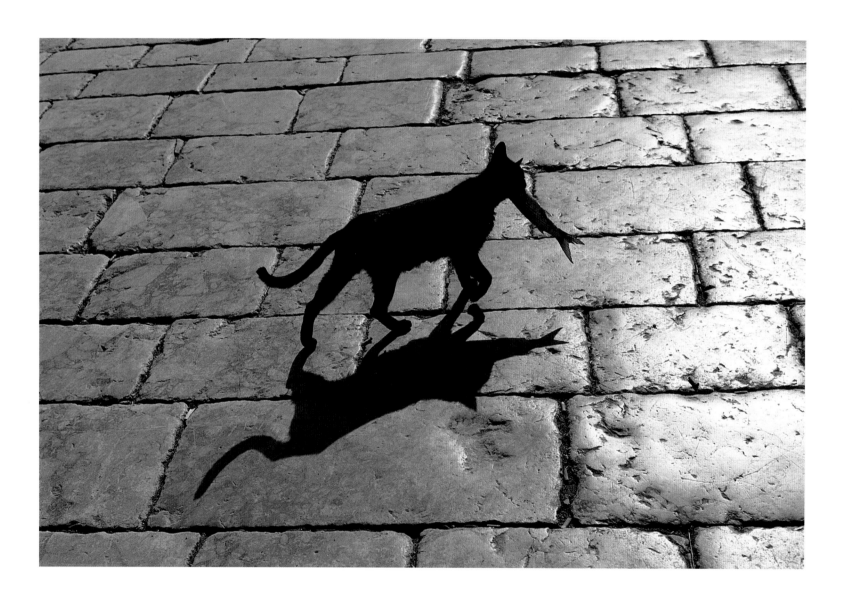

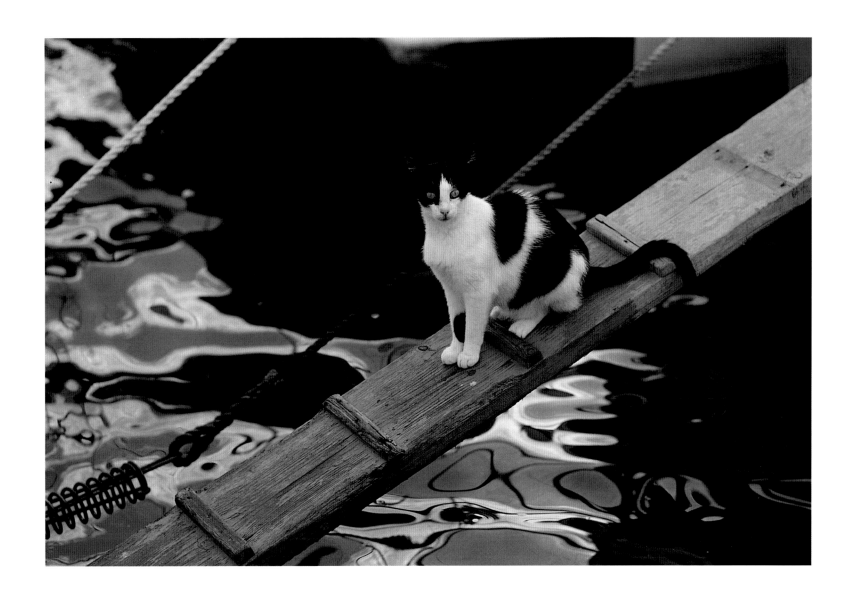

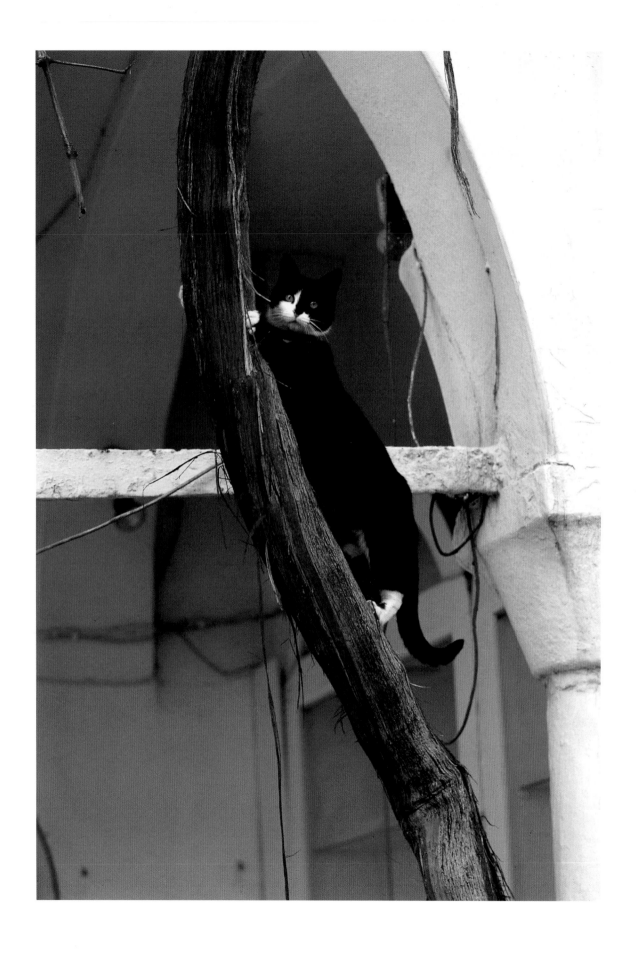

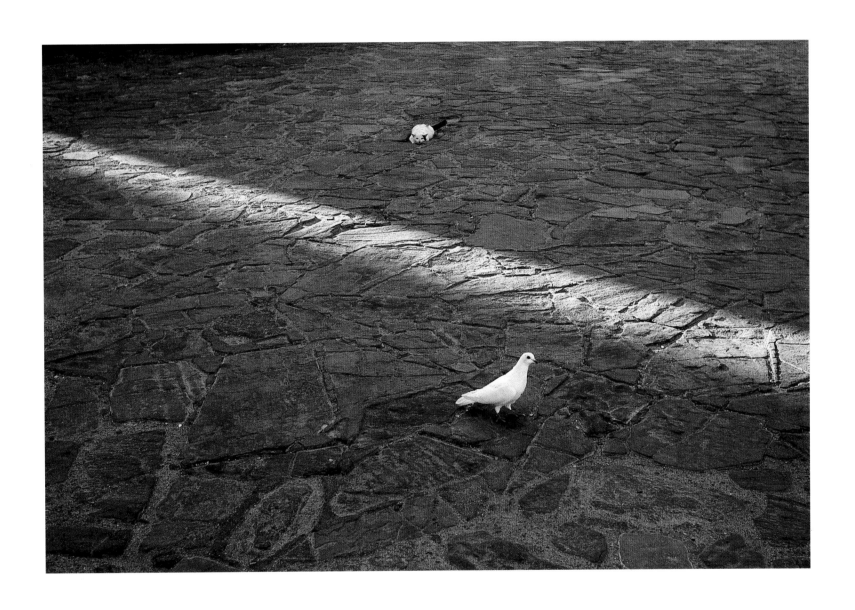

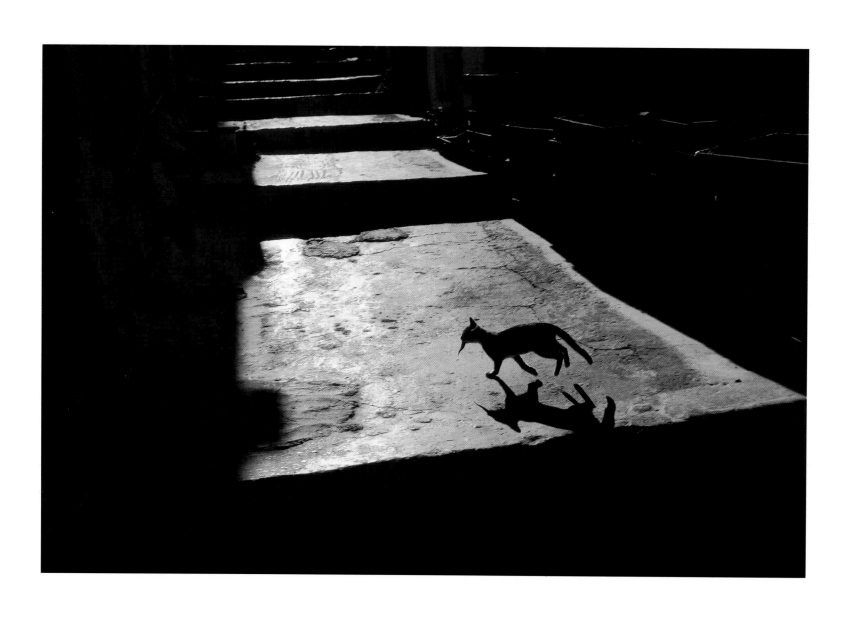

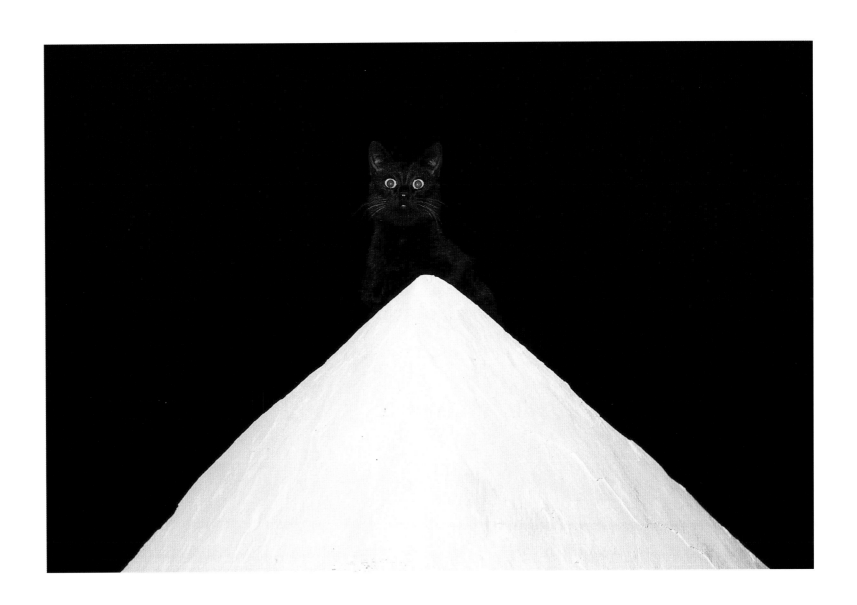

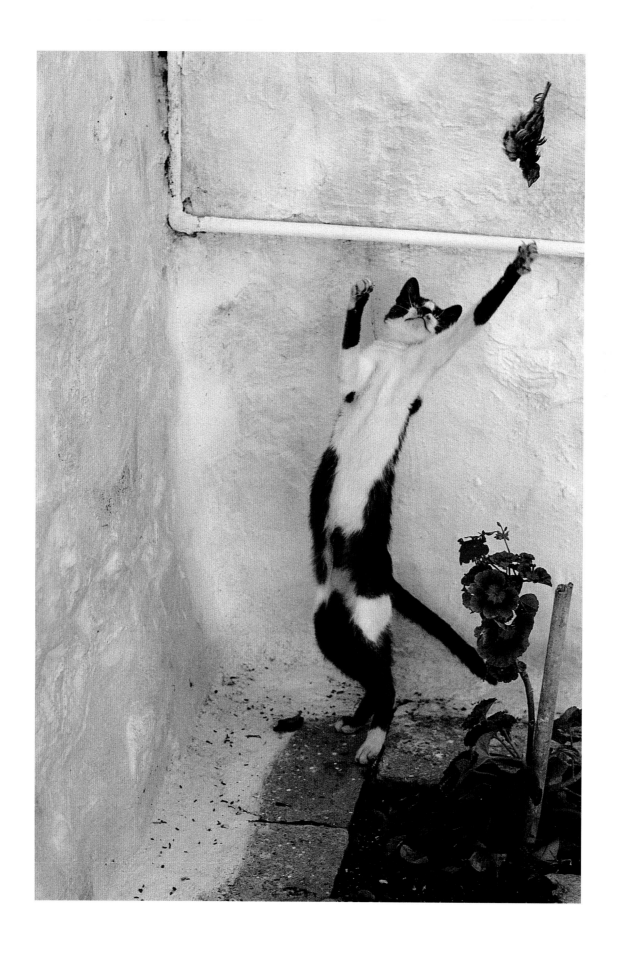

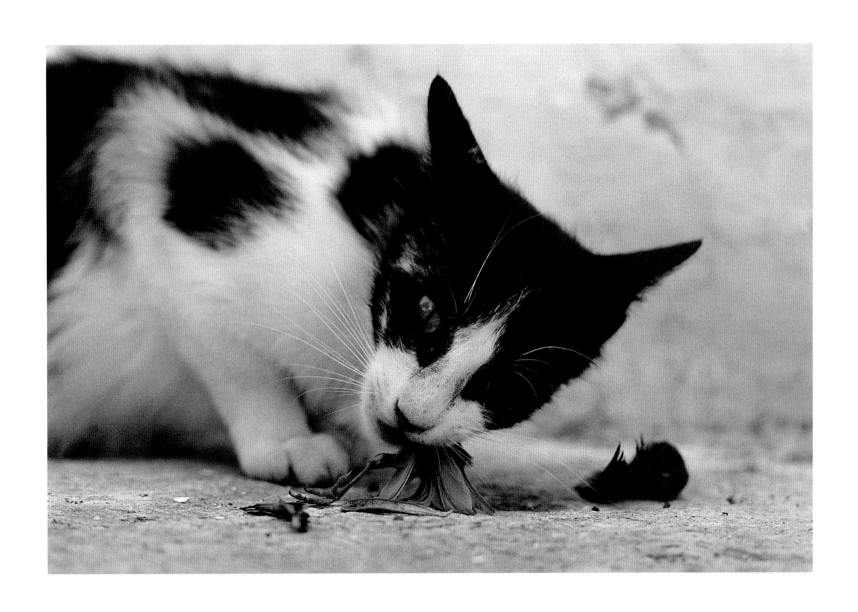

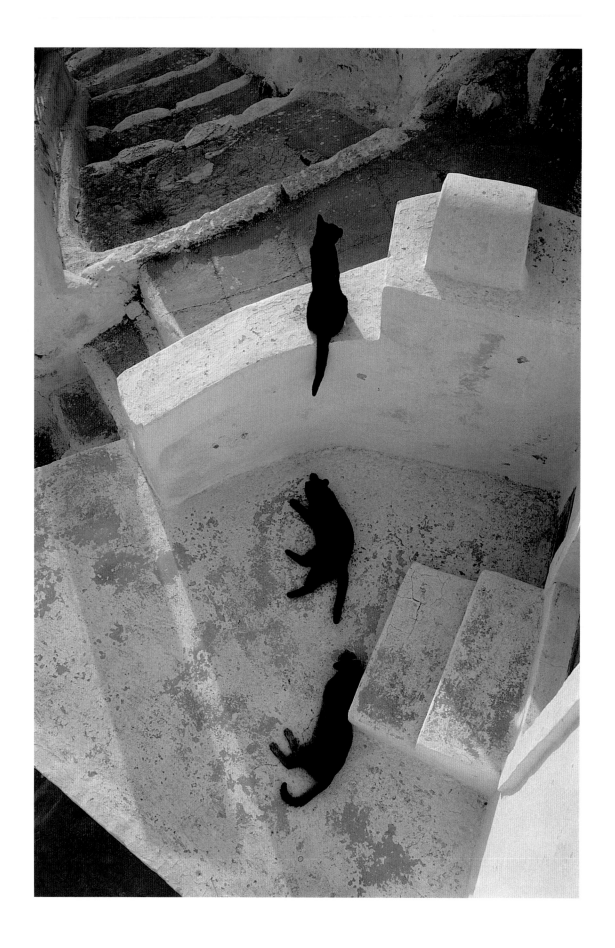

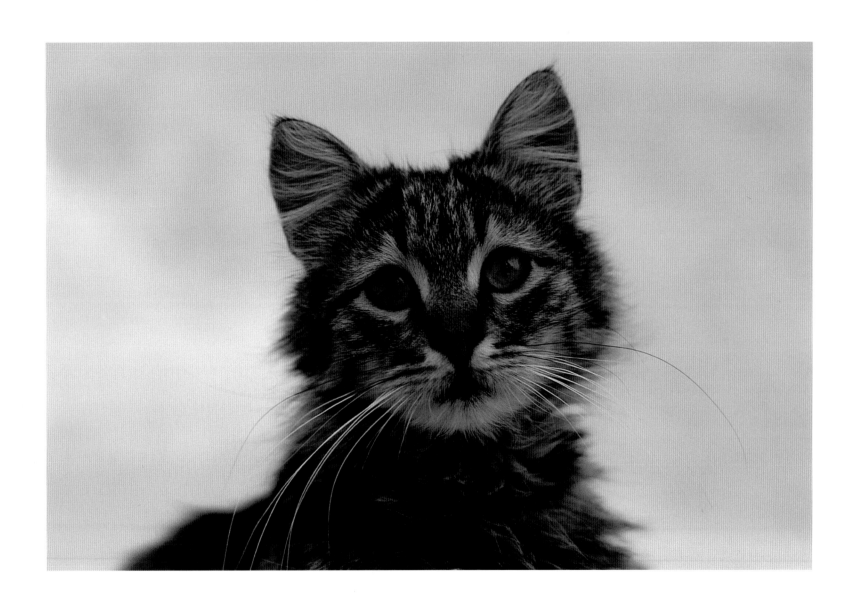

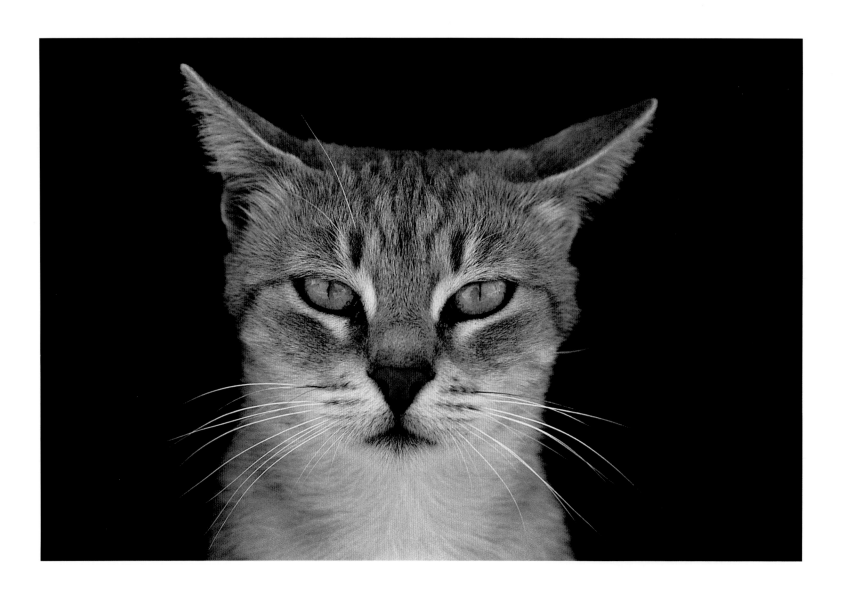

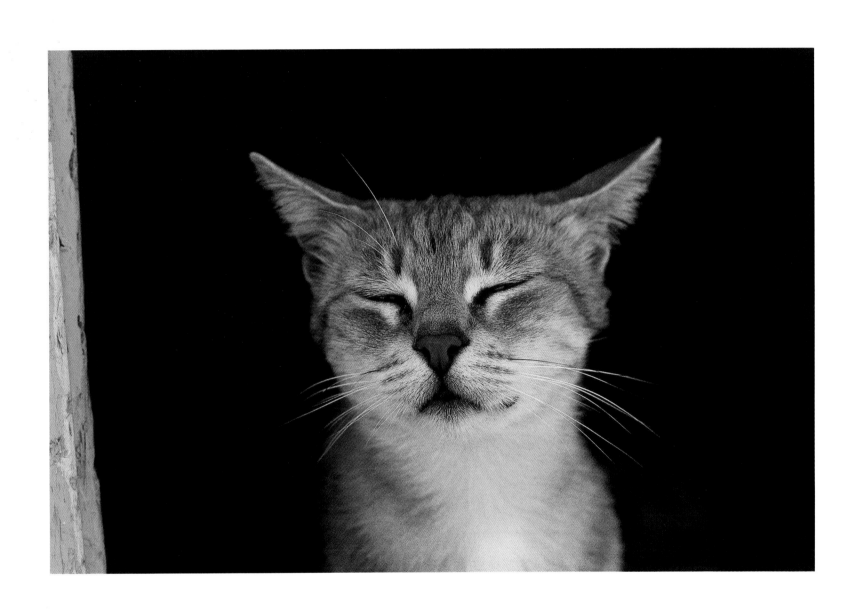

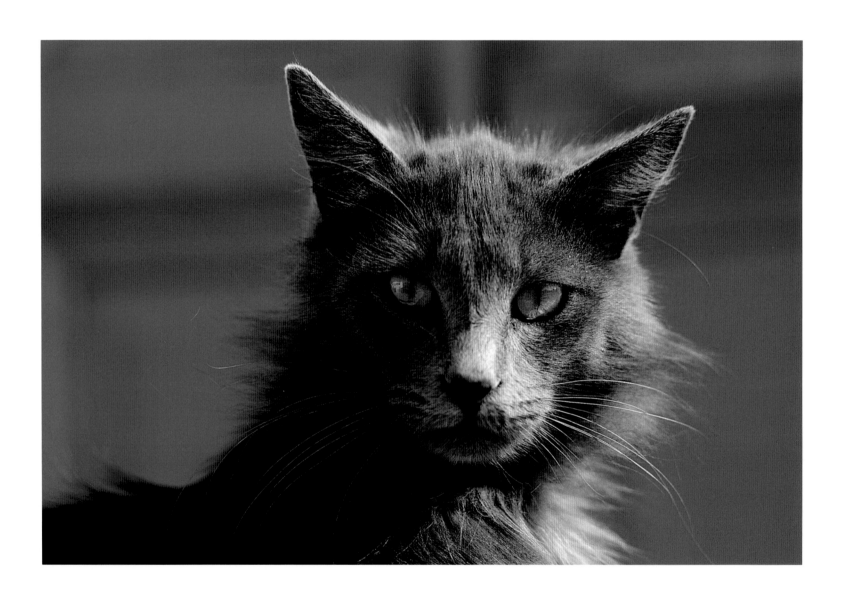

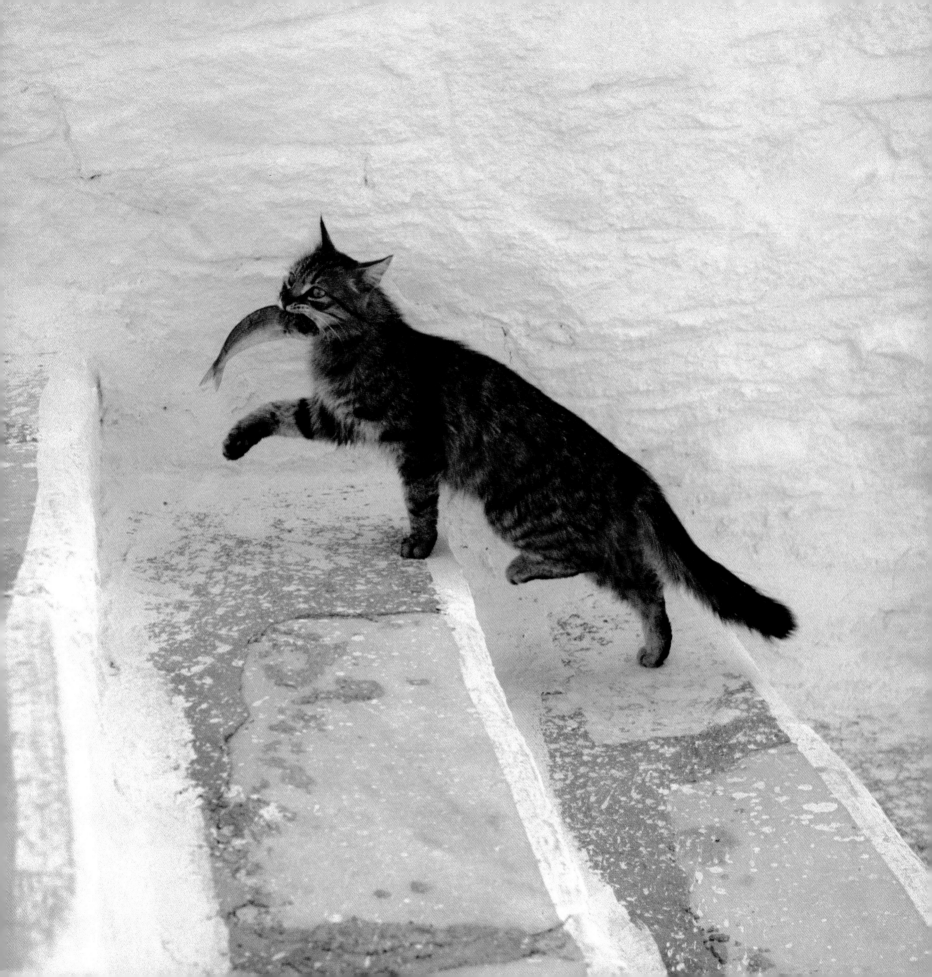

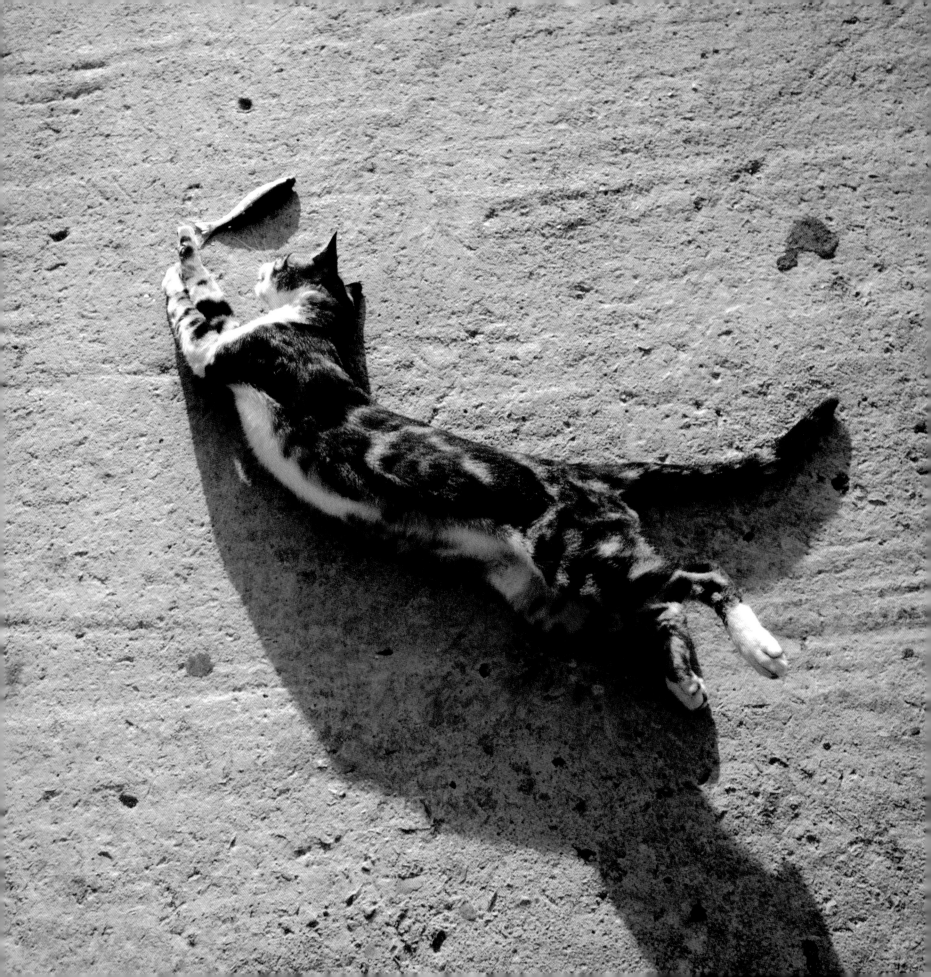

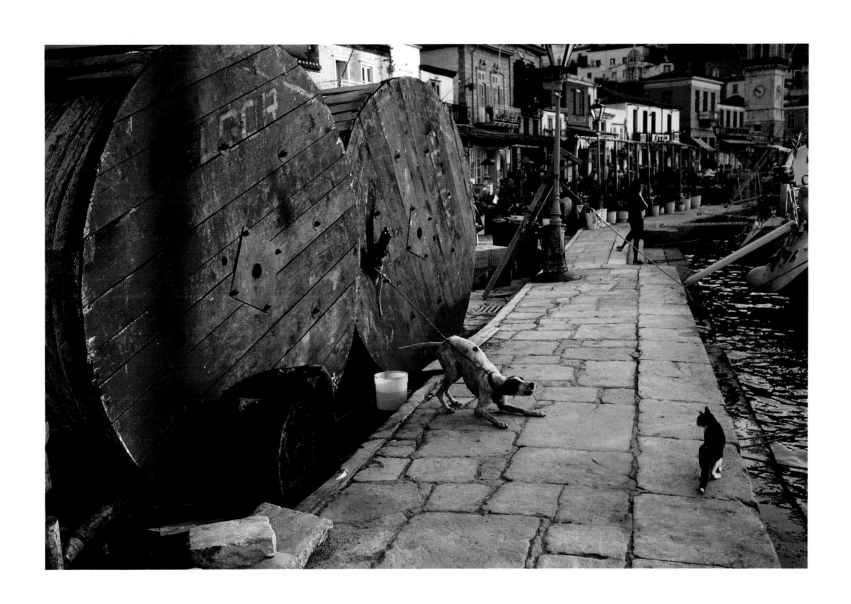

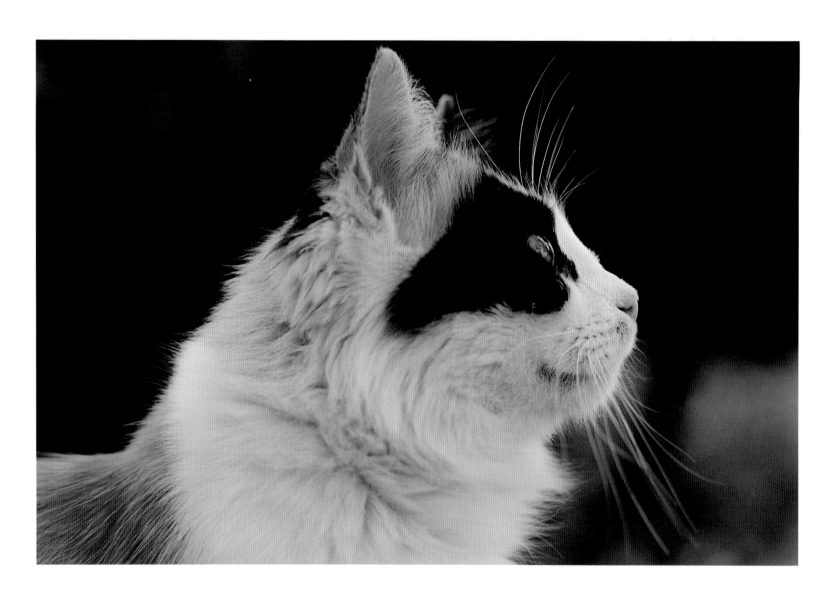

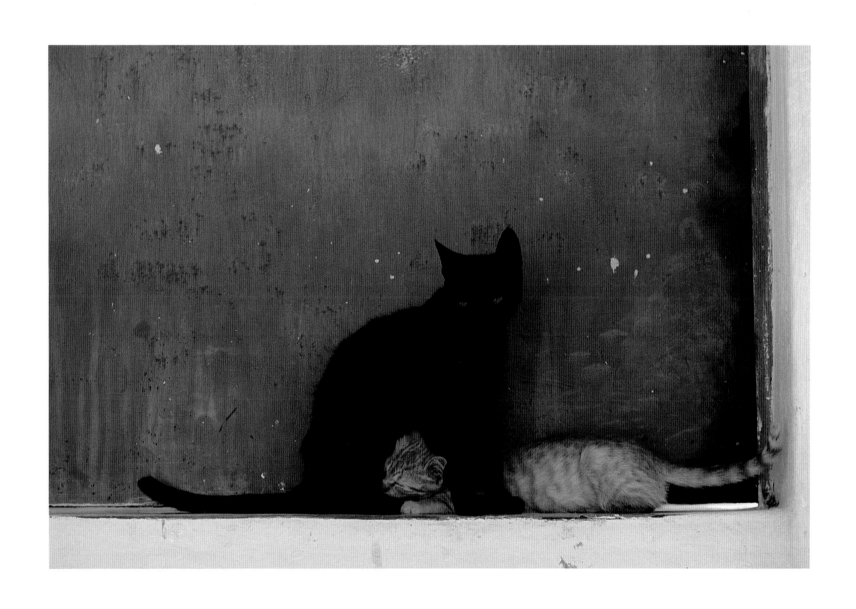

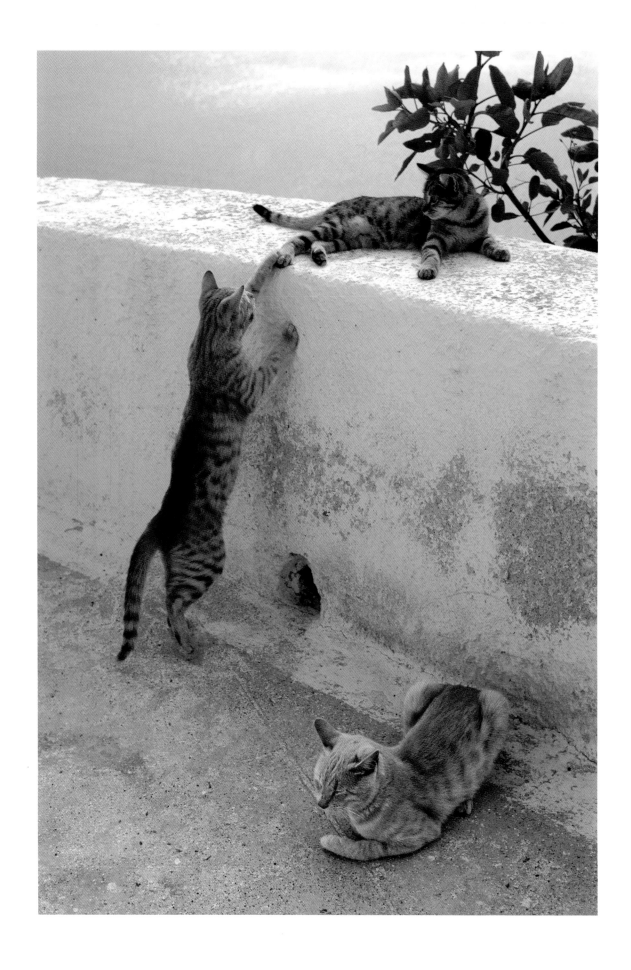

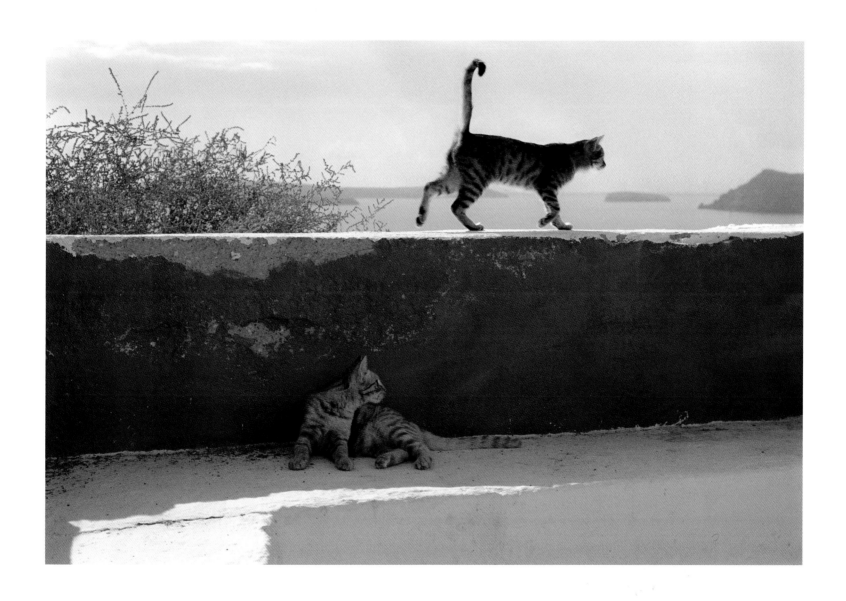

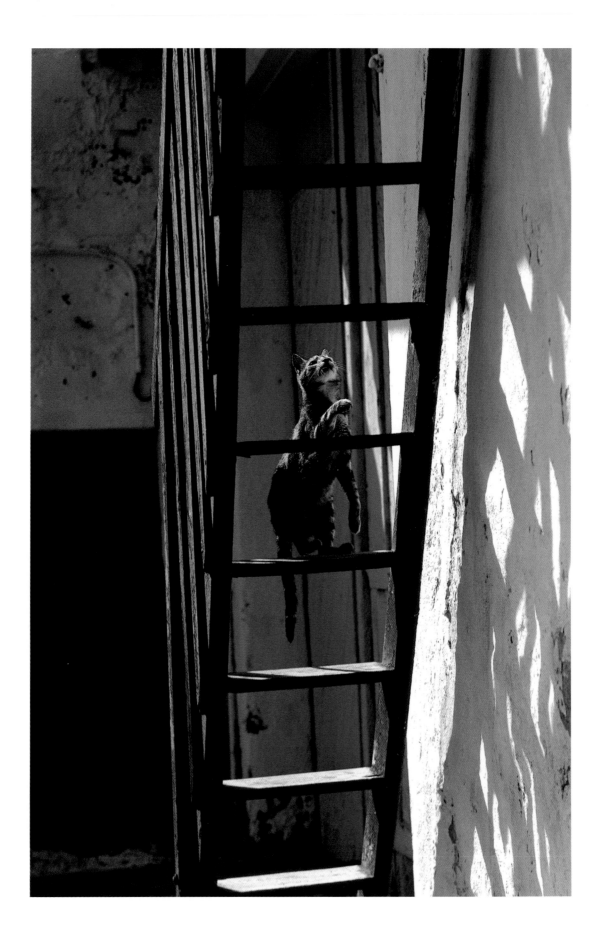

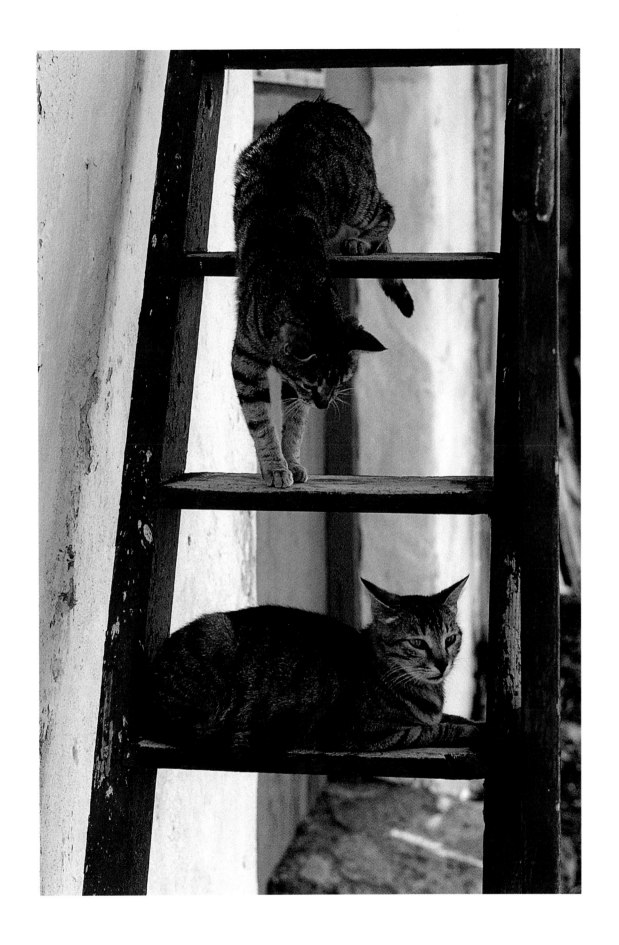

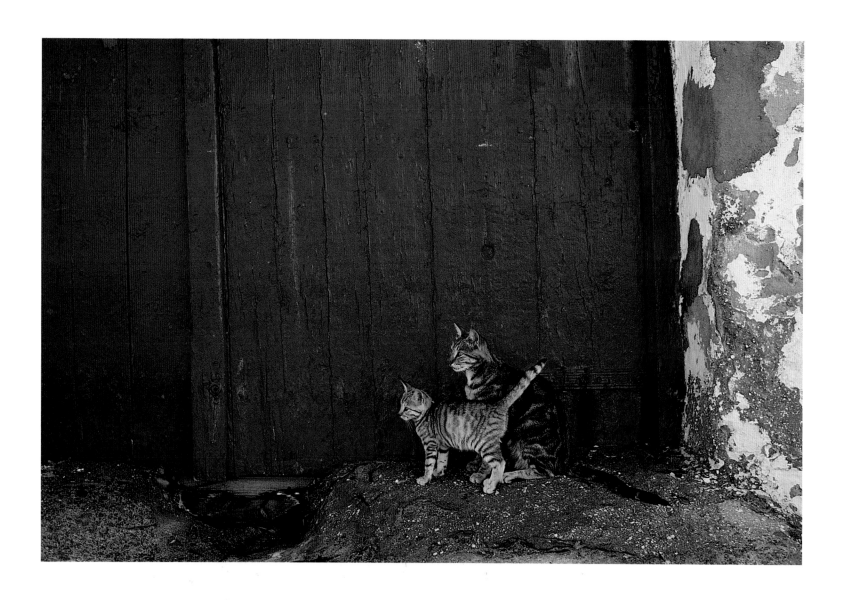

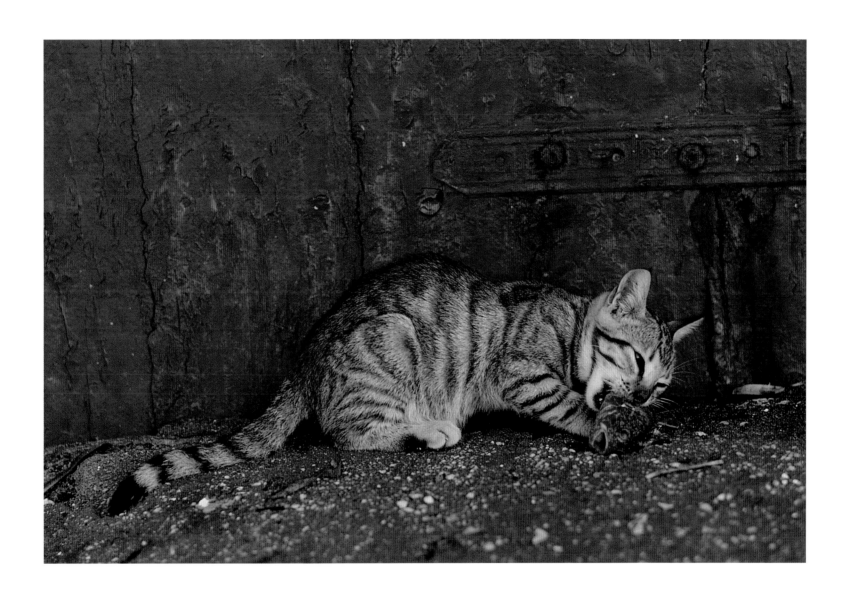

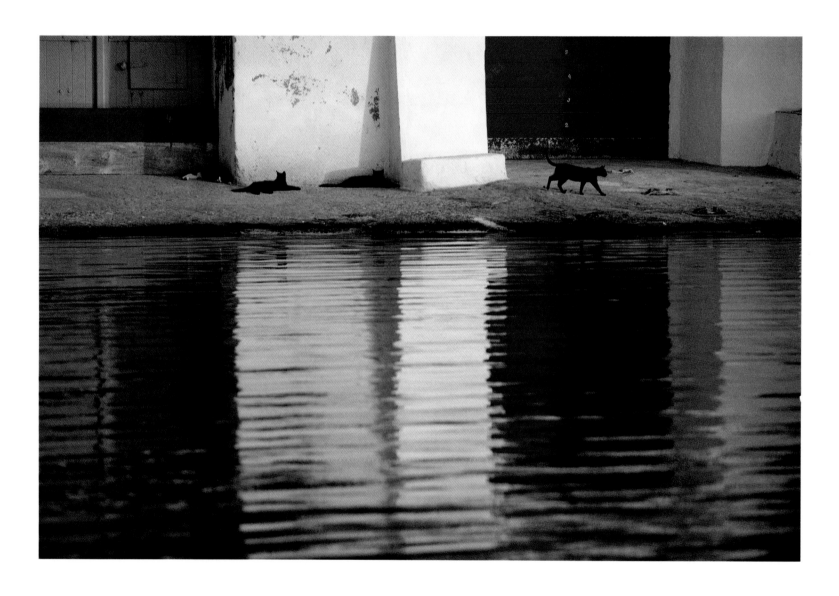

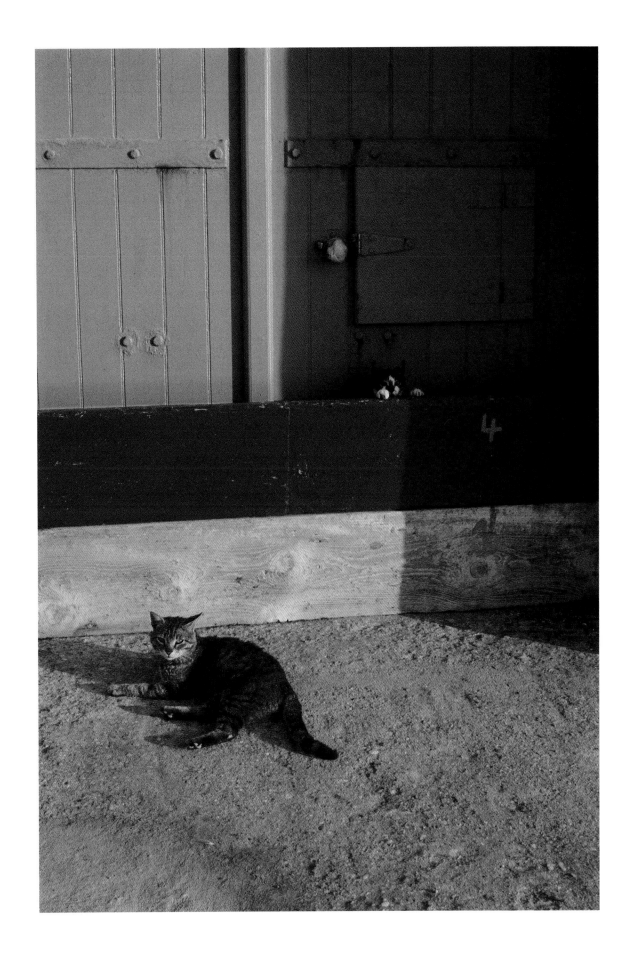

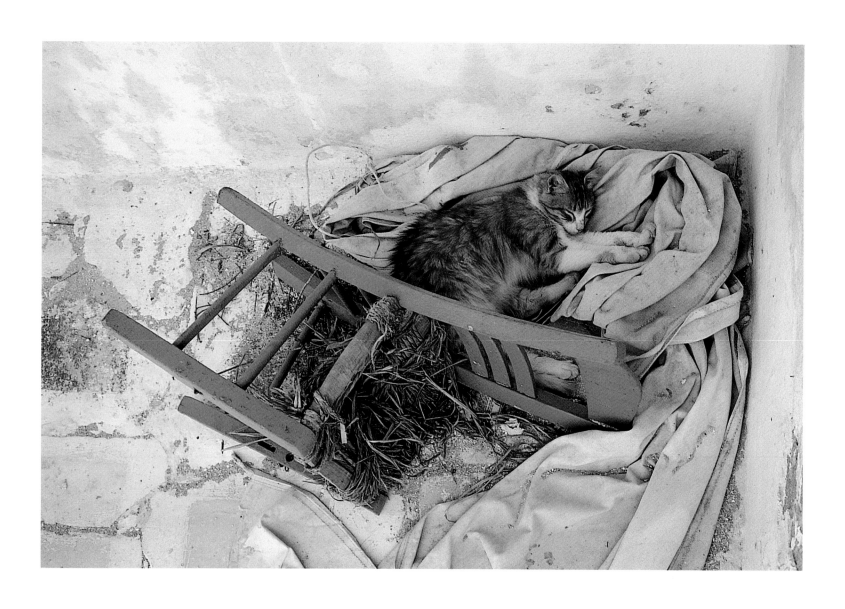

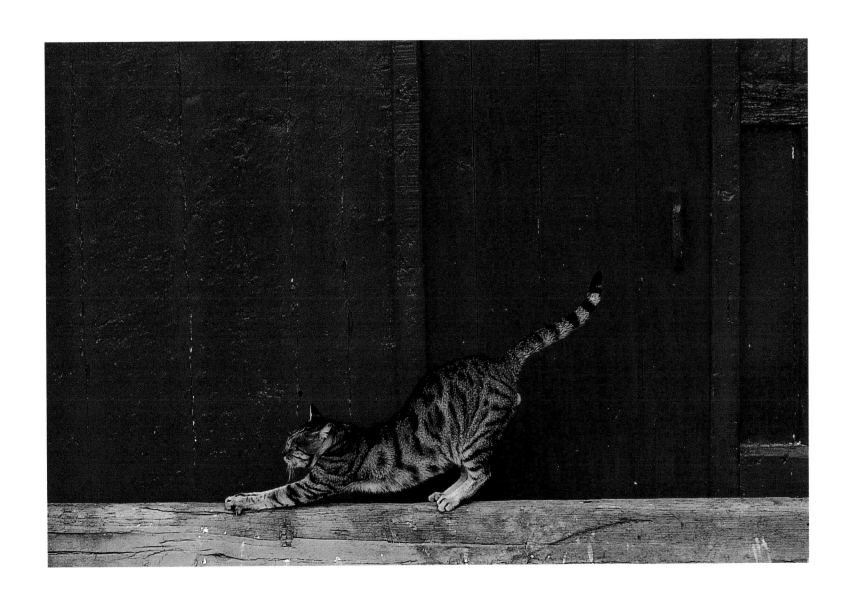

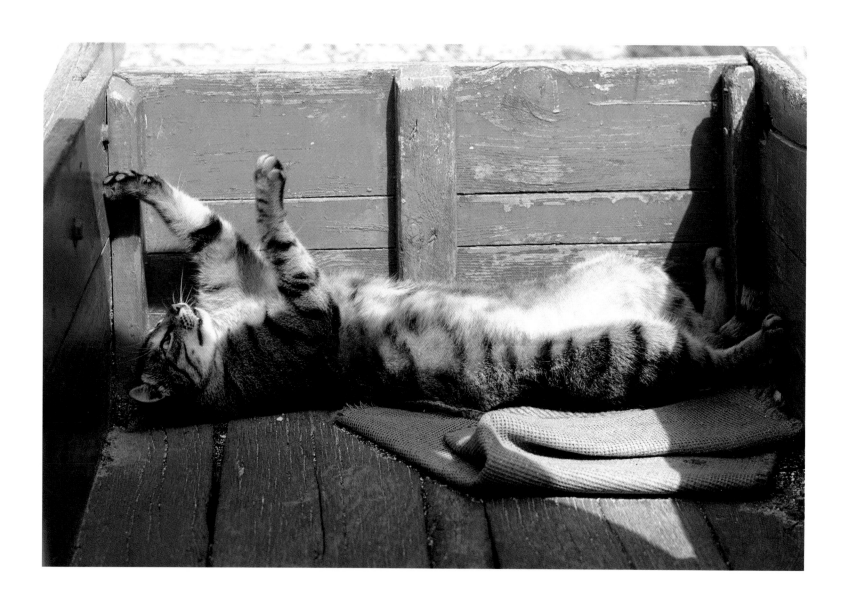

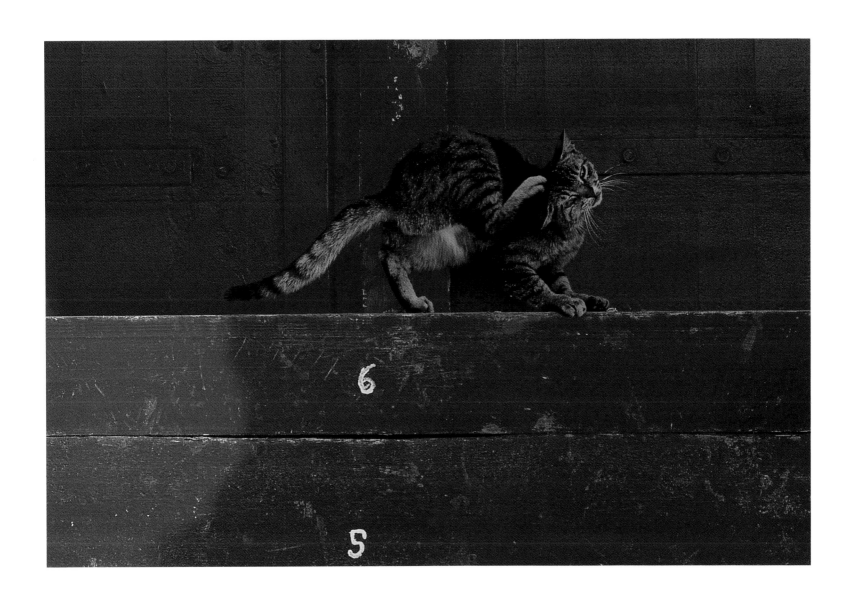

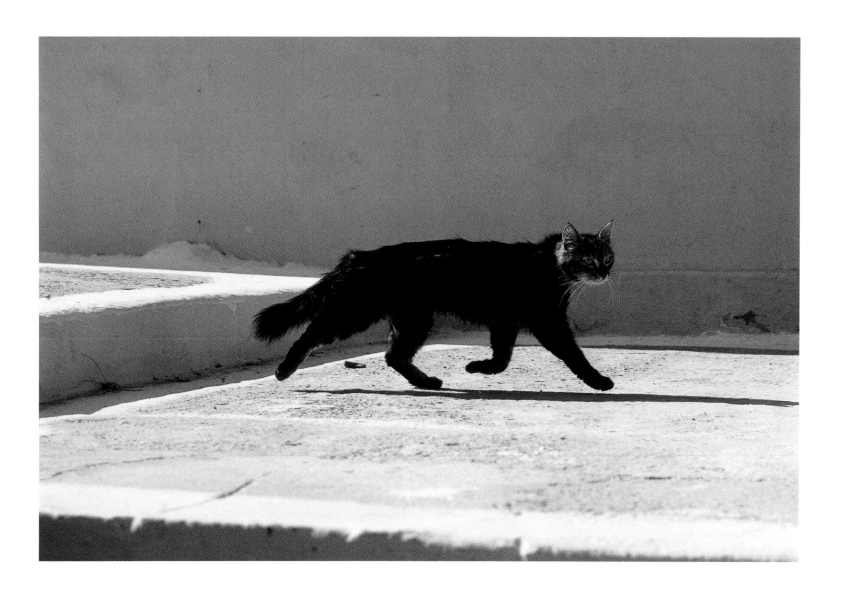

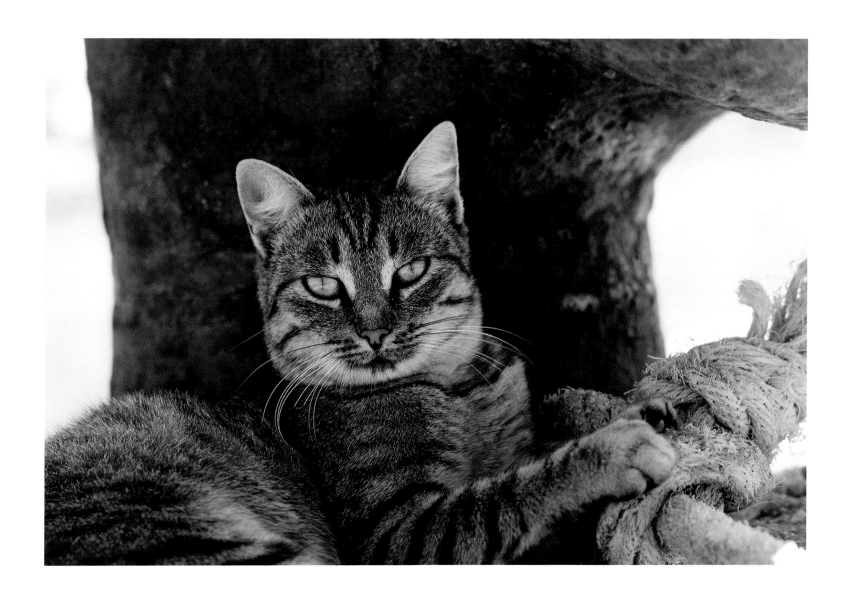

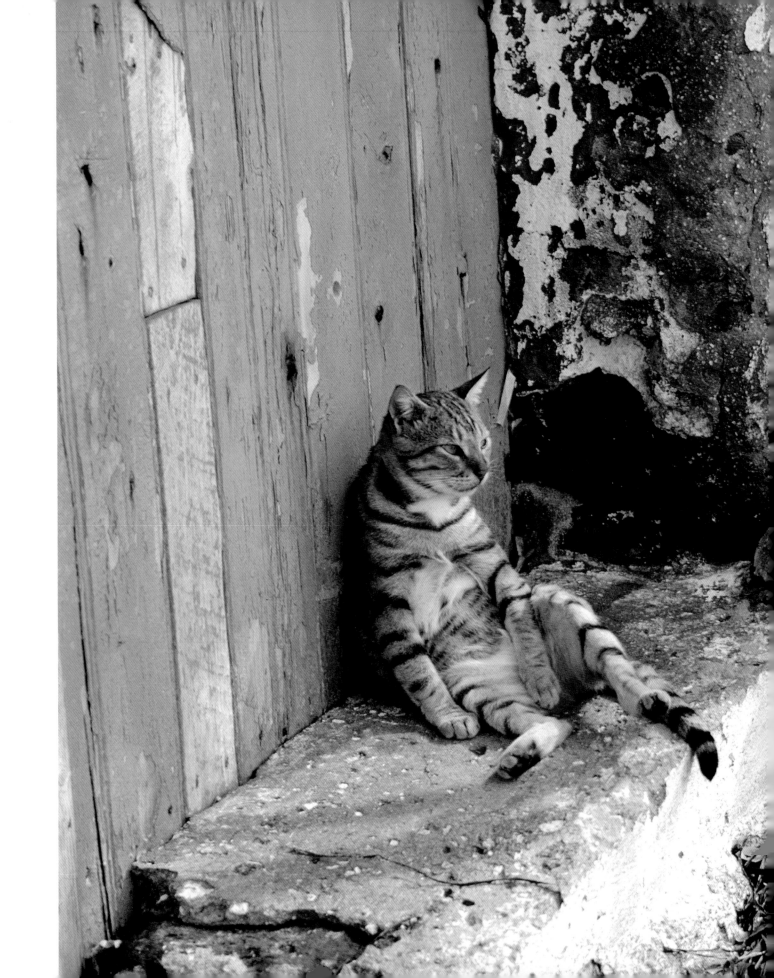

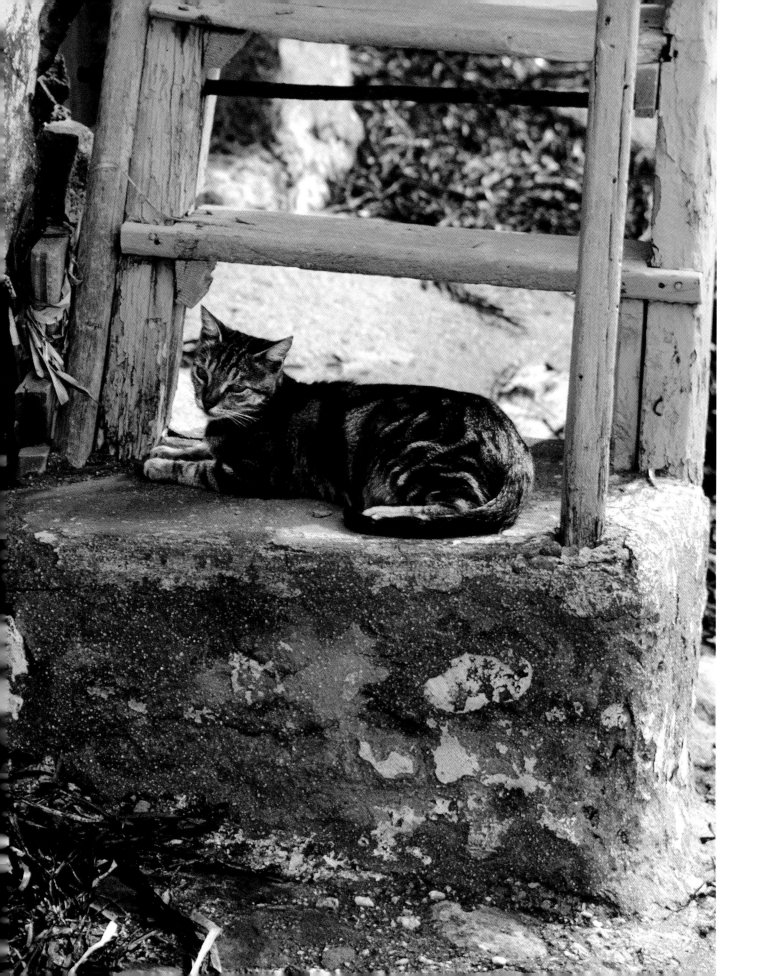

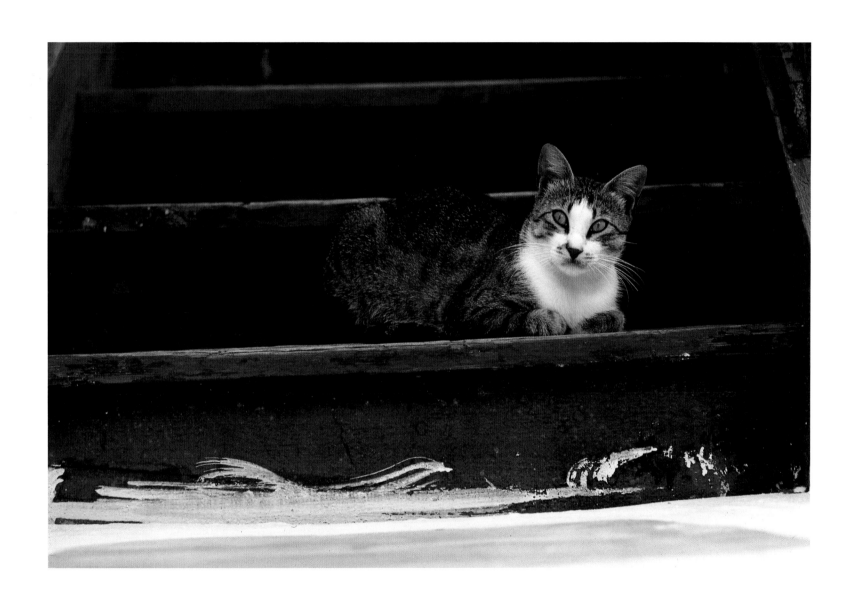

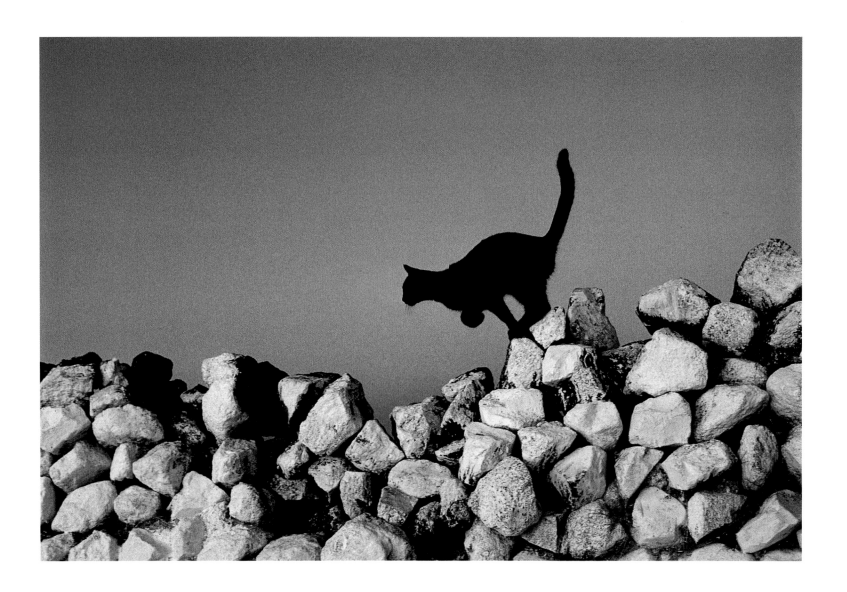

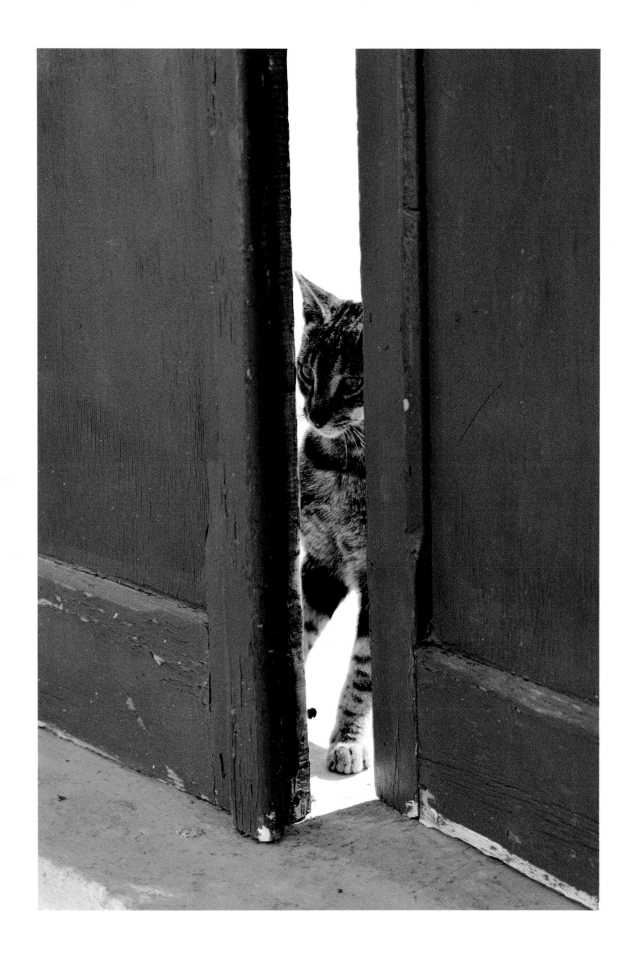

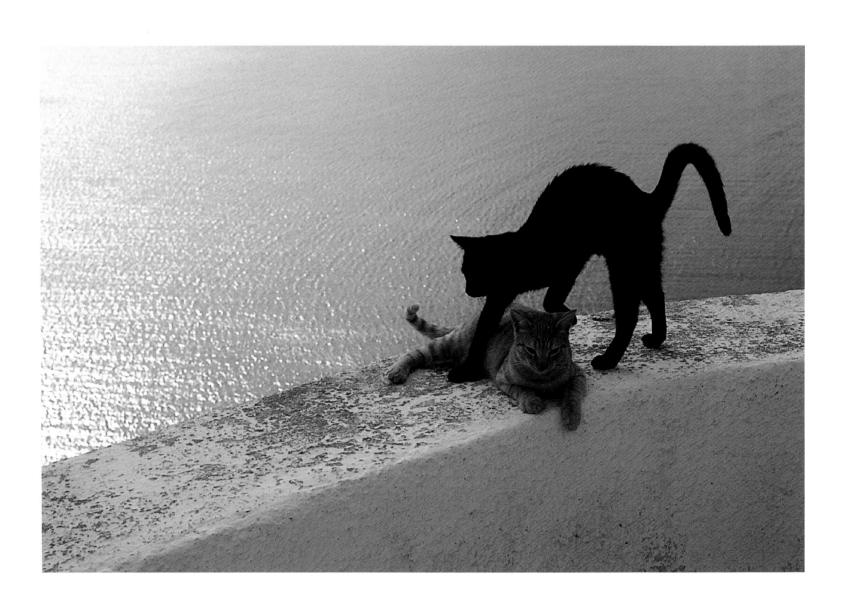

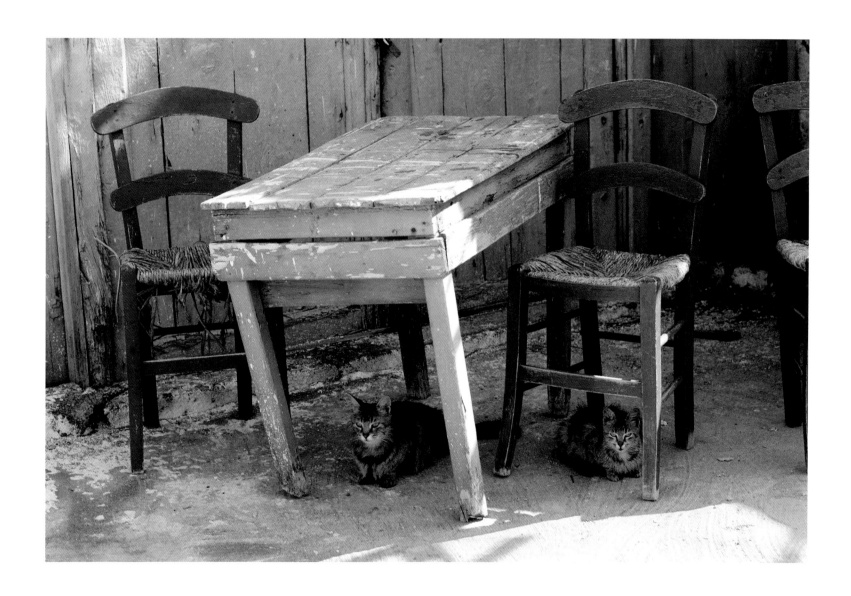

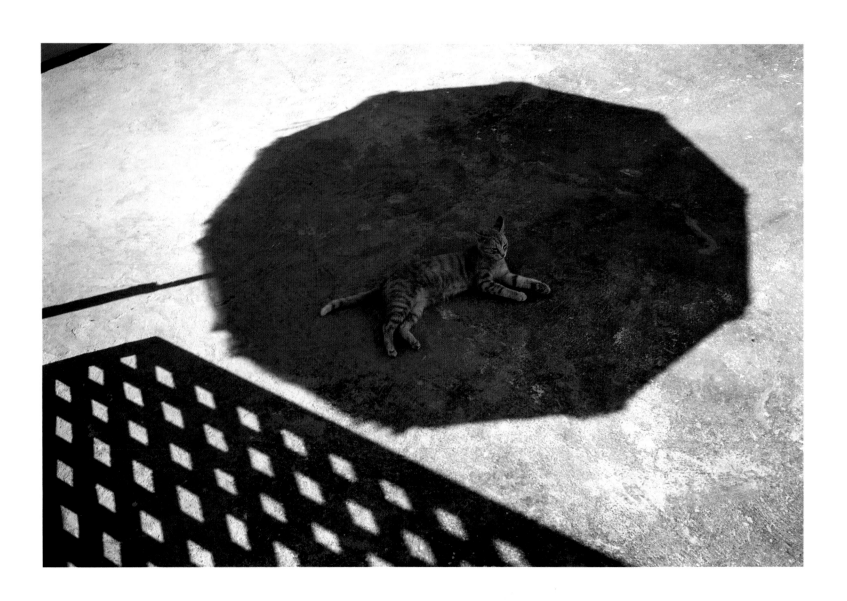

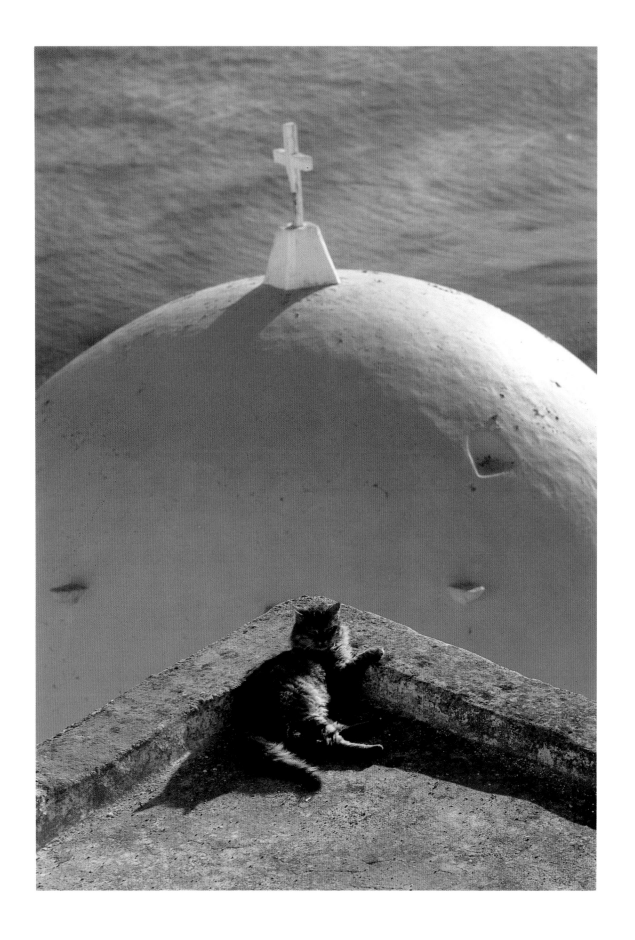

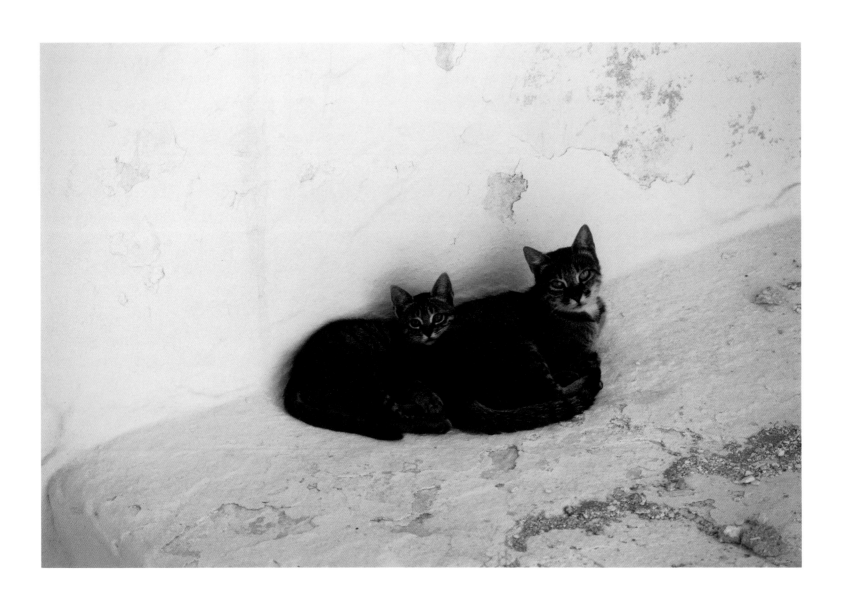

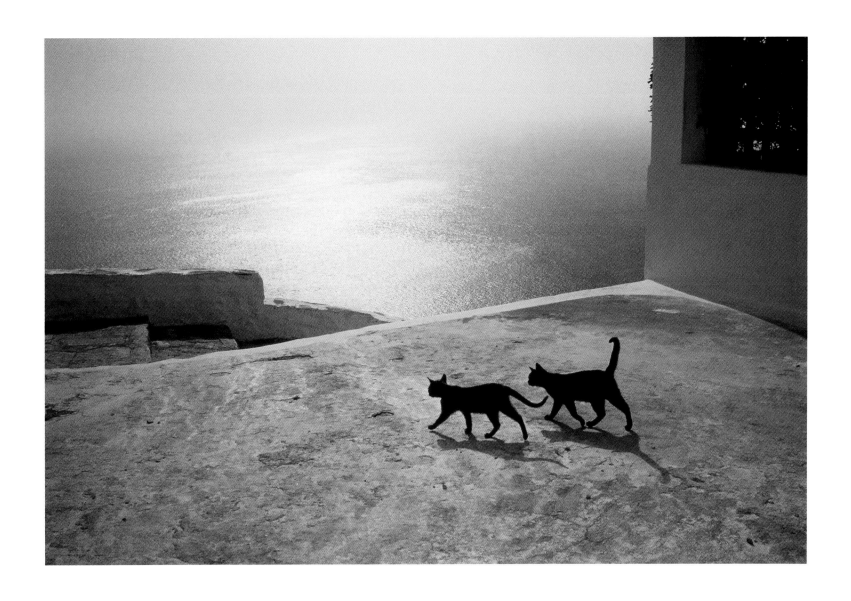

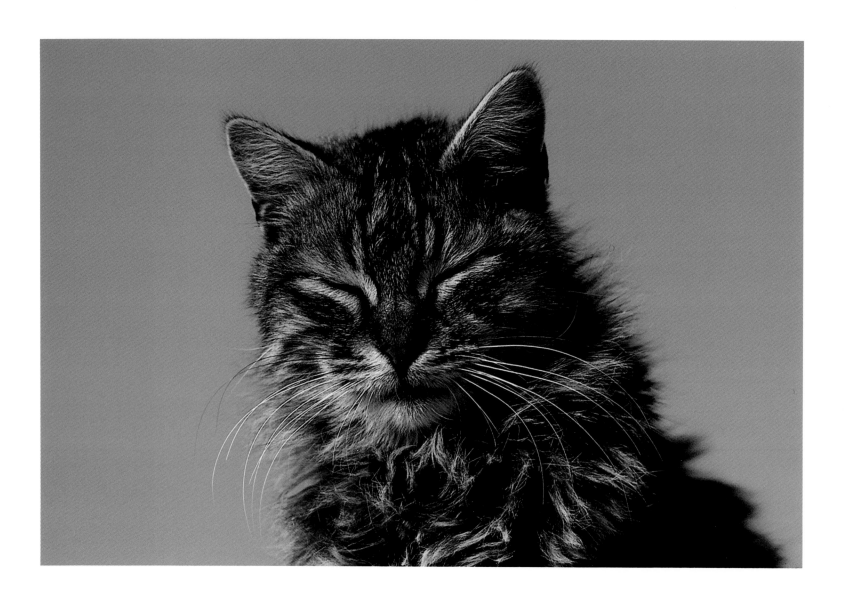

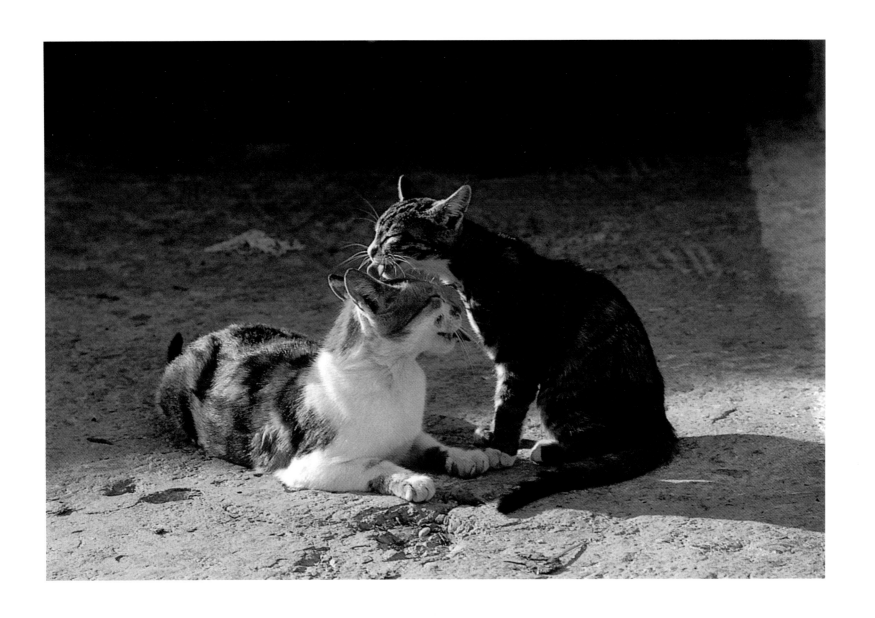

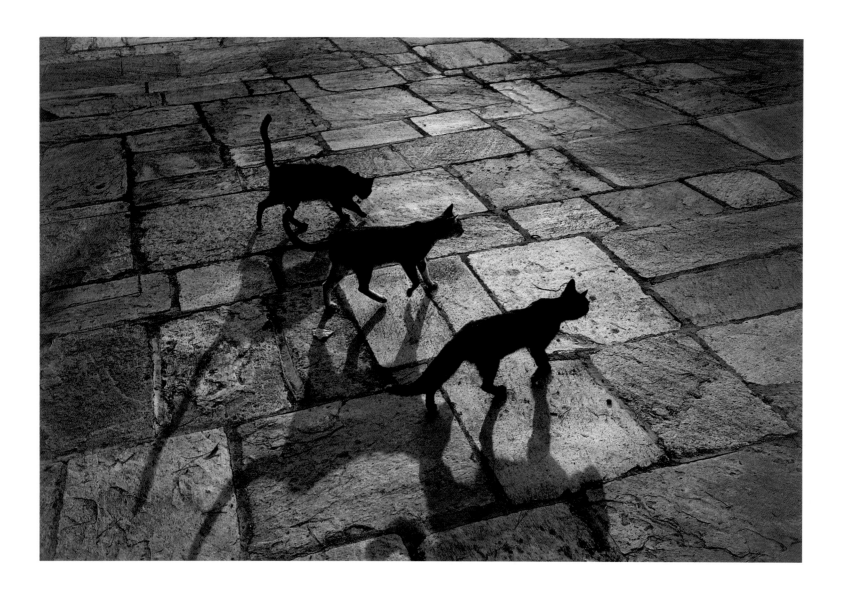

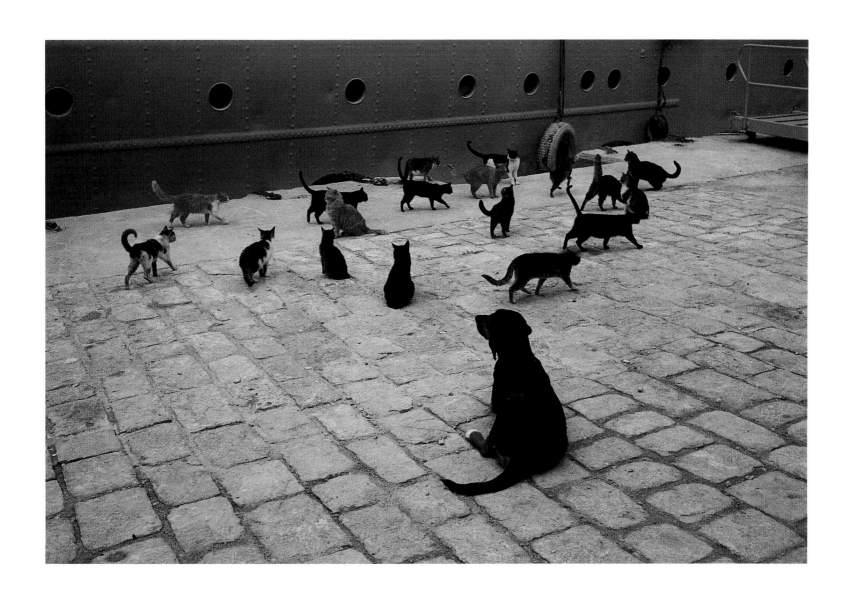

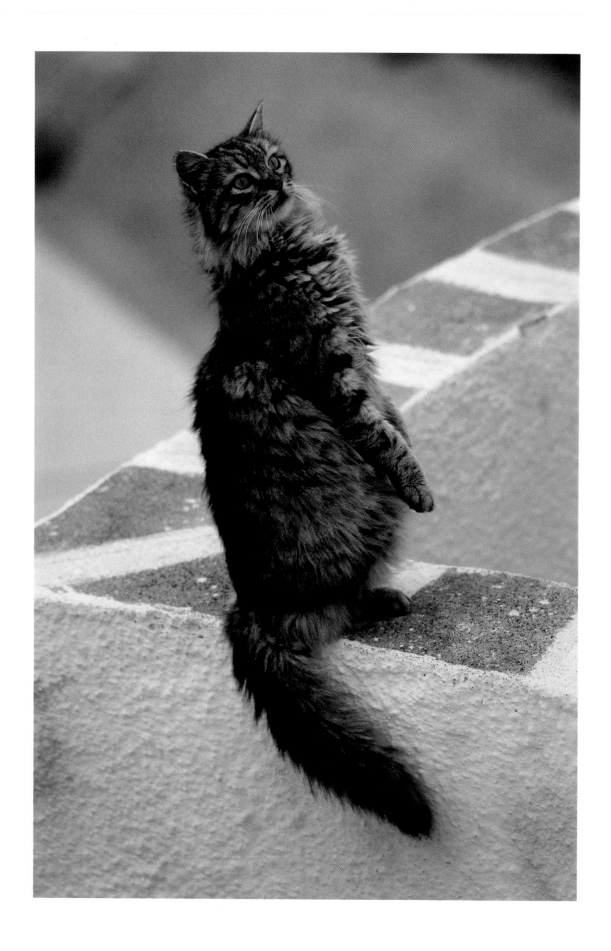

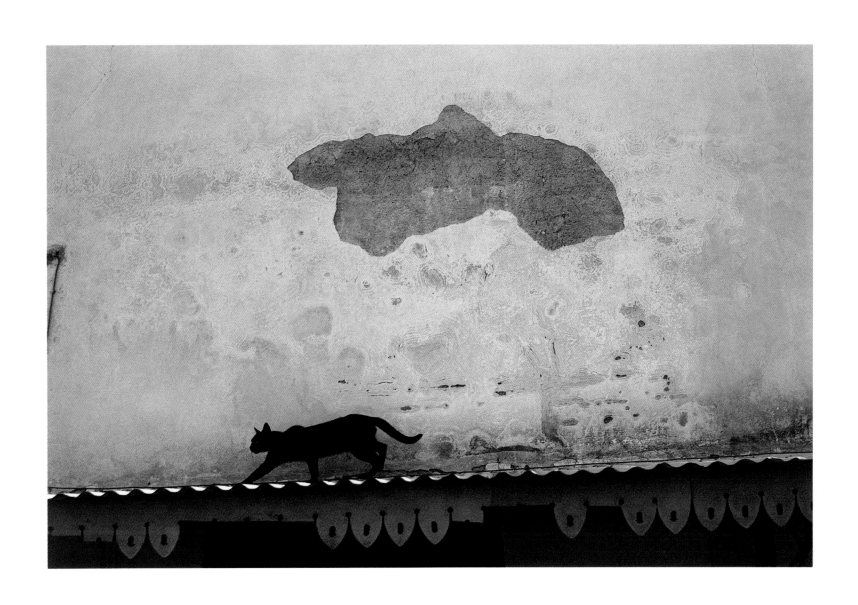

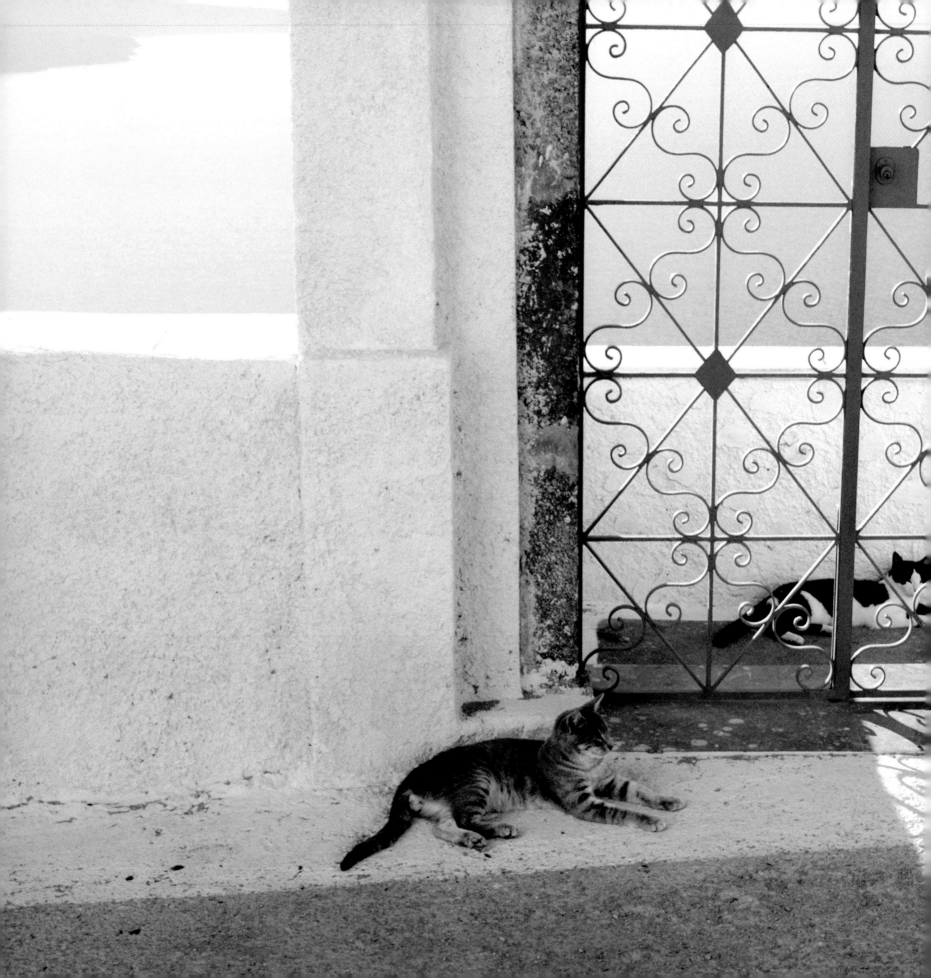

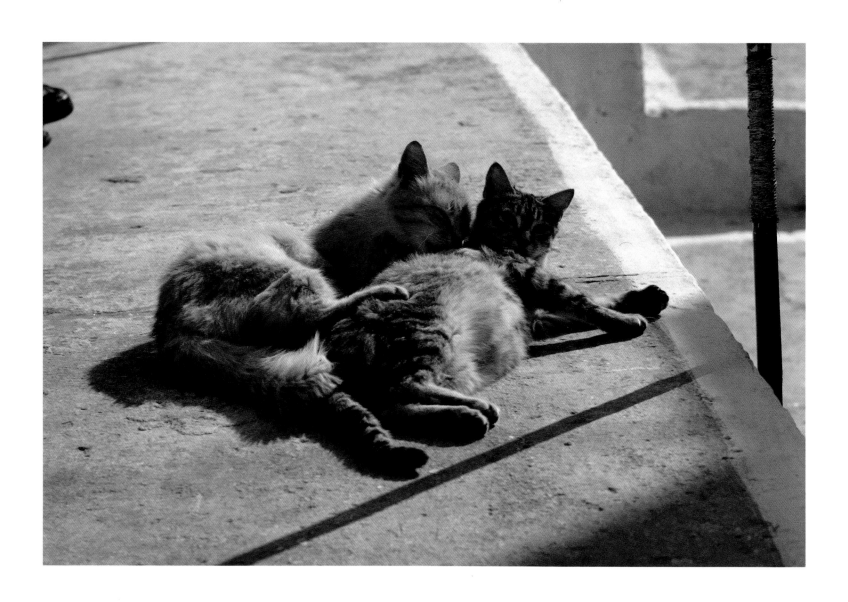

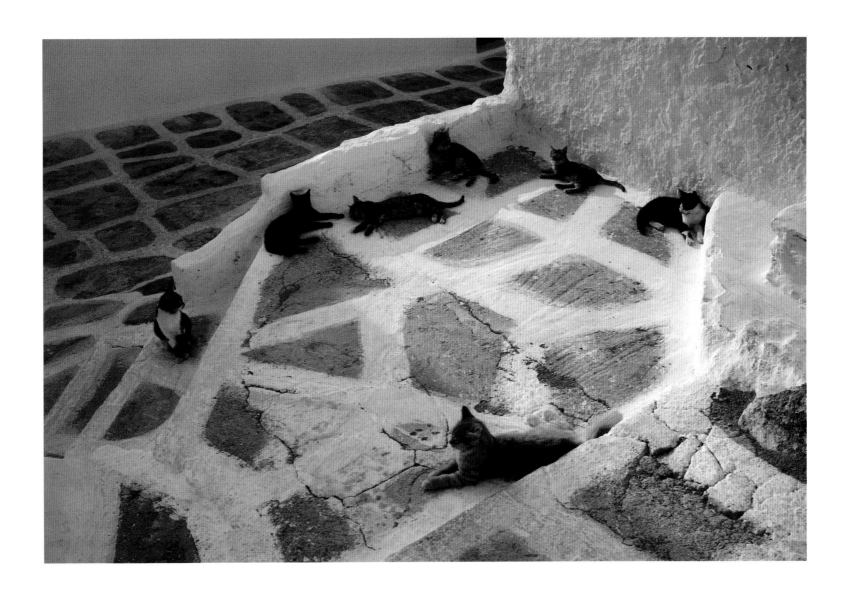

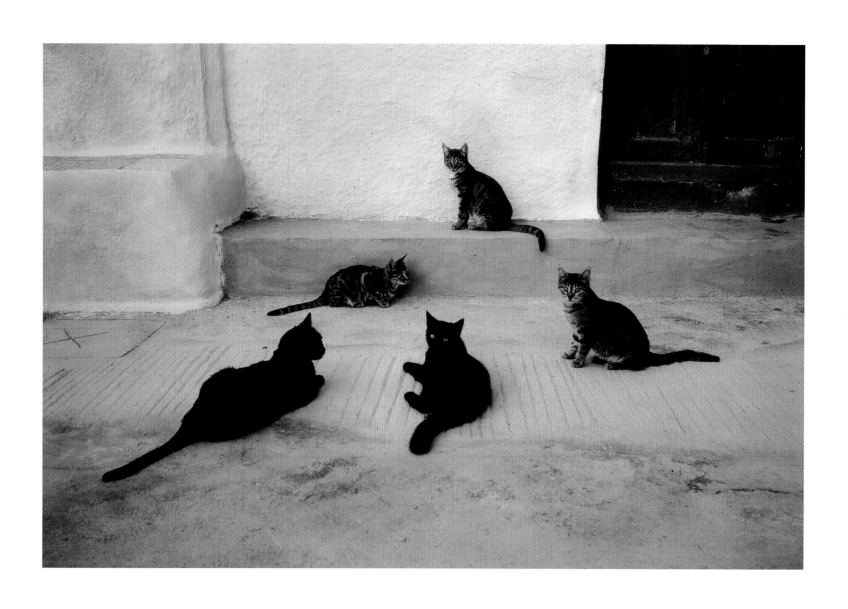

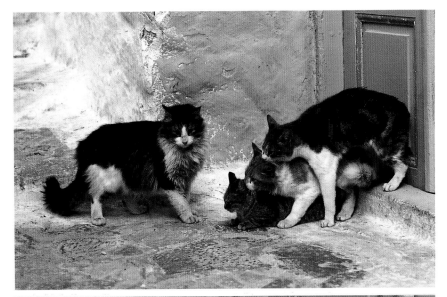

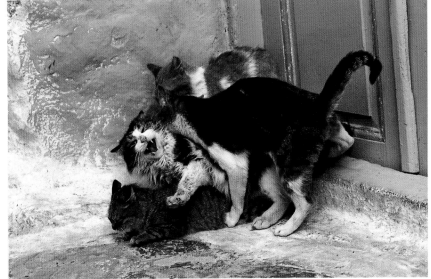

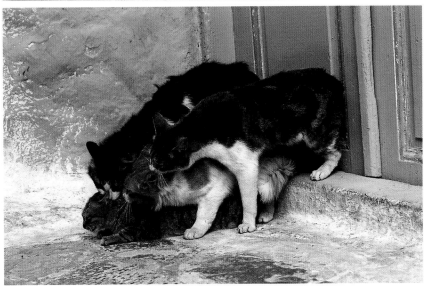

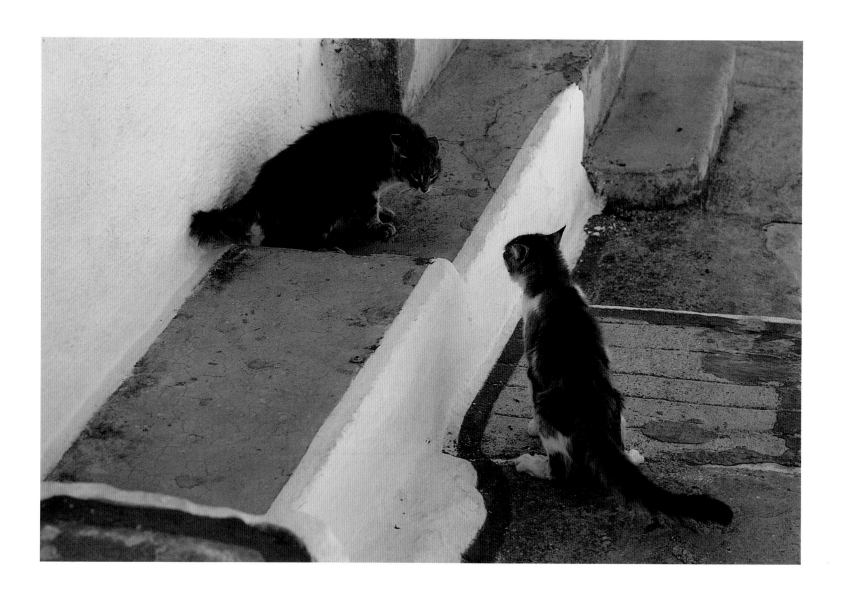

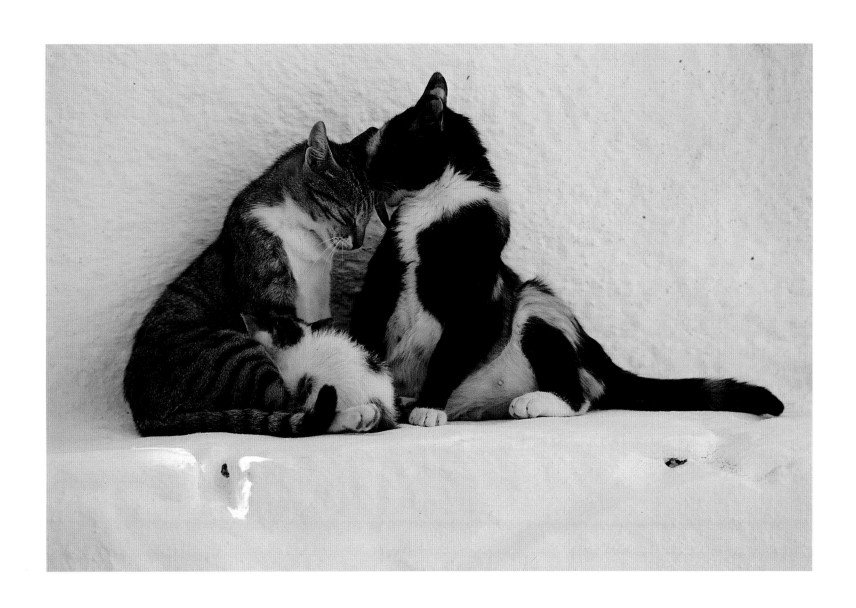

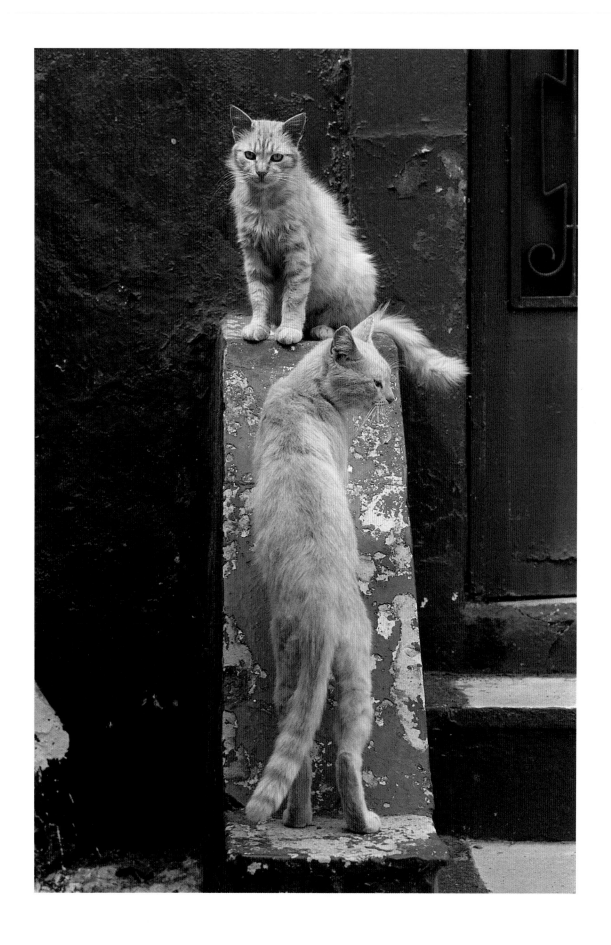

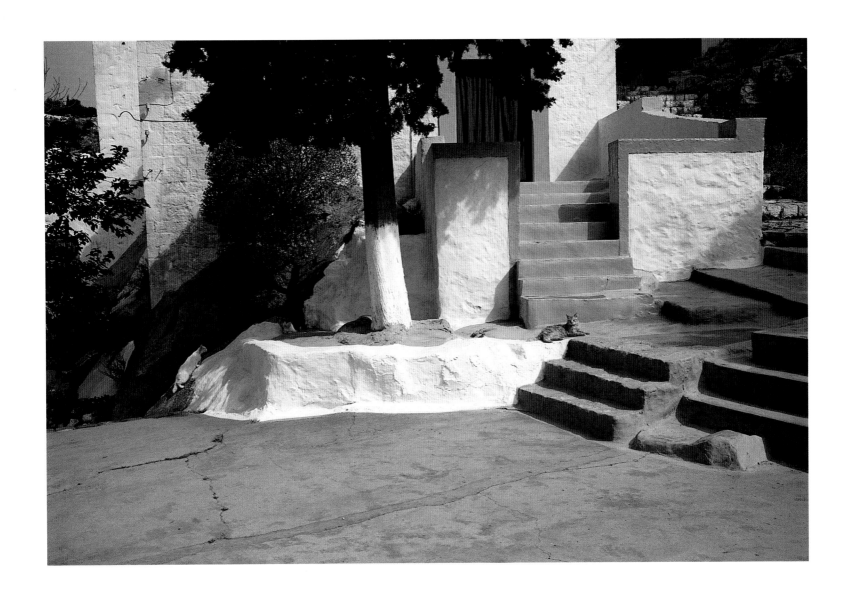

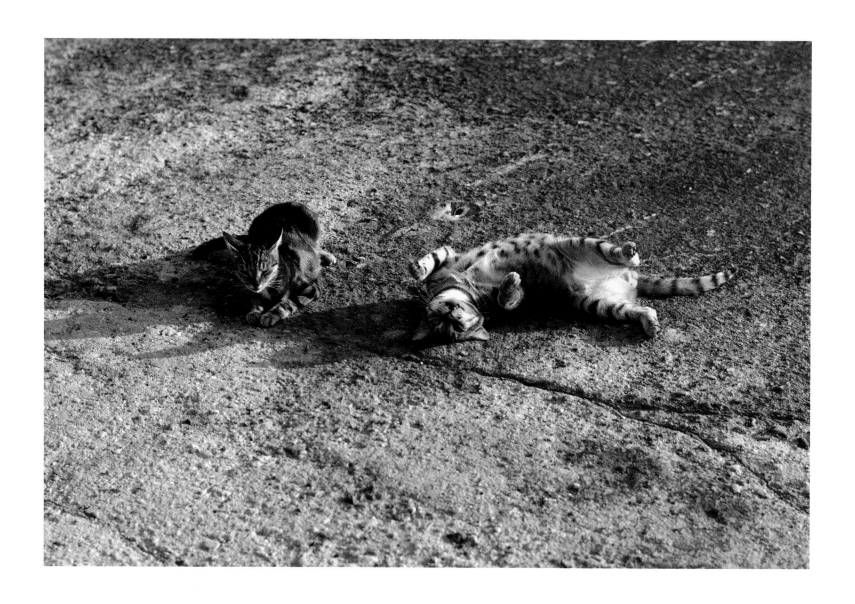

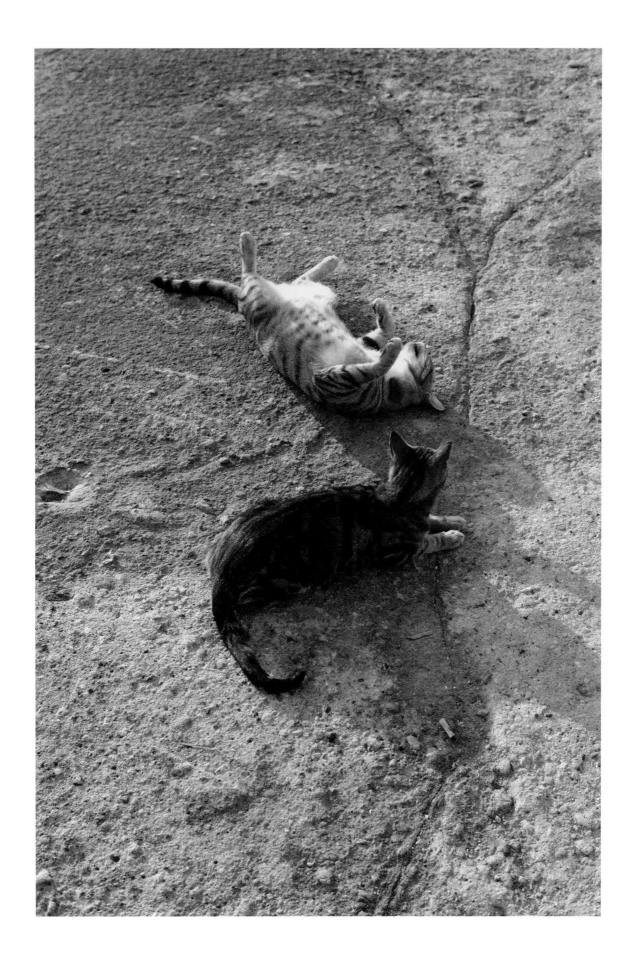

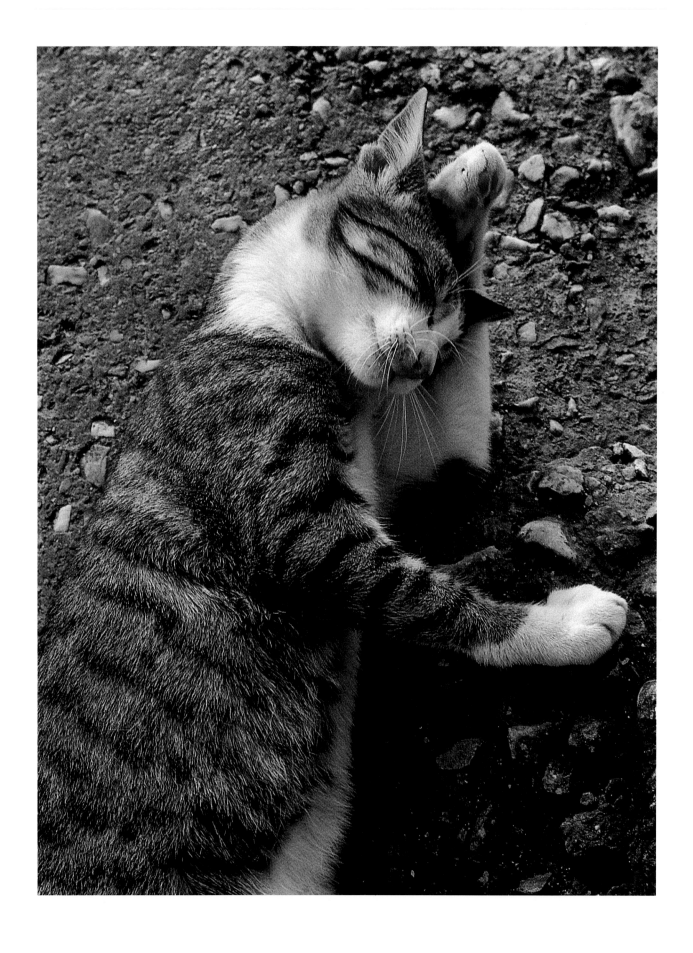

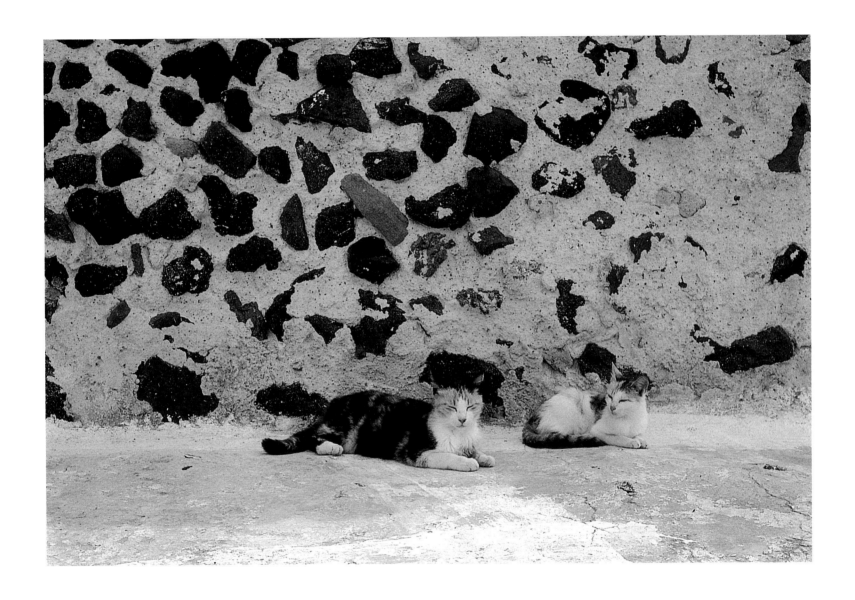

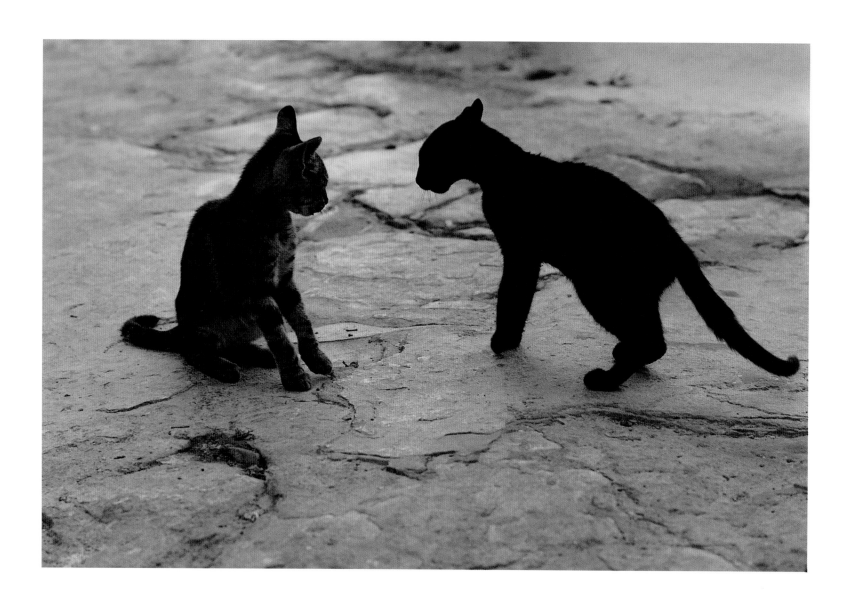

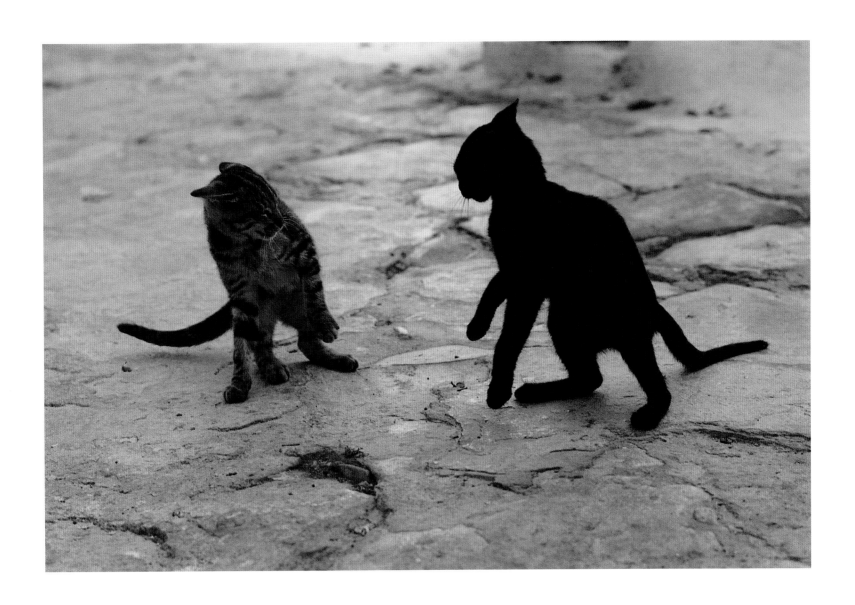

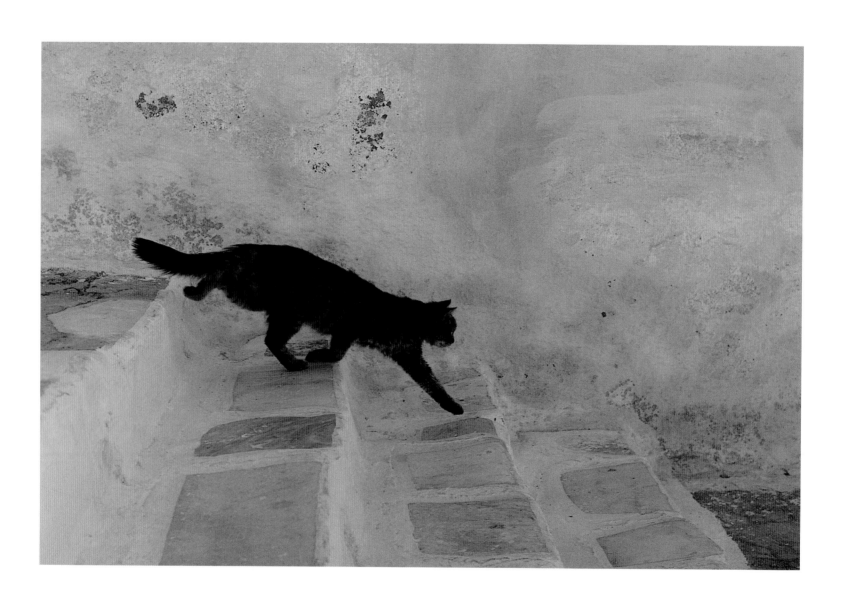

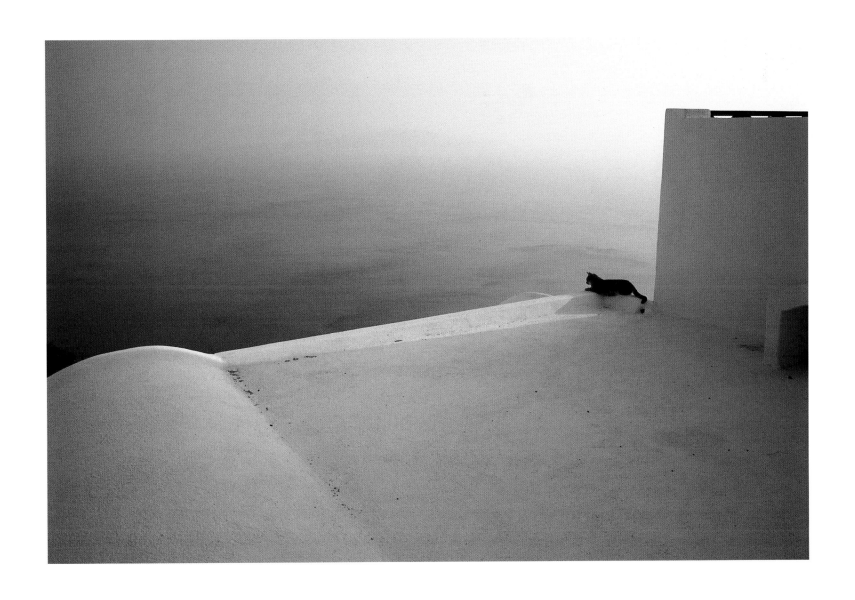

347

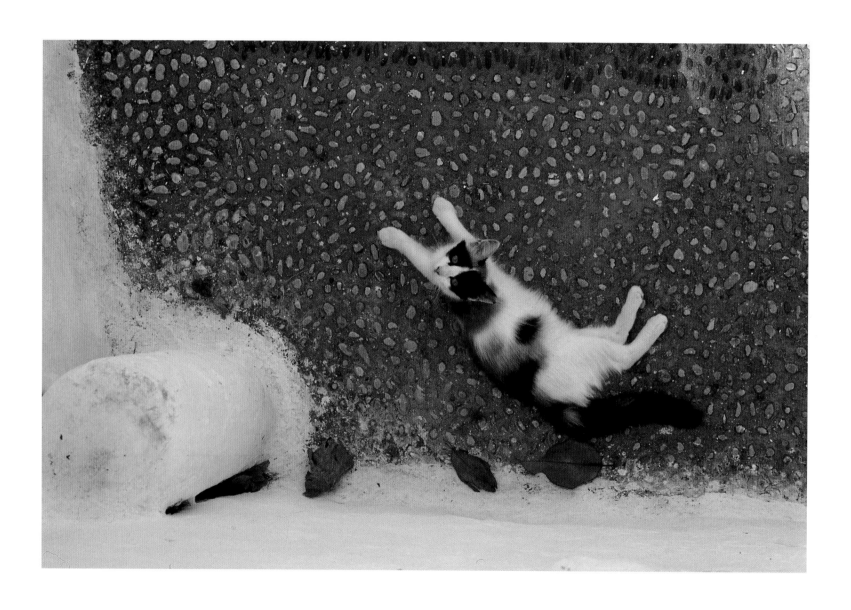

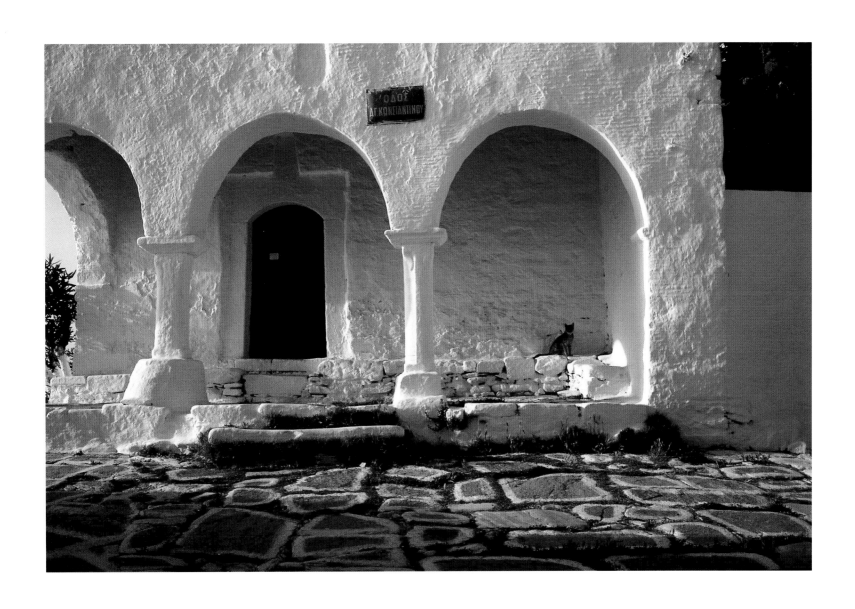

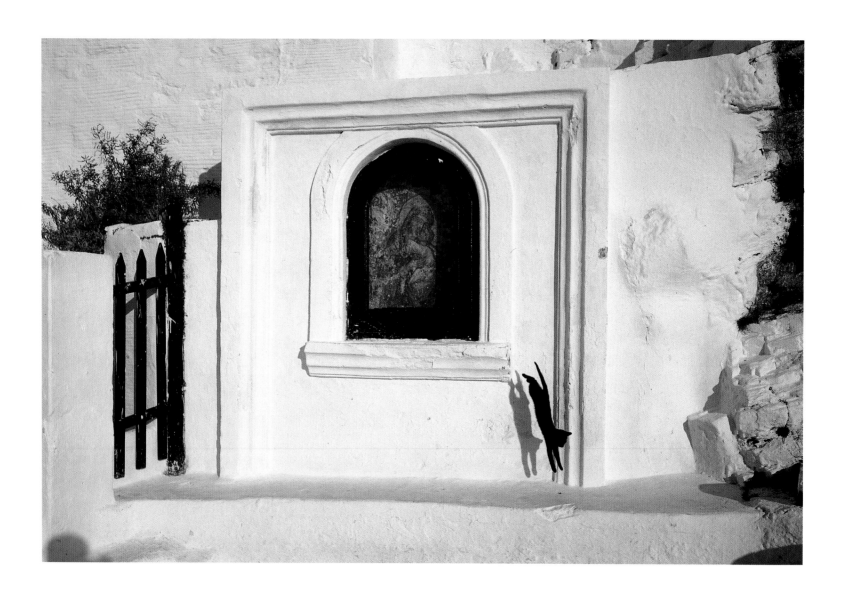

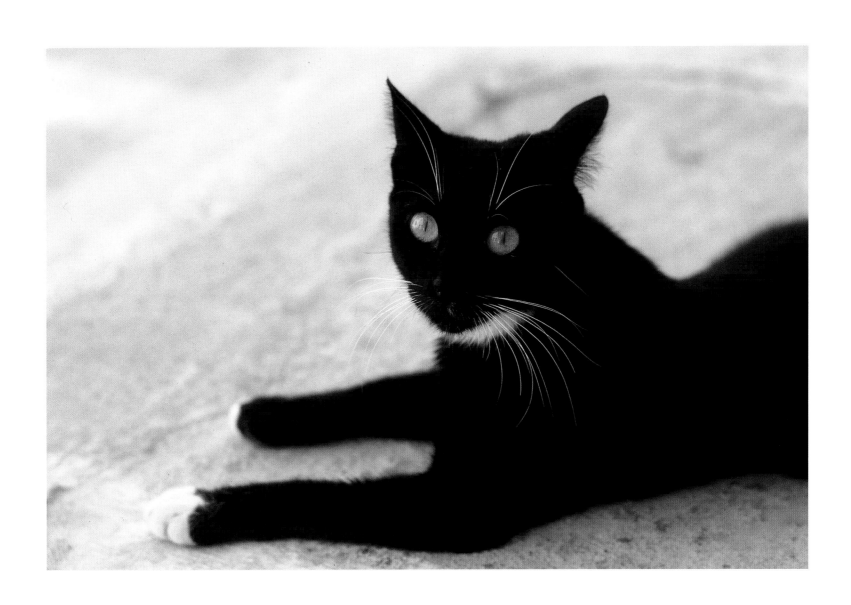

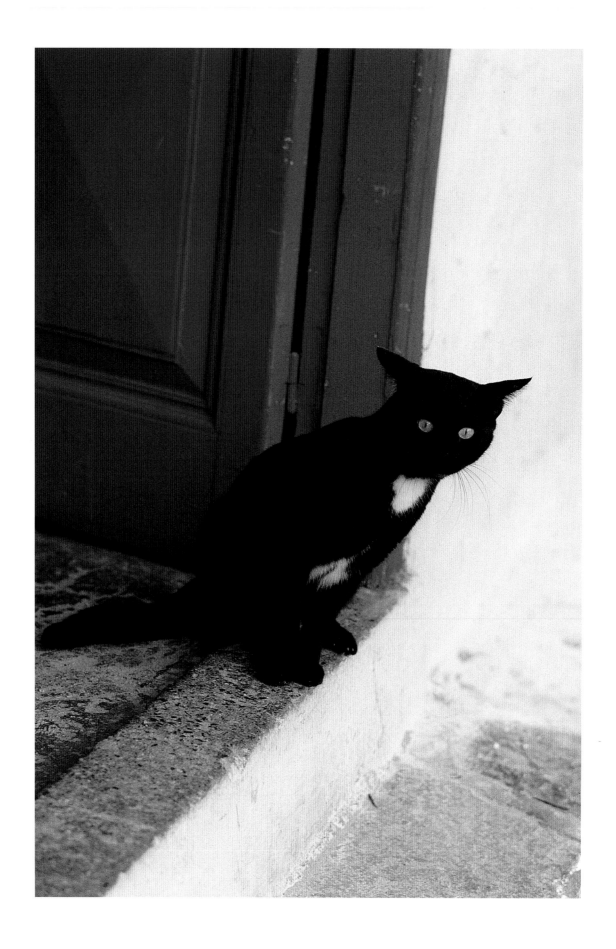

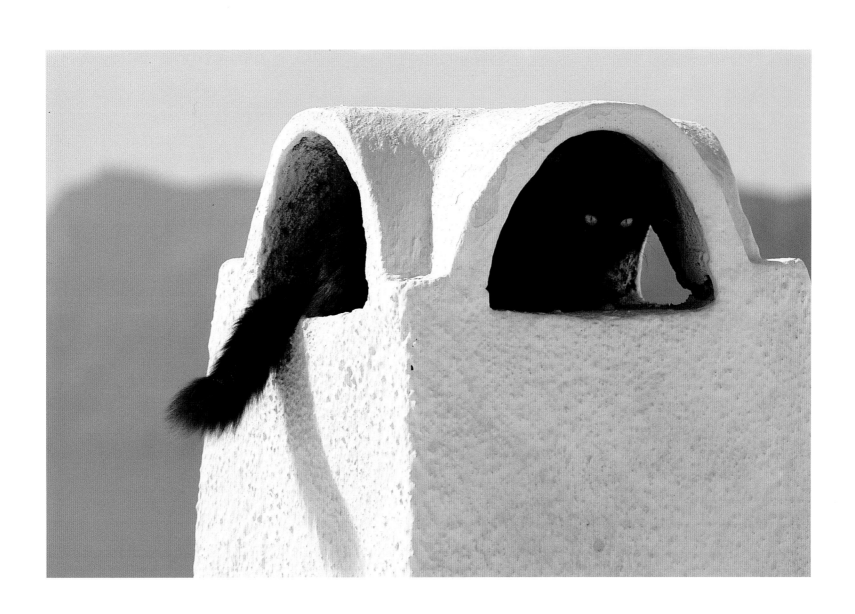

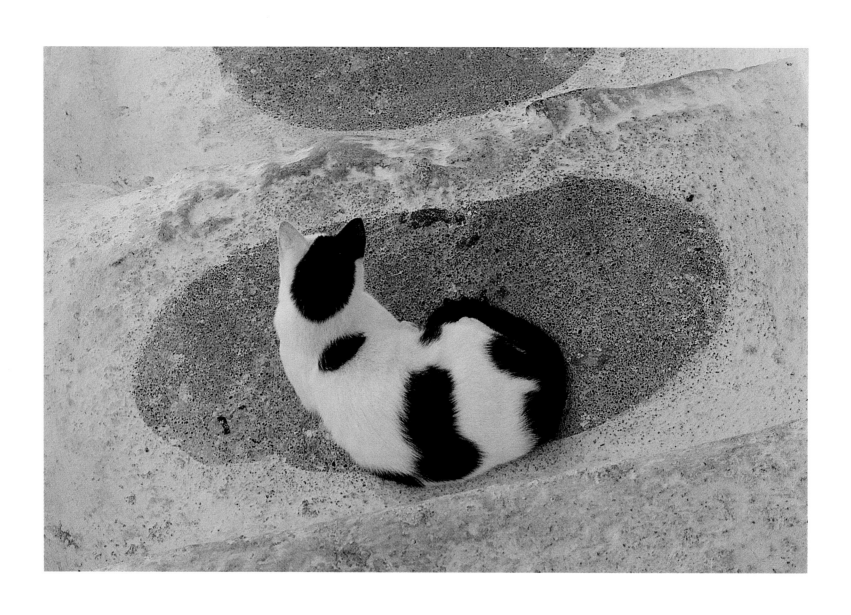

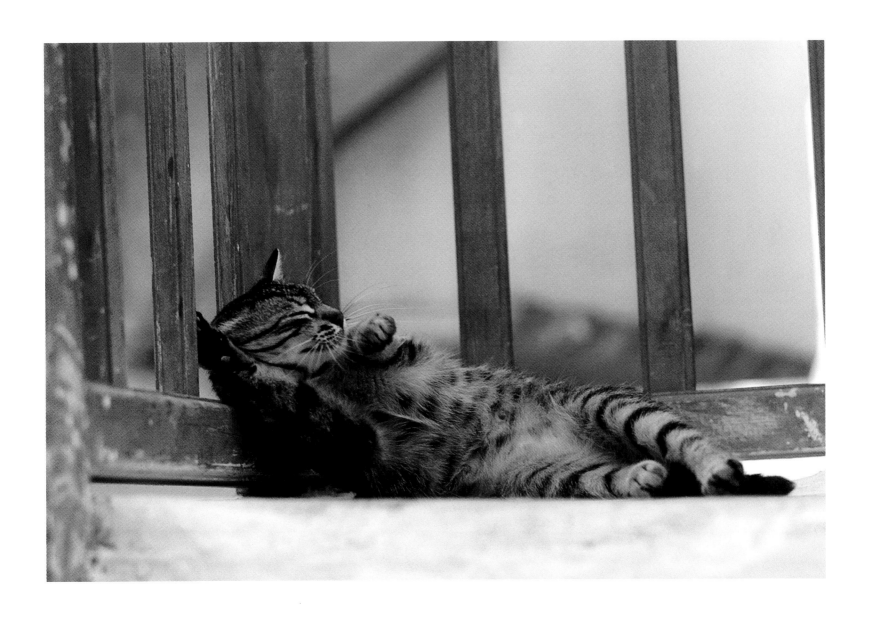

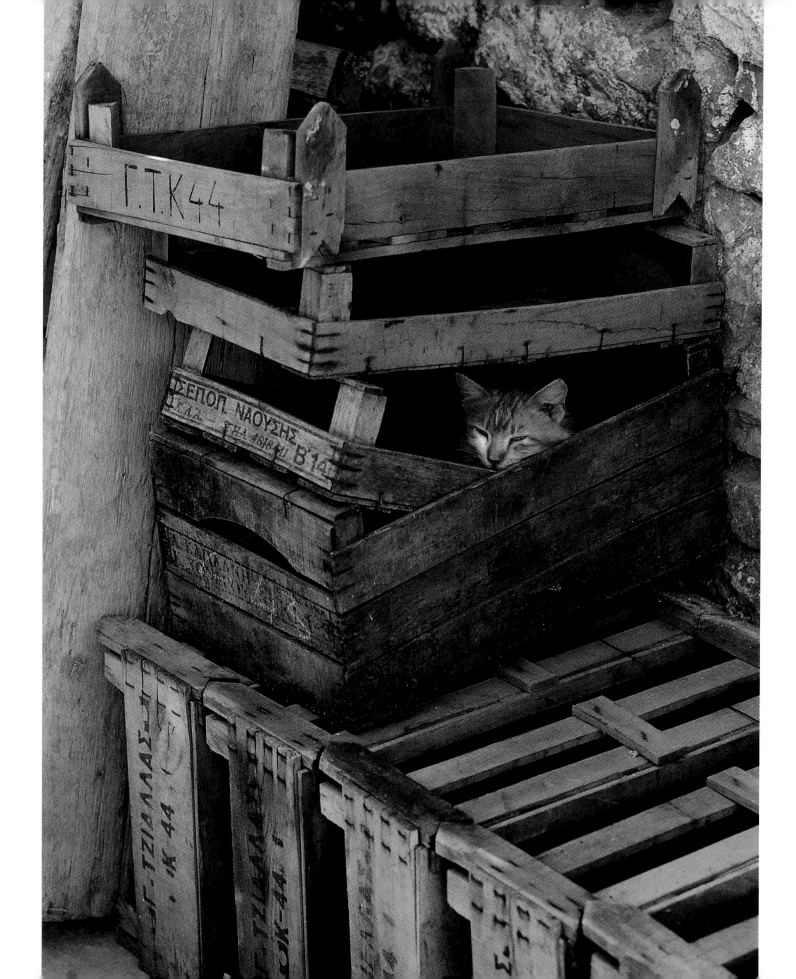

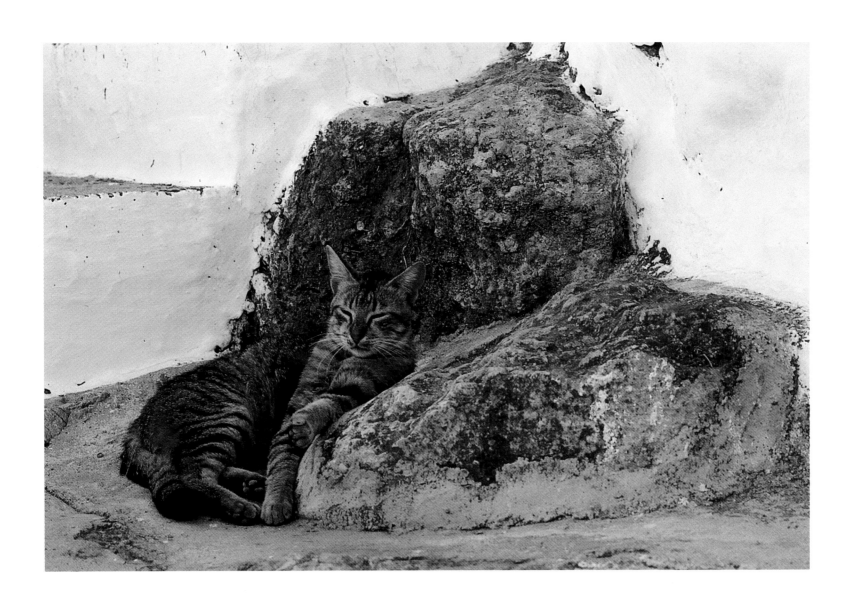

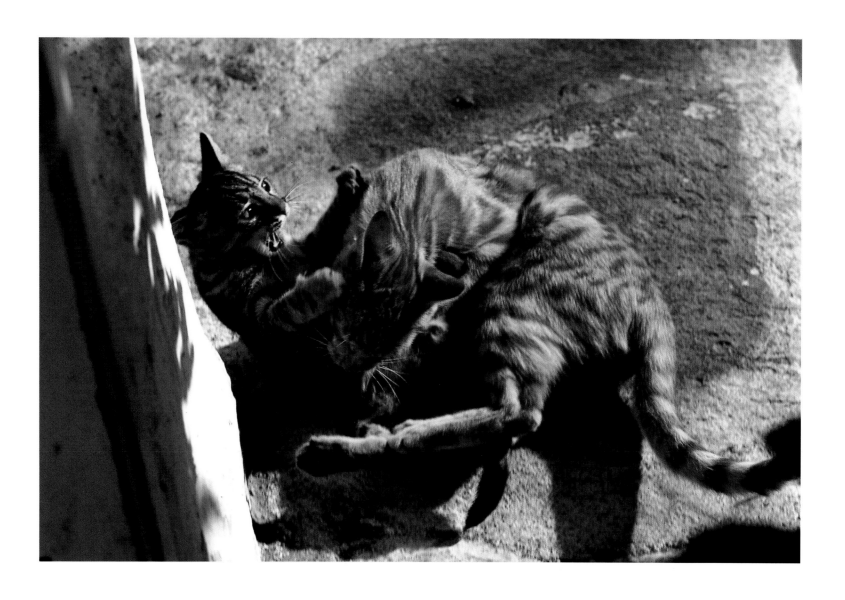

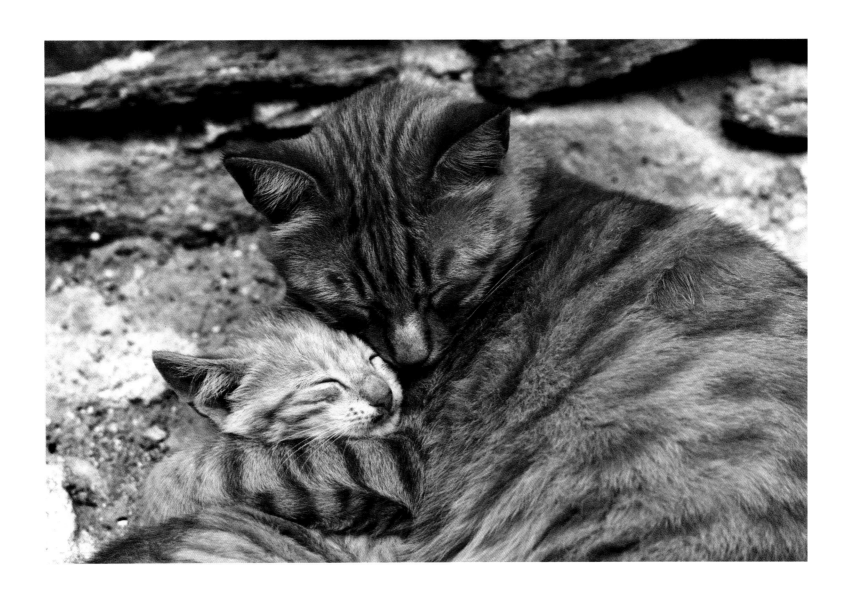

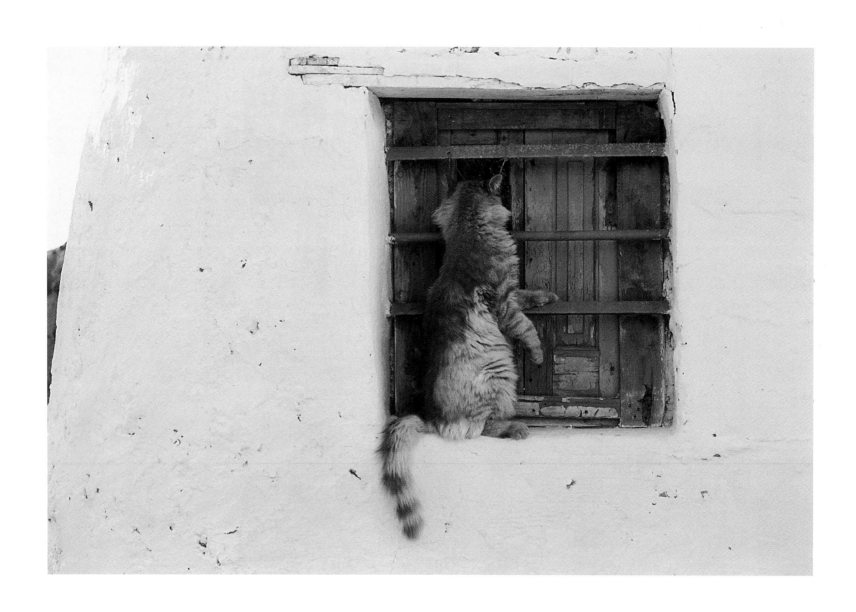

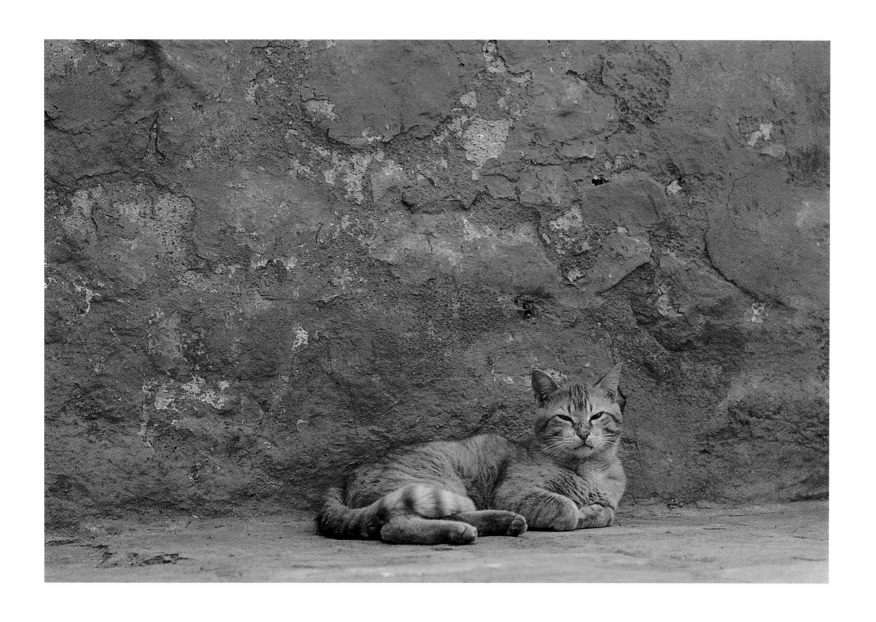

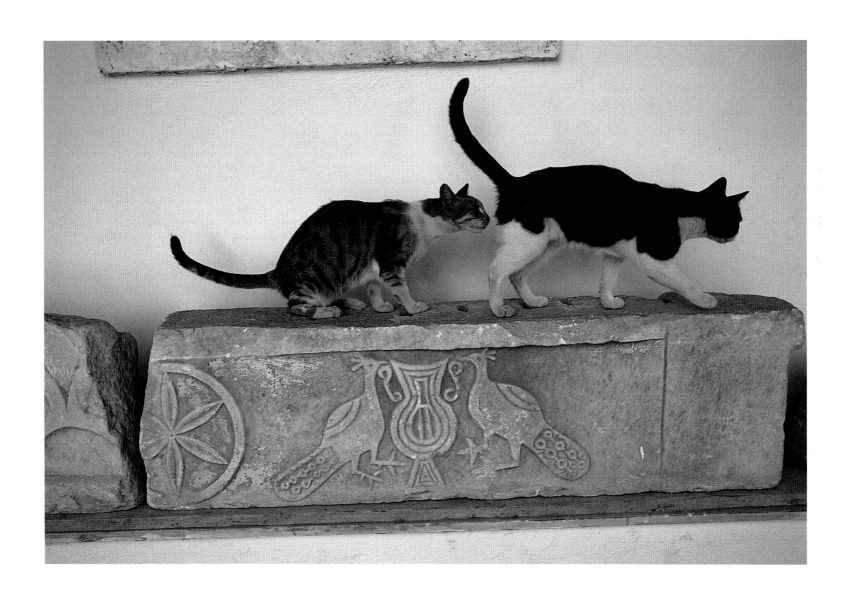

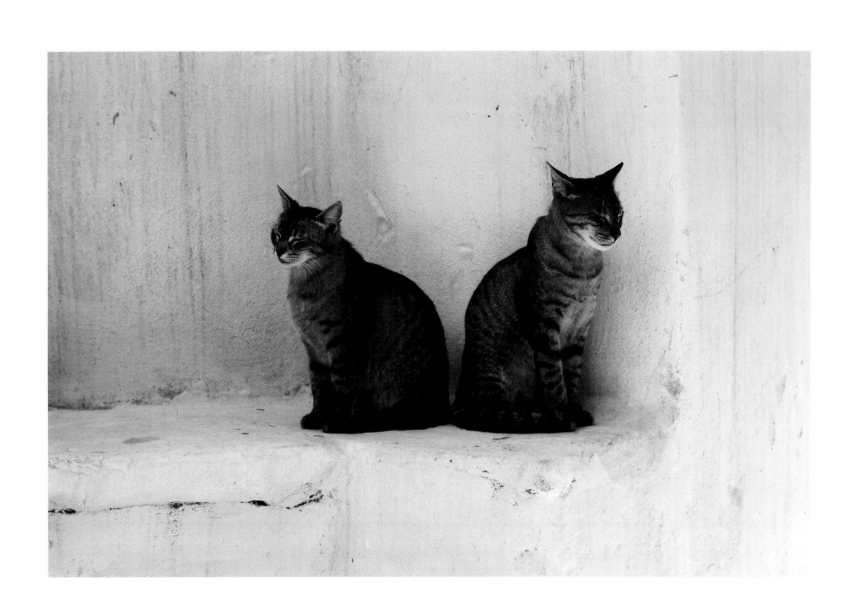

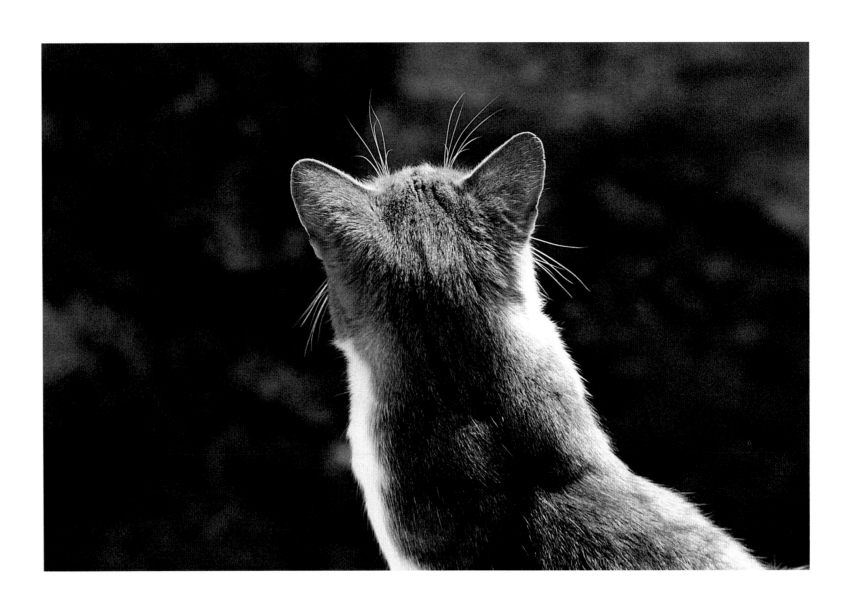

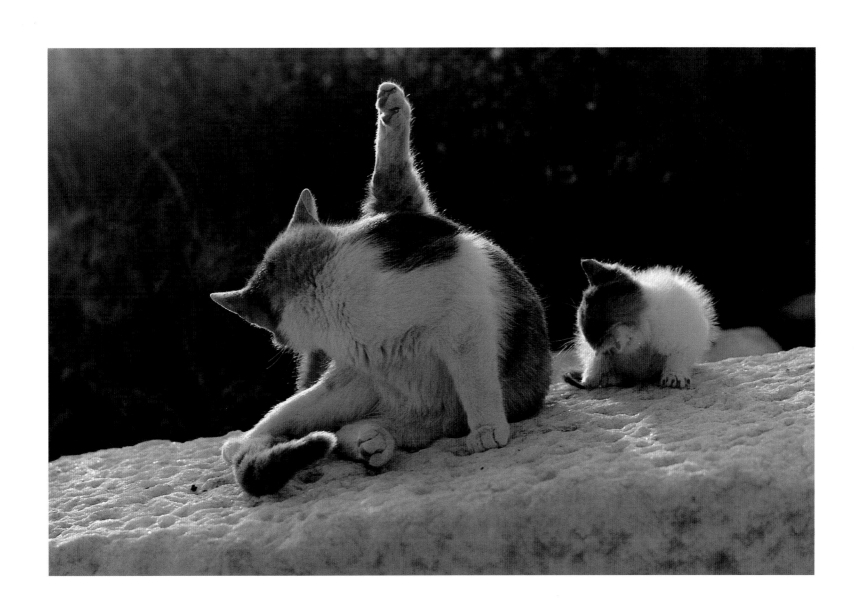

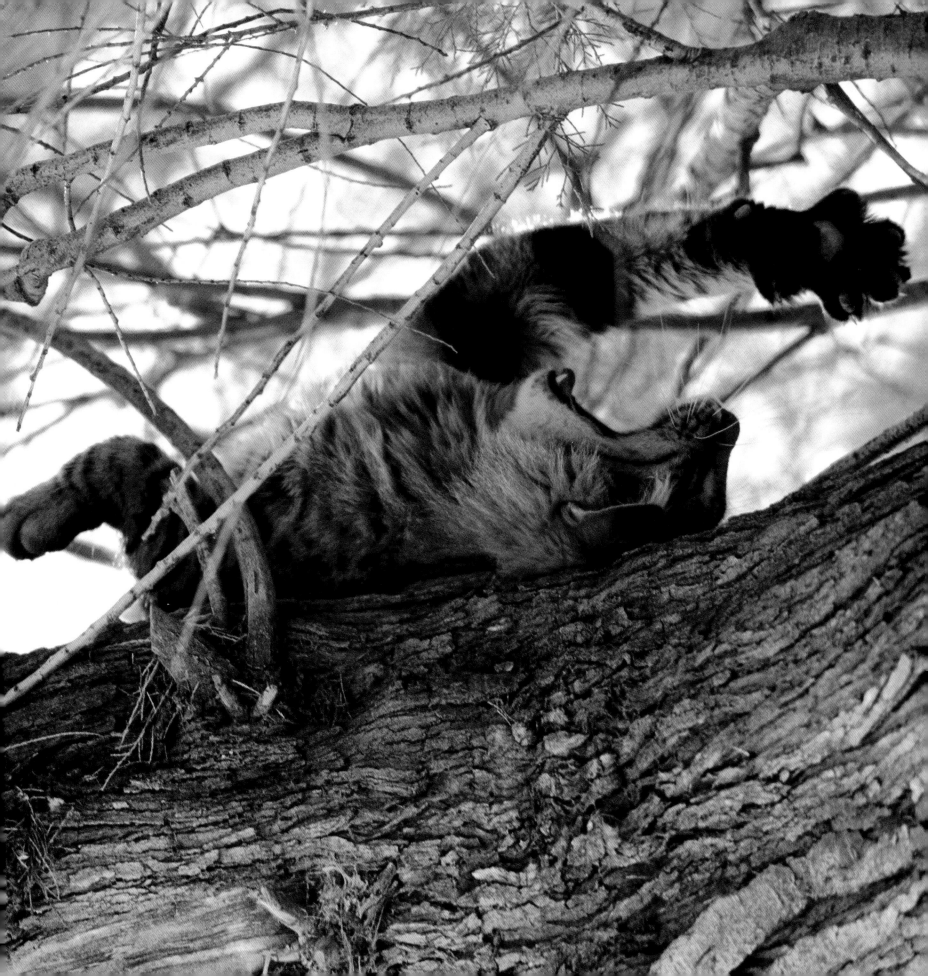

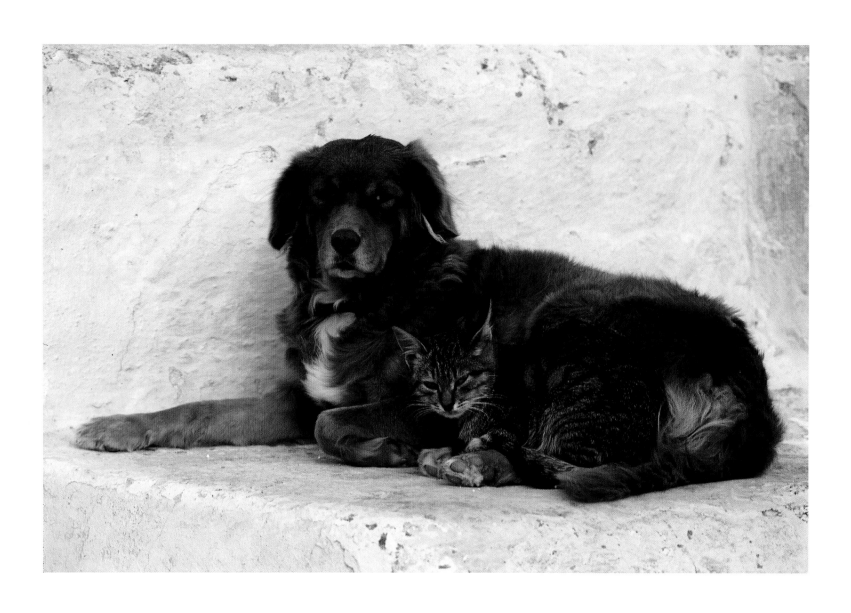

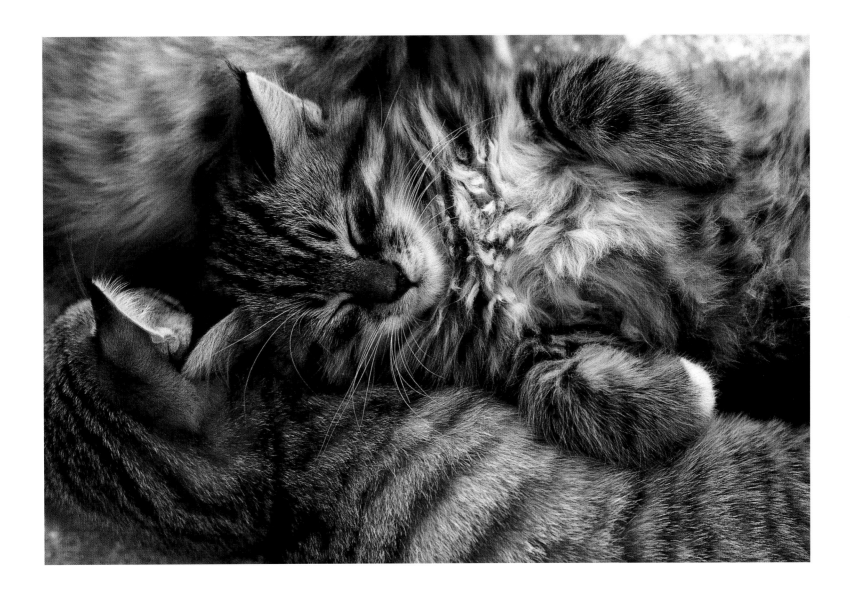

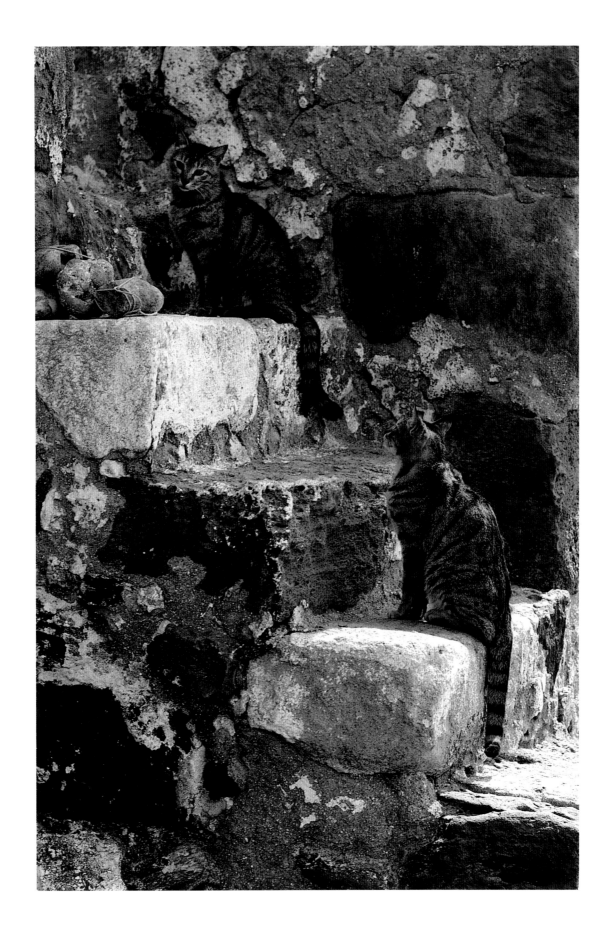

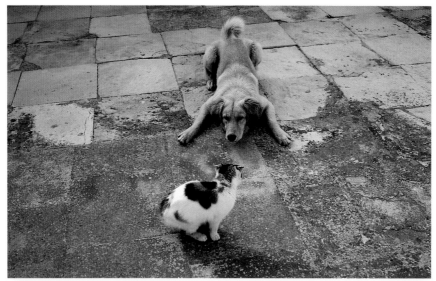

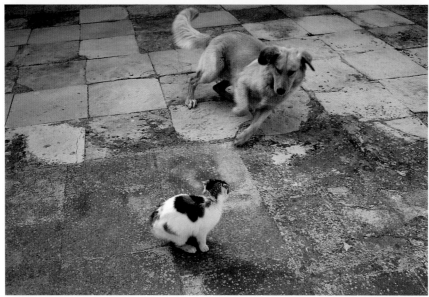

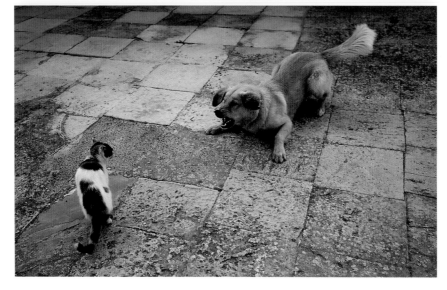

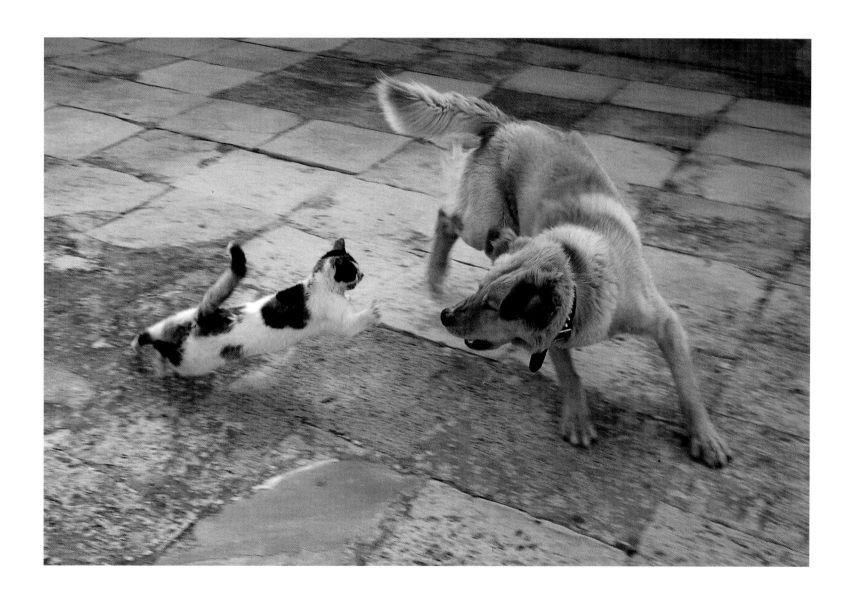

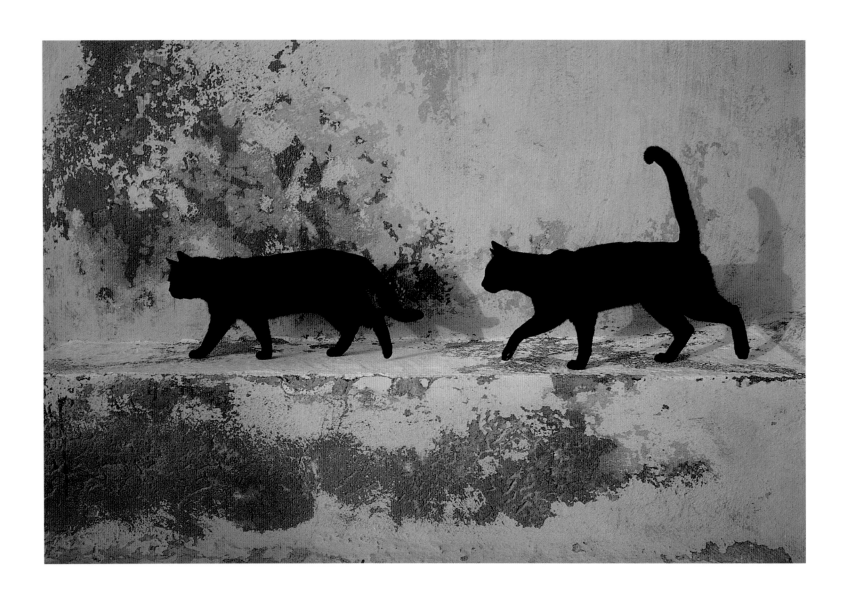

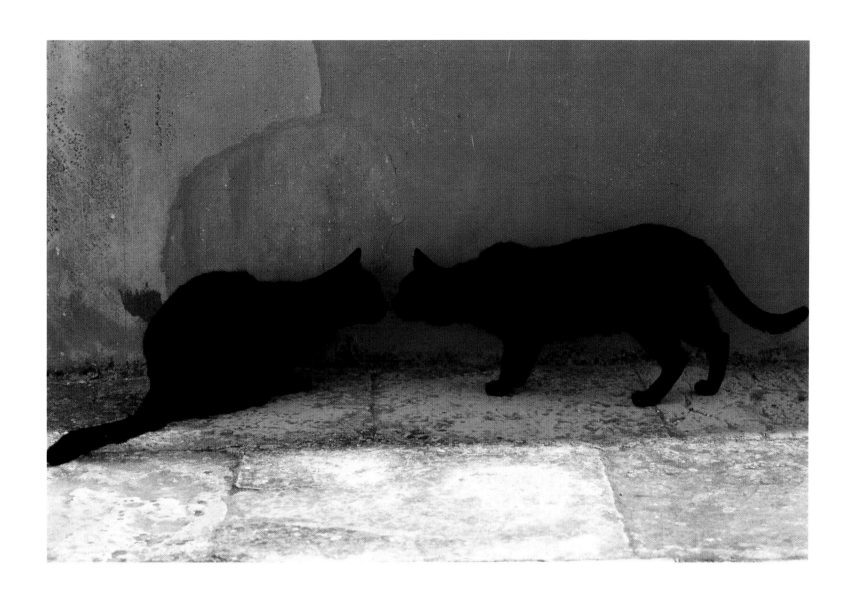

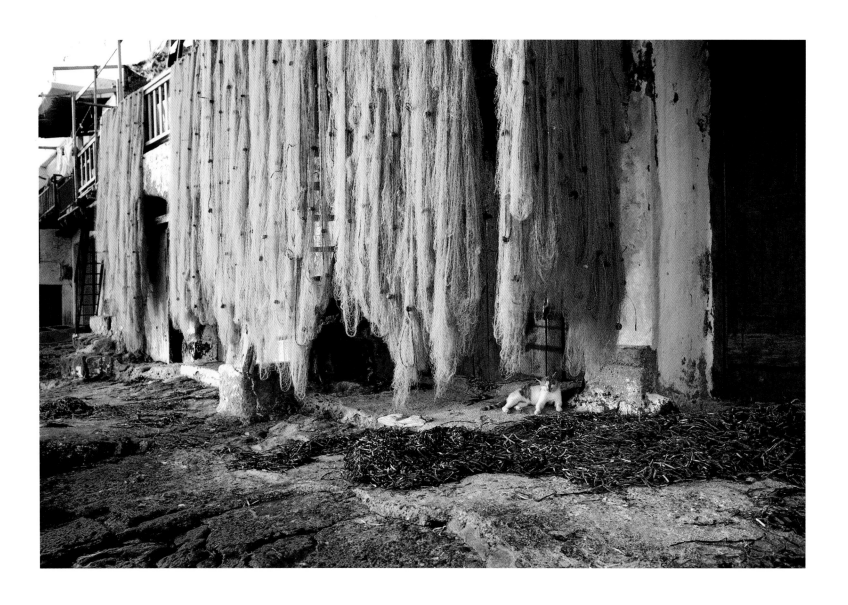

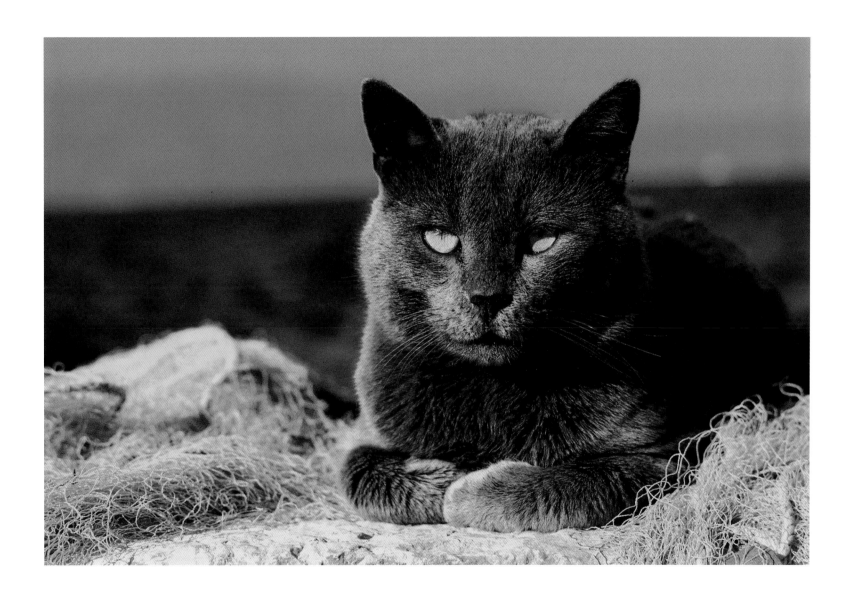

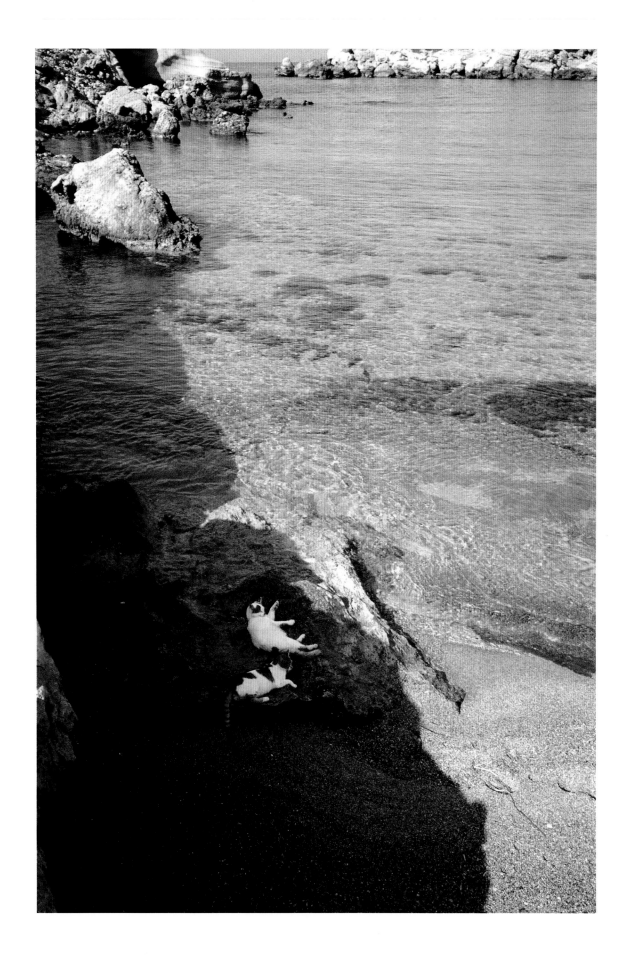

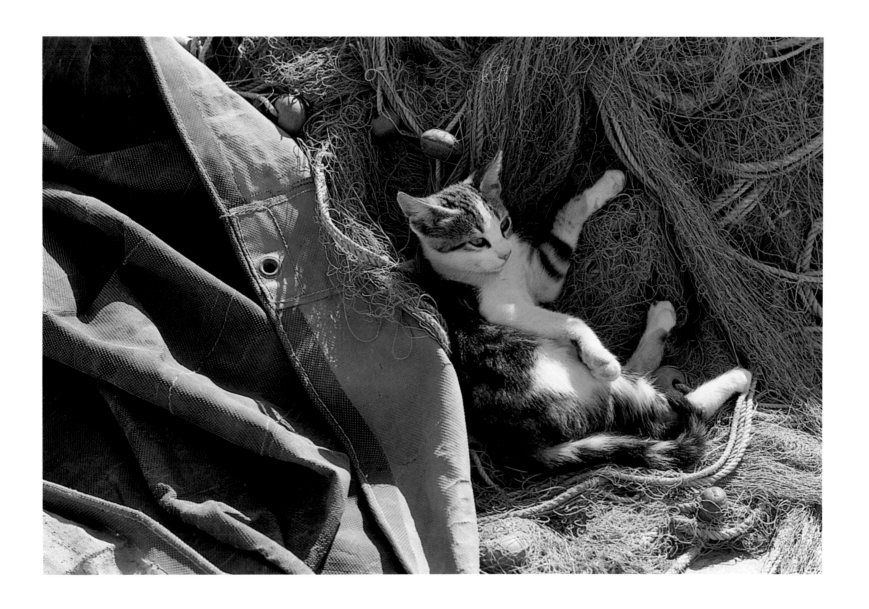

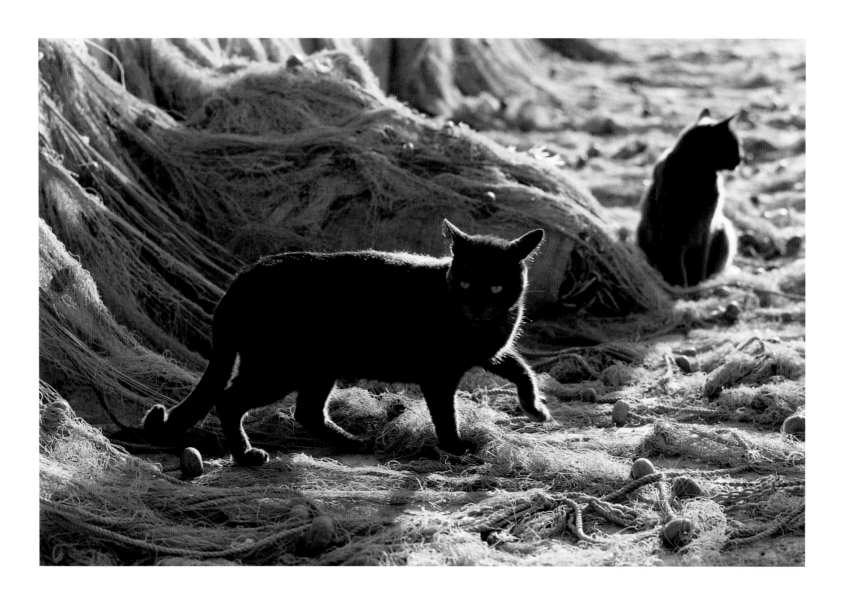

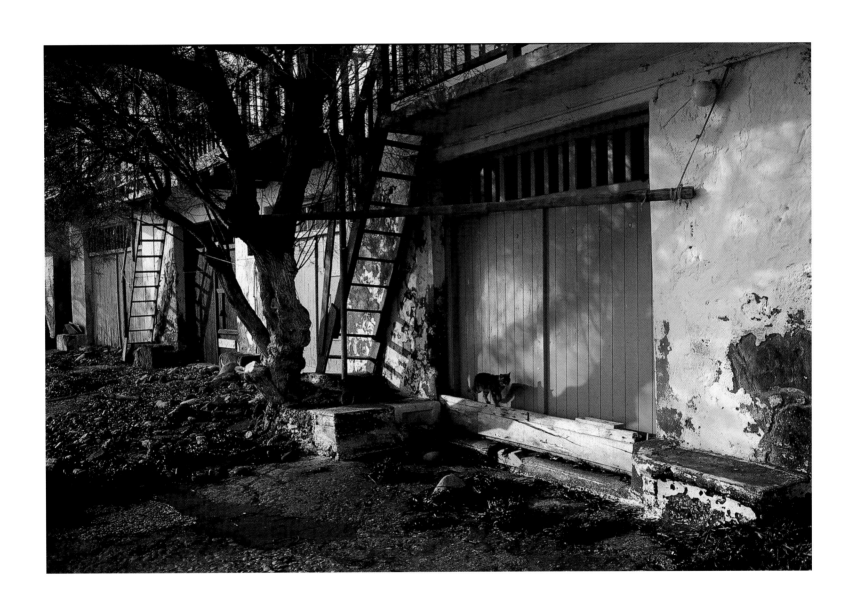

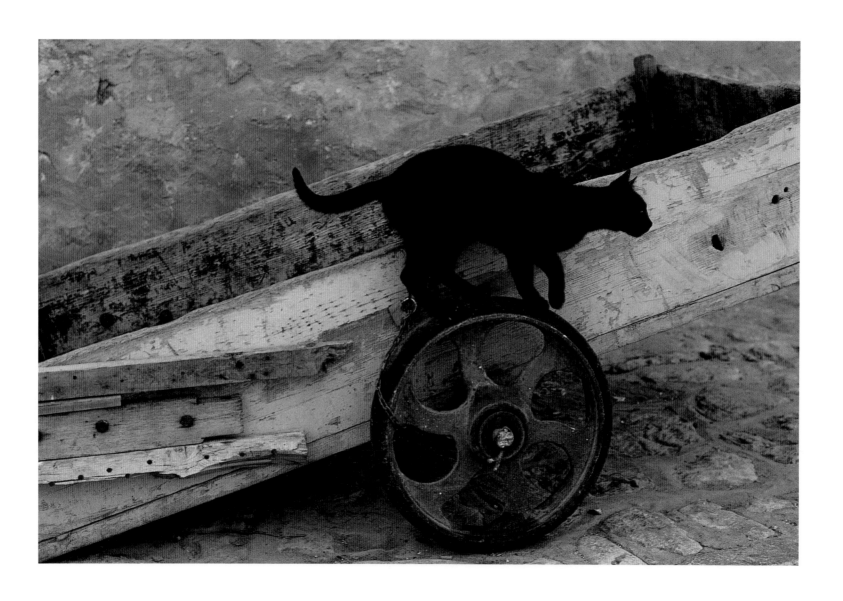

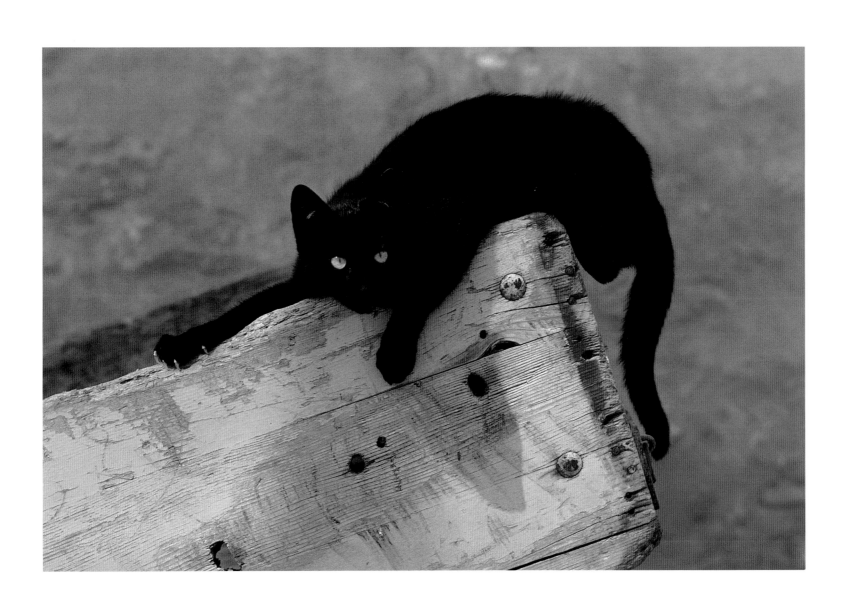

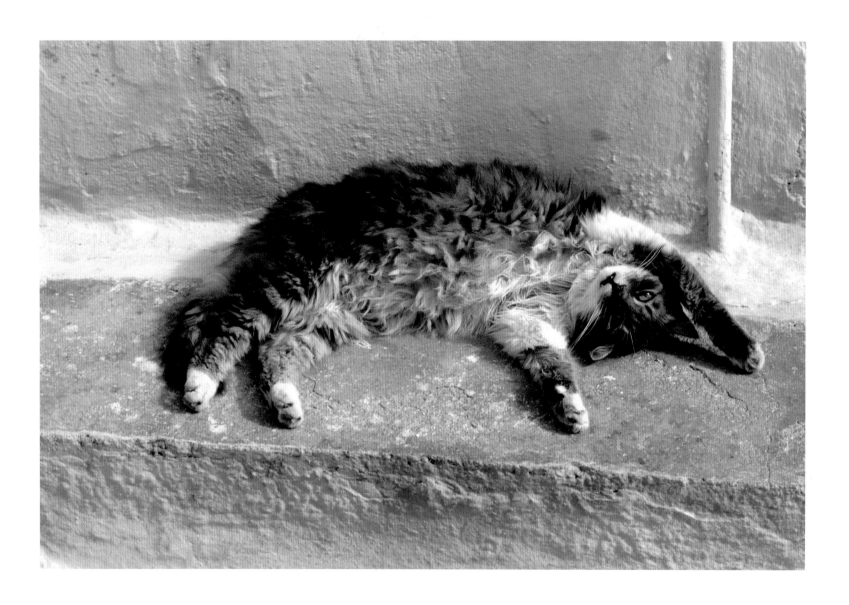

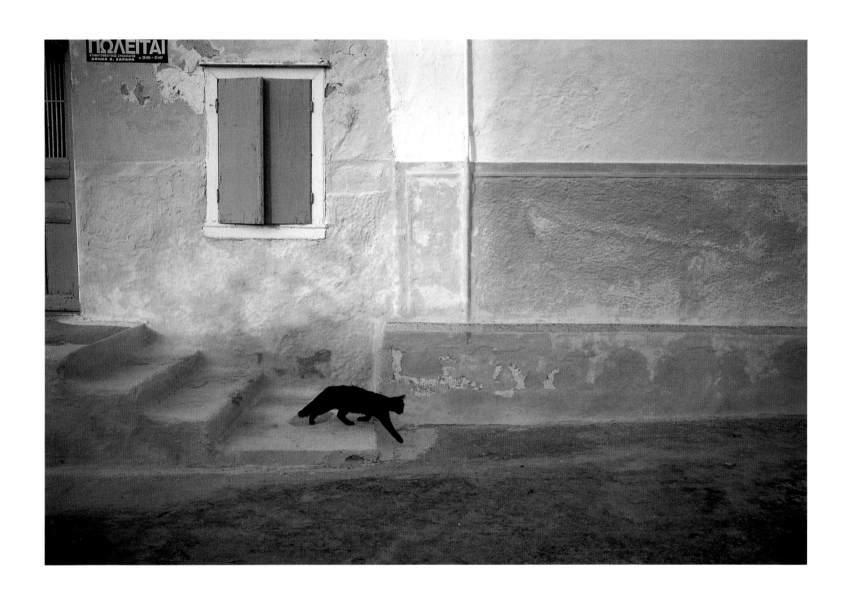

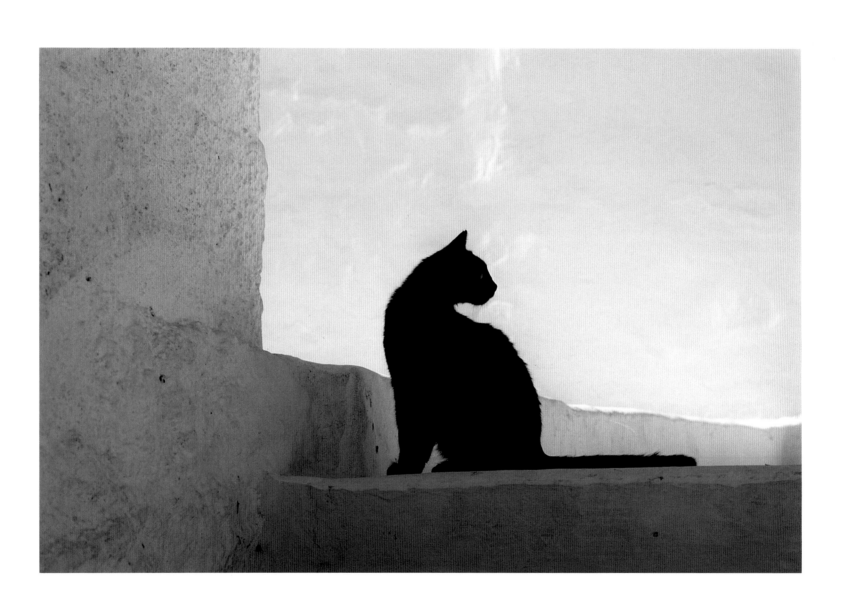

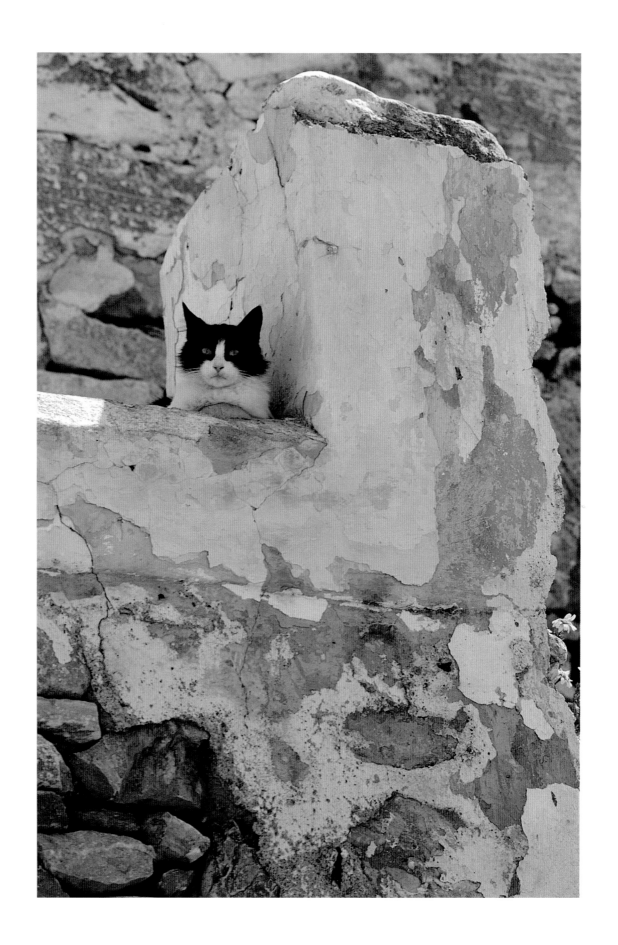

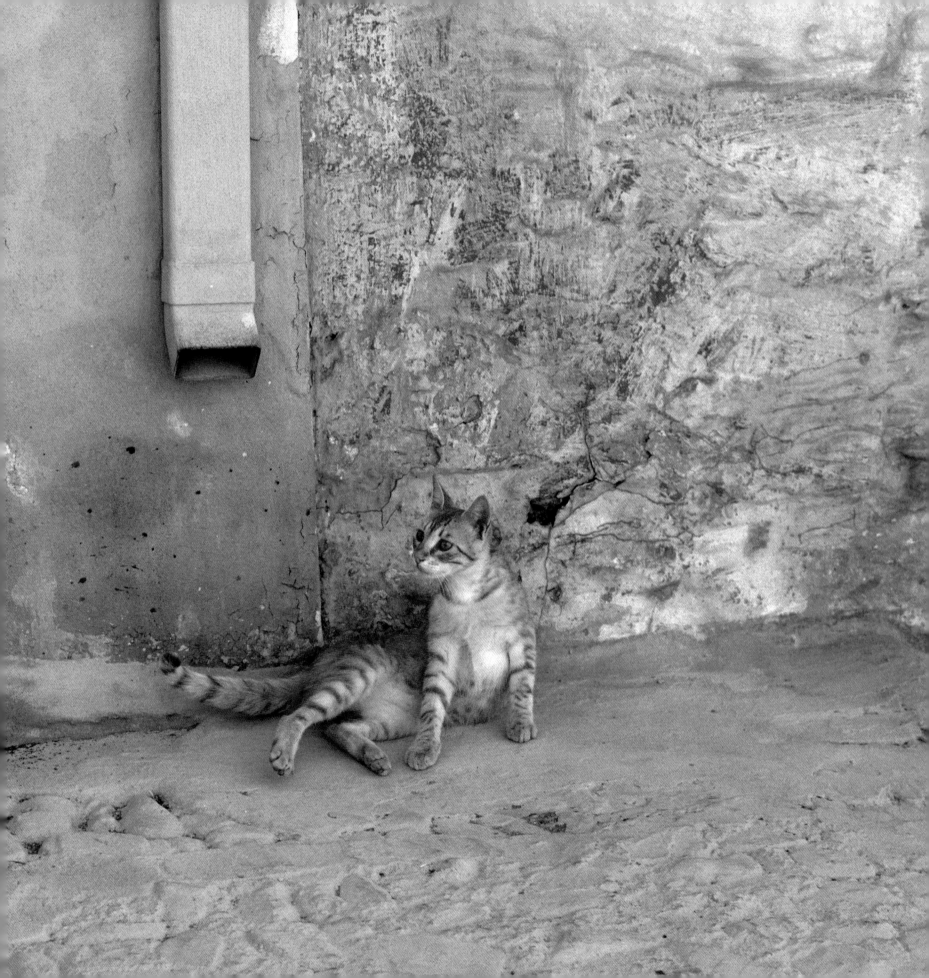

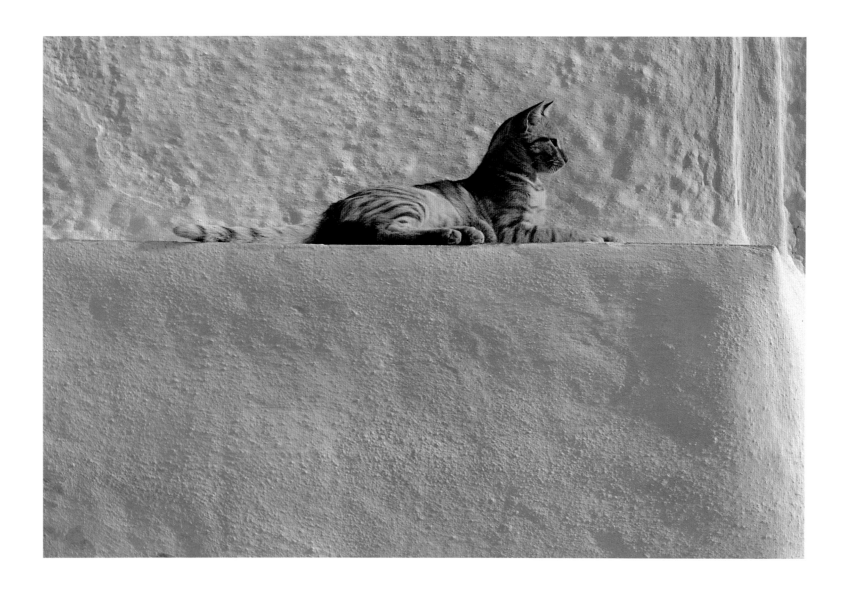

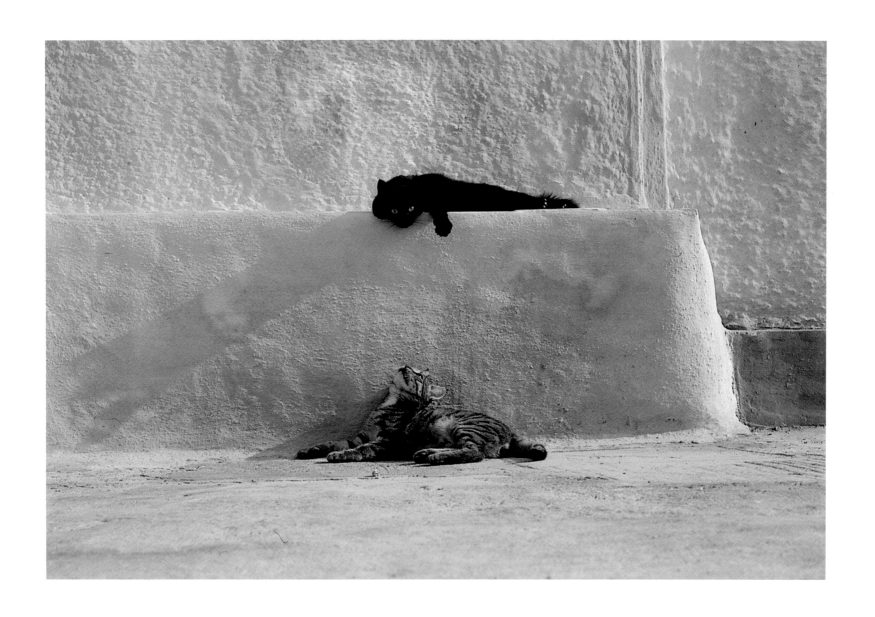

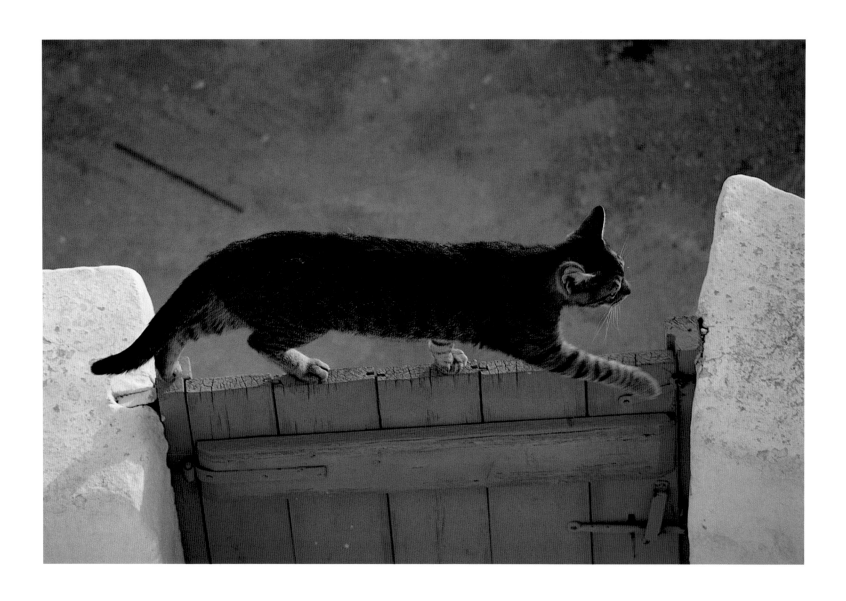

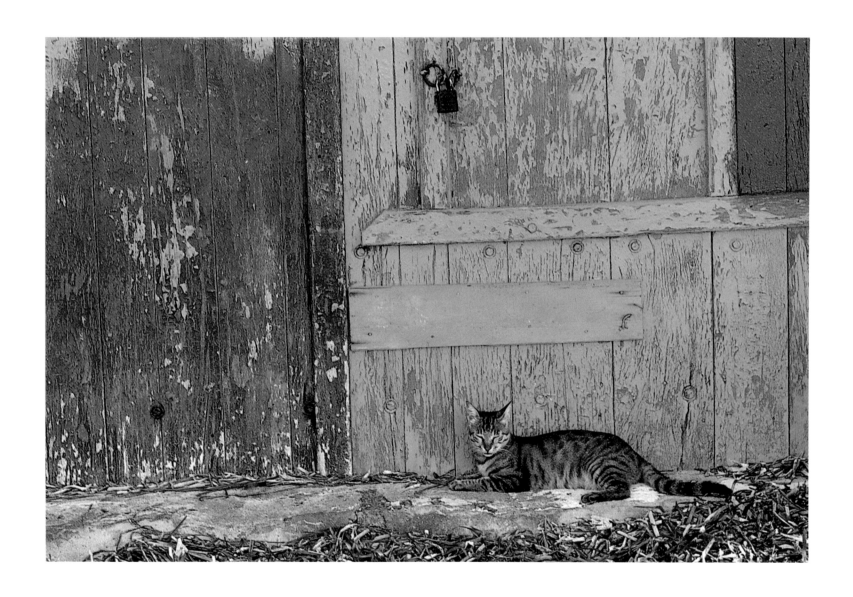

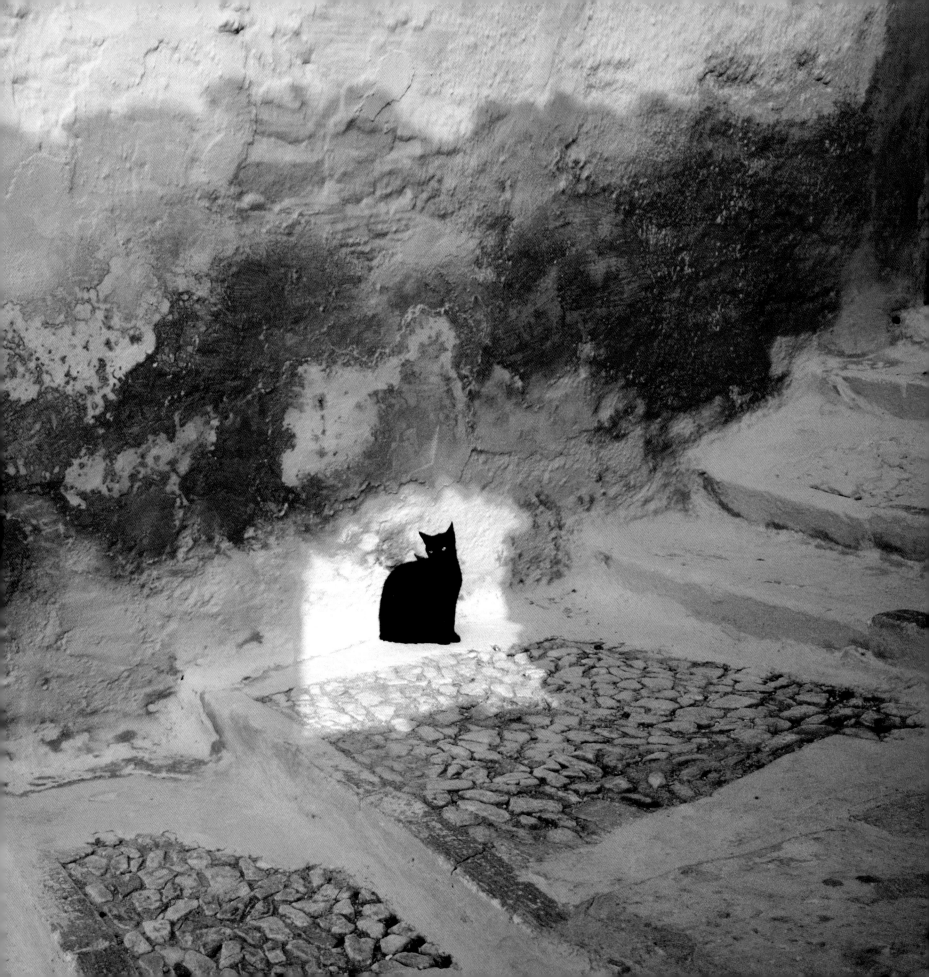

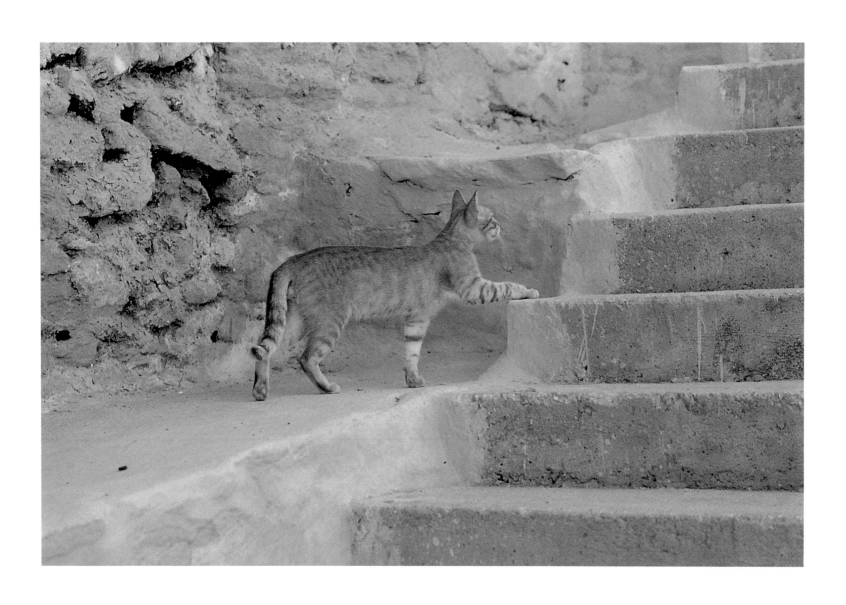

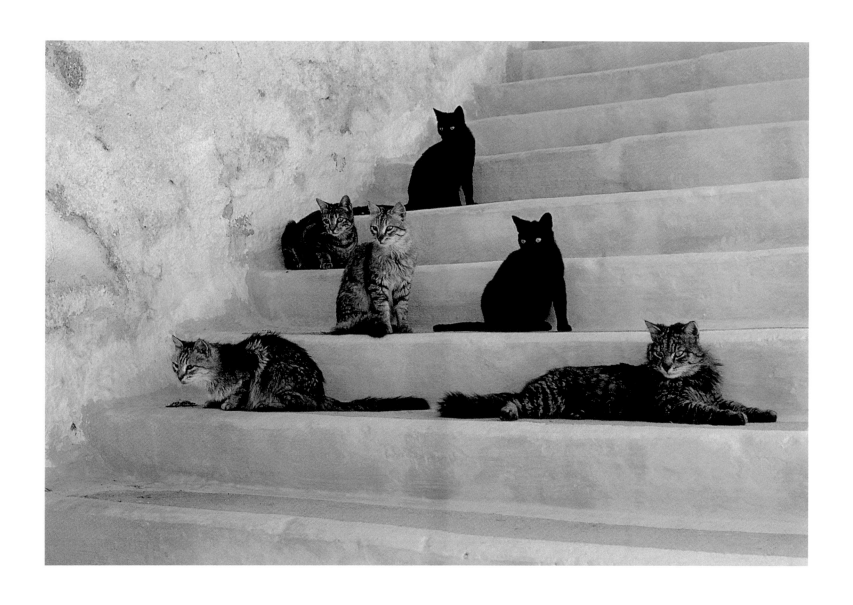

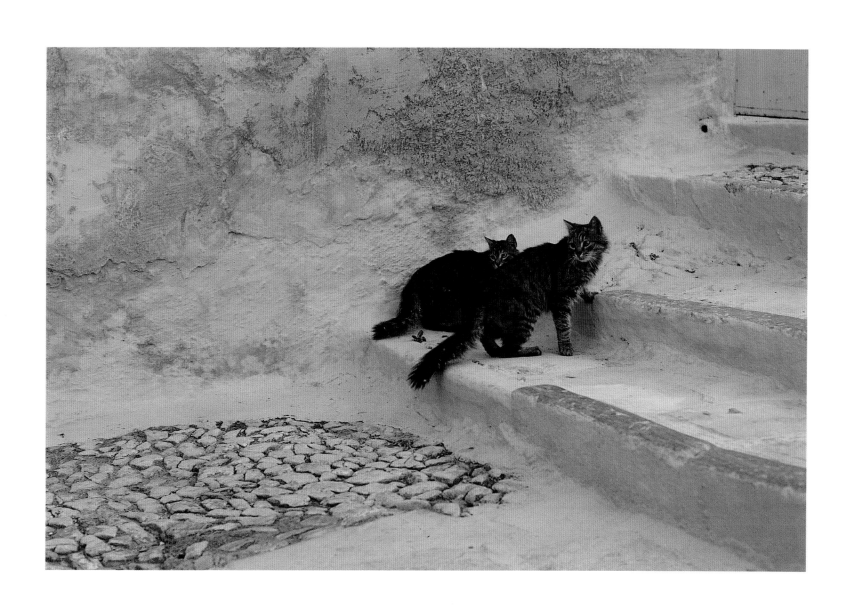

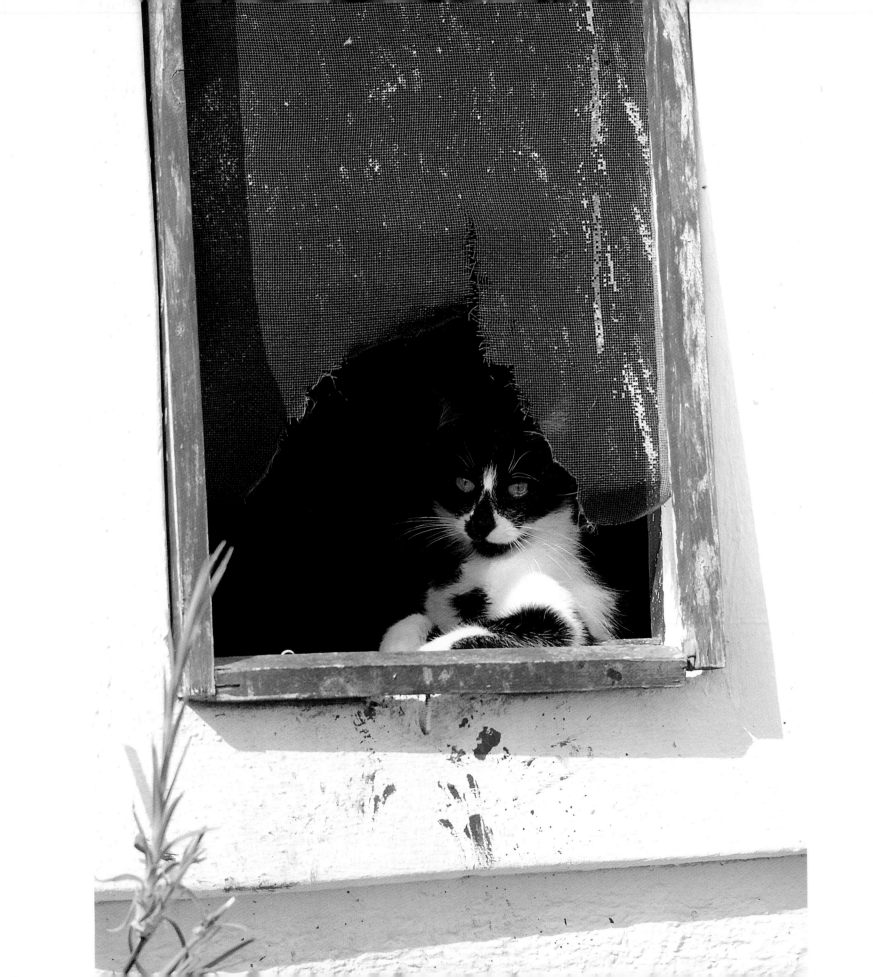

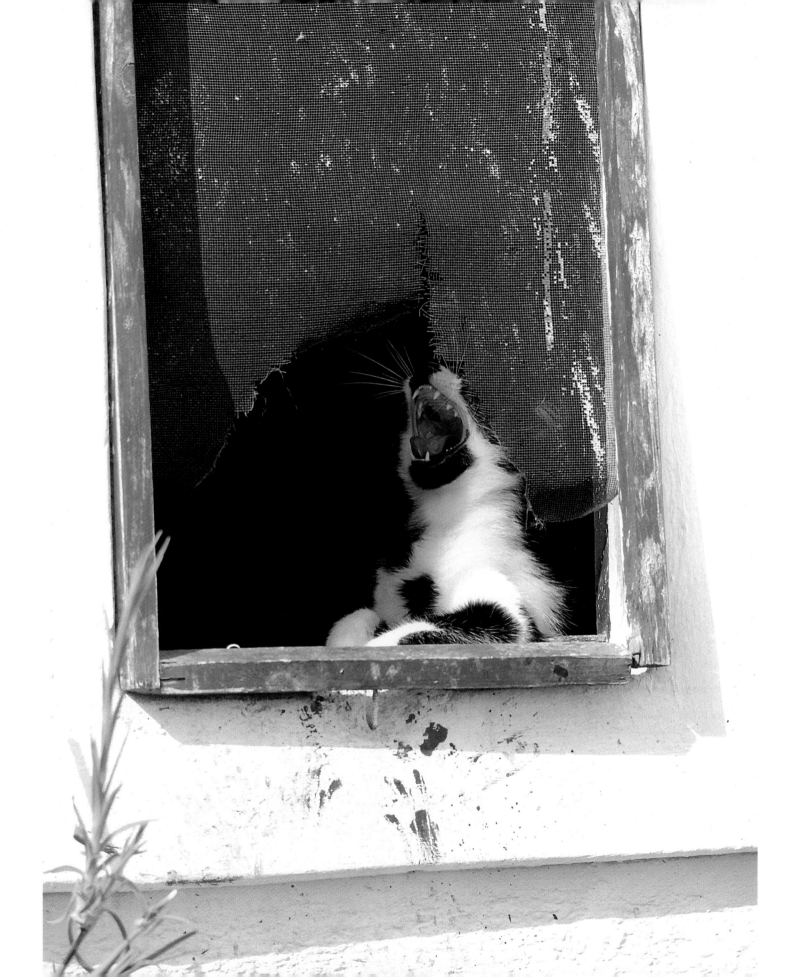

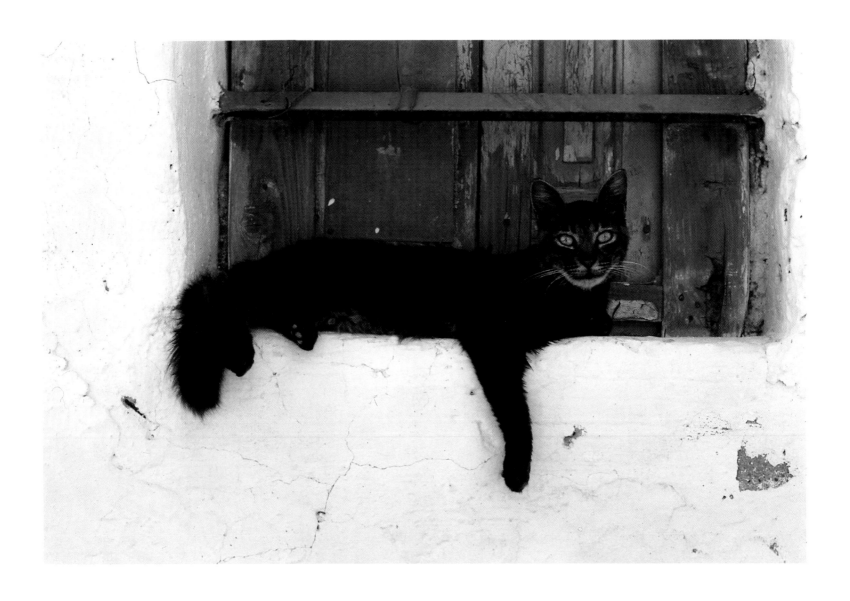

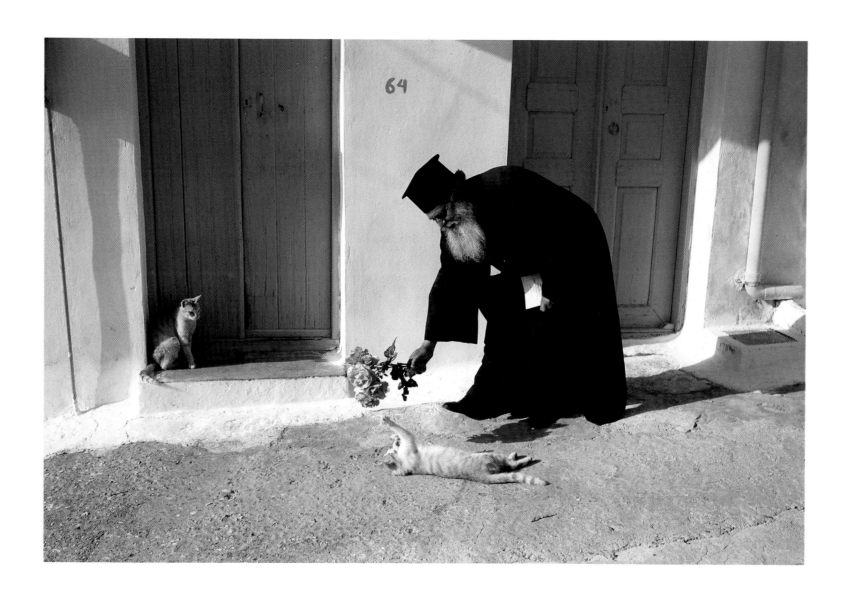

403

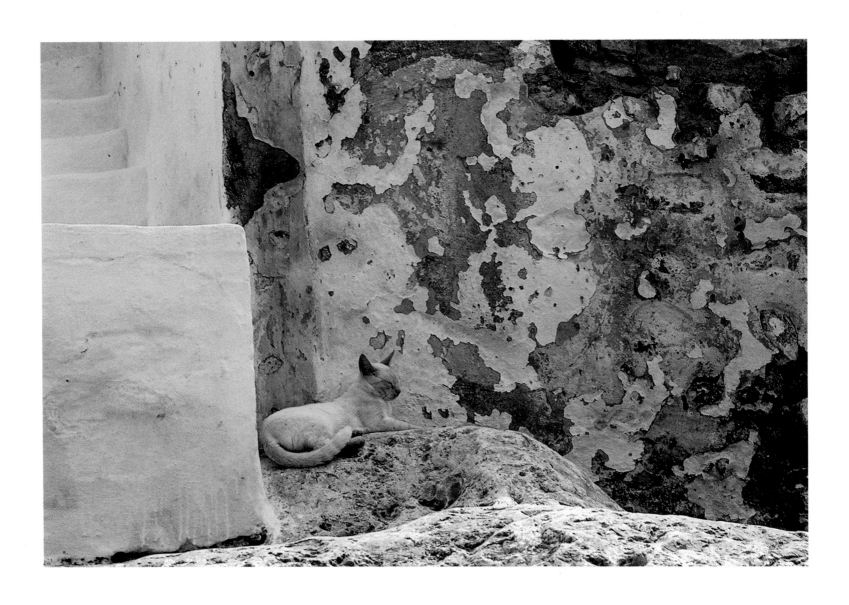

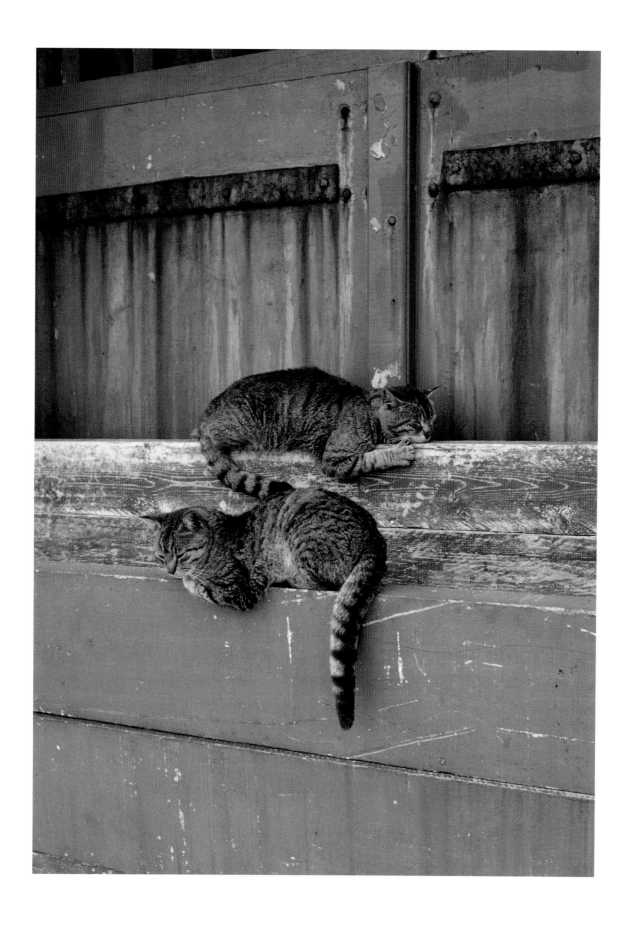

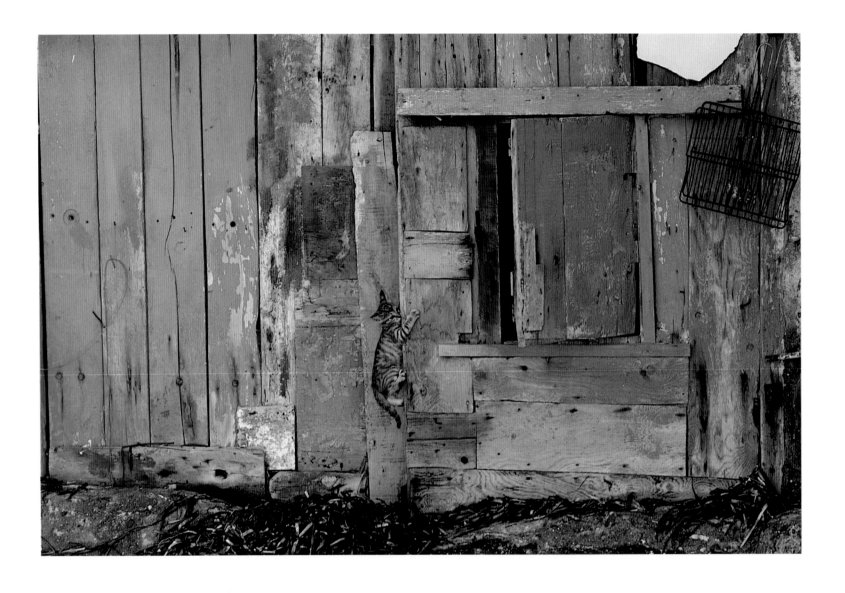

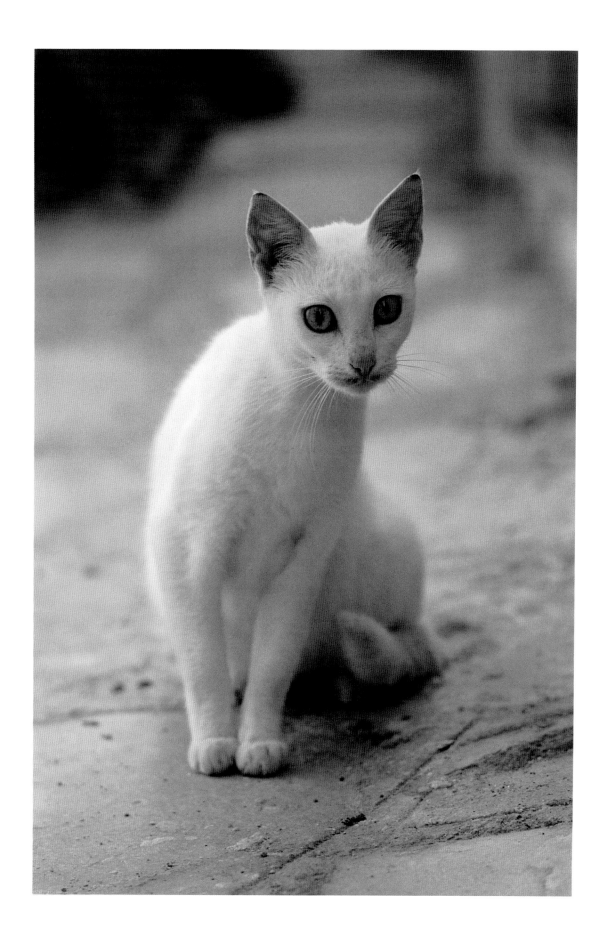

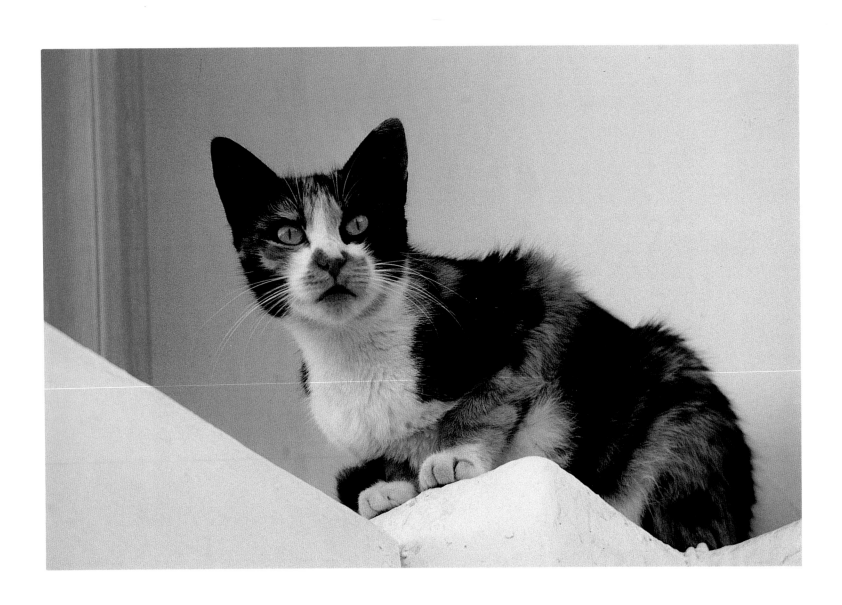

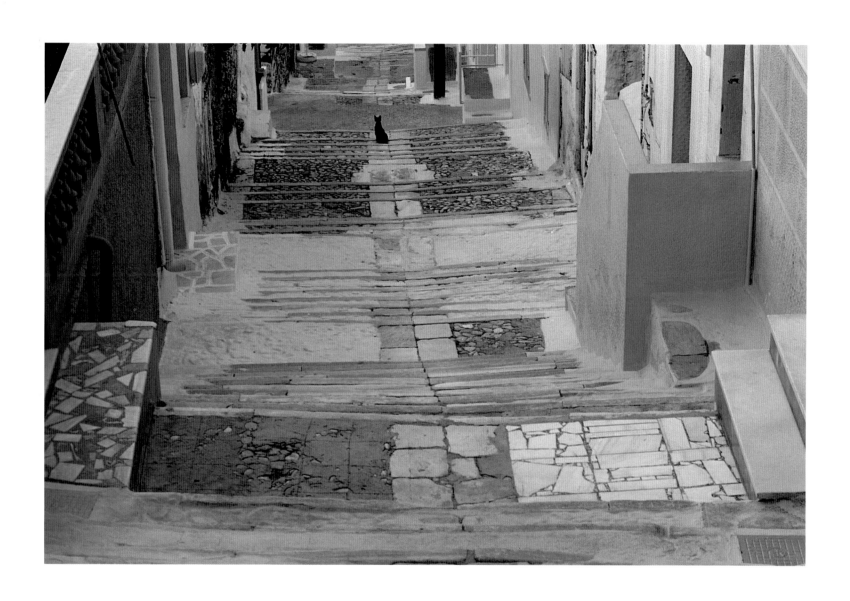

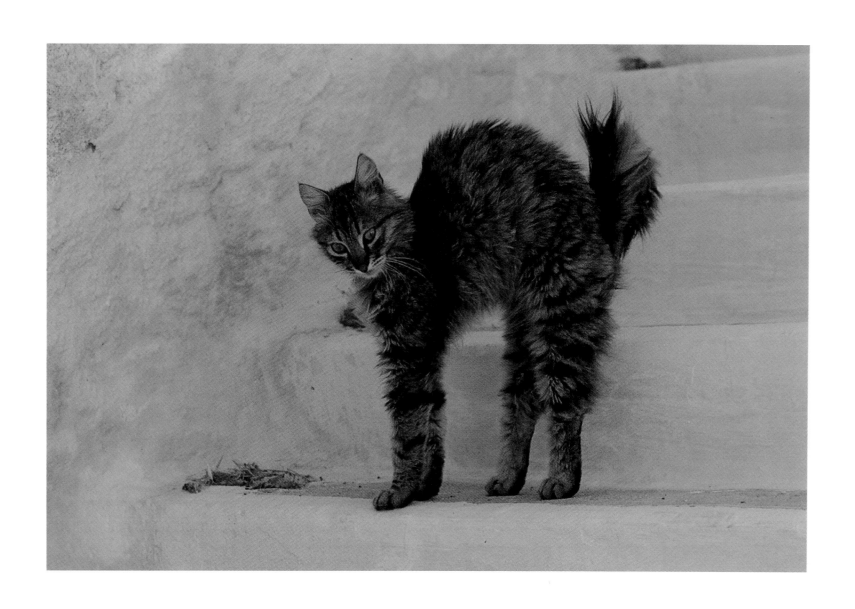

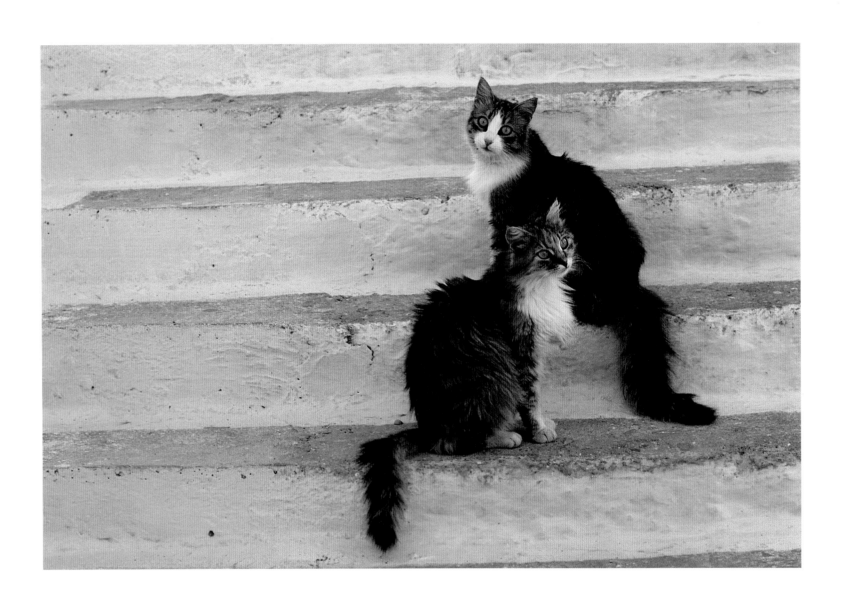

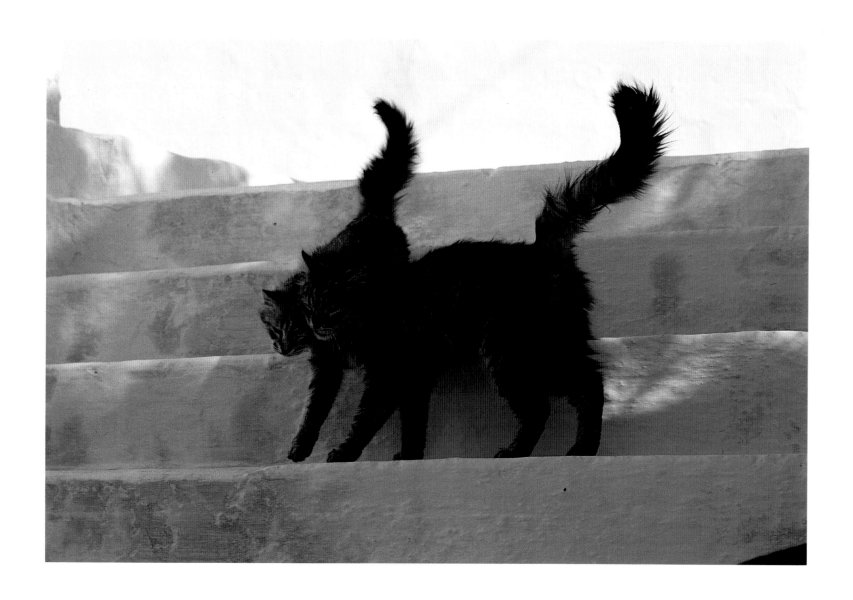

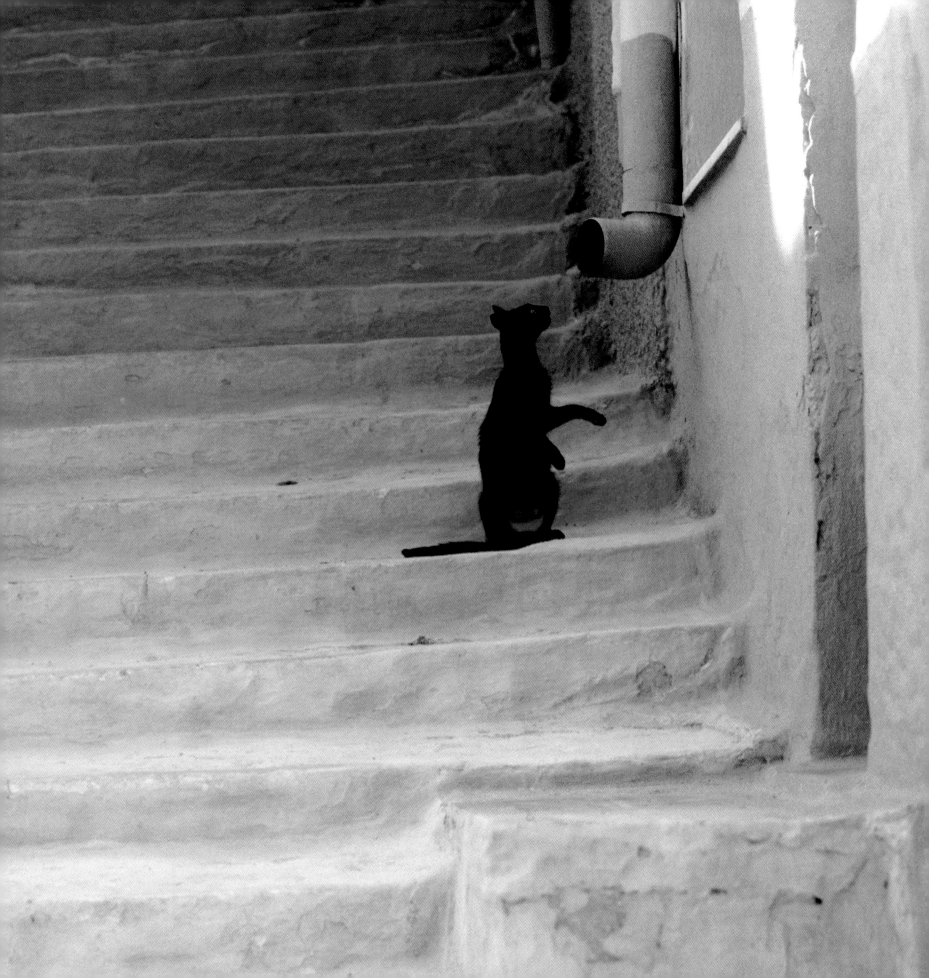

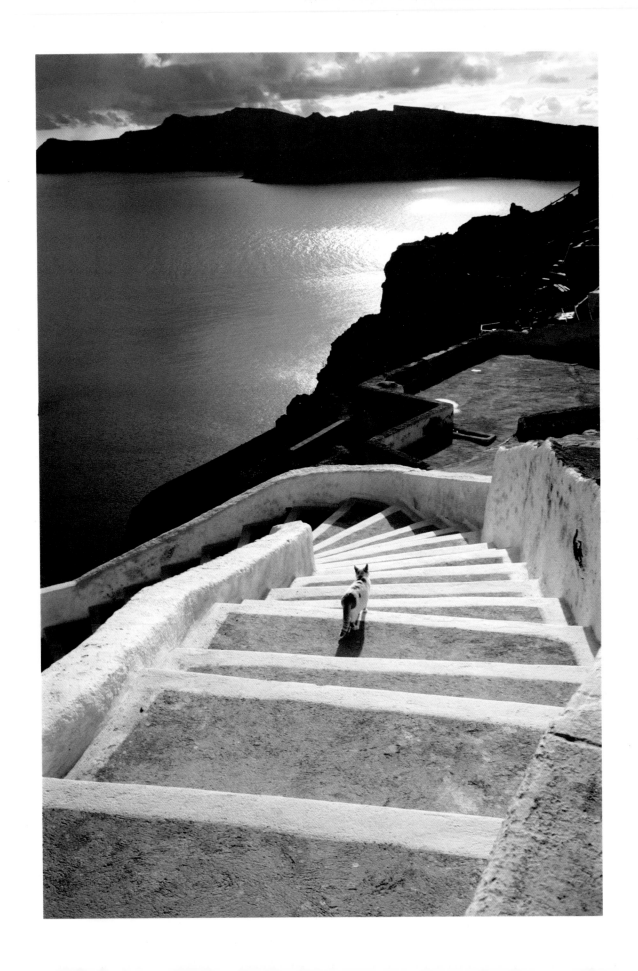